Sun Pictures

Sun Pictures
the Hill-Adamson calotypes

David Bruce

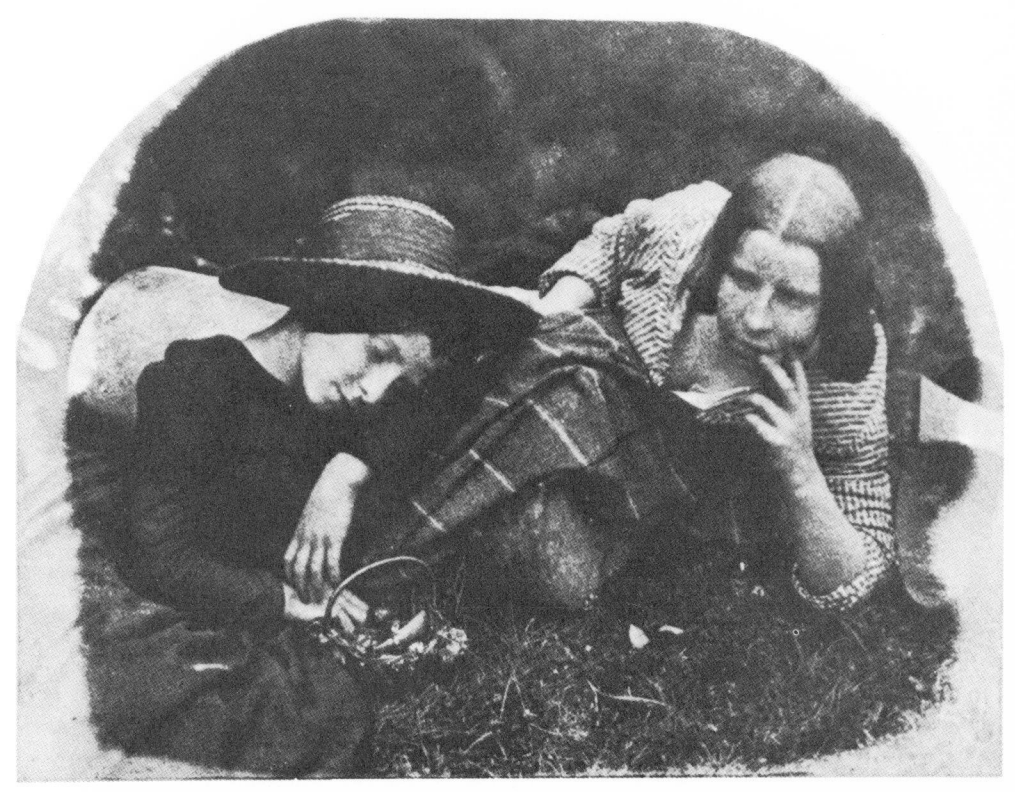

New York Graphic Society Ltd.
Greenwich, Connecticut

International Standard Book Number 0–8212–0588–9 Cloth

International Standard Book Number 0–8212–0590–0 Paper

Library of Congress Catalog Card Number 73–87361

First published 1973 in Great Britain by Studio Vista Publishers, London.

Published in the United States of America 1974 by
New York Graphic Society Ltd., Greenwich, Connecticut 06830.

Printed in Great Britain

Contents

Acknowledgements

The author and publishers are grateful to the following institutions for permission to reproduce calotypes from their collections: Edinburgh Public Libraries, National Library of Scotland, National Portrait Gallery, Royal Scottish Academy, Scottish National Portrait Gallery.

The sources of the calotypes and the dimensions of the original prints are indicated opposite each illustration in the book. The Disruption Painting is reproduced by kind permission of the General Trustees of the Free Church of Scotland.

The main sources of reference for this book are listed in the bibliography at the end but I should particularly like to thank Mr Helmut Gernsheim for his encouragement. His writings on the history and aesthetics of photography are required reading in this area and his infectious enthusiasm for Hill and Adamson is well known. I should also like to make special mention of Dr D. B. Thomas whose *The First Negative* provides a most excellent account of the discovery of the calotype process. The same publication contains extracts from Fox Talbot's correspondence with Brewster and Herschel, on which I have drawn.

In the production of this book I have been given a great deal of assistance by those associated with many national and local institutions. I am especially indebted to Mr Robin Hutchison, Curator, Scottish National Portrait Gallery and Mr A. M. Mackenzie; to Dr E. F. D. Roberts, Librarian, National Library of Scotland; to Mr I. W. Cockburn, Edinburgh City Librarian and to Mrs E. S. N. Armstrong in the Edinburgh Room; to Mr Robin Philipson, President, Royal Scottish Academy; and to Mr Colin Ford, Keeper, Film and Photography, and Miss Valerie Lloyd, National Portrait Gallery, London.

As may readily be appreciated, the technical problems of reproducing the calotypes satisfactorily are considerable. For his great skill and patience in rephotographing the originals, I happily record my debt of gratitude to Mr Tom Scott, a worthy successor to the calotypists.

In 1964 I was given the opportunity to make a short film *The Sun Pictures* on the calotypes. As this book has its origins in that venture I should like to record my thanks to Films of Scotland and that organization's Director, Mr Forsyth Hardy.

My warm thanks are also due to Josephine Hickey and Stephen Adamson of Studio Vista and to all those about me who have given of their time and energies in this project.

In particular I thank Mr Brian Hannan for research assistance; Miss

Muriel Falla for expert secretarial help; my father, George Bruce, for research and advice; my colleagues at the Scottish Film Council, particularly the Director, Mr Ronald Macluskie, and Mr Richard Tucker for their encouragement; and my wife for typing help and much forbearance.

Finally, I acknowledge a very substantial debt to Mrs Katherine Michaelson on whose unpublished thesis on Hill and Adamson she has most generously allowed me to draw freely. To her I owe a great deal of the information in this book, particularly that used in the captions. To her and to her Director of Studies I am most grateful.

There is no greater propagandist for Hill and Adamson than Mrs Michaelson. I would like to think that some of her considerable enthusiasm for them has found its way into this book.

Introduction

The sense of surprise and pleasure which is generated by discovery is the moving force behind this book. The surprise occasioned by the discovery of the latent image on a piece of paper hitherto apparently blank can be experienced, at least to some degree, by any amateur photographer who does his own printing; Fox Talbot's astonishment on his very first discovery of the phenomenon, in September 1840, we can only guess at.

The discovery, or rather rediscovery, of the Hill/Adamson calotypes, however, is something that we can all share. The significance of the work of Hill and Adamson has long been recognized by historians of photography but recognition by a wider public is comparatively recent.

My own discovery of the calotypes happened more or less by chance. I was almost entirely unprepared for it, having only the faintest idea of who David Octavius Hill was, and never having heard of Adamson. I was fortunate enough to be shown some of the examples in the largest collection of Hill/Adamson calotypes, that in the Scottish National Portrait Gallery in Edinburgh. I remember that among my first responses was the perhaps irrational one of annoyance that I had never been told before about these marvellous photographs. But I remember also the feeling of surprise at the artistic quality, and of disbelief that the pictures before me could really be so old. This was the camera as time-machine, giving not simply a clinical account of what had passed before the lens, but recreating a style of living.

There was also surprise in discovering – an important discovery I think – that one's concept of Victorian photography could be proved inadequate. Stereotyped images of family elders propped stiffly in chairs while their small wives stood deferentially by, are probably what many people imagine to be the staple diet of that period. To be sure, the commercialization of photography, which began almost with the invention of the medium, was responsible for the inordinate flood of indifferent stuff. But early photography was more than a tradesman's bonanza. Diverse technical developments ensured that many techniques were practised, and each practised with a great variety of expertise. The daguerreotype, the calotype, the collodion process, the ambrotype, the platinotype, the gum print, and carbon print all have their own characteristics; and, though its adherents will protest that the calotype with its soft orange-browns and sepias is inherently the most engaging and truly artistic medium, as each successive system displayed its virtues and drawbacks there arose photographers who found one or other process most suited to their particular needs for expression. If the attention now being bestowed on the Hill/

Adamson calotypes does nothing else it should surely cause a reappraisal of many other nineteenth-century photographers.

The over-riding problem in seeking to present the Hill/Adamson calotypes whether in book, exhibition, television or film, is the problem of selection. The number of negatives extant is in some doubt – certainly it can be measured in hundreds, of which all but a handful are in Edinburgh. Positives, however, are fortunately available in quite considerable quantities. There must be nearly three thousand original prints in existence and that number has been boosted at various times both by copies made from the original negatives and by rephotographing of the positives.

It was, of course, one of the main virtues of the negative/positive process, in comparison with the daguerreotype system, that any number of copies could be made (for instance, Hill and Adamson made a hundred copies of a calotype of a particular painting) but this does mean that whoever seeks to make a selection of the calotypes must not only choose them shot by shot but must also have regard to the possibility that a better copy of the same photograph may be available elsewhere.

The selection for this book has been made from these major sources: the Scottish National Portrait Gallery, the Royal Scottish Academy (of which Hill was Secretary), the National Library of Scotland, and Edinburgh Public Libraries, and from the National Portrait Gallery, London.

The criteria for selection have been both aesthetic and technical. Inevitably, time has taken its toll of the calotypes and there are, sadly, many which were worthy of exposure on grounds such as the historical significance of the sitter but which have deteriorated to a point at which the technical discrepancies, even after expert rephotography, are such that they had to give way to pictures in better condition. Nonetheless, portraits of persons of distinction, and others, form a major part of this selection, as is only proper since this is representative of Hill's and Adamson's original output.

If there is a bias towards any other area of the output it is towards those prints which give the greatest sense of contemporary life and, as a result, pictures taken 'on location' are well represented. The more distant these scenes become in time, the more compulsive it becomes to see the variety of life then – especially as Hill and Adamson present it to us. This is a selection, therefore, for our time.

It should also be stated that the field of research on Hill and Adamson is far from exhausted. For instance, the identity of some of the subjects of the photographs have not been established (further information is always welcome). There may indeed be mistaken identities in this book despite the assistance the writer has had from Mrs Katherine Michaelson, who has very kindly collaborated with the author in the preparation of this volume and to whom he is most grateful.

2

There is rarely a development in the arts which comes about without the element of chance playing at least a small part in it. It could be argued, in the case of the calotypes of Hill and Adamson, that good fortune played an inordinately large part. Photography is an art based on technology and though it was not especially fortuitous that the first two really practical photographic processes, the daguerreotype and the calotype, should emerge at the same time, it was a little lucky that the circumstances should be such in one particular corner of Europe, that the latter system was allowed to reach its aesthetic peak virtually as soon as it had been invented.

In an age in which technology appears to be forever straining at the leash, it is not altogether easy for us to come to terms with the notion that practical photography, as a process, was invented *late*. In other words, it depended on virtually no new technology so that it might well have emerged sooner. It is a pity, of course, that it did not. Most of the fundamental principles of photography had been known, if not understood, for years before Louis Daguerre and Henry Fox Talbot, in that order, announced their inventions to the world, within weeks of each other, in January 1839.

Their two systems shared at least some common ground. Both depended on the basic fact that the action of sunlight effects a change on certain chemical substances when they are exposed to it, and the fact that it is possible to produce an image on the inside wall of a simple box provided that box has a hole or lens to concentrate the rays of light and focus them to form a picture. Neither phenomenon was a novelty in the 1830s.

The camera obscura, then as now the basic item in the photographer's equipment, has a genealogy stretching back to the Middle Ages. Leonardo da Vinci is said to have used this device, not in its 'photographic' mode, however, but as an aid to drawing. The camera obscura is a means of concentrating light – nothing more – and if you choose to replace one wall or the top of a box with reasonably translucent paper then you may trace on the paper the view·or object at which the lens is pointing, in convenient miniature.

If the mechanics of the camera were well enough known and understood, then the chemistry of photography, though a little more complex, was also based on a natural phenomenon observed and remarked upon many times before the 1830s, namely, that sunlight affects the colour of many substances exposed to it but particularly has the effect of darkening silver nitrate. For example, in the early eighteenth century, Johann Heinrich Schulze, a Bavarian Professor of Anatomy, had explored the principle by

exposing to sunlight a solution of chalk and silver nitrate in a glass bottle on the surface of which some cut-out silhouettes had been stuck. When the cut-outs were removed their 'ghosts' remained to be seen, lighter than the surrounding solution. These negative images were, however, only transient and disappeared, instantly if the bottle was shaken, or slowly, if left in the light.

From that time until Daguerre's and Fox Talbot's announcements the action of light upon chemicals remained an intermittent preoccupation of scientists, and in England in particular several distinguished gentlemen became interested, at one time or another, in the phenomenon. Thomas Wedgwood, a son of Josiah, and Humphry Davy came very close to a major breakthrough in the last years of the eighteenth century when, having succeeded in obtaining impermanent white on black negative silhouettes on treated paper, they attempted to repeat the experiment with a camera obscura and failed because the chemicals they used were insufficiently sensitive to light. Nonetheless, they published their findings in 1802, a date which is significant only in that it antedates what is commonly thought of as the invention of practical photography by the best part of forty years.

The problem that all the photographic pioneers had to solve, and which might well have still defeated Wedgwood and Davy even if they had managed to improve the sensitivity of their materials, was in the matter of 'fixing', of securing, permanently, the image on paper, glass or metal. To discover and control the processes by which light affects a chemical substance was one thing, to fix the resultant image quite another. Strangely enough, when it came, the first real answer to even that problem was in a substance nowhere near the boundaries of scientific knowledge – a solution of common salt, applied after the development of the image had been arrested, to prevent the picture fading.

William Henry Fox Talbot, distinguished gentleman scientist of Lacock Abbey, Wiltshire, did not invent photography. The fact is that no one person did. So varied were the developments associated with photography that emerged in France and England during the early part of the nineteenth century, that all we can do is briefly to mention some of them. The earliest permanent reproductions of an actual scene by the agency of light on a chemical substance are those of Nicéphore Niepce made in, or about, 1826. In his process bitumen on a pewter plate was exposed in a camera for several *hours* to produce a rather crude image. The system owed more to lithography than to photography as we know it. Moreover, it proved something of a dead end in terms of any further sophistication.

Daguerre (1787–1851) worked closely with Niepce until the latter's death in 1833 but he chose a distinct and separate line of attack on the problem when the bitumen process ceased to be in the running as the first

practical photographic system. The 'Daguerreotype' was a much more satisfactory method and one which, like the calotype, was significantly susceptible of improvement beyond its first stage of development.

The original process consisted of exposing copper plates, themselves previously exposed to iodine fumes, in a camera for a quarter of an hour or more and then developing the latent image with mercury vapour and fixing it with sodium hyposulphate. The resultant picture was a single positive on metal with the image reversed laterally. The detail and precision of the process was its greatest strength; its weakness, even after the reduction of exposure times to a few minutes, was simply that each picture was unique, could not be reproduced, and moreover was liable to damage in ordinary handling unless it was protected by glass.

Daguerreotypes were indeed beautiful and their precise reproduction of architectural detail, for instance, delighted a public for whom this was the first experience of a new art. In a famous phrase the *Spectator* of 2 February 1839 called it 'the self operating process of Fine Art'. Such expressions of enthusiasm were common. The language employed by Fox Talbot to describe photography in its early days may sometimes strike us as quaint, but 'The Pencil of Nature', 'Photogenic Drawing' and 'Sun Pictures' are terms which remind us of the extent to which the process was regarded as nature's invention, not man's. One of the nicest instances is to be found on the reverse of an early Hill/Adamson calotype. It says, simply, 'Sol fecit', i.e. 'The sun made it' – Sun Pictures.

William Henry Fox Talbot (1800–77) was, in effect, forced by events into announcing his system of photography in January 1839. He eventually called it the 'Calotype' deriving the word from the Greek 'kalos', 'beautiful', but his associates, taking their cue from events on the other side of the Channel, christened it the Talbotype. A full account of the events leading up to that climactic period in January 1839 is given in Arthur Booth's biography *William Henry Fox Talbot* (Arthur Barker, London 1964). The timing, three weeks after Daguerre had announced his process, was no accident. Fox Talbot, though not entirely unaware of the French experiments, had assumed that these were on similar lines to his own and he certainly had no conception of the technical superiority of the daguerreotype, at that time at least.

In fact, what Fox Talbot announced in 1839 was not strictly the process which Hill and Adamson were to use with such success. What Fox Talbot (at the instigation of Michael Faraday) described to the Royal Institution of 25 January was his means of 'photogenic drawing', that is of producing negatives on paper by extremely long exposure, quite unsuitable for portraiture and it was not until September of the following year with the discovery of the latent image that the calotype process was really born. By May 1839, however, Fox Talbot, who had yet to see a daguerreotype,

must have had some inkling of what he was up against. Sir John Herschel, who had also been working on photography, went to Paris where he saw Daguerre's work. In his letter to Fox Talbot, Herschel commented of the daguerreotypes, 'It is hardly saying too much to call them miraculous. Certainly they surpass anything I could have conceived as within the bounds of reasonable expectation. The most elaborate engraving falls far short of the richness and delicacy of execution, every gradation of light and shade is given with a softness and fidelity which sets all painting at an immeasurable distance.'

But Fox Talbot persevered. In April 1839 he introduced gallic acid, which accelerated development, into the process (a device already employed by another photographic pioneer, the Rev. J. B. Reade). His reward was the discovery, on 20–21 September 1840 of the phenomenon of the latent image. Daguerre had made the same discovery independently, but if any specific event marks the invention of practical photography, this surely is it. Fox Talbot's discovery is reputed to have come by chance when he resensitized some photogenic paper which had failed to show results in an earlier experiment. As the gallo-nitrate of silver was applied a hitherto invisible image appeared. Evidently manageable exposure times were within reach. From that point onwards photography's progress was assured, in a technical sense at least. Its potential as an art form had still to be established.

In February 1841 Fox Talbot took out patents for 'Photographic Pictures'. In these he describes how he selects 'the best writing paper' and sensitizes it by brushing on a solution of crystallized nitrate of silver dissolved in distilled water. He took care to cut the paper to remove the watermark, something which Hill and Adamson sometimes omitted to do. When dry the paper is then dipped in a solution of iodide of potassium. A subsequent treatment of the paper with a mixture of gallic acid and nitrate of silver was required but this was best left until just before exposure in the camera, after which the picture was fixed in a solution of bromide of potassium. The net result was a paper negative from which positives could be produced by contact printing in a frame. The patent applied to England, Wales and Berwick-on-Tweed only. On the advice of his friend Sir David Brewster he did not seek to extend the patent to Scotland. Brewster did not think it would be worth while. Within three years, the best examples of the calotypes and arguably some of the most outstanding photographs of any period were being produced, in Edinburgh.

3

Major Scottish achievements in the visual arts are regrettably rather few and far between. Considering the variety of landscape and natural colour in Scotland it is remarkable that it is perhaps only in architecture, the Adams family, Charles Rennie Mackintosh, and others, that Scotland has produced men of world stature. On the other hand, in many other fields of human endeavour, but mainly in the sciences, the Scots have been better represented in numbers and attainment at the highest levels than could reasonably be expected.

The Scotland into which the calotype process was introduced was more conscious of its culture than it had been since the Union of the Crowns in 1603 and the consequent departure of the Royal Court down that high road to England which, as Dr Johnson observed in another context, was the finest prospect for any Scot. Edinburgh, in particular, had a good conceit of itself. Over the previous seventy years it had built its 'New Town' to the north of the Castle beyond what had been the Nor Loch. The New Town remains an outstanding example of eighteenth-century town planning, and the most extensive one anywhere; it provided a polite environment in sharp contrast to the city as it had been on the spine of the Royal Mile between the Castle and Holyrood Palace. Moreover this was the Edinburgh of Sir Walter Scott.

By the time of his death in 1833 Scott had, through the popularity of the Waverley Novels, spread throughout the literate world the idea of a romantic Scotland populated by characters attired for dramatic happenings. He even influenced the attitudes and dress of the natives themselves so that a decade later Hill and Adamson were still working in a social framework which Scott himself had shaped. The people in the calotypes have strong connections with the characters of Scott's fiction.

Scott, it could be said, marked practically the end of Edinburgh's Golden Age, the age of the Enlightenment when the city was famous throughout Europe for her scholars, philosophers and scientists. One of the foremost was Sir David Brewster and it was he who was to play a key role in bringing together all the elements that led to the production of the calotypes.

Sir David Brewster was born in 1781 at Jedburgh in the Borders where his father was a schoolmaster. As a child of ten he invented a telescope and he went to University a year later, a precocious achievement even in Scotland at a time when students were a great deal younger than now. By his early twenties he had combined his scientific experiments with the completion of his studies for the ministry in the Church of Scotland and had also developed some skill in writing poetry. His ministerial career was

fairly brief, though his attachment to the Church became of great importance to him in the 1840s, and he turned his considerable energies to science and literature.

Following the submission of papers, including 'Some Properties of Light' (1813) and 'The Polarization of Light' (1814) he was elected a fellow of the Royal Society in 1815. From that date onward his inventions and the honours which were given him multiplied at an astonishing rate. He introduced the kaleidoscope, the stereoscope and a system for the illumination of lighthouses. His papers and treatises concerned such subjects as the 'Optical Condition of the Diamond', 'Magnetism' and the nature of colour-blindness. He was actively involved in the work of several learned bodies including the British Association for the Advancement of Science and it was at the British Association meeting in Bristol in 1836 that he was introduced to photography by Fox Talbot who had, not unnaturally, made contact with him on account of Brewster's valuable experience in the field of optics.

In 1837 Brewster was appointed Principal of the united colleges of St Salvator and St Leonard at St Andrews, a post which he retained until 1859 when he became Principal of Edinburgh University. Moreover, there was yet another aspect of Brewster's activities that was to have a bearing on the story of the Hill/Adamson calotypes, his considerable literary and artistic interests.

So we have a man who was an expert in optics, with an interest in photography, a devout presbyterian who would stand by his principles, a supporter of the arts with strong Edinburgh ties and an academic post in St Andrews. His standing as a scientist gave him not only contact with Fox Talbot, but perhaps some influence over him. His religious scruples caused him to side with the protesters in the Disruption when the Church of Scotland suffered its famous schism in 1843; his contact with the arts in Edinburgh made him familiar with the circles in which David Octavius Hill moved. His post at St Andrews meant that his attempts at photography to Fox Talbot's mailed instructions were made in collaboration with one Dr John Adamson and his brother, Robert.

The combination of circumstances may seem almost too convenient to be true, but then we may view the situation in a perspective supplied by time which sifts out the irrelevancies. In any case Brewster was the catalyst. He supplied the key that unlocks the calotypes but the motivation that turned it came from another quarter. As periodically happens in Scotland, the force that shapes large and small events is the Kirk and at just about the time that the calotype process matured so there was an event of enormous importance to the Kirk – known as the 'Disruption'.

4

It was unlikely, to say the least, that an outstanding contribution to progress in photography should be brought about by an upheaval in the Church of Scotland. But the relationship between the calotypes and the Disruption is a direct one, and in examining the circumstances in which the calotypes were made, it is as well to be aware of the heightened emotional and moral climate of the time.

Perhaps the best barometer of events is to be found in the rhetoric of the leaders of the Disruption. Their phrases resound with references to the Old Testament and to the Reformation. In particular, the name of John Knox is evoked many times and their long periodic sentences convey a strength of purpose and of character which remains admired to this day.

The dispute itself concerned the government of the Church of Scotland, and the power of secular courts and individuals outside of the Church to determine its course and management. The reformers wished the Church to govern its own affairs entirely, and be free from the encumbrances and interferences which the Church of Scotland had to suffer by virtue of its position as the Established Church of the nation.

The events of the Disruption were solemn and dramatic. The Church met in General Assembly at the High Kirk of St Giles just after one o'clock on Thursday, 18 May 1843. The Moderator, Dr Welsh, preached on a text from Romans 14, , 'Let every man be fully persuaded in his own mind', in which he urged that the decisions every man would have to make later that day should be based on a true understanding of Scripture, and he concluded (according to the *Scotsman* of 20 May) with 'a few observations as to the glorious results which might be expected to arise, at some future period, out of the difficulties and dangers in which the Church was placed'.

The Assembly then adjourned to St Andrew's Church in George Street where Dr Welsh read a statement of protest including the words:

and we do now withdraw accordingly humbly and solemnly acknowledging the hand of the Lord in all things which have come upon us, because of our manifold sins, and the sins of this Church and nation; but at the same time with an assured conviction that we are not responsible for any of the consequences that may follow from our enforced separation from the Establishment which we loved and prized – through interferences with conscience the dishonour done to Christ's crown, and the rejection of his sole and Supreme authority as King in his own Church.

Dr Welsh then left the church followed by some two hundred of the 'fathers and brethren' and with them made his way to the Tanfield Hall

17

at Cannonmills, where a crowd was already waiting. There, for the next three days the First General Assembly of the Free Church of Scotland and the signing of the Act of Separation and Deed of Demission took place in the presence of almost five hundred people.

The Assembly at Tanfield was a stirring occasion and had a profound effect on those who took part, not least upon the representatives of the arts and the professions who were present in some numbers. One such was the Secretary of the Royal Scottish Academy, David Octavius Hill, and it was he who undertook the task of commemorating the great event in a painting.

The problems which Hill had landed on himself were as immediately appreciable as they were enormous. To reproduce on canvas, even if only as an impression, the spectacle of between four and five hundred people crowded into a hall would be a daunting task for any painter, however gifted. Hill's aim was to capture the scene by producing an enormous work containing accurate likenesses of all those present. When it was finally finished, over twenty years later, it contained 470 people and measured five by eleven-and-a-half feet. Working on such a scale and with such numbers Hill could hardly expect to sketch all the participants individually. In fact, to achieve his object the answer was to use what would now be termed a 'visual aid'.

The suggestion that the calotype process could be of assistance in his predicament and that the first appropriate step was to enter into partnership with the young chemist, Robert Adamson came from another spectator, Sir David Brewster. He wrote to Fox Talbot on 3 July:

> I got hold of the artist – showed him your calotype and the eminent advantage he might desire from it in getting likenesses of all the principal characters before they dispersed to their respective homes. He was at first incredulous, but went to Mr Adamson, and arranged with him the preliminaries for getting all the necessary Portraits. They have succeeded beyond their most sanguine expectations. They have taken, on a small scale, groups of *twenty-five* persons in the same picture all placed in attitudes which the painter desired, and very large pictures besides have been taken of each individual to assist the Painter in the completion of his picture. Mr D. O. Hill the painter is in the act of entering into partnership with Mr Adamson and proposes to apply the calotype to many other general purposes of a very popular kind . . . I think you will find that we have, in Scotland, found out the value of your invention, not before yourself, but before those to whom you have given the privilege of using it.

(Katherine Michaelson has pointed out that there is a faint air of

apology in this letter. A possible reason for this diffidence is that Brewster may have felt he had overstepped the mark in encouraging calotype production on such a commercial scale without Fox Talbot's blessing, particularly since it was he, Brewster, who had discouraged Fox Talbot from taking out a patent in Scotland.)

5

David Octavius Hill (1802–70) 'was all his life of a speculative turn': so said the *Scotsman* on his death. It was a just observation on someone who had led a life which was punctuated by occasions when an ability to be flexible, to enquire and to grasp opportunities had stood him in good stead.

He was born in Perth, the son of Thomas Hill, a successful bookseller and publisher, and one of a very large family. He was educated at Perth Academy and moved to Edinburgh to study at the School of Design in Picardy Place. The first evidence of his 'speculative turn' was shown in his interest in the still fairly new technique of lithography and his first efforts in this medium, *Sketches of Scenery in Perthshire* was duly published by his father's firm. In the following years he pursued landscape painting and lithography but, in addition, he became active in what might be described as Edinburgh art politics. As was to be the case in Scottish church life some fifteen years later, Hill found himself part of a break-away group, this time from the Royal Institution. The result was that Hill became Secretary to the new Royal Scottish Academy in 1830. For the first six years there was no remuneration for the job but he held the post until a year before his death forty years later. In the course of his duties he visited London at least once each year to find pictures for the RSA exhibitions, and he was evidently a successful and businesslike person to deal with.

An area of his own private endeavour which was to have considerable importance in relation to the calotypes was that of book illustration, and though the best known is his *Land of Burns*, written by John Wilson *alias* 'Christopher North', his work also includes illustrations for a Railway Prospectus and, significantly, for Scott's novels, *The Abbot*, *Redgauntlet* and *The Fair Maid of Perth*.

By the early 1840s Hill was married and living in Inverleith Place, on the northern edge of the New Town and, incidentally, quite close to the scene of the Disruption meeting at Tanfield. His wife, Ann MacDonald, was apparently not very strong and indeed Hill's domestic life was not altogether a happy one since one of his children died in infancy and both his wife and surviving daughter, Charlotte, predeceased him by some

19

years. (Hill was to re-marry in 1862 and his new wife, Amelia Paton the sculptress, may very well have been responsible for persuading him finally to finish the Disruption Painting.) Nevertheless, 'his manner in society was blythe and genial and he sang a capital song, not infrequently entertaining his companions with a ballad of his own composition' (*Scotsman*).

Because of the fairly public nature of D. O. Hill's life, to say nothing of his copious correspondence, it is possible to form quite a solid impression of Hill as a personality; of Robert Adamson, however, practically the only thing that was ever said was that he was Dr John Adamson's brother. Indeed, in tracing the events that lead up to the establishing of the 'daylight studio' at Rock House on the Calton Hill in Edinburgh it is frequently more important to refer to John than Robert.

Robert Adamson was born in 1821 in St Andrews and died there on 14 January 1848 at the age of twenty-seven. The record of his death gives no indication as to cause but it has generally been assumed that he died, like so many young men of his time, of consumption. It was John Adamson, however, who made the first calotypes, working from such instructions as Fox Talbot had communicated in his correspondence with Brewster. Indeed John had already succeeded in making daguerreotypes prior to July 1841 when Brewster reported to Fox Talbot his failure to get results with the calotype process, but by November John had made sufficient progress for three of his efforts to be sent to Fox Talbot. By the following spring he was certainly getting good results. It was at about this time that Fox Talbot asked Brewster if someone in Scotland might be persuaded to take up calotyping professionally and by August 1842 it had been established that Robert Adamson, trained by his brother, would set up in business in Edinburgh, which duly happened probably quite early in 1843. By that summer, when he entered into partnership with Hill, as Brewster reported, there were 'crowds every day at his studio'.

John Adamson was a doctor whose duties were not very onerous. They apparently left him considerable time to master the daguerreotype and calotype. It is interesting to speculate what would have been the outcome if he and not his brother had become the professional calotypist whom Fox Talbot wished to see in Scotland. Certainly John's work is highly proficient, technically, but there is no knowing whether the relationship between John and Hill could have been as productive as that between Hill and Robert.

Robert had some ambition to become an engineer, but his health was deemed to be insufficiently strong for such a pursuit and so the opportunity to practise photography was no doubt welcome. Clearly he learned well from his brother, and clearly too, he established a working relationship with David Octavius Hill that must rank as one of the most successful of all partnerships in the arts.

6

By the end of May 1843 all the elements of the story were in place. Through Brewster's contact with Fox Talbot, Adamson was in business as a calotypist. Hill had accepted the idea of entering into partnership with Adamson in order to obtain likenesses of the ministers, elders and laymen whom he was to include in his monumental painting. Another, potentially tricky matter was also being resolved; a subscription was being raised to pay for the painting.

Hill and Adamson began work immediately for there was a considerable problem of organization to be tackled. Even allowing for the difficulties of photographing people in groups of twenty or more with an as yet unsophisticated system there was the problem of how to bring all the participants in front of the camera before they dispersed all over Scotland. In fact the job was to be spread over a considerable period of time and involved hundreds of sittings with individuals and groups in Edinburgh and also in Glasgow where the following year's Assembly of the Free Church took place.

One wonders what element in it made Hill regard the calotype as more than a tool? He must, of course, have been struck at once by the beauty of the image. A calotype in mint condition has a softness in its pastel shades of brown or sanguine that is immediately attractive and one is tempted to think that what began as a chore very soon gave a sense of pleasure and achievement and stimulated thoughts of new applications beyond immediate needs. There is some danger, however, in even mild speculation of this sort for the whole subject of the Hill/Adamson calotypes is hedged about with myths and misunderstandings. But it seems fair enough to remark that the care with which the studies for the Disruption Painting were taken is rather more than would be necessary if the total and exclusive purpose of the exercise was to gain a sufficient likeness of the participants for copying on the canvas. Indeed, in this connection the question is sometimes asked, 'Why the calotype at all?' The daguerreotype was certainly more precise in rendering detail and it is sometimes a little difficult even to recognize the same sitter in two different calotypes. Moreover, we already know that the Adamsons had succeeded with the daguerreotype before they achieved any results at all with the alternative system. The answer, prosaically, may conceivably have less to do with art than with that regular Scottish preoccupation, money. A daguerreotype was expensive, costing between five and six shillings to make, according to the *Edinburgh Review* of January 1843, whereas a calotype 'will not cost as many pence'.

Most of the calotypes were made at Rock House, Calton Stairs, Edinburgh. The house stands in an elevated position on the side of one of Edinburgh's several hills a few hundred yards from the East End of Princes Street. The photographs had to be taken out of doors in direct sunlight and although many of the pictures made at Rock House use settings slightly apart from the house itself, the majority, particularly of the single portraits, were taken at the 'daylight studio' a protected 'set' (as it would now be called in film terms) on the south-west wall of the house itself. This part was furnished with drapes, chairs, and various 'props' to give the appearance of being an interior. As can be seen from the calotypes this arrangement had its limitations and the recurrence of certain props in shot after shot can be amusing or even a little irritating.

A very large number of the sitters for the Disruption Painting were photographed in precisely the attitude in which they appear in the final work. (For example, see pp. 36, 43, 45 and 50. Hill was obviously very well organized in this respect, as we shall see when we consider the painting itself.) However, that is not to say that they were photographed in such a manner that they could be easily arranged in serried ranks. The remarkable thing about these 'studies' (for that is what they are), is how well they stand scrutiny as separate photographs in their own right. Whatever the subject matter – portraits, groups or landscapes – the sense of repose is a feature of Hill's and Adamson's work, heightened by the colour of the calotype with its broad areas of light and shade. Indeed 'repose' was a vital element in the calotypes for only if a sitter was entirely comfortable could he be expected to remain motionless for the very long exposures of a minute and more – and Hill and Adamson scarcely ever used neck-rests.

There may be a case for arguing that some of the sitters appear in the calotypes largely as they themselves wish to be depicted – the sitter for a portrait who is so dispassionate as to have totally shrugged off all vanity has yet to be born. There are instances among the calotypes where such a suspicion may well be justified, but even if some of the sitters had such a conscious notion as how to present themselves to the best advantage, the number who could do so with effect would have been very small, if only because the experience of photography of the individuals or indeed of the community must have been extremely limited. Practical photography was not five years old, if one measures from even the first announcements, by Daguerre and Fox Talbot, when work began at Rock House. It was less than ten years old when the partnership was destroyed by Adamson's illness and death.

This was the measure of their achievements: that they took an infant medium, grasped at once its virtues and limitations and made it their own. Where others had played with photography as a toy they were able to

draw it into the mainstream of artistic expression. The calotype was simply another way to make pictures; and the executants were not to know of the years to come in which photography, by proliferation, would seem almost deliberately to debase itself.

How conscious were the calotypists of their power to evoke personality, to find the presence below the surface, to probe behind appearances, for this they must be shown to have done if their claim to being great photographers and great portraitists is valid? The fact that their medium was based on technology would be no defence.

One can only turn to the pictures themselves. Are they the product of skilful technicians who quickly found the most efficient way to obtain likenesses and then exploited the system for all it was worth? The evidence is that the calotypes were produced with elaborate care and that, if anything, the easiest charge to lay against them is that some pictures appear to be the result of a conscious artistic effort bordering on contrivance.

This brings us to the most famous conundrum of the Hill/Adamson calotypes, namely what contribution did each of the partners make? For a long time Adamson's part in the affair was rated so low that he scarcely merited a mention. Almost all the credit went to Hill and it is only comparatively recently that their names have automatically been bracketed together. Yet the truth of the matter has always been available in Hill's own declarations that he had 'direction' of the photographs and that Adamson made the negatives and prints. When the calotypes were exhibited at the Royal Scottish Academy the expression used was 'executed by R. Adamson under the artistic direction of D. O. Hill', and in 1870 the *Scotsman* commented, 'In the joint business Mr Hill's part was to see to the posing and grouping of the figures, the practical manipulation being conducted by Mr Adamson.'

This then was the formal position but it still leaves open the question of whether Adamson's role was solely that of a technician. One feels that this cannot entirely be so on the evidence of Hill's subsequent ventures in photography with other collaborators. There is no need to suspect that McGlashan, the photographer with whom Hill worked to produce 'Some Contributions towards the use of Photography' (1862) was a less able technician than Adamson. On the other hand, there is something rather plain about the Adamsons' products from the early days in St Andrews, which gives no weight to the suggestion that it was the younger man who was the real moving force.

It would seem that it was quite genuinely the fact of partnership that caused the products of the Rock House studio to be outstanding. Added to that, however, some consideration must be given to the state of photography and the proposition that it was the very technical inadequacy of the early calotypes that brought out the best in Hill's direction, and

Adamson's manipulation. They were forced to concentrate on the deployment of broad sweeping areas of shading and to restrict composition to the business of controlling key, well-focused, portions of the image and never allowing themselves to be distracted by the wealth of prosaic detail. Such detail was, after all, the hallmark of the daguerreotype and, incidentally, of the Pre-Raphaelites who were so influenced by photography. Hill himself remarked that the very life of the calotypes was that 'they look like the imperfect work of man . . . and not the perfect work of God'.

Hill's and Adamson's output can usefully be divided into four sorts. The first is the *raison d'être* of the whole affair, that is, studies for the Disruption Painting; the second comprises all those numerous portraits of friends, relations, associates in the arts, their wives and children, and some visiting dignitaries. Thirdly, there are those pictures which do most to bring us close to Hill's and Adamson's time. They could be described as reportage, or documentary, and they frequently employ large numbers of people. These are the 'location' shots at places such as Newhaven, St Andrews, Linlithgow and Durham. In this connection it is worth noting that some of the pictures of Newhaven fisherfolk were taken at Rock House.

Finally there are the landscape pictures. It is strange that Hill and Adamson are rarely given full credit for their ability to tackle landscape. Indeed, it is not uncommon to hear or read the comment that it is surprising that Hill who as a painter would be remembered (if at all) for his landscapes should choose to exclude the medium in his photographs. In fact the landscape calotypes, though comparatively few in number, are among the most satisfying.

The total calotype output of Hill and Adamson was surprisingly large in view of the short space of less than four and a half years they had together. They worked all year round and were no doubt grateful for the hard east coast sunlight that is a feature of the Edinburgh winter and spring. In fact they were aided and abetted by the weather to some extent as the summers of 1846 and 1847 were unusually sunny and dry. Time was not really on their side however and in the autumn of 1847 Adamson returned to St Andrews where in a few months he died.

7

If it was some ingredient of good fortune that brought together all the disparate elements that produced the Hill/Adamson calotypes then that streak of luck ran out very abruptly on Adamson's death in the first weeks of 1848. For a time it might just have been possible that John Adamson would join with Hill but that potentially fruitful development did not materialize.

Even the calotypes themselves were causing Hill a good deal of concern. They were (and are) prone to fading and the only safe way to distribute them was in albums (the only alternative was to store them in the dark or in boxes); and these albums were widely sold or otherwise distributed, some through the agency of Hill's brother Alexander who had a shop in Princes Street.

Though Hill returned briefly to photography in later years with McGlashan, as mentioned before, and later still with Thomas Annan for the purpose of making reproductions of the Disruption Painting, his achievement in photography ended with the death of Adamson. The famous painting itself was completed in 1866 by which time, not surprisingly, the drama of the events surrounding its conception had somewhat lost the original interest.

Hill died in 1870 and was buried in the Dean Cemetery beneath a leonine bust of him executed by his second wife, Amelia Paton. His photographic stock was valued at £70, and however much his contemporaries had admired his joint output with Adamson twenty-five years previously his work now quickly fell into obscurity.

Fortunately, however, the calotypes have survived in quite considerable numbers; fortunately, also, periodic revivals of interest since the turn of the century have meant that an increasingly wide circle of photographers and others have come to recognize the nature and scale of the calotypists' achievements.

There are now several major collections of Hill/Adamson calotypes in Britain, Europe and America and over thirty of these are in places with at least some degree of public access. Within the last ten years three exhibitions have been mounted and more are planned, so it would seem that at last Hill's and Adamson's achievement is securely acknowledged.

It is a technical and aesthetic achievement, but there is another achievement beyond that. What we have in the calotypes is a recording of a time, and of a cross section of all society – great ladies, stone-masons, doctors, ministers, fishermen, soldiers, men of distinction and men of dubious reputation. The calotypes are of a time out of our reach but, in their freshness and unexpectedness, they are for our time, and for all time.

The Disruption Painting

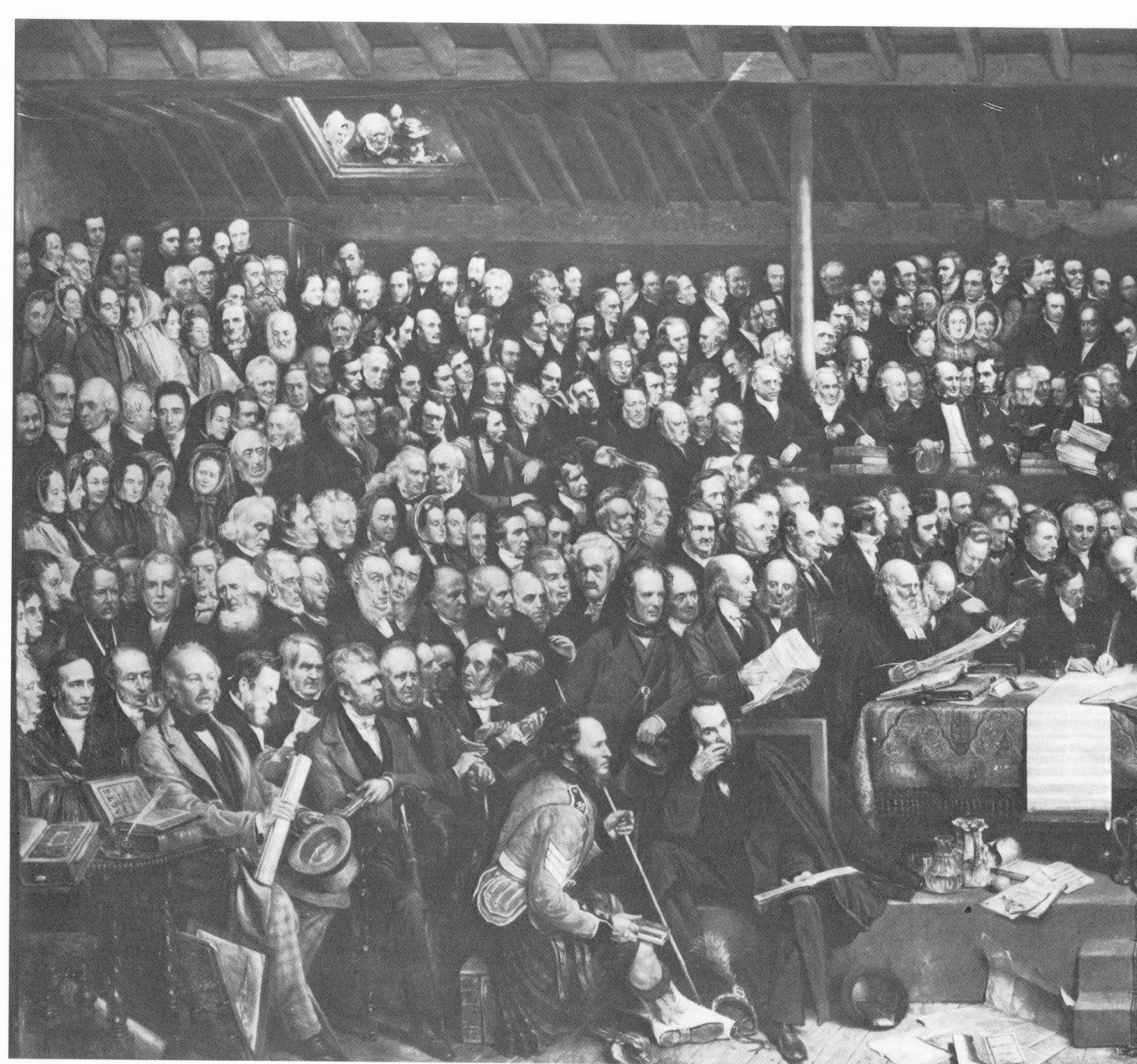

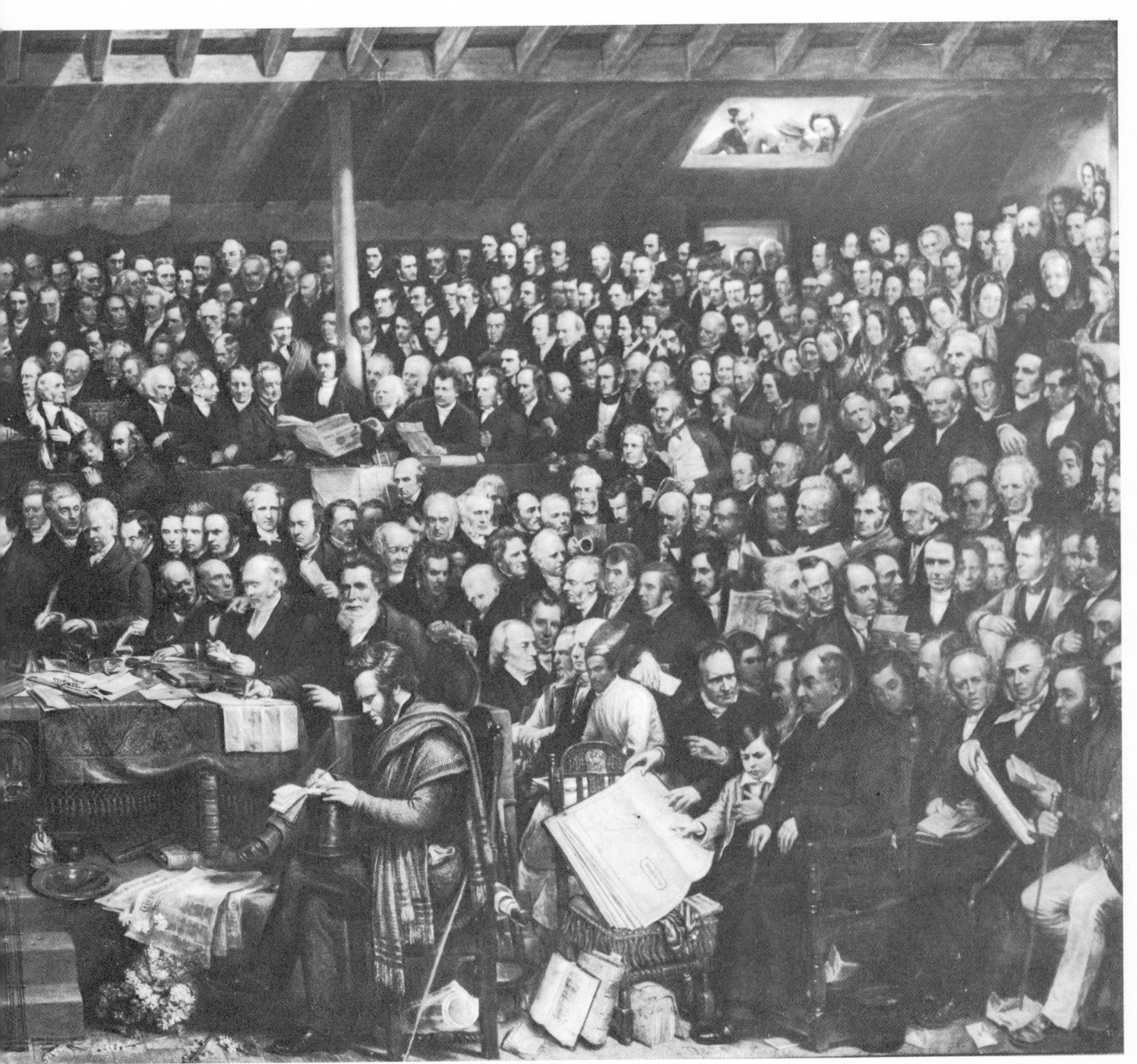

The First General Assembly of the Free Church of Scotland - Signing the Act of Separation and Deed of Demission at Tanfield, Edinburgh, May 1843

David Octavius Hill

152 × 344 cm. (5 ft × 11 ft 4 in.) 1866
Free Church of Scotland, Edinburgh

The Disruption Painting was begun in the latter part of 1843. It was not completed until 1866. Several studies for the painting exist and from one of these it appears that Hill's first conception of the painting was to show Chalmers preaching. This was a good idea because not only was Chalmers the first Moderator of the Free Church but he was a renowned evangelist (see p. 37) whose oratory had had a considerable bearing on the events of May 1843. For whatever reasons, Hill was advised against this notion. Instead the painting became a commemoration of the moment when a large proportion of the ministers of the Church of Scotland signed away their livings by putting pen to the Act of Separation and Deed of Demission.

Large-scale commemorative works containing group portraits of the principal participants were not unknown at the time. B. R. Haydon's *The Reform Banquet* 1832 is a picture which Hill might well have seen, since he knew Haydon. But the Disruption Painting is significantly different from *The Reform Banquet* and similar works in that *all* the participants are intended to be recognized and not just those in the foreground. Hill's is therefore a group portrait of nearly five hundred people.

It has been suggested that the use of the calotype process to provide 'sketches' for the painting proved to be a mixed blessing, for though it undoubtedly facilitated the business of obtaining likenesses, it may have increased the artist's ambition to include as large a number of recognizable individuals as could be squeezed on to the sixty-eight square feet of canvas. The result is impressive in its boldness and scale but it has never been hailed as a masterpiece.

The principal figure in the painting is the Moderator, Chalmers, who sits on a raised platform in the centre. The most important scene, however, is taking place below him where Dr MacFarlane of Greenock is in the act of signing away the highest living in the country. Others are waiting to follow him.

Immediately to the left of Chalmers is Dr Welsh holding the Protest, which he had read in St Andrew's Church prior to the walkout. Beyond him

is Sir David Brewster (his hand to his face). On the other side of the Moderator is Lord Provost Forrest (see p. 50), in his civic robes. In the right foreground Hugh Miller is taking notes.

Much of the painting is divided into groups showing a common interest so that, for instance, in the right foreground the committee on the Jewish Missions is gathered around a map of Palestine. Other missionaries are in the same area. Julius Wood of Malta (p. 48) is above and left of the atlas. Up and to his left, immediately below the camera, is William Govan (p. 53).

On the left hand side is a group of distinguished people, including Lord Cockburn who is in the third row from the front, the second, from the left, of four men. Above and some six figures to the right of Cockburn is Dr Capadoze of the Hague (p. 45). Dr Brewster of Craig (p. 43) is at the base of the left hand pillar.

The painting does not pretend to represent accurately what took place at Tanfield. It commemorates an event that covered several days and it includes people who were not present at the Assembly but whose support was crucial to the Free Church Movement. It also includes some whose presence in the painting is hardly justifiable on historical grounds but who are welcome nonetheless.

In the left hand skylight are Henning, Handiside Ritchie and a Newhaven Fisherman. One can only guess who the lady is but possibly she is Lady Cockburn. It seems to be a group with particularly strong calotype references.

Hill and Adamson are in the right hand portion of the painting. Hill, with a sketch book in his hand (the sketchbook is extant) is at the end of the Moderator's table. Adamson, leaning over the camera, is immediately below him.

Of the painting one portion at least deserves special attention. In the central triangle, of which Chalmers is at the apex, there is much fine detail in the Pre-Raphaelite style. When the picture was begun painting still looked backwards to the eighteenth century and photography was in its infancy. More than twenty years later when all the sketches and calotypes (almost two hundred still exist) had been laboriously transferred to the canvas, one of the influences on painting was photography itself.

The Calotypes

David Octavius Hill

214 × 162 mm. ($8\frac{7}{16} \times 6\frac{3}{8}$ in.)
Scottish National Portrait Gallery

David Octavius Hill (1802–70), the central character in the story of the calotypes, would probably have preferred to be remembered as a landscape painter and illustrator, rather than as a photographer. Without the calotypes (and without Adamson) he might scarcely rate a mention in the history of art except perhaps as the assiduous Secretary of the Royal Scottish Academy and as an illustrator of Burns and Scott.

As it transpired he was the prime mover in changing photography from a technical device for recording images on metal or paper to a means of artistic expression. That he began to do so when the technique was less than five years old is remarkable; that his major contribution was complete within another five years, and that that contribution has scarcely ever been surpassed is extraordinary.

This calotype shows Hill as he wished to be seen. The negative has been retouched.

32

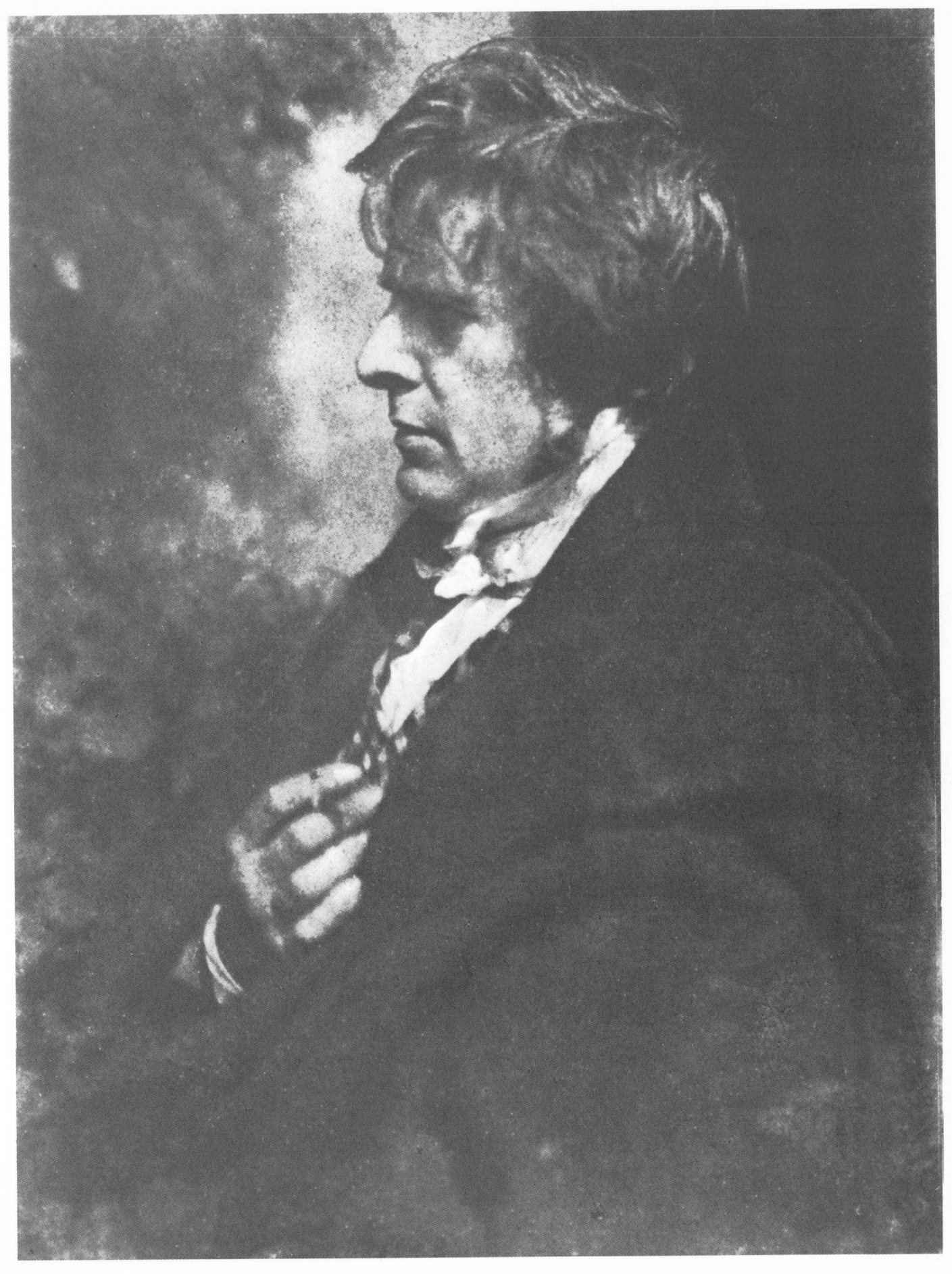

33

Robert Adamson

152 × 112 mm. (5$\frac{31}{32}$ × 4$\frac{13}{32}$ in.)
National Library of Scotland

Robert Adamson was born in 1821 and died on 14 January 1848. He is an
enigmatic figure. His ambition was to be an engineer but the frailty of his health
– he was probably consumptive – which ended his life at twenty-seven years of
age, made such an occupation impossible. Instead, his brother John taught him
the technique of making calotypes, and he set up in business at Rock House,
Edinburgh, in the early summer of 1843. Within weeks he had established a
partnership with David Octavius Hill that was to win them both an eminence in
the history of the visual arts.

The enduring puzzle is what part Adamson played, artistically, in the making of
the calotypes. Hill said the calotypes were made by Adamson under his 'direction'.
But the suspicion must remain that Adamson was more than a technical assistant,
a view which would seem to gain substance when we see Hill's later photographs
produced with other collaborators.

Of Hill's distress at the loss of Adamson there is no doubt. In a strange, almost
surreal, painting he made a few years after Adamson's death he shows the
calotype equipment set up on the Calton Hill near Rock House. There is about
it a sense of desolation.

34

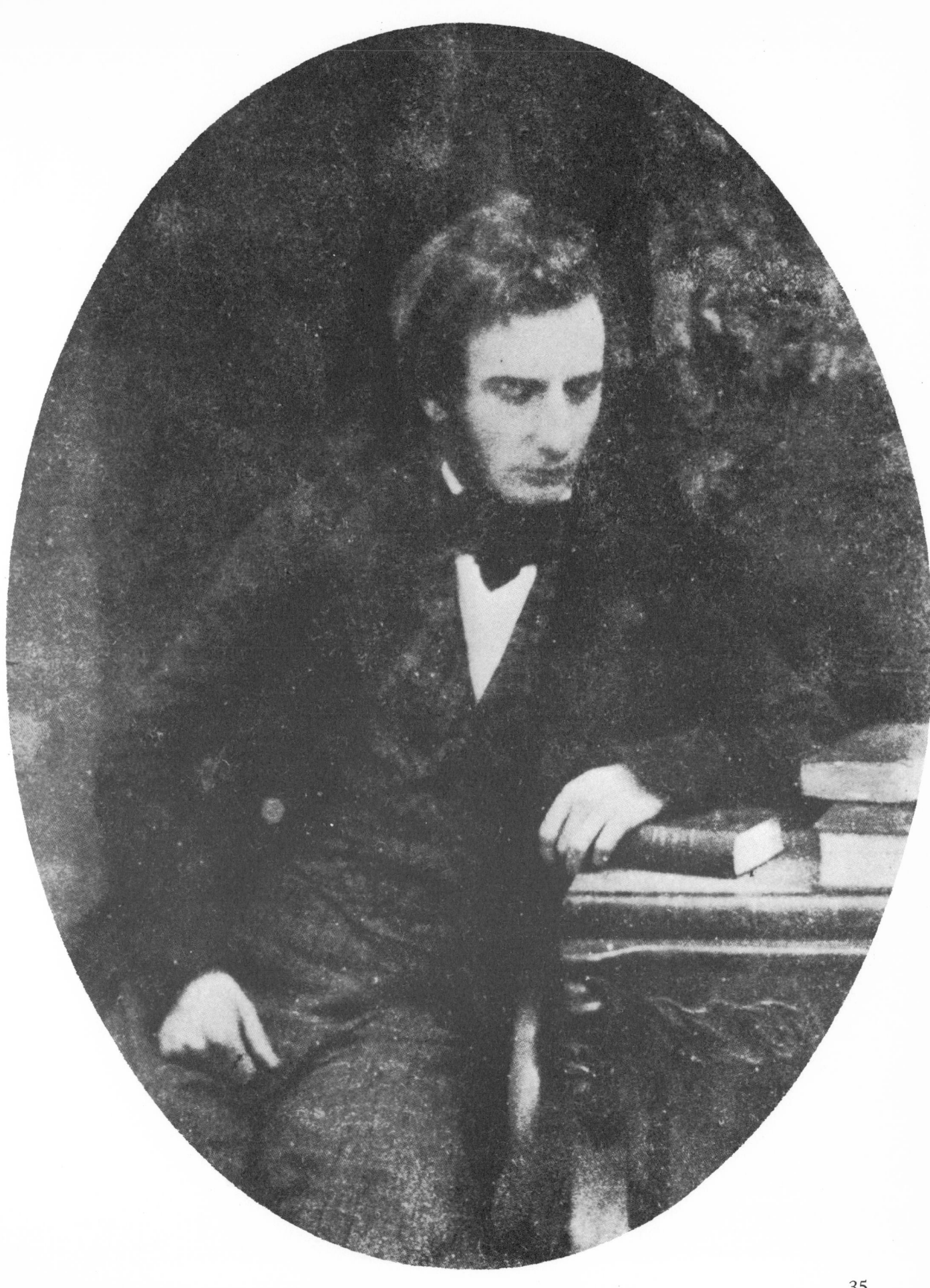

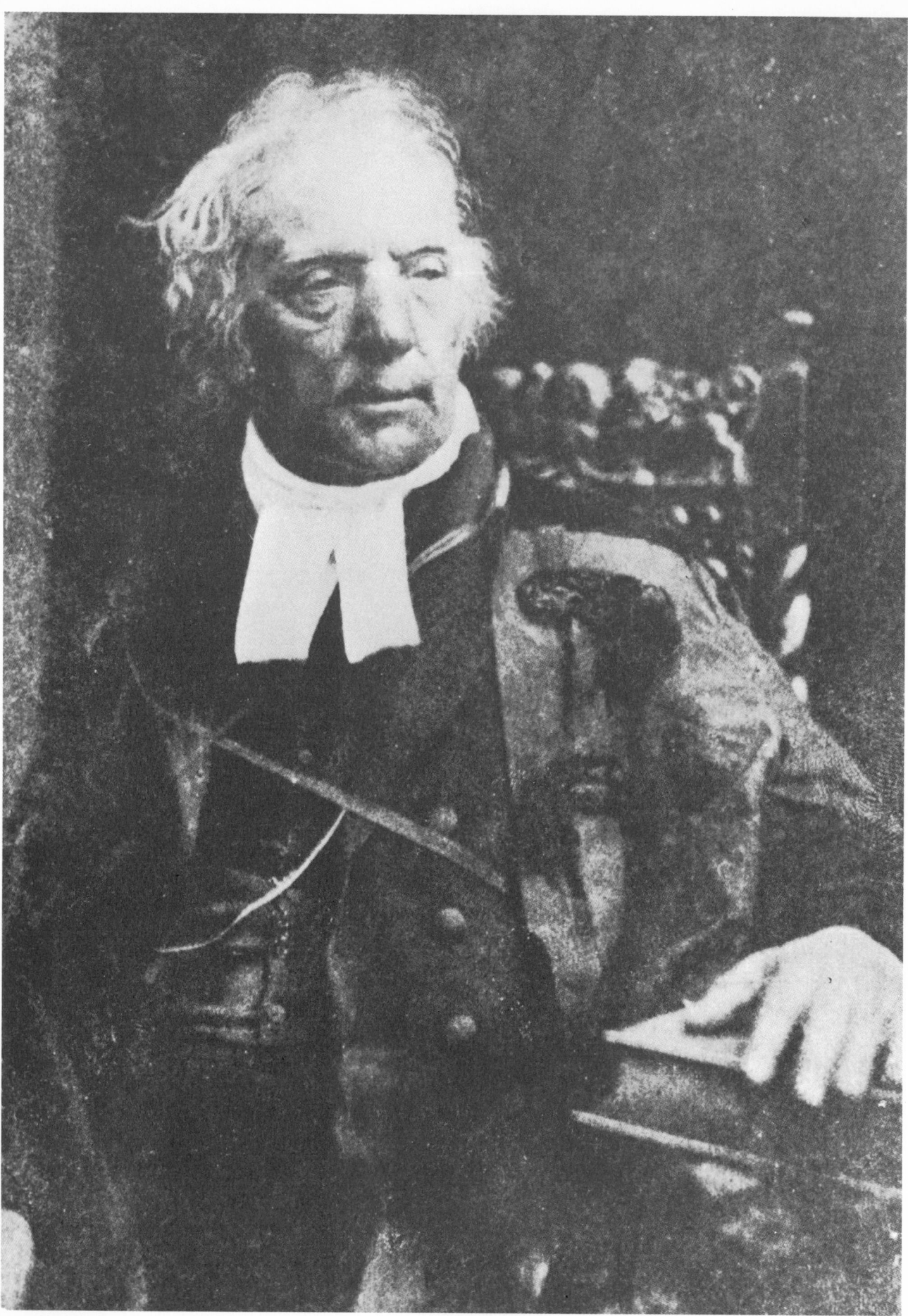

Dr Thomas Chalmers

158 × 114 mm. (6$\frac{7}{32}$ × 4$\frac{1}{2}$ in.)
National Library of Scotland

Dr Chalmers (1780–1847) was a key figure in the Disruption. He was the first Moderator of the Free Church. Ironically, he was against the separation because he felt it would inhibit the evangelical work that was so necessary among the population of Scotland.

Chalmers represents a kind of man apparently quite common amongst the worthies of the Free Church, the inheritors of the 'democratic intellect' who could be churchmen, scientists and humanitarians all in one. Sir David Brewster was an ordained minister; Chalmers wrote *Astronomical Discourses*; Miller wrote of God and fossils.

His evangelical preaching made Chalmers famous. Wilberforce wrote that he had never heard a preacher 'whose eloquence is capable of producing an effect so strong and irresistible as his. All the world is wild about Chalmers.'

The calotype is a study for Chalmers's central role in the Disruption Painting. It has a strength which belies its role as a sketch.

Dumbarton Presbytery

149 × 206 mm. (5⅞ × 8⅛ in.)
Royal Scottish Academy

'Dumbarton Presbytery' is the best known of the groups transferred intact from a calotype to the Disruption Painting. The Rev. Mr Alexander of Duntocher, the Rev. Mr Smith, the Rev. Mr Pollok and the Rev. Mr McMillan are to be found towards the left hand end on the second top row of the painting.

Since they posed for the calotype on 29 March 1845, and the painting was not completed for another twenty years, Hill thought it expedient to age his sitters slightly. In the painting, therefore, Mr Smith is much balder than he is in the calotype.

Hill even applied this ruse to himself as a comparison of his image in the painting (centre right above Adamson and the camera), and as he appears in the photographs in this book will prove.

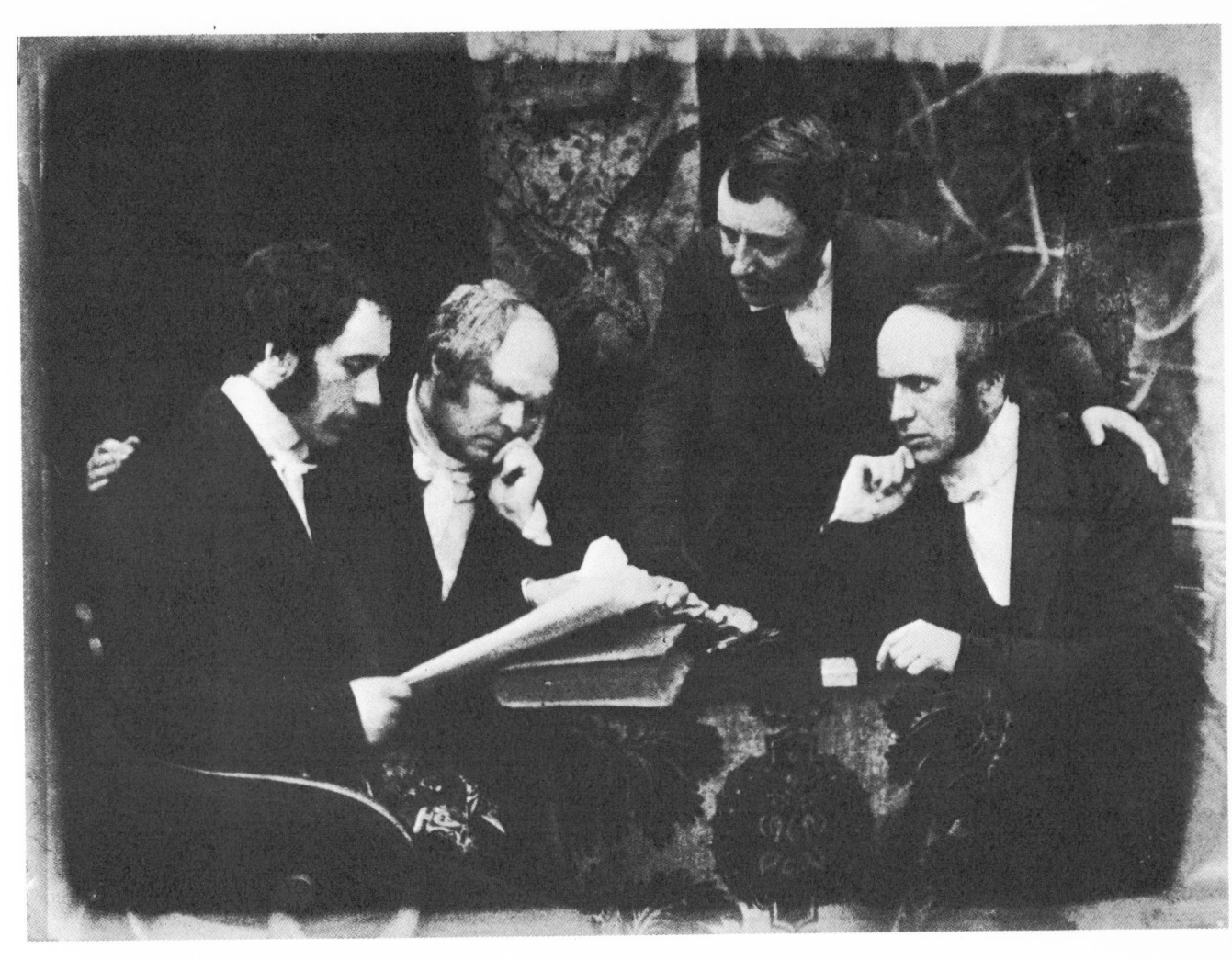

Sir David Brewster

194 × 144 mm. ($7\frac{5}{8} \times 5\frac{21}{32}$ in.)
National Portrait Gallery

Sir David Brewster's role in the creation of the Hill/Adamson calotypes is clearly of great importance. From his correspondence with Fox Talbot we know that he introduced to Hill the notion of using the calotype to enable portraits to be made of the ministers and elders of the Free Church of Scotland. He introduced the calotype process to Scotland and worked with Robert Adamson's brother, John, in the first attempts to produce photographs to Fox Talbot's instructions.

Even before this time, however, he had met and corresponded with Fox Talbot because he, Brewster, was the leading authority on optics. Finally, it was because of Brewster's firm religious convictions that he was present at the Disruption in May 1843.

In view of this, it is perhaps surprising that there are not more, and possibly better, calotypes of the great scientist. Nevertheless this particular example conveys a considerable sense of dignity and of presence. He was, by this time, into his sixties, but his career was by no means finished. In 1859 he was made Principal of Edinburgh University and a year later Vice Chancellor.

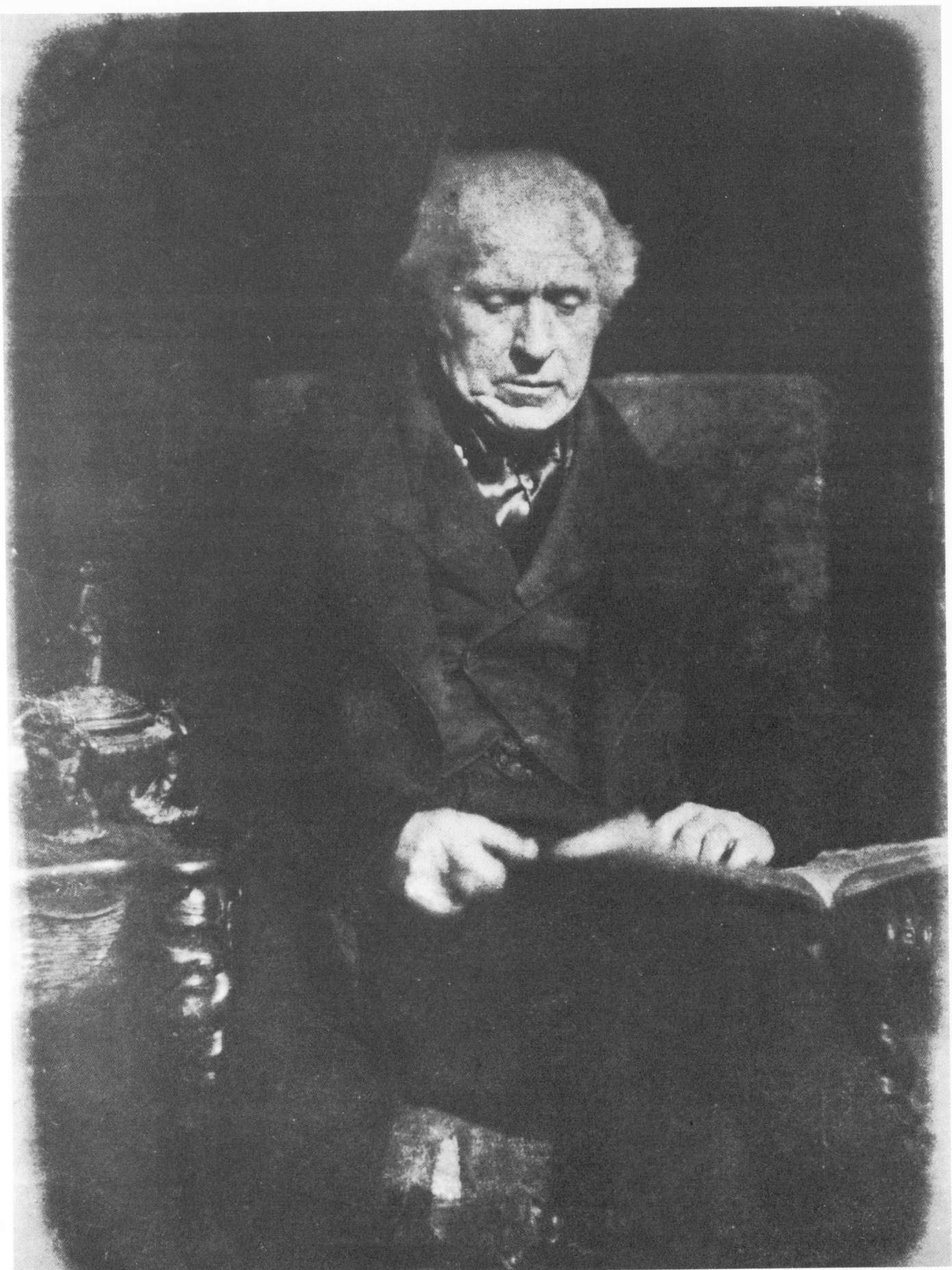

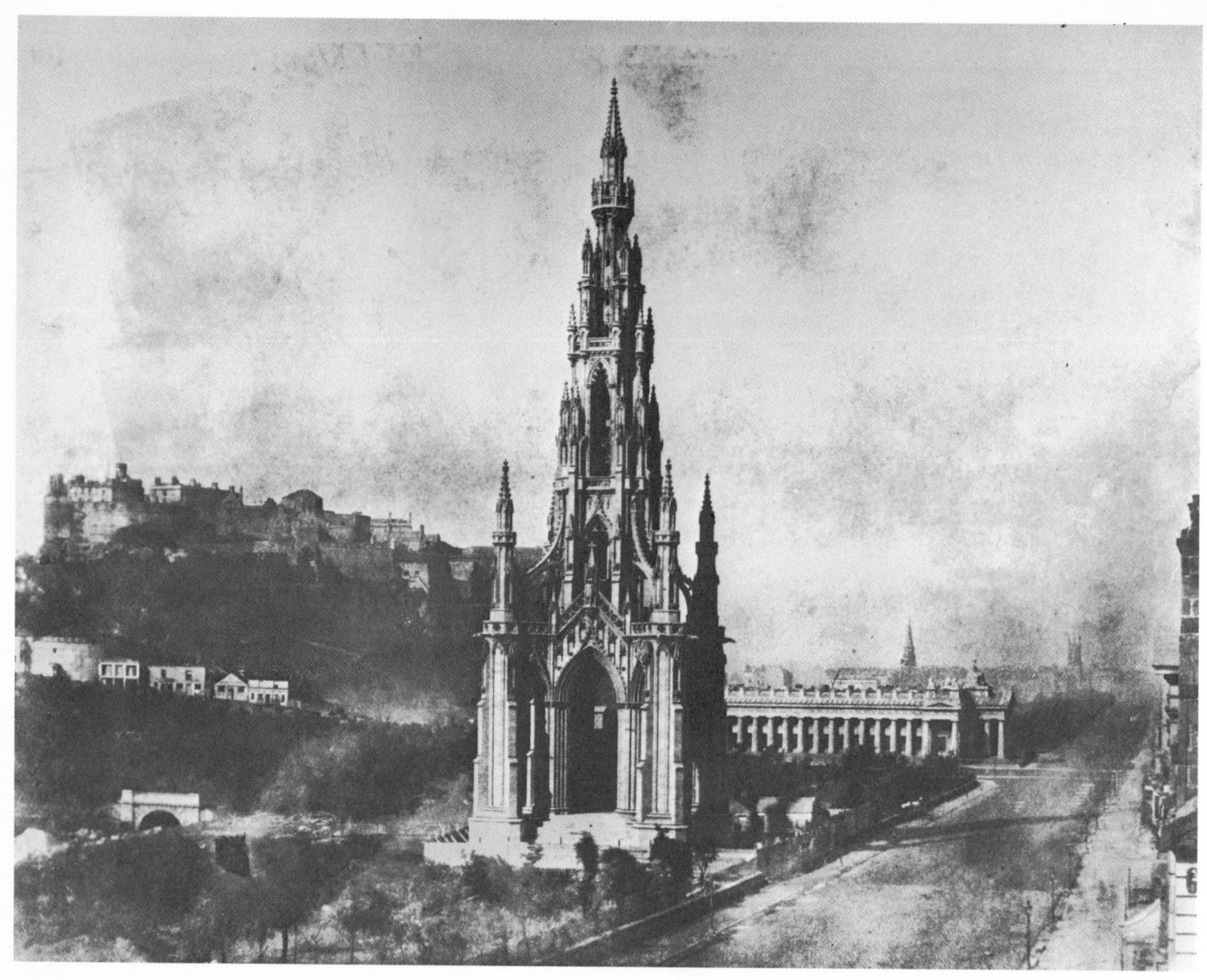

The Scott Monument and Edinburgh Castle

290×375 mm. ($11\frac{13}{32} \times 14\frac{25}{32}$ in.)
Edinburgh Public Libraries

In an early morning light the new, indeed not quite complete, monument to Sir
Walter Scott stands at the heart of Edinburgh. The statue of Scott is still to be
put in place. The builders' huts and fences are still in evidence and, in fact, it
would be many years yet before the last niches would be filled with their statuettes
of Scott's characters.

It took an Act of Parliament to give clearance for building on the site since it
was strictly the intention that the south side of Princes Street should be left clear
of obstruction. In fact there were periodic controversies on the subject.

In the last one hundred and thirty years the changes made in the scene
opposite have been substantial. Though the Castle remains as ever, the buildings
below it, left, on The Mound (the artificial earthwork linking the Old Town with
the New) have gone. The National Gallery of Scotland now stands to the left
of the columns of the Royal Scottish Academy and the gas lamps, along the
edge of the pavement in Princes Street, have inevitably been superseded.

Edinburgh is most fortunate to have such a souvenir of itself.

Rev. Dr Brewster of Craig

203 × 148 mm. (8 × 5 13⁄16 in.)
Scottish National Portrait Gallery

Dr James Brewster (1777–1847), the elder brother of Sir David Brewster, was rector of Jedburgh Grammar School. He is one of the most immediately recognizable figures in the Disruption Painting in which he is to be found at the base of the left hand column in precisely the pose adopted for this calotype.

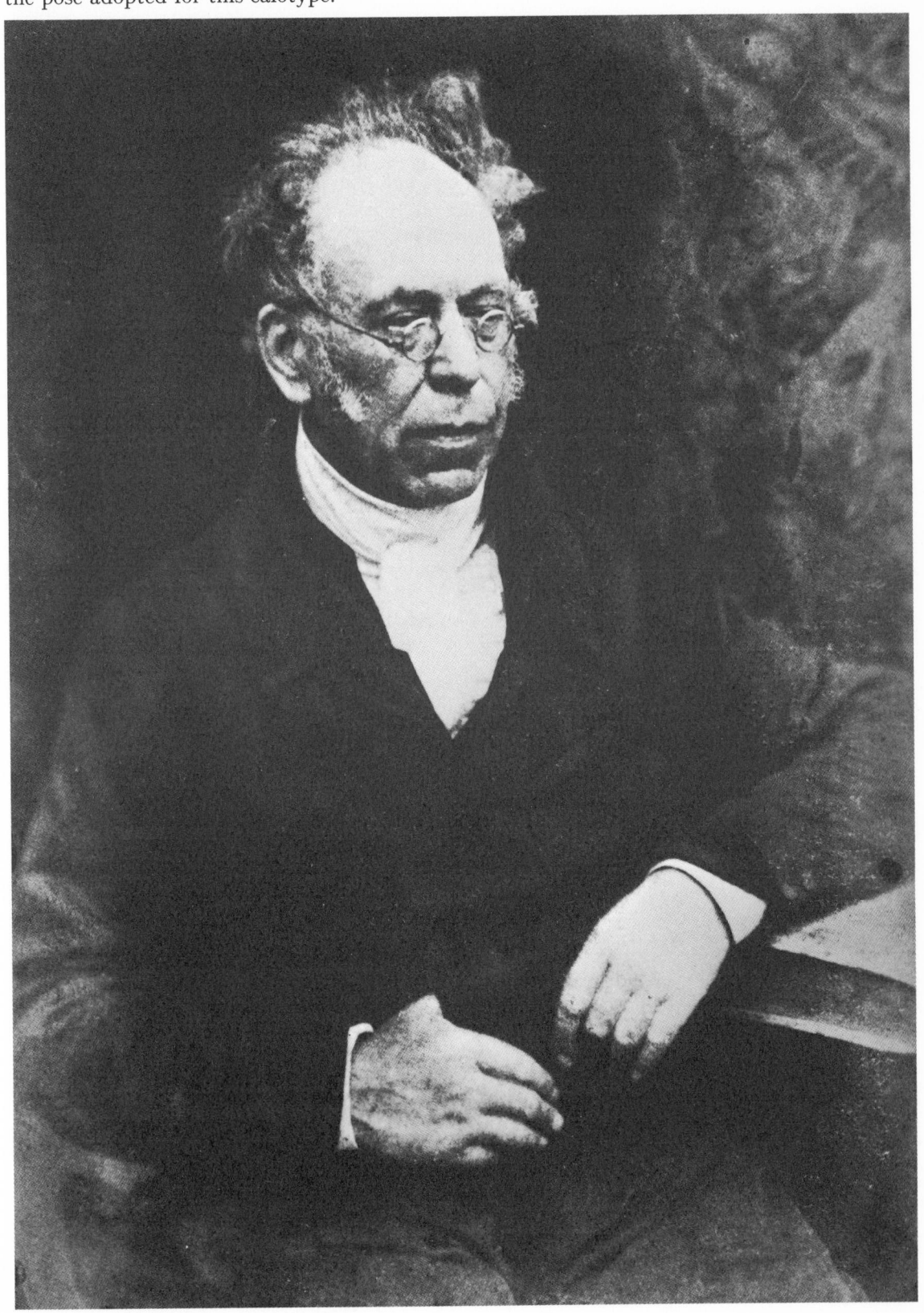

Dr Abraham Capadoze

194 × 146 mm. (7⅝ × 5¾ in.)
Scottish National Portrait Gallery

Dr Abraham Capadoze (1795–1874) of The Hague is one of the most distinctive
of the hundreds of sitters whose presence among the calotypes is a direct result
of participation in the Disruption. He was a physician and Calvinist writer who
visited Scotland many times and was much in sympathy with the Free Church.
In the Disruption Painting he is to be found on the extreme right, half way up
the canvas. As was commonly the case with sitters for studies for the Disruption
Painting he posed for more than one shot. It is in a similar position to the one
shown here that he appears in the painting.

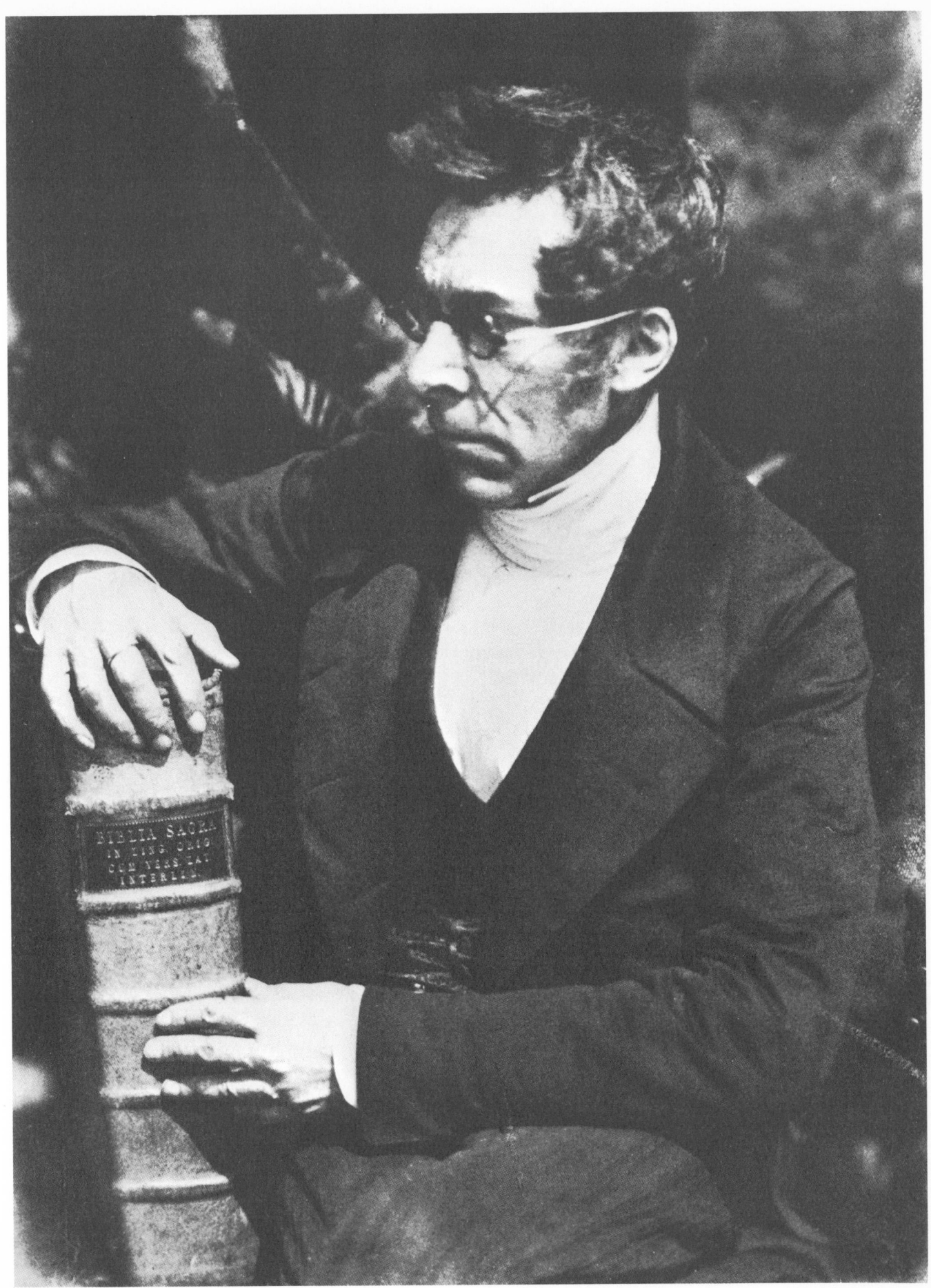

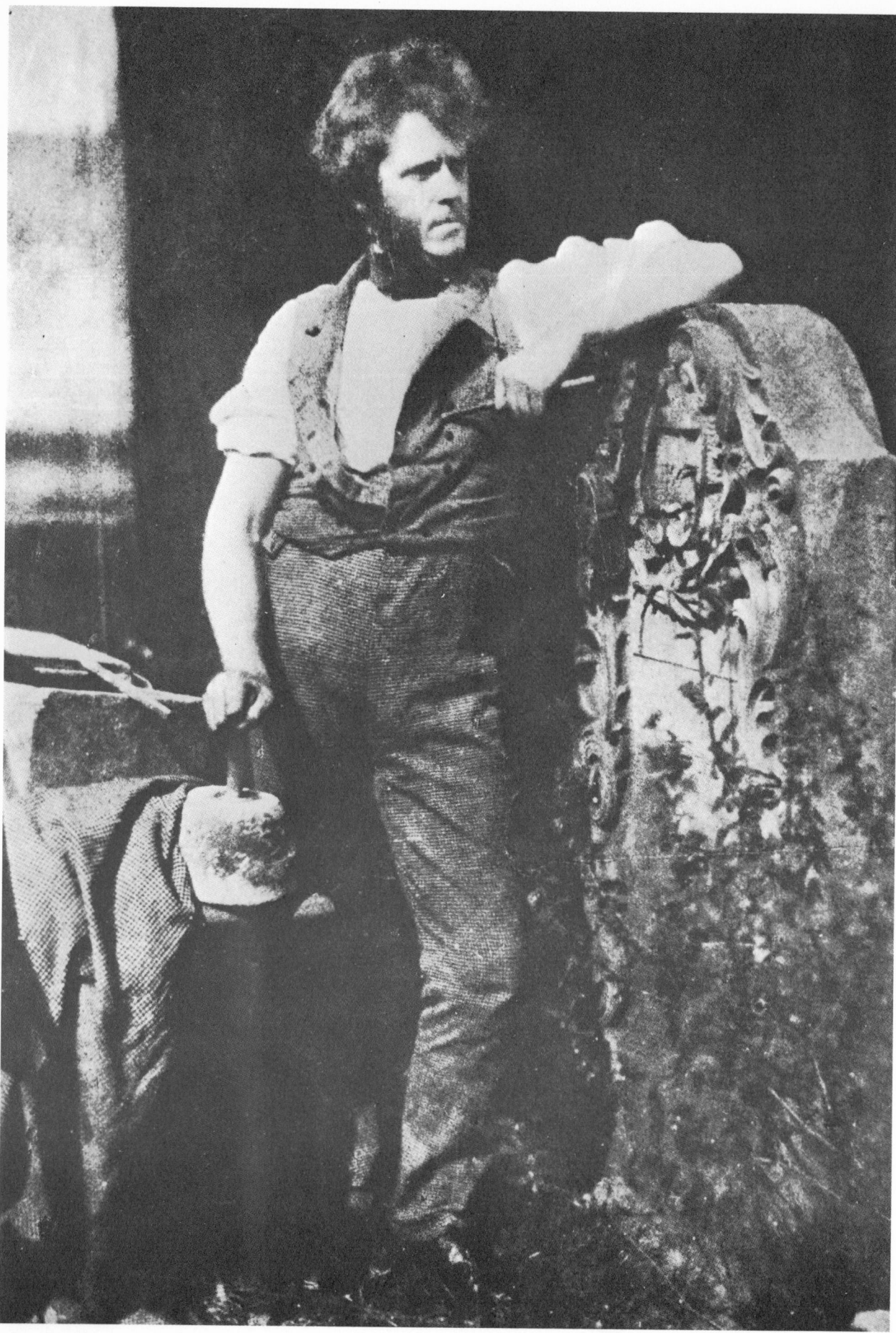

Hugh Miller

265 × 182 mm. (10$\frac{7}{16}$ × 7$\frac{5}{32}$ in.)
Scottish National Portrait Gallery

Hugh Miller, geologist and writer, was born in 1802 at Cromarty. His contributions to the Free Church Movement, to journalism and to geology are such that it is not possible to give more than the briefest account of his life here. He was first a stonemason, but one who studied the rocks of his native land.

He was caught up in the controversy surrounding patronage in the Church of Scotland and moved to Edinburgh where he became editor of *The Witness*. In 1841 he published *The Old Red Sandstone*, the result of his geological research. *The Testimony of the Rocks* appeared in 1857 but by then Miller was dead. He committed suicide on 23 December 1856.

Much of his writing was concerned with the twilight area between science and religion and indeed *The Testimony* was an attempt to explain the Book of Genesis in scientific, non-evolutionary terms. His journalism in *The Witness* was one of the key factors in persuading thousands to side with the Seceders at the Disruption.

This picture is itself significant for we know it was taken before 5 July 1843, thereby making it a very early product of the Rock House Studio. It may have even greater significance, however, since it was almost certainly one of the set of calotypes sent to John Ruskin. Ruskin, who up till then probably knew photography only in the medium of the daguerreotype, was very impressed by Hill's and Adamson's efforts.

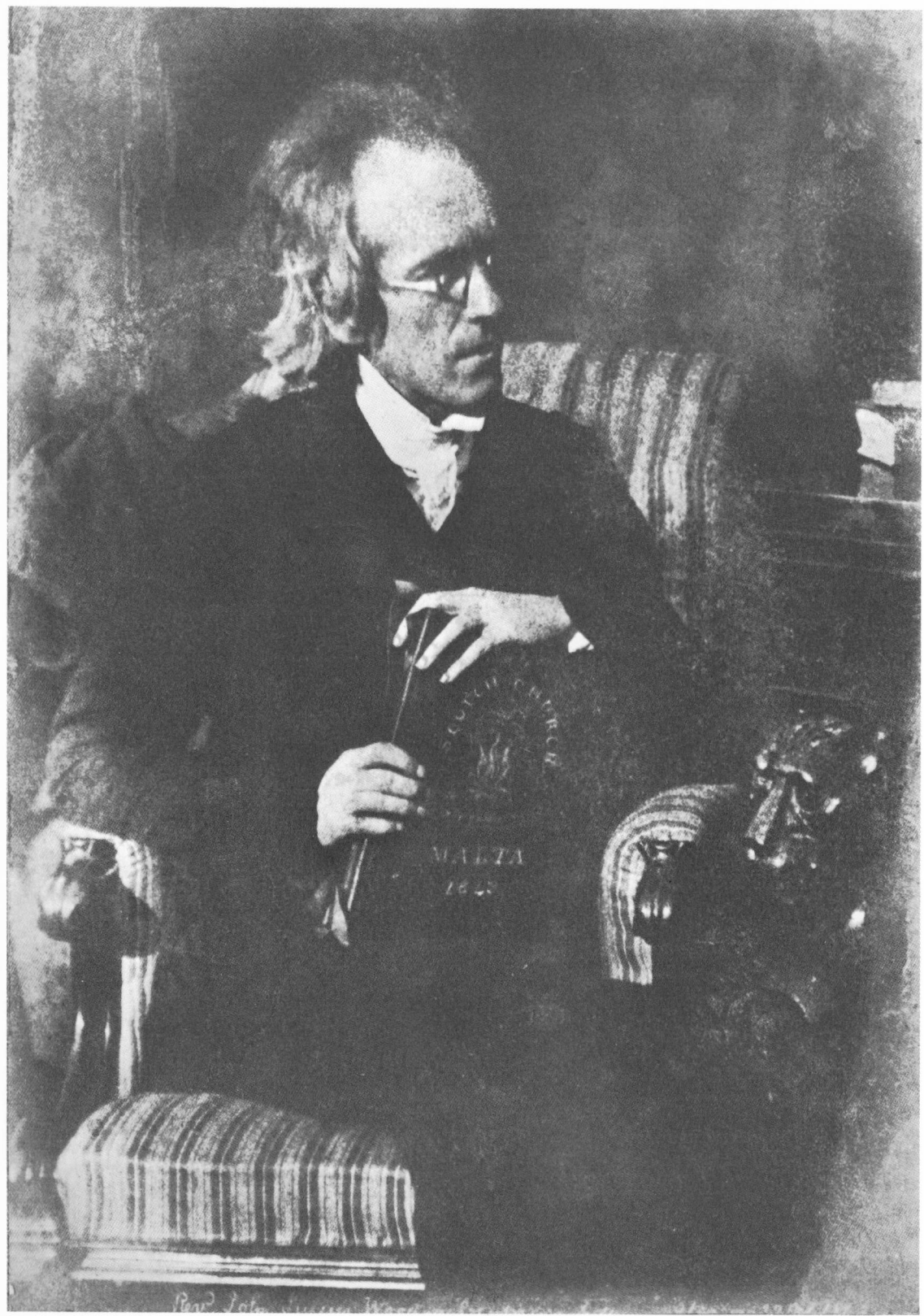

Rev. John Julius Wood of Malta

198×143 mm. $(7\frac{25}{32} \times 5\frac{5}{8}$ in.)
Scottish National Portrait Gallery

Some misunderstanding has grown around this calotype. One story goes that
Wood was in Malta at the time of the Disruption and his wife took it on herself
to sign the Deed of Demission in his place. According to Ewing, *Annals of the
Free Church*, however, he did not go to Malta until well after this calotype was
made and therefore could perfectly well have been at the Disruption.

There are two technical matters of special interest. The details on the cover of
the book which Wood is holding simply could not have shown up (if they were
ever there) as comparison with the surrounding area of a dense nature shows.
In fact 'Scottish Church, Malta 1843' was carefully drawn in, reversed, in ink, on
the negative. The negative (which incidentally disproves any remaining notions
that Hill and Adamson were above retouching their work when necessary) is
marked 'Glasgow 22 Oct. 1843'. It is held by the Scottish National Portrait
Gallery.

The other matter concerns the possibility that a head rest may have been used
in this shot. Evidence of 'pencilling out' is to be found on the left hand side.

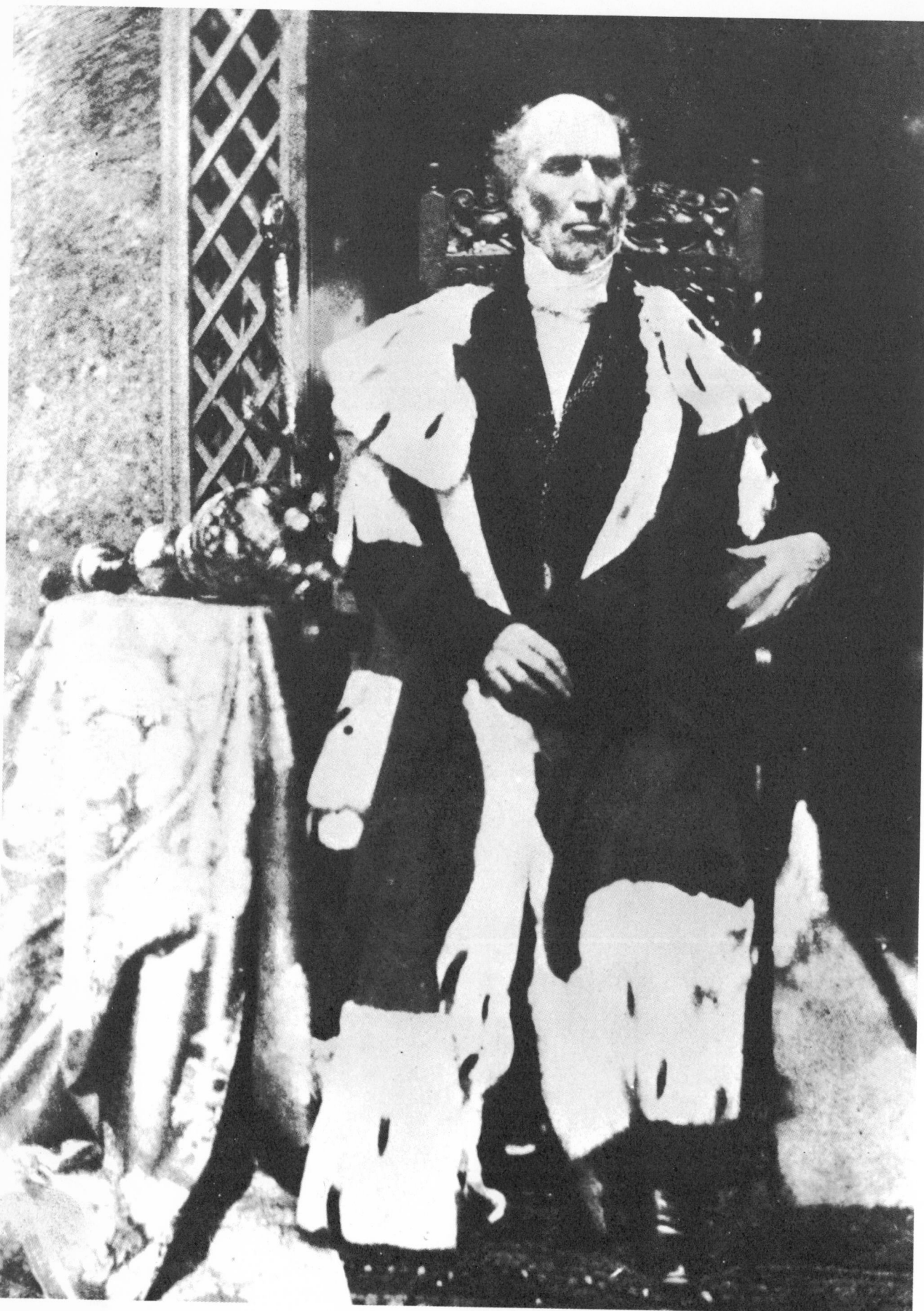

Sir James Forrest of Comiston

157 × 103 mm. (6$\frac{3}{16}$ × 4$\frac{1}{16}$ in.)
Scottish National Portrait Gallery

Sir James Forrest, Grand Master Mason of Scotland, figured prominently in the two great Edinburgh events of the 1840s. On 15 August 1840 he laid the foundation stone of the Scott Monument. On 18 May 1843 he walked out of the General Assembly of the Church of Scotland along with Welsh, Chalmers and the rest of the seceders.

For the Lord Provost of Edinburgh, a figure so obviously identified with the Establishment and the status quo, to join in what was a political as well as a moral revolt, was surprising. In Sir James was vested all the dignity of Scotland's ancient capital yet he chose, bravely, to side with the Free Church. ('It was a victory of principle over interest' – Cockburn.)

This early calotype is one of a pair showing the Lord Provost in his full robes with the city mace on the table beside him. It was a study for the Disruption Painting in which he appears and to which he was one of the first subscribers.

William Govan

203 × 148 mm. (8 × 5 $\frac{13}{16}$ in.)
Scottish National Portrait Gallery

William Govan (1804–75) was born in Paisley. For a time he was Town Clerk of
Dumbarton but his inclination was towards education and missionary work. In
1840 he was sent to South Africa by the Glasgow Missionary Society. He opened
a school at Lovedale in 1841.

Although this calotype has not been subjected to as heavy correction by Hill
as some were, the negative may have been retouched to enhance the sitter's
profile. In this connection it should be noted that Hill undoubtedly retouched a
similar portrait – his own.

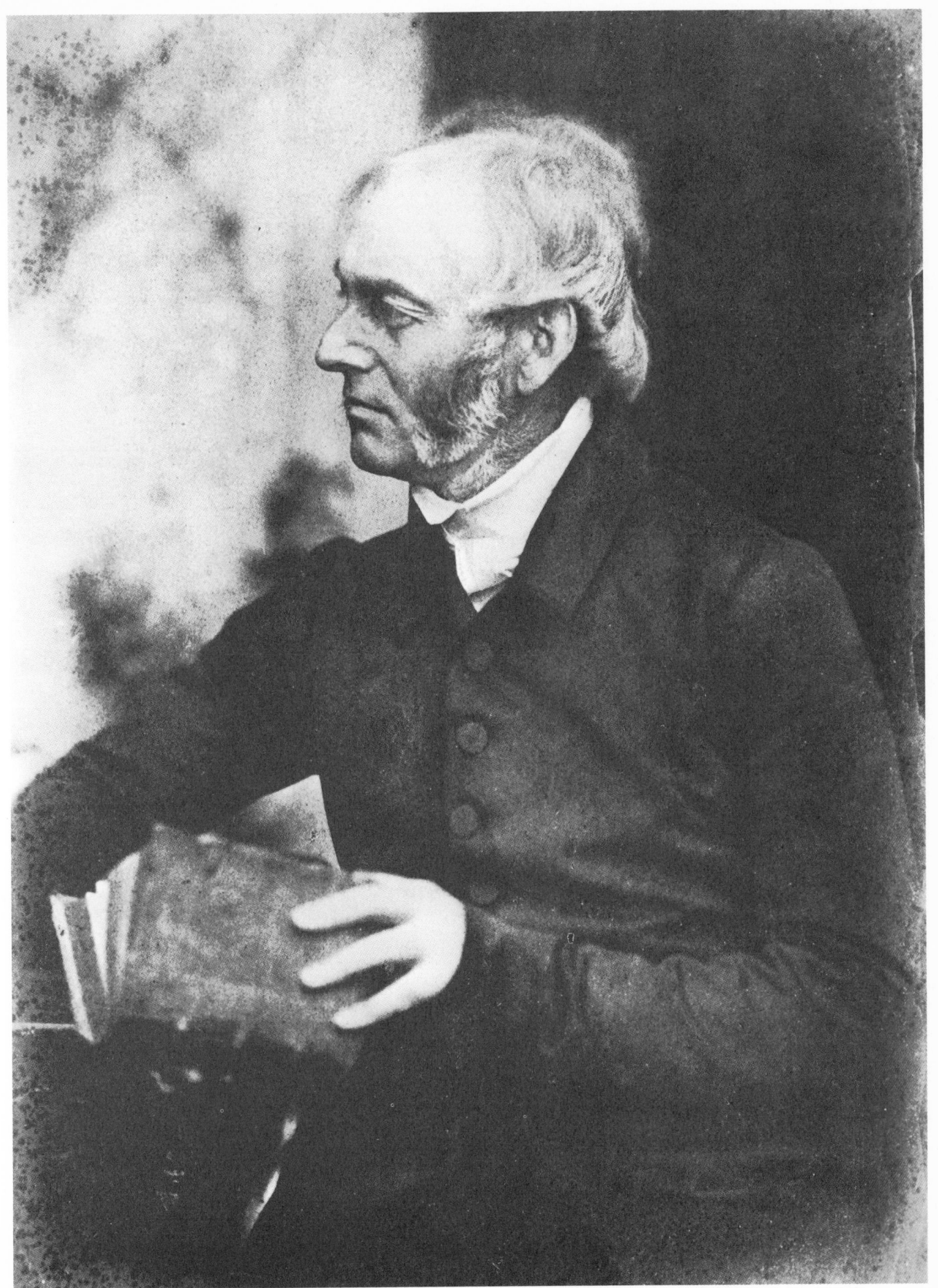

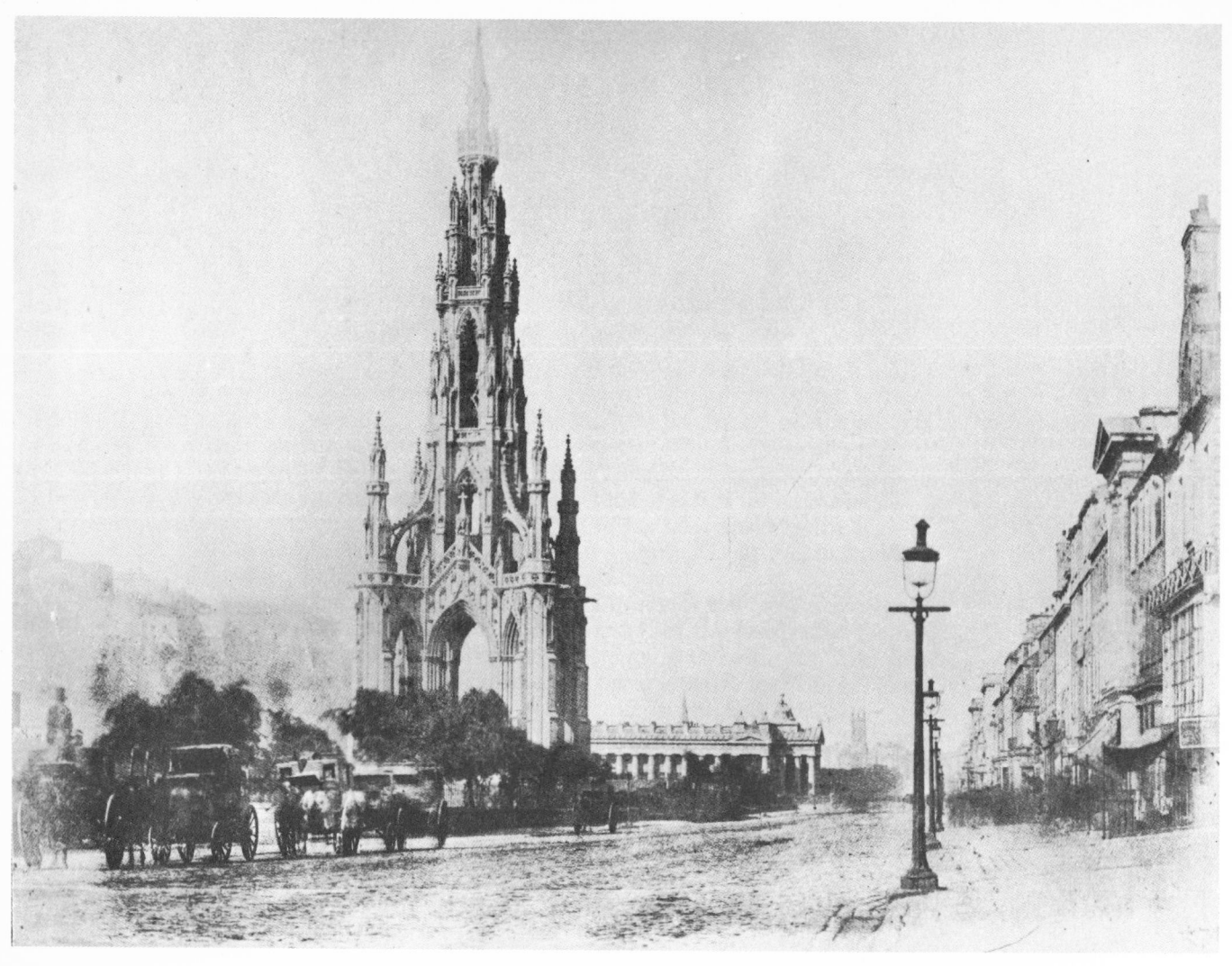

Princes Street

196×151 mm. $(7\frac{23}{32} \times 5\frac{5}{16}$ in.)
Edinburgh Public Libraries

Princes Street is one of the most famous thoroughfares in the world. As we know
it today it is a busy shopping street, and crossing it can be a hazardous business.

According to James Craig's New Town plan of 1767, Princes Street was to be
one of three parallel streets of *houses* of which the most important was to be
George Street, to the north. Princes Street and Queen Street on either side were
conceived as residential with open prospects of the Castle, and the Firth of Forth,
respectively. However, the plan was modified (one might say compromised) and
Princes Street's commercial life began as soon as it was built.

By 1845 a variety of businesses were operating in Princes Street including those
of people connected with the calotype venture. Hill's brother, Alexander, had
premises from which the photographs and albums were distributed. His neigh-
bours included Bryson, the clockmaker (see p. 181) and the rival daguerreotype
establishment of Mr Howie whose studio was on the roof.

In this early morning picture the street appears to be deserted, apart from a
few cabmen. The fact is that there would have been hundreds of people within
the camera's field of vision but because they, unlike the cabmen, are on the move
they have left no trace of their existence on the long-exposed negative. Only a
blur along the pavement indicates where they walked.

54

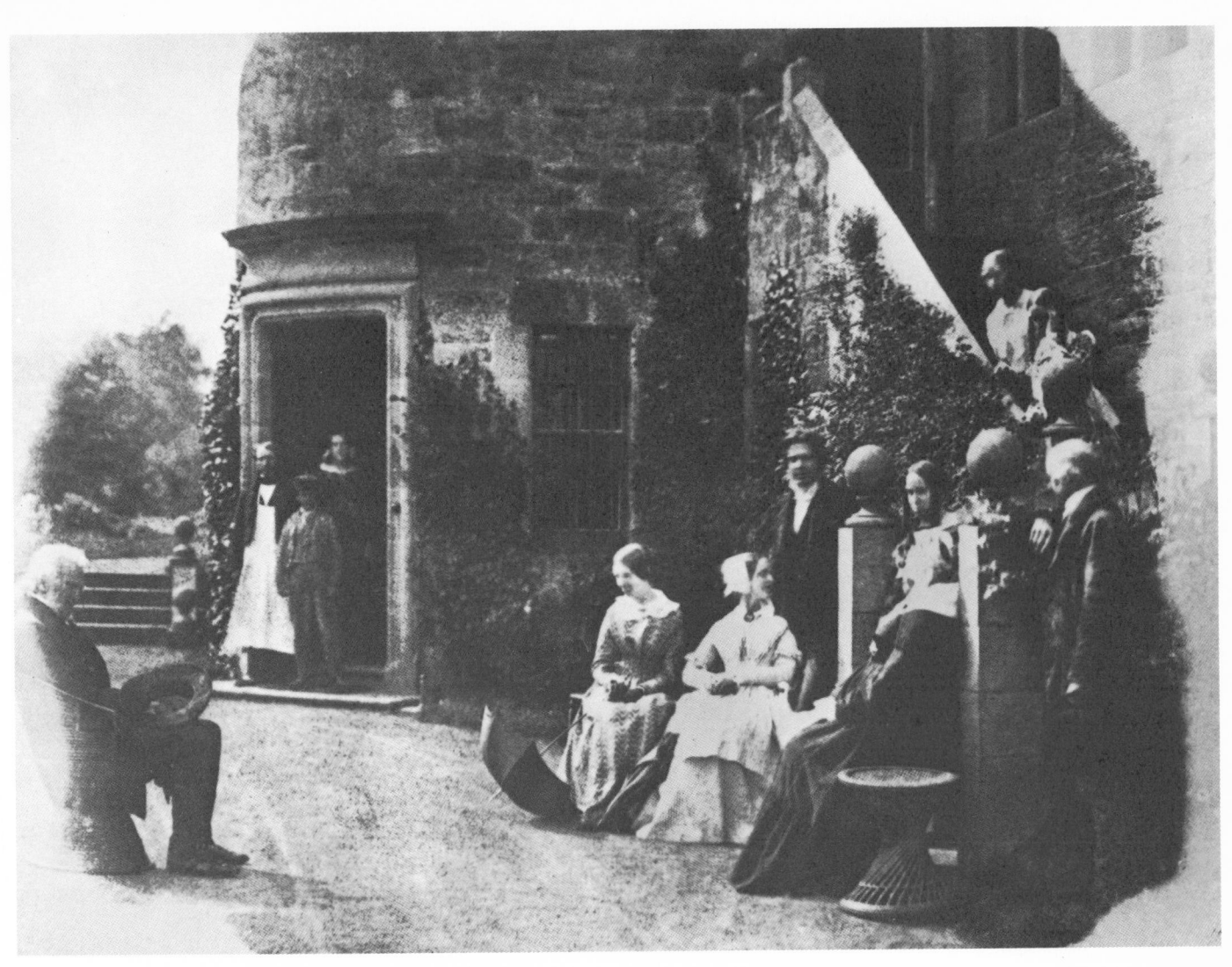

Lord Cockburn and His Family at Bonaly

148 × 203 mm. (5 $\frac{13}{16}$ × 8 in.)
Scottish National Portrait Gallery

This group photograph at Bonaly is one of a pair. In the alternative shot Hill, here seen standing beyond the bottom of the stairs, appears on the other side of the frame beside John Henning.

Henry, Lord Cockburn, standing on the right behind his wife, was a close friend of Hill's and gave him a great deal of support at the time of the setting up of the Royal Scottish Academy. He was born in 1779 and rose to great eminence at the Scottish bar, being made a Lord of Justiciary in 1837. He was one of the major figures of Edinburgh society; he felt strongly about the development and preservation of the city. At one point he wrote ironically to the magistrates telling them how best to destroy the capital. It is a letter which has a Swiftian ring and a relevance to our times.

Cockburn took a great interest in the calotypes, receiving a set in 1847. It had been intended that a further album, a 'Bonaly Book', would be produced but the project was abandoned on the death of Adamson in 1848.

James Spence

209 × 156 mm. ($8\frac{7}{32} \times 6\frac{5}{32}$ in.)
Scottish National Portrait Gallery

James Spence (1812–82) was one of Edinburgh's distinguished medical fraternity. He was a lecturer and surgeon at the Edinburgh Royal Infirmary and in 1854 became the senior surgeon in that famous establishment. In 1865 he was appointed Surgeon in Ordinary to the Queen in Scotland and though latterly his skill and reputation were very considerable he seems to have been opposed to the new methods of antiseptic surgery which he did not think were necessarily any better than his own. A contemporary description remarks on his rather pronounced features and 'anxious, half sad expression' for which he earned the unprepossessing nickname 'dismal Jimmy'.

The paper used by the calotypists was ordinary writing paper and occasionally, as in this instance, the watermark (J. Whatman) shows up clearly. Fox Talbot, in his instructions for making calotypes, was very specific about taking care to cut off the watermark from the writing paper before it was treated in case it spoiled the picture. Evidently Adamson, who prepared the materials, sometimes omitted to do so. Whether the picture is thereby 'spoiled' or gains interest is another matter.

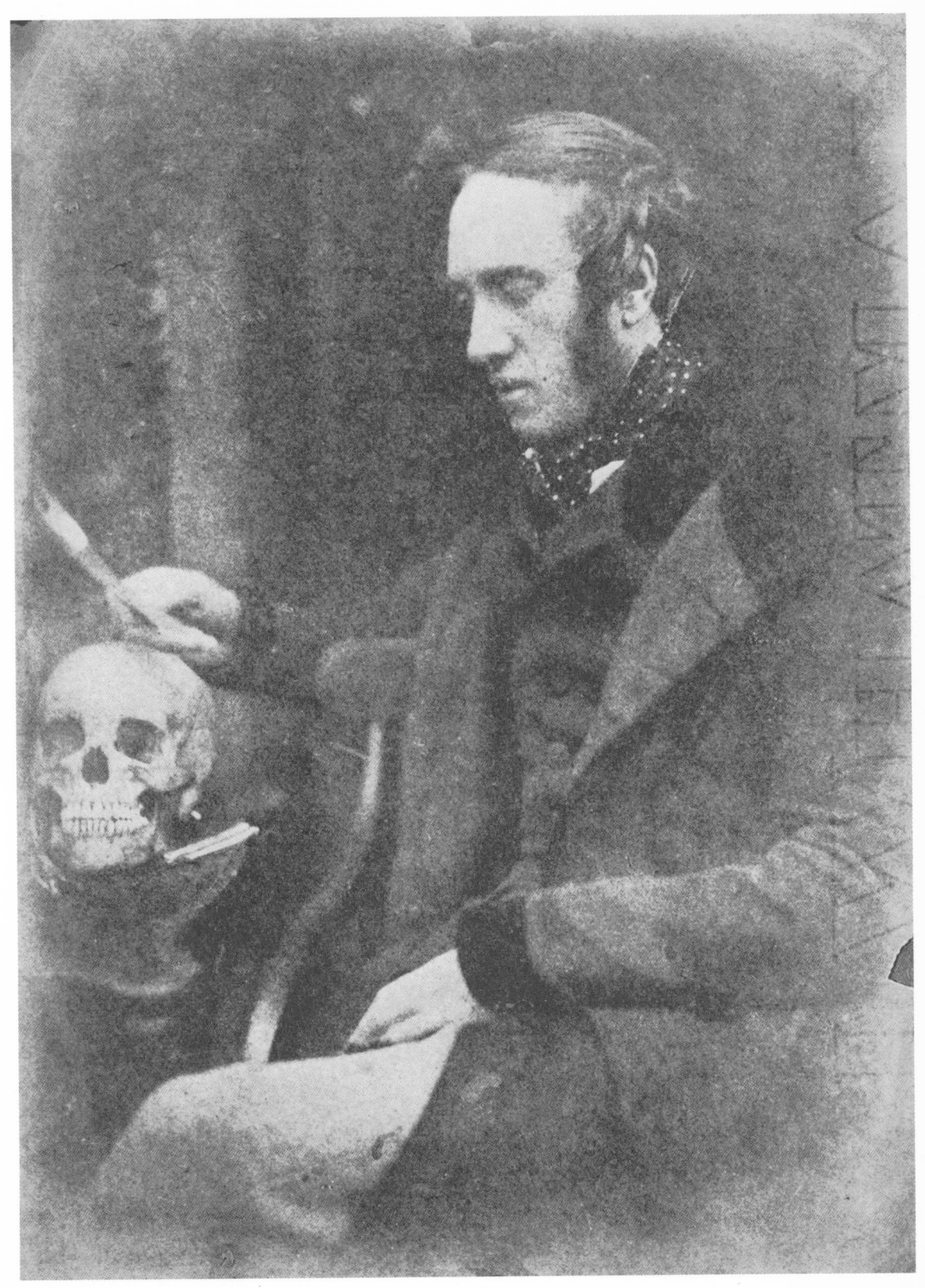

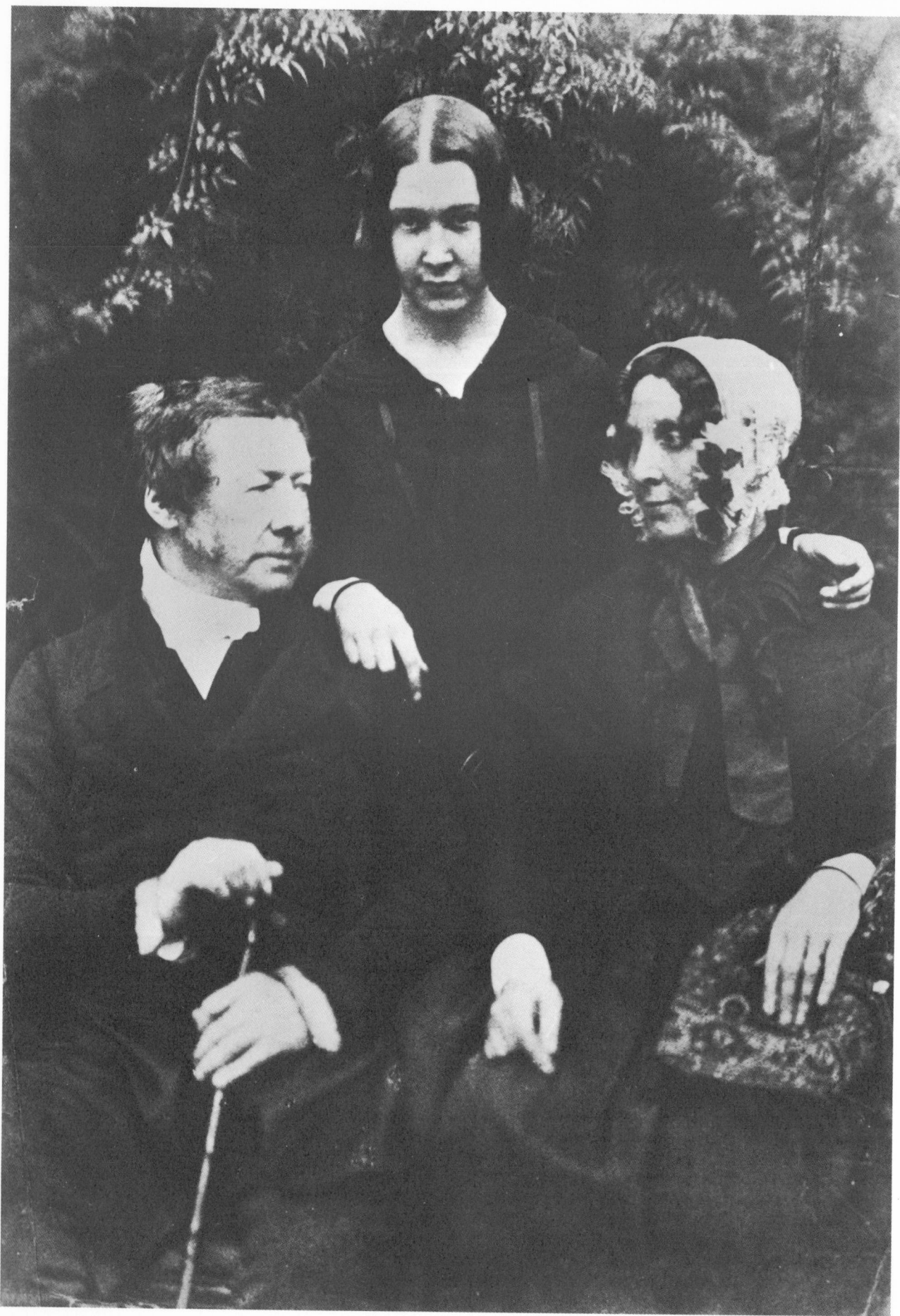

The Bruces

200 × 138 mm. ($7\frac{7}{8} \times 5\frac{7}{16}$ in.)
Scottish National Portrait Gallery

The identity of the sitters is not known beyond their surname and the fact that they were a family. The composition, however, is striking: within the overall pyramidal shape the triangle formed by the three heads is typical of the symmetry found in the Hill/Adamson calotypes. Less usual, however, is the device of having the two seated figures look at each other while the girl stares straight out at the camera. It is interesting that this latter touch which has featured later in the work of so many great photographers should be employed so confidently by Hill and Adamson in the very infancy of the medium.

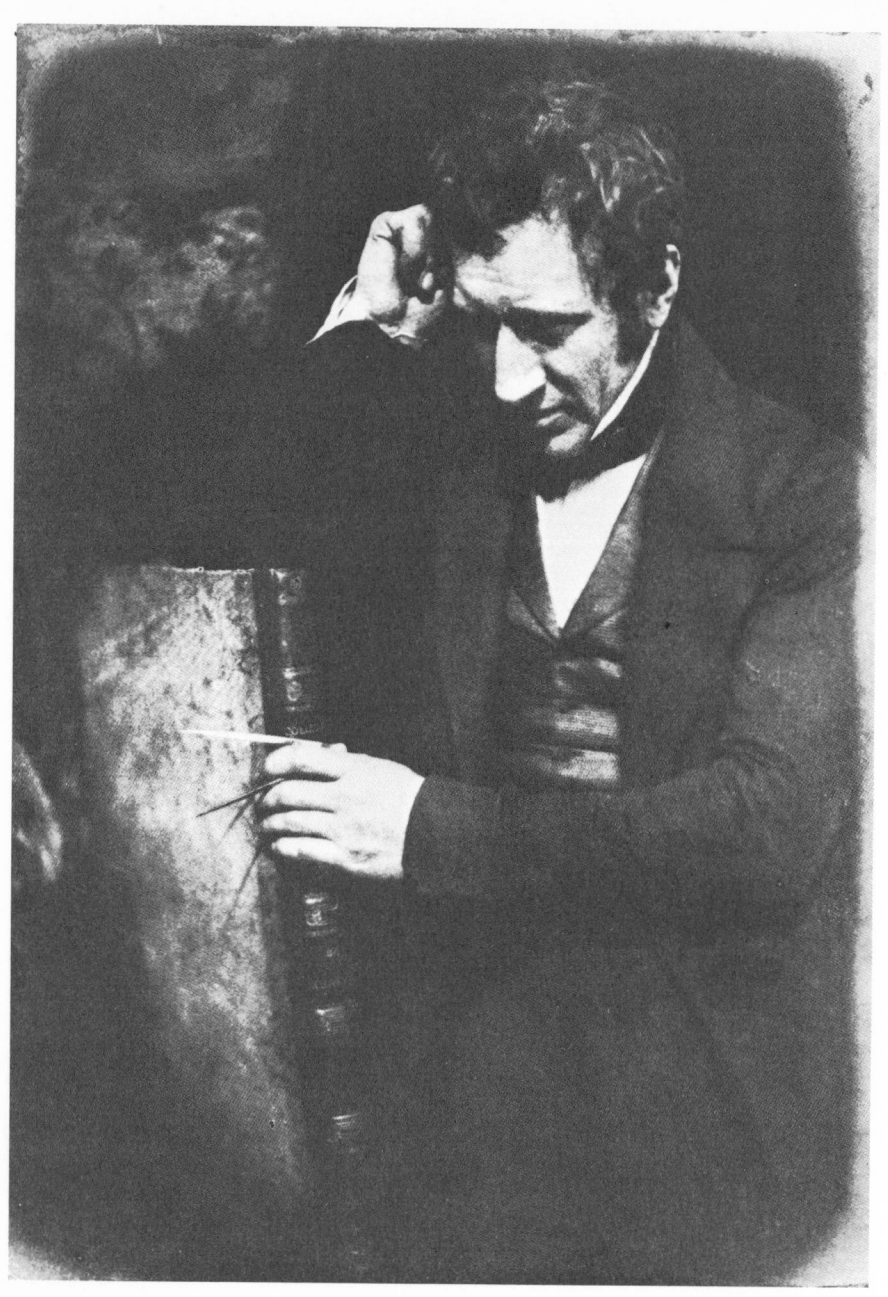

James Nasmyth

197 × 146 mm. (7¾ × 5¾ in.)
Royal Scottish Academy

This fine portrait is of a man in the best traditions of Scottish inventors.
James Nasmyth's father Alexander was a painter (he is best known for
his portrait of Robert Burns) and so was his brother Patrick. James
(1808–90) was, however, interested in mechanics and went into business
in Manchester.

In 1839 he devised his famous steam hammer which was the
cornerstone of his fortune. By 1856 he was able to retire to Kent. His
publications include *Remarks on Tools and Machinery* (1858) and *The
Moon* (1874).

William Borthwick Johnstone

197 × 146 mm. (7¾ × 5¾ in.)
Scottish National Portrait Gallery

William Borthwick Johnstone (1804–68) was a close friend of D. O. Hill and
appeared in several calotypes including one in which he was dressed as a monk.
He was treasurer of the Royal Scottish Academy, and, in 1858, became the first
Director of the National Gallery of Scotland.

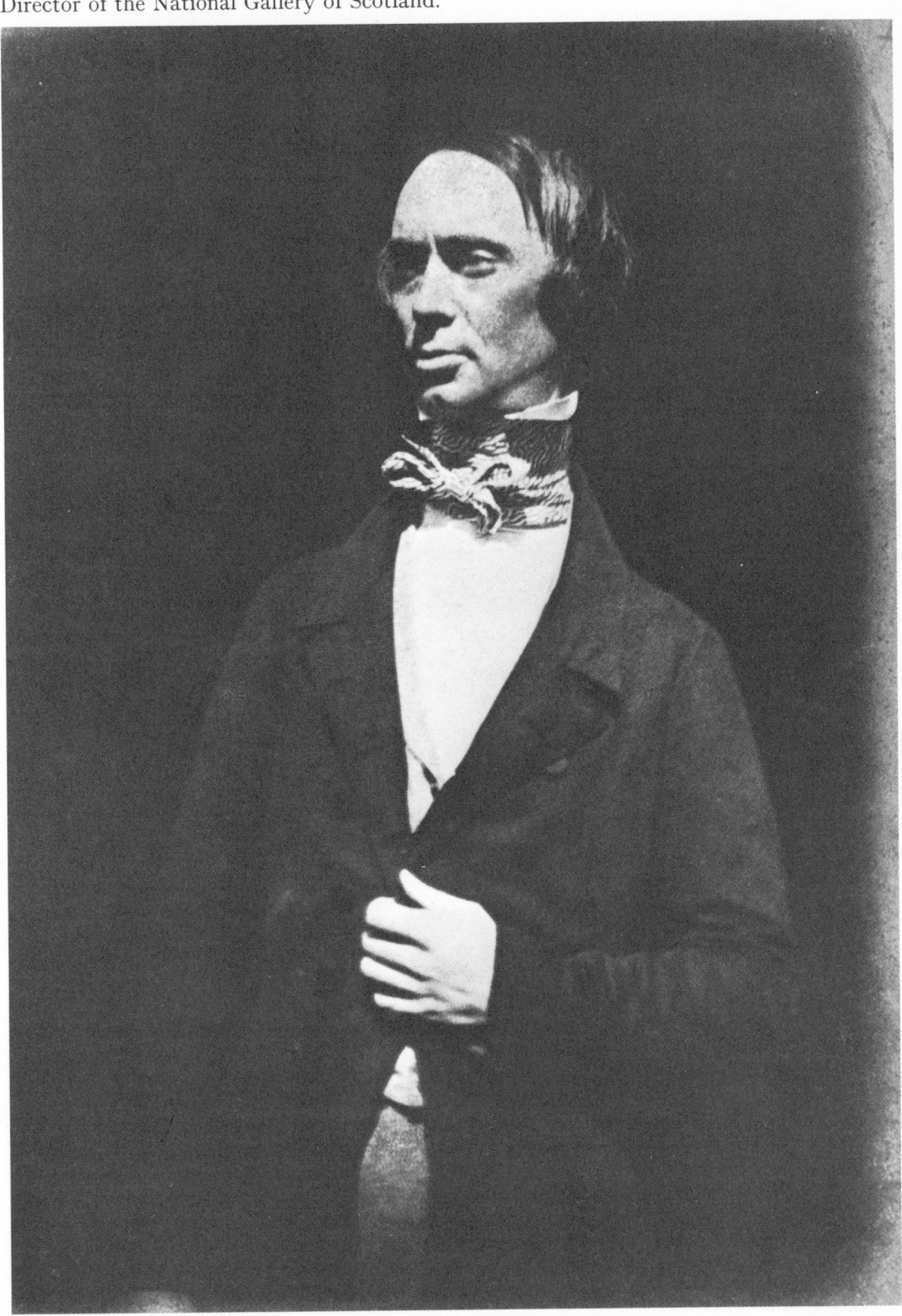

Sir William Allan

153 × 104 mm. $(6\frac{1}{32} \times 4\frac{3}{32}$ in.)
Royal Scottish Academy

The painter Sir William Allan, RA, PRSA was born in Edinburgh in 1782. He was trained at the Trustees Academy in Edinburgh and subsequently at the schools of the Royal Academy in London. Thereafter, he spent nine years in Russia (living through the French invasion) and returned to Edinburgh in 1814. In 1835 he was elected an RA and three years later he became President of the Royal Scottish Academy in which capacity he was closely associated with Hill who was the RSA's Secretary. He died in February 1850.

The calotype is one of several of Sir William Allan. It dates from January 1844.

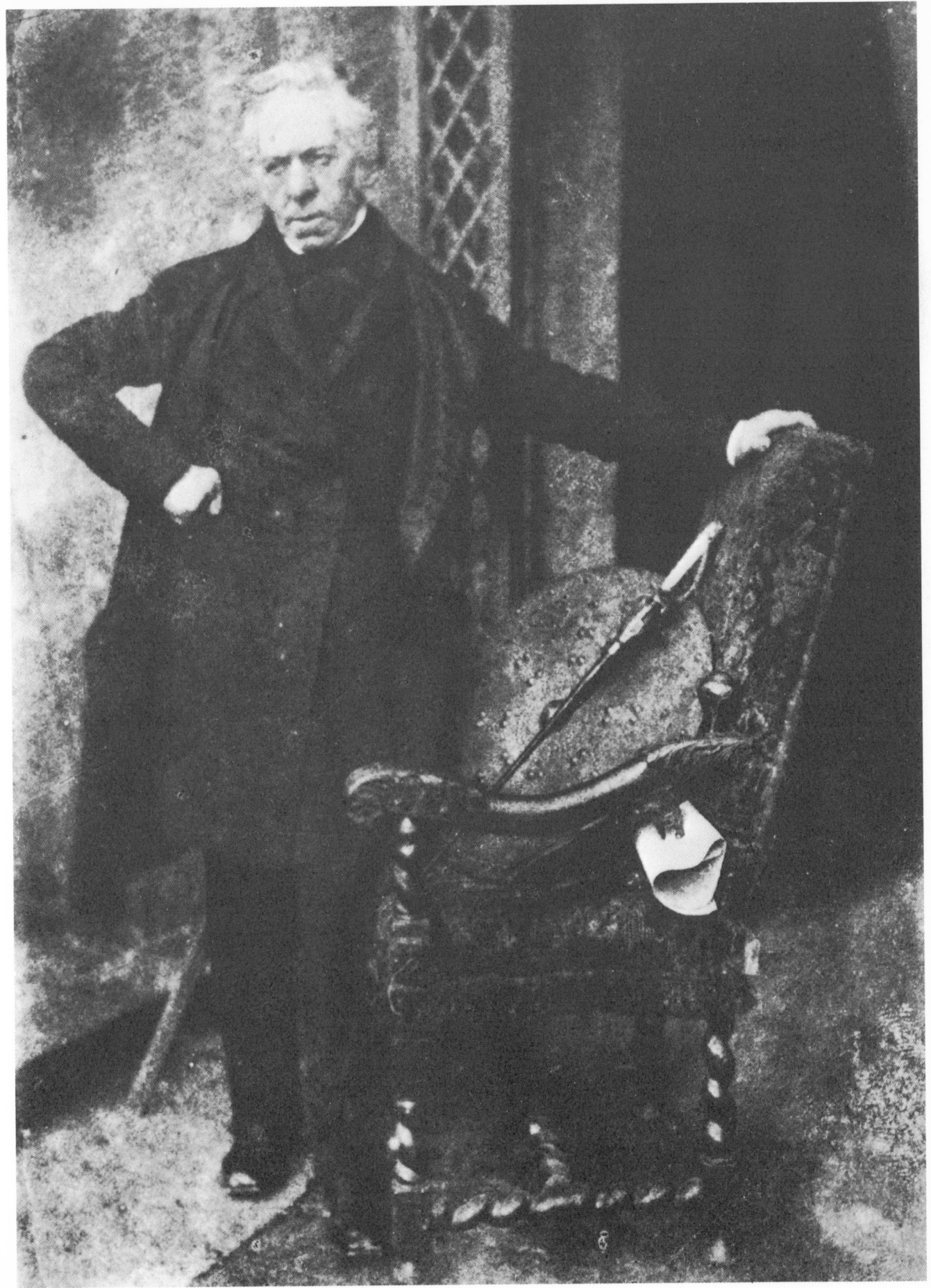

The Scott Monument

205 × 157 mm. (8$\frac{1}{16}$ × 6$\frac{3}{16}$ in.)
Edinburgh Public Libraries

The decision to build what became one of Edinburgh's most celebrated landmarks
was taken by a committee set up in October 1832, less than a fortnight after the
death of Sir Walter Scott. Between that date and its opening fourteen years later
the monument was to be the subject of considerable controversy.

Money had to be raised and even during the building it was necessary to hold
two 'Waverley Balls' to keep pace with costs, which rose faster than the
structure. When this calotype was made, in 1844 or 1845, building costs already
exceeded the budget. The sources of money were not confined to Edinburgh and
contributions came from as far away as St Petersburg (nearer home, Glasgow
decided to erect its own statue).

Reactions to the Monument were mixed. Dickens was 'disappointed'; Gladstone
called it 'elaborate and very lofty'. Ruskin thought it 'a small vulgar Gothic
steeple', but he had wanted another kind of monument altogether. It was to be
massive, like natural rock, and built near the cliffs of Salisbury Crags. It is
doubtful if that proposition would have been so welcome to the Edinburgh
citizens who wanted a memorial in their midst.

This photograph was taken from the roof of the Royal Institution to the west
of the monument. Calton Hill (on whose slope Rock House is situated) is behind it
and to the right.

64

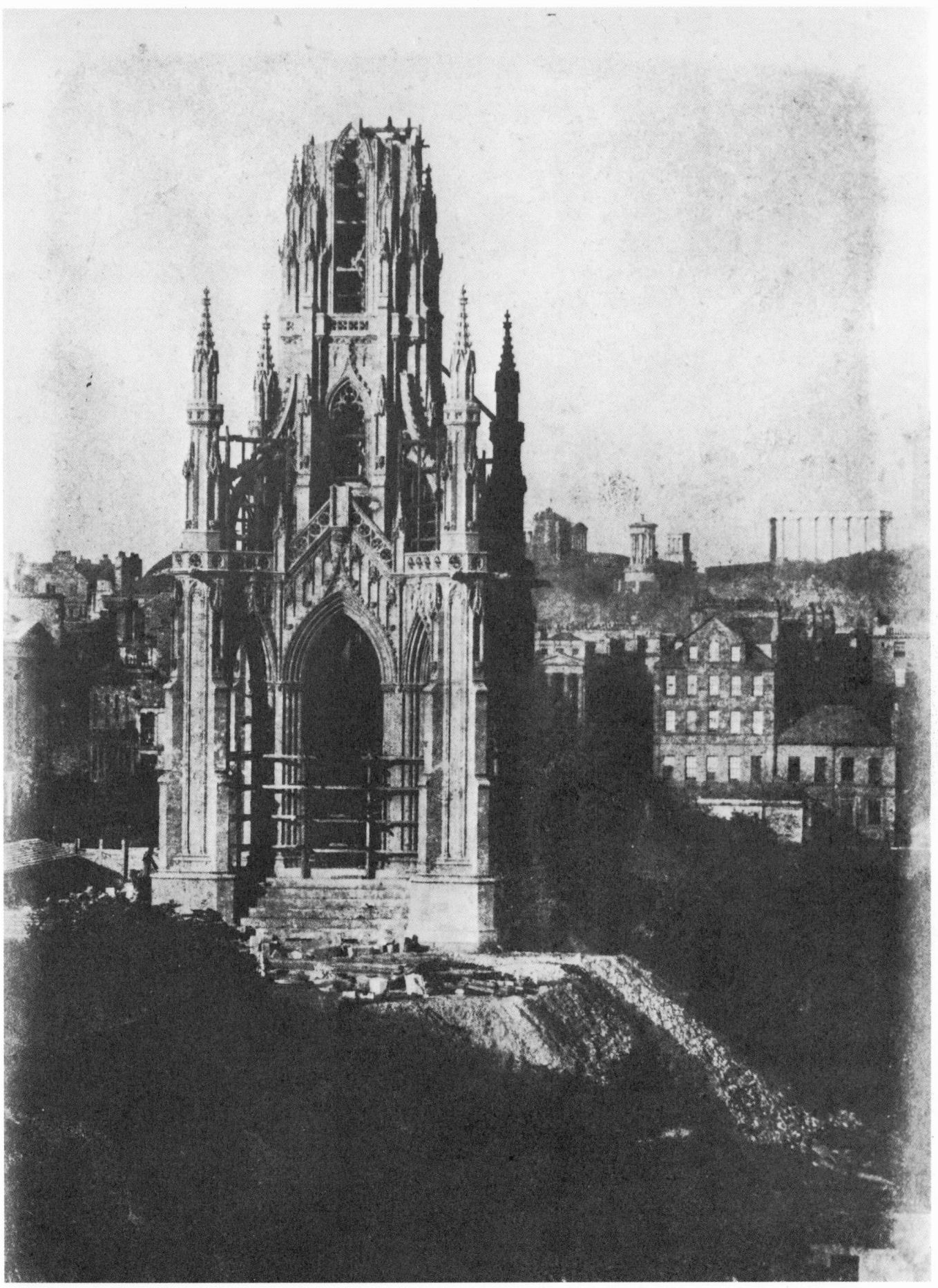

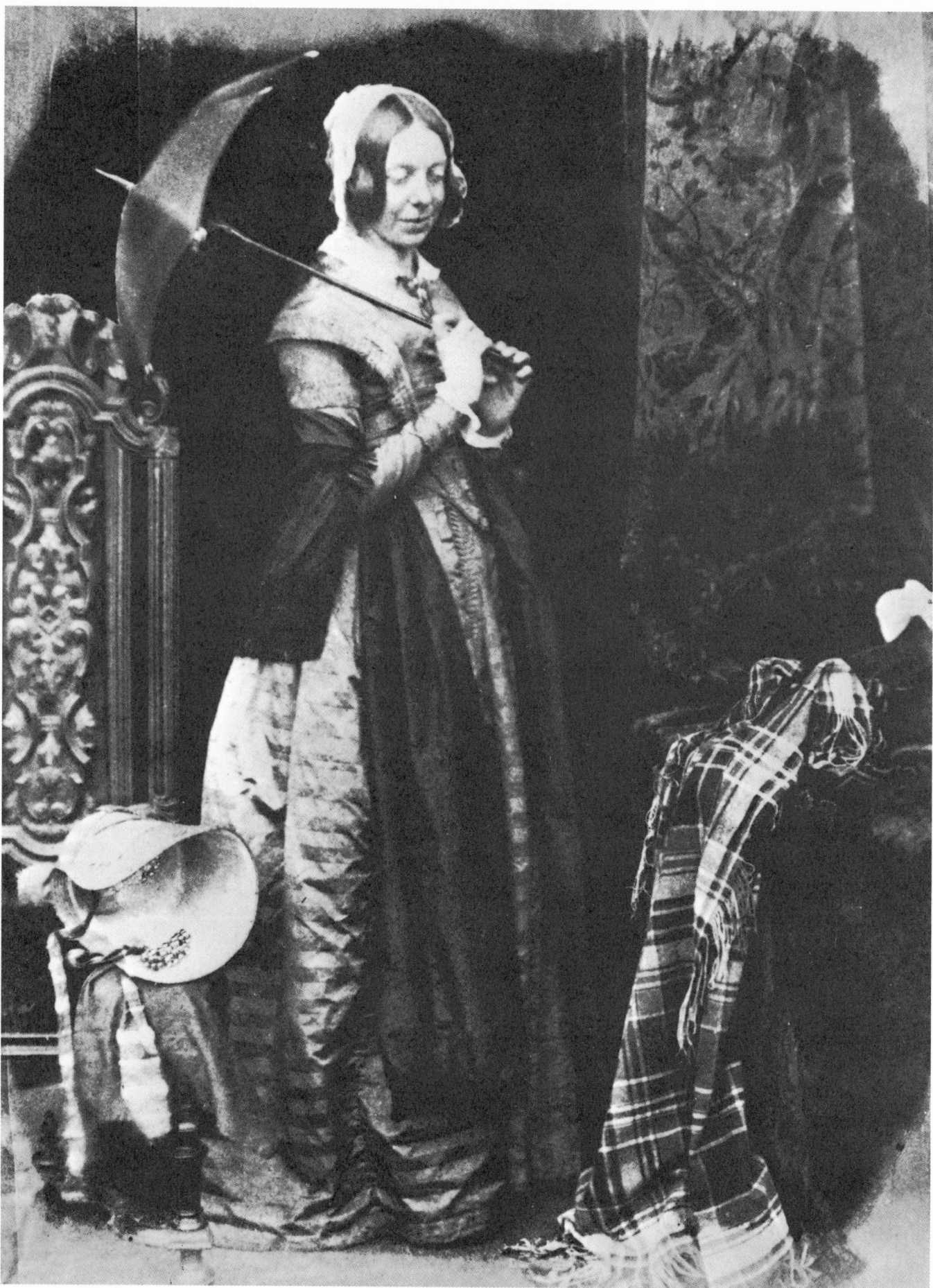

Mrs Crampton

202 × 152 mm. (7$\frac{15}{16}$ × 5$\frac{31}{32}$ in.)
Scottish National Portrait Gallery

Mrs Crampton and her husband, Philip (1777–1858) both sat for Hill and
Adamson. They were on a visit to Edinburgh from their native Dublin where
Dr Crampton was a surgeon. Crampton, a Fellow of the Royal Society, was later
knighted.

Of the Rock House Studio 'props' in use in the calotype the chair and the drape
are well known. The umbrella adds a charming touch.

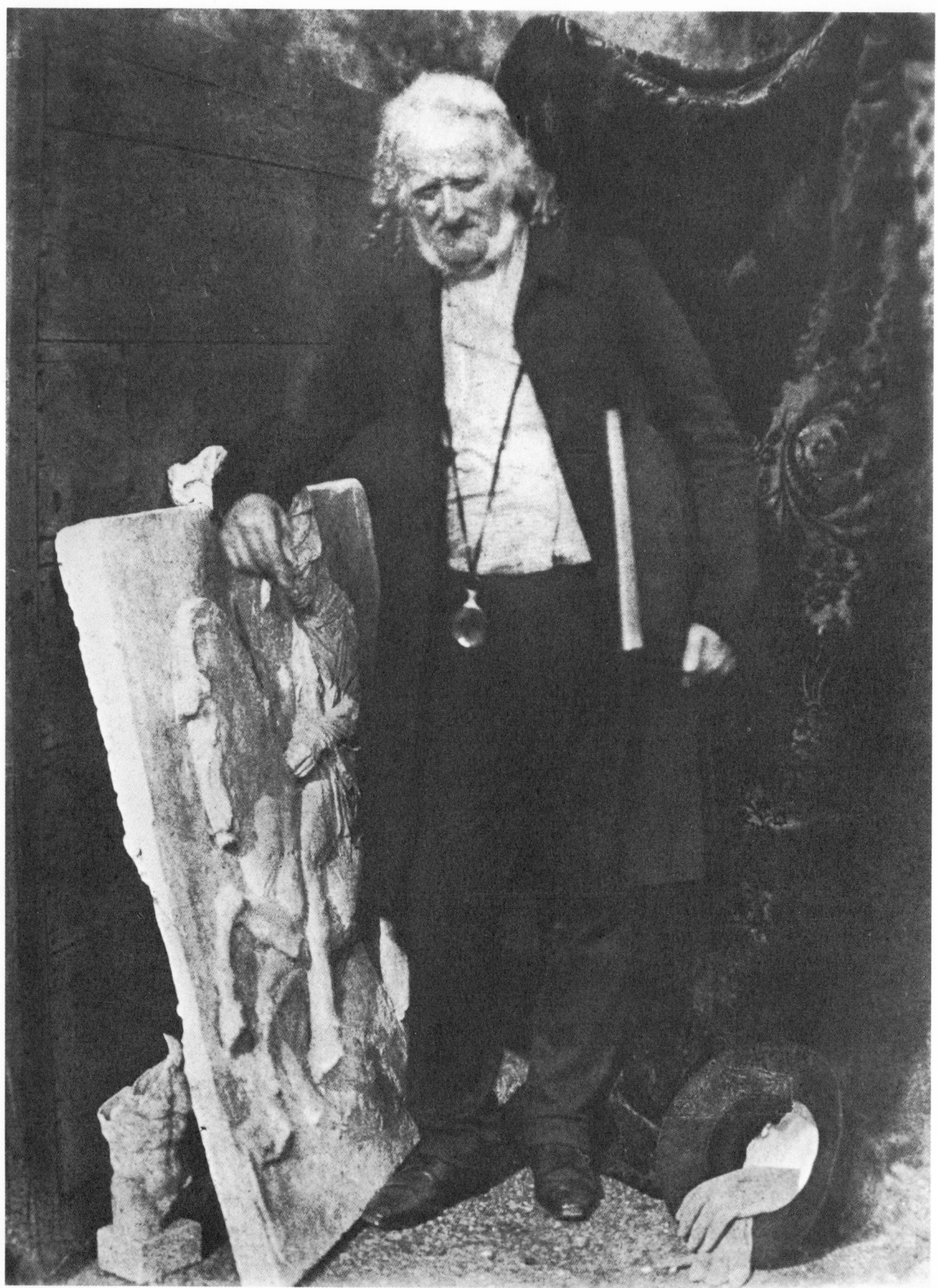

John Henning

215 × 162 mm. (8 15/32 × 6 3/8 in.)
Scottish National Portrait Gallery

John Henning was born in Paisley in 1771 of which he was given the 'freedom' in 1846. He began his career humbly as a portraitist in wax. In 1800 he set up in business in Glasgow and moved to Edinburgh three years later where he made busts of the famous, including Scott.

In 1811 he went to London where he was fascinated by the Elgin Marbles, so much so that he spent twelve years modelling them for a frieze on the exterior of the Atheneum. His portraiture continued, at up to ten guineas for a bust; and among his sitters were the Duke of Wellington, James Watt, and Sir Humphry Davy. He thereby provided an unwitting link between the photographic pioneers, Davy, and Hill and Adamson.

He returned to Edinburgh in 1846 and died in 1851.

Henning's striking features are seen frequently in the Hill/Adamson calotypes, often in the character of Edie Ochiltree, the tramp in Scott's *The Antiquary*. It is appropriate, however, that the best picture of the old man should show him with a model of one of the marbles to which he had devoted many years.

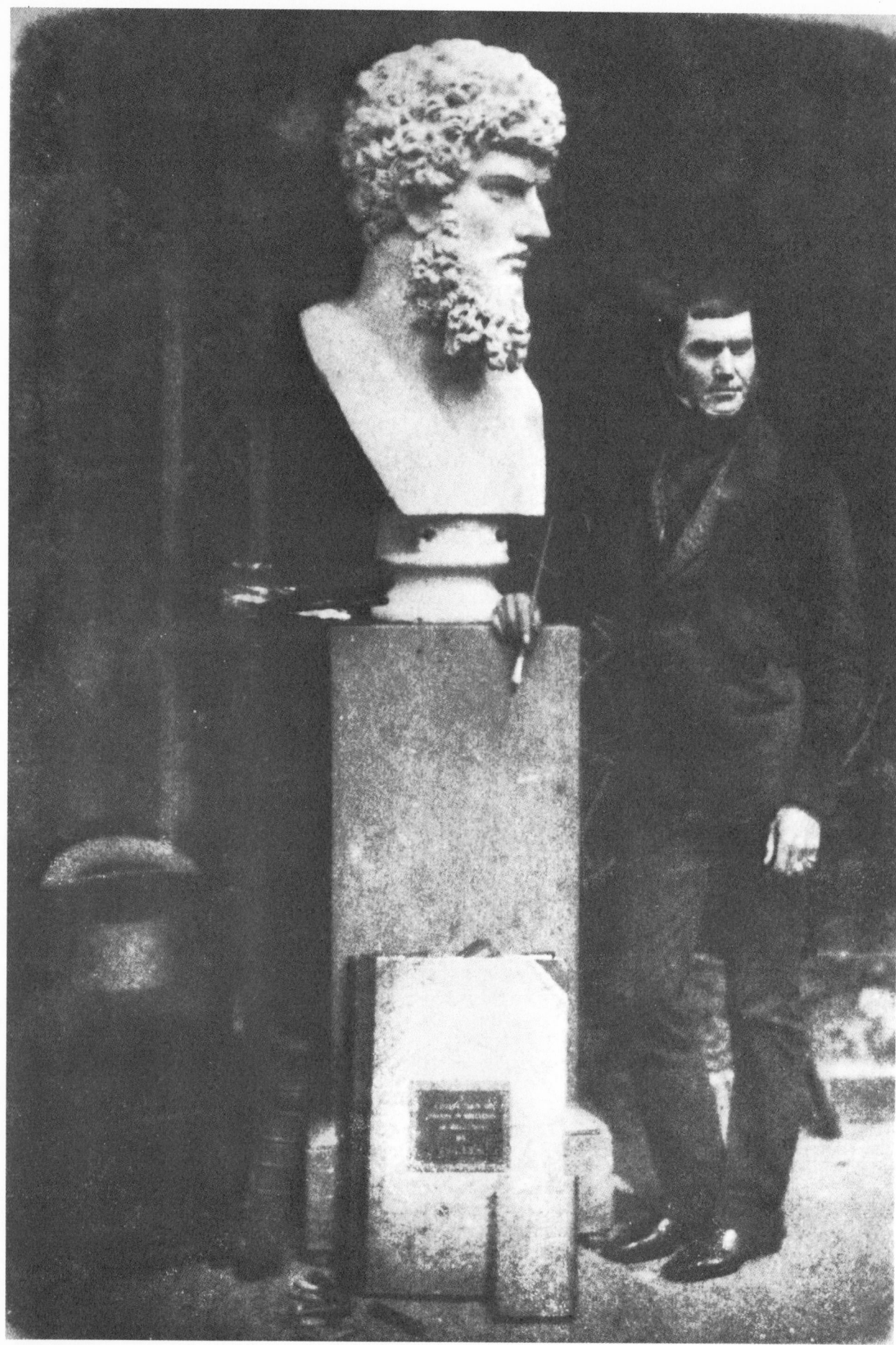

John Stevens

194×135 mm. (7⅝×5⁵⁄₁₆ in.)
National Library of Scotland

There are at least two calotypes of the painter John Stevens, RSA, posing with the monumental Roman bust *Lucius Verus*. The bust also features, not altogether seriously, in 'The Morning After' (see p. 97).

The skill with which Hill and Adamson handled broad areas of light and shade is demonstrated here quite dramatically. Few calotypes have such a large proportion of dark in their composition. Stevens's rather rugged features peering from the shadows look positively sinister but the slightly incongruous paint brush in his hand, breaking the line of the top of the plinth, and the hat on the chair lighten the mood of near melodrama.

John Knox's House

140 × 197 mm. (5½ × 7¾ in.)
National Library of Scotland

The calotypes have a strong bias towards
the New Town of Edinburgh and away
from Edinburgh's dingy past. This is
only to be expected as it was in the New
Town that the bourgeoisie lived. The
Old Town had largely been abandoned
to the 'lower orders'. Dr Bell (see p.125)
could look at the squalid 'closes' of the
High Street and soberly compare them
to Hell.

The Royal Mile had not lost its
fascination entirely, however. The
picture shows what is still referred to as
John Knox's house, although there is
evidence that he lived there only for a
very short period. It may have been
made in the course of a campaign to
preserve the building.

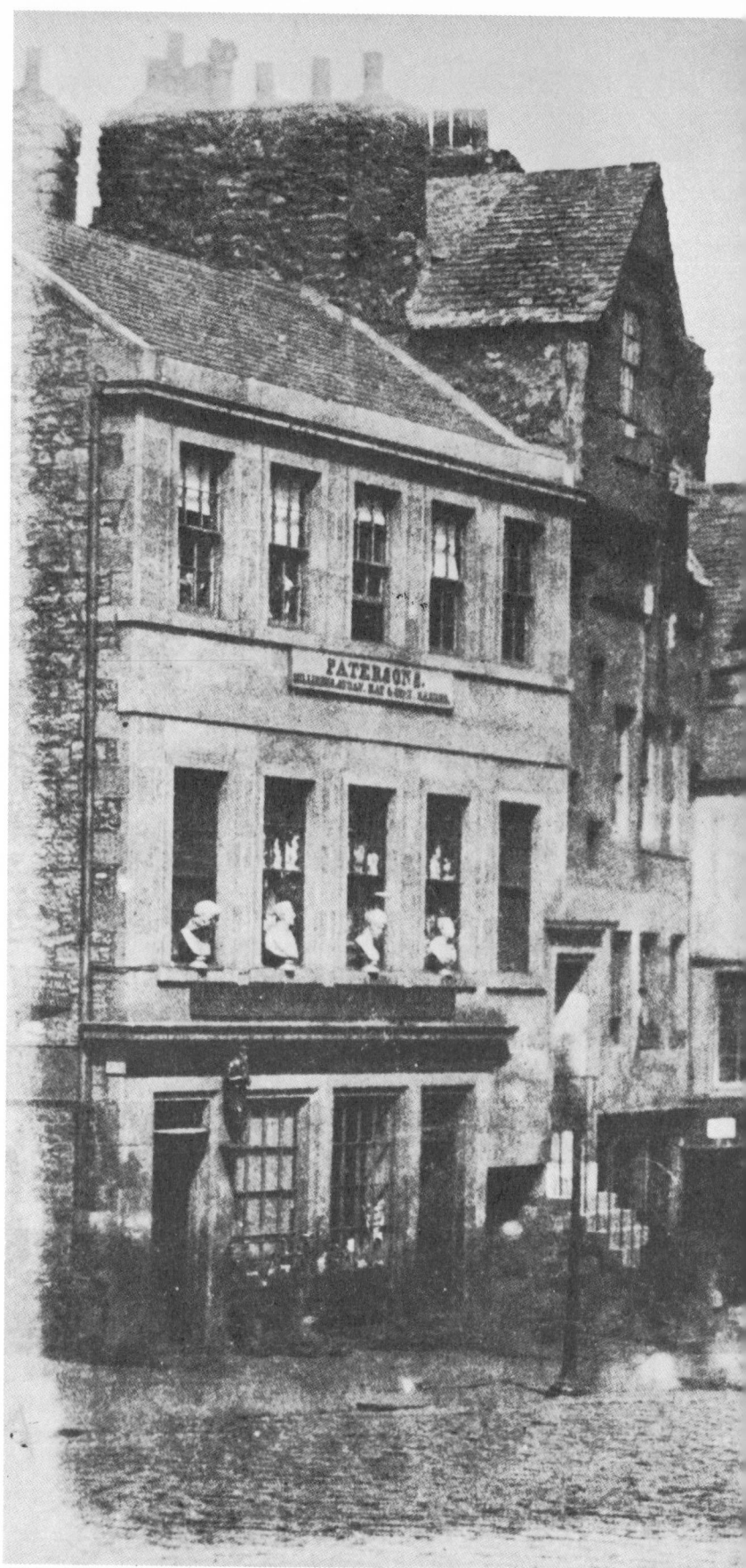

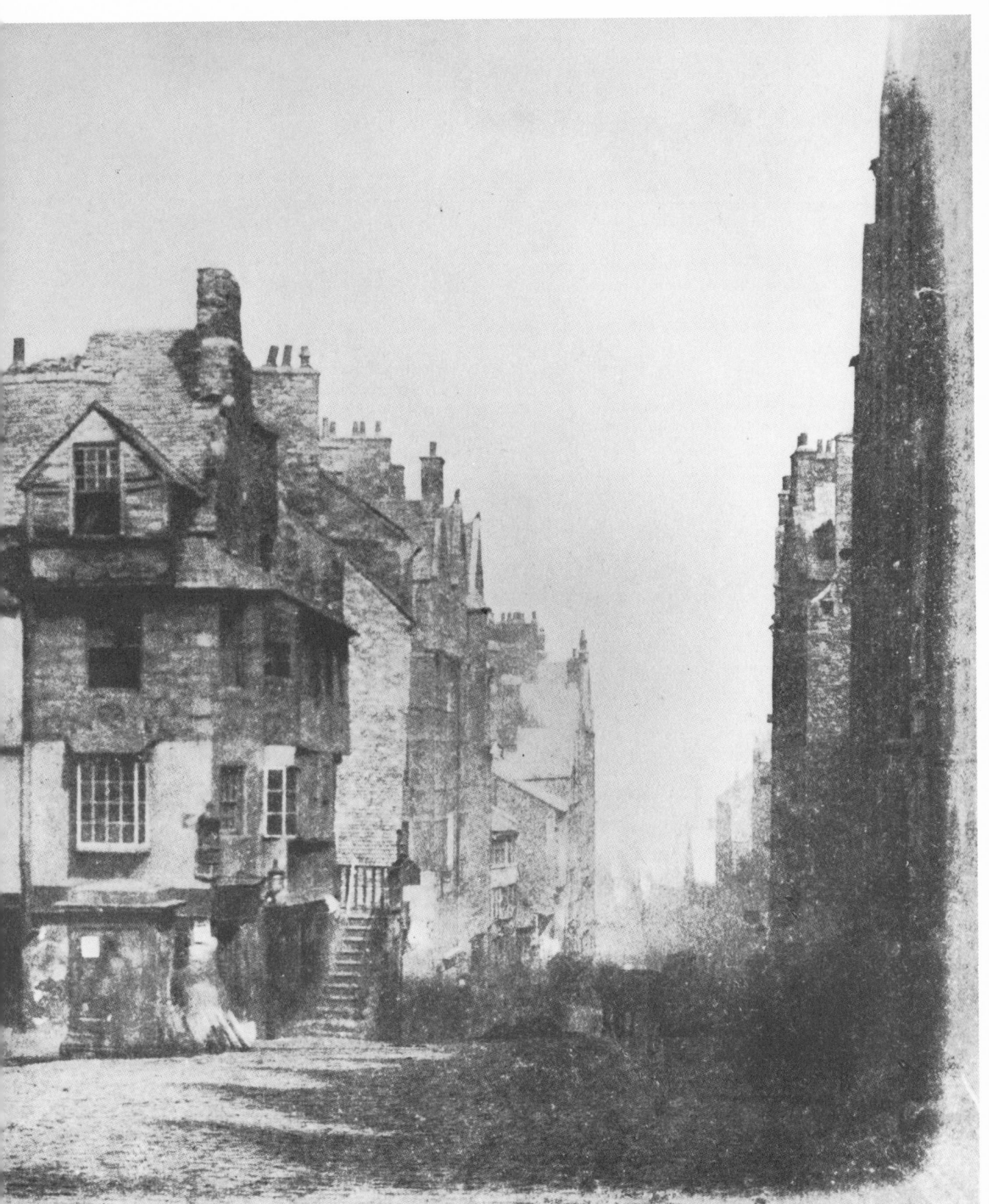

Professor Monro

200 × 144 mm. ($7\frac{7}{8}$ × $5\frac{11}{16}$ in.)
Edinburgh Public Libraries

Dr Alexander Monro, the subject of this splendid portrait, was the last of a remarkable succession of Professors of Anatomy at Edinburgh. His grandfather, father, and he, each held the chair in turn and were known as Monro *primus*, *secundus* and *tertius* respectively.

Tertius Monro seems to have been the least able of the three. Nevertheless, after studying in Paris he was appointed assistant to his father at twenty-five years of age in 1800 and became sole Professor in 1817. He suffered from the opposition of the other distinguished anatomy lecturers who also worked in Edinburgh, Dr Barclay and the infamous Dr Knox, whose reputations as anatomists were more substantial than his own.

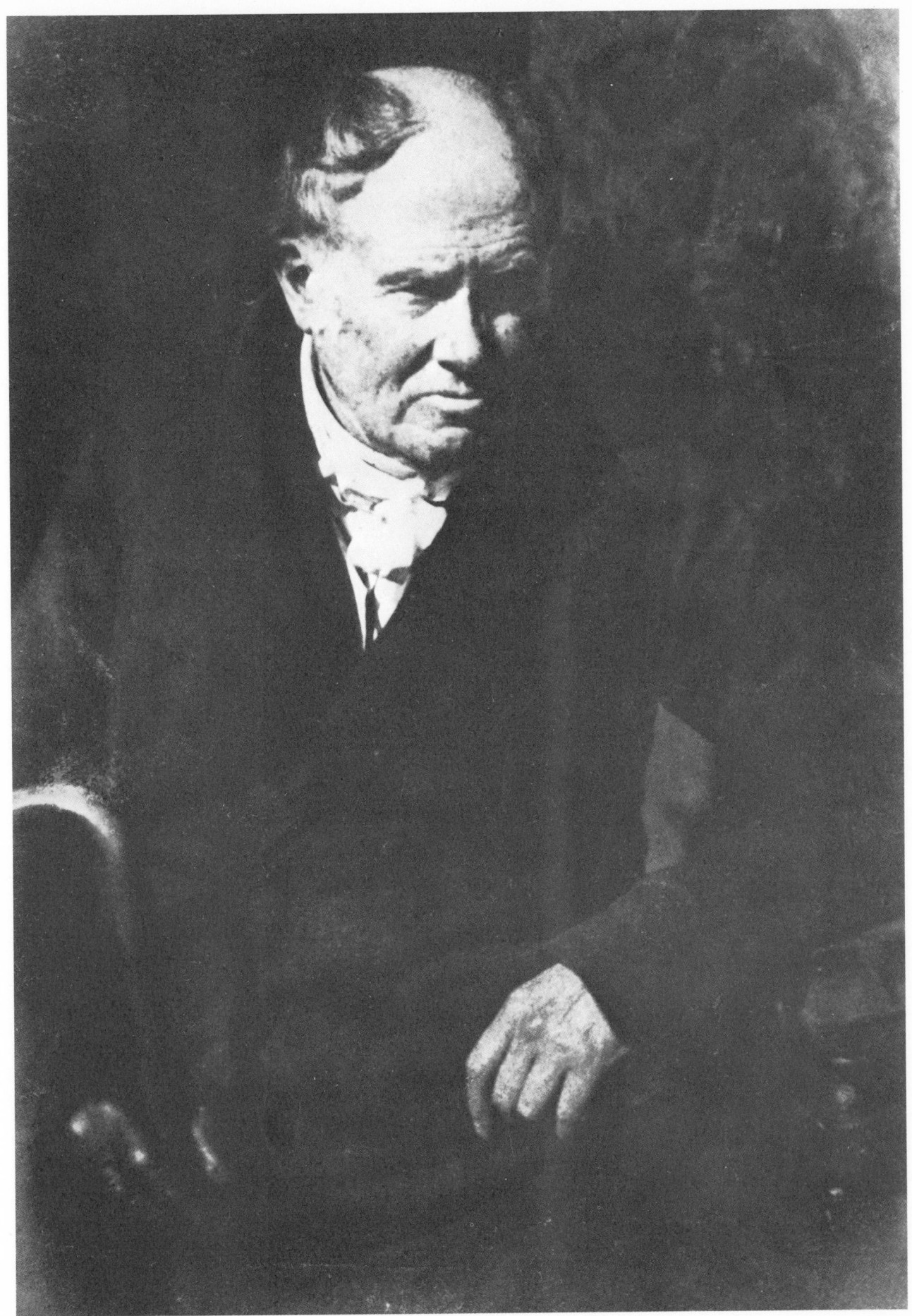

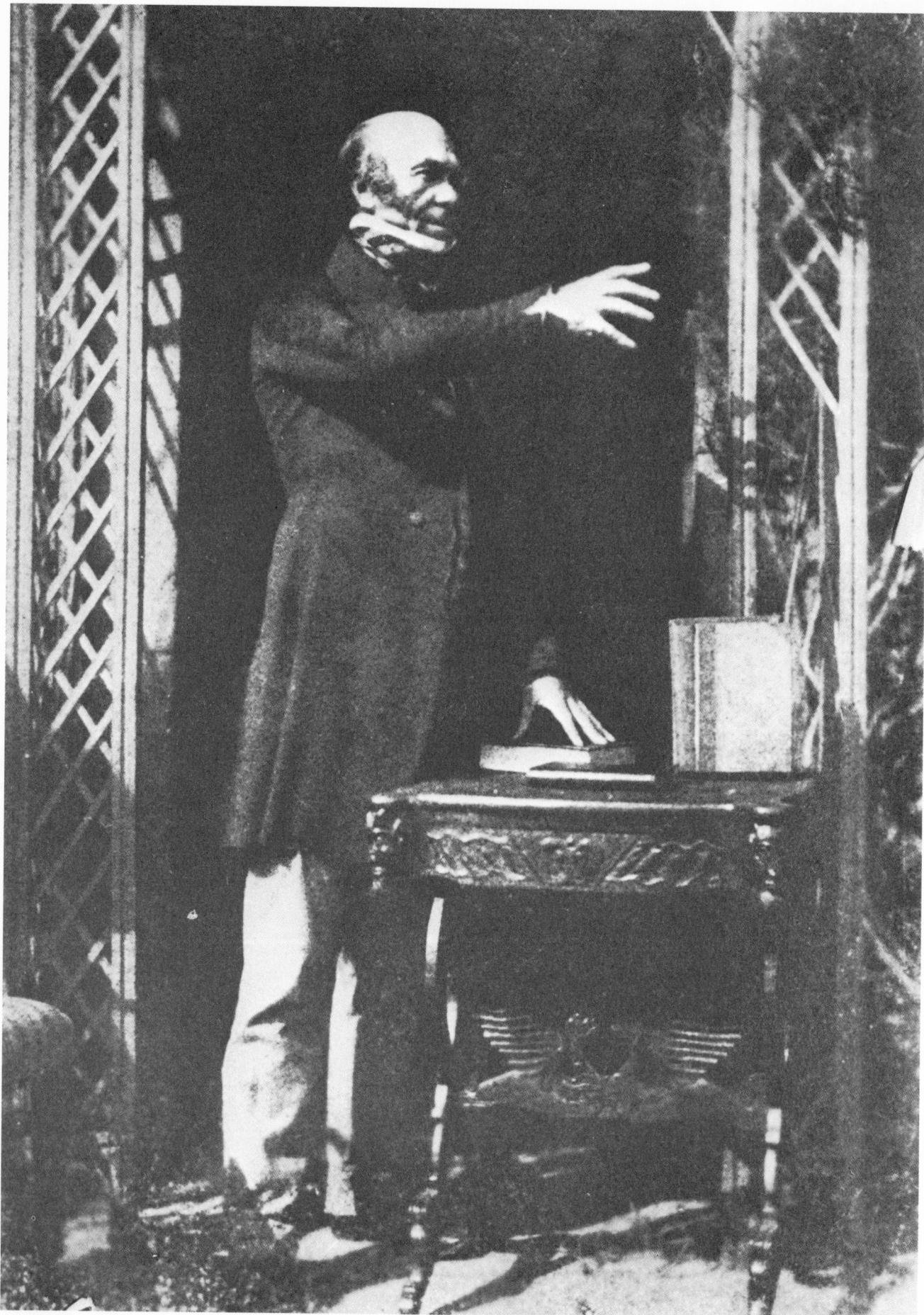

Dr Robert Knox

156 × 112 mm. (6⅛ × 4¹³⁄₃₂ in.)
Edinburgh Public Libraries

'The Anatomist' Dr Robert Knox (1791–1862) was one of the strangest characters to pose for the calotypists. Certainly he was the most notorious, and his picture is noticeably absent from Hill's presentation albums. Knox graduated MD from Edinburgh University in 1814, became an army surgeon and was present at the Battle of Waterloo. He eventually returned to Edinburgh where he became a partner in, and subsequently the principal of, a school of anatomy.

He was at the height of his fame as a lecturer when he became involved (1828) in the macabre episode of Burke and Hare. Until the passing of the Anatomy Act (1832) it was very difficult to come by specimens, i.e. corpses, a basic commodity in the practice of anatomy. William Burke, a vagrant, and William Hare, who ran a lodging house, hit on the idea of supplying Knox's requirements, not by the usual practice of bodysnatching from fresh graves but by murder.

When they were caught, Hare turned 'King's evidence' and Burke was hanged. The case caused a great scandal, a good deal of which rubbed off on Knox, who did not defend himself against John Wilson's (see p. 143) attacks in *Blackwood's Magazine*, the implication being that he knew the source of his cadavers. His decline dates from this time, though he made a brief comeback as a lecturer in the mid-1840s. Among other ventures, he tried, unsuccessfully, to be a showman to a tribe of Ojibway Indians (see Jones, p. 81). In the end he died destitute in London.

The calotype itself is interesting for several reasons. There appears to have been a thread, erased from the negative, supporting Knox's outstretched arm. The angle to camera may be explained by Knox being blind in the left eye due to smallpox. His name is written on his collar on the negative.

John Henning as Edie Ochiltree

208 × 154 mm. ($8\frac{3}{16}$ × $6\frac{1}{16}$ in.)
Scottish National Portrait Gallery

Scott's description of the 'Blue-Gown' or 'gaberlunzie', Edie Ochiltree, a central character in his novel *The Antiquary* reads, 'He had the exterior appearance of a mendicant. A slouched hat of huge dimensions; a long white beard, which mingled with his grizzled hair, an aged, but strongly marked countenance, hardened by climate and exposure to a right brick-dust complexion: a long blue gown, with a pewter badge on the right arm; two or three wallets or bags slung across his shoulder, for holding the different kinds of meal when he received his charity in kind from those who were but a degree richer than himself – all these marked at once a beggar by profession and one of that privileged class which are called in Scotland the King's Bedesmen, or, vulgarly, Blue-Gowns.'

Scott based the character on two gaberlunzies in the Borders and Edinburgh. The Blue-Gowns, who took a pride in their status, were a superior race of beggars with certain rights and privileges. That Henning should pose as a character from Scott demonstrates how strongly Scott's influence was felt in Edinburgh at the time. Numerous calotypes show such influence. With this influence a circle is completed. Scott drew from life but shaped it for his fiction. In turn, the fictitious characters influenced the style of life in Scotland itself.

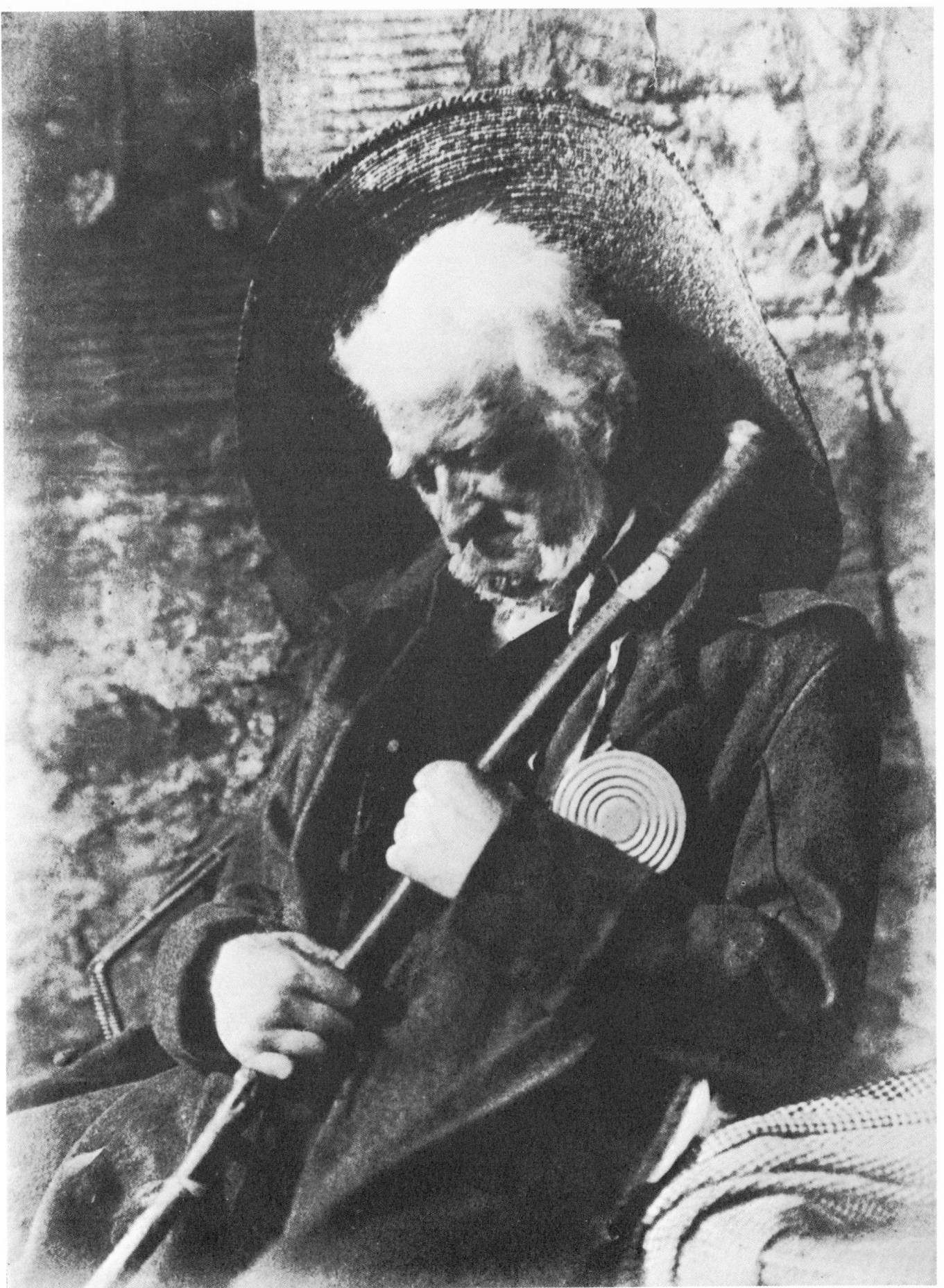

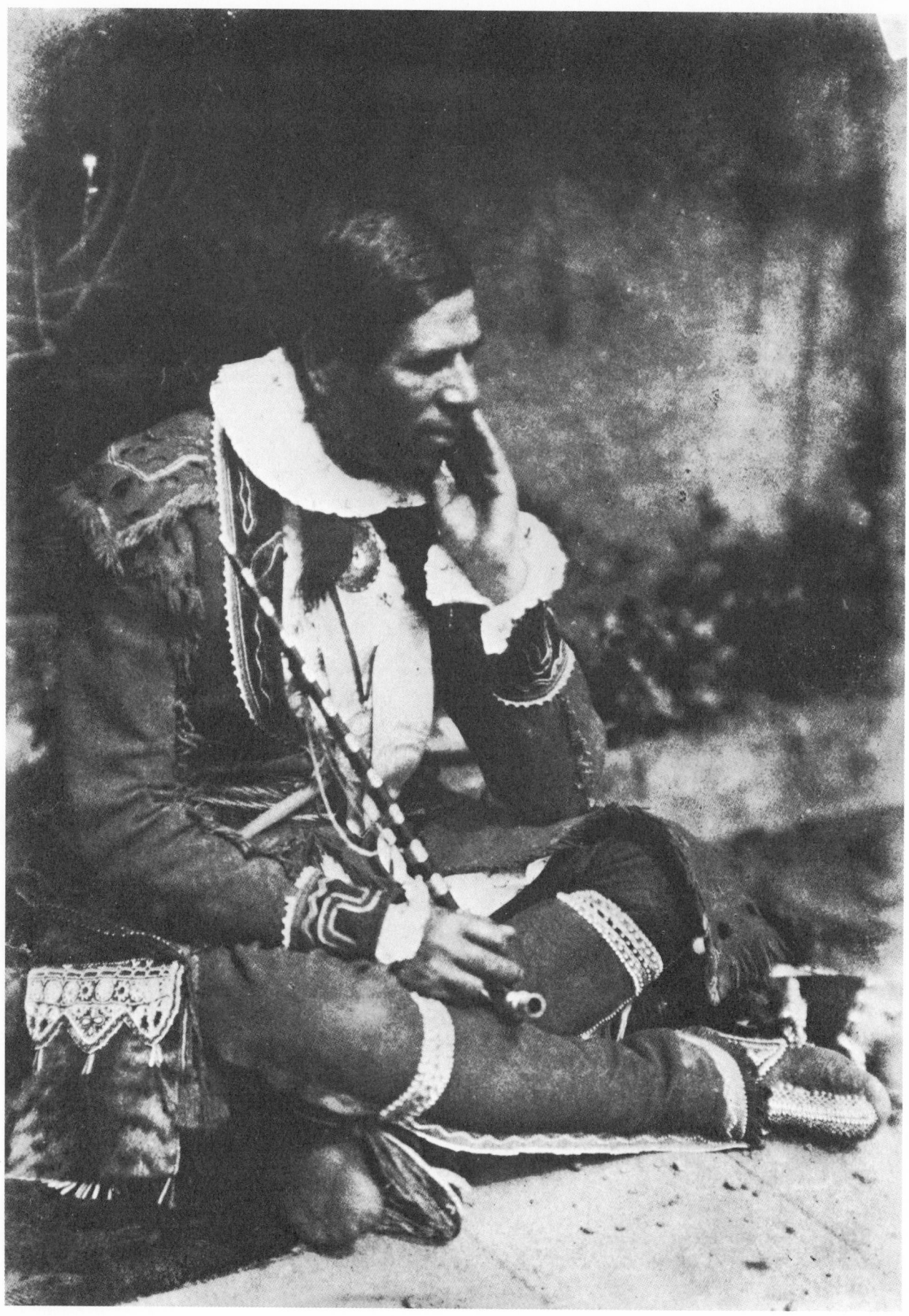

Rev. Mr Peter Jones (Kahkewaquonaby)

198 × 142 mm. (7$\frac{25}{32}$ × 5$\frac{19}{32}$ in.)
Scottish National Portrait Gallery

Who was the gentleman in Red Indian costume? The mystery of his identity has caused much puzzlement and some amusement.

Peter Jones was born in 1802 at Burlington Heights, near Hamilton, Upper Canada. According to the *Macmillan Dictionary of Canadian Biography* he was the son of Augustus Jones, a surveyor (of Welsh descent), and of an Ojibway Indian woman. He was brought up with his mother's tribe, was converted to Christianity, became a minister of the Wesleyan Methodist Church and spent most of the remainder of his life as a missionary to his own people into whose language he translated two of the Gospels, a hymnary and a spelling book.

He was the author of a history of the Ojibway People and his own *Life and Journals of the Rev. Peter Jones* was published posthumously in 1860. He visited Britain on at least three occasions to further the cause of his people and to protest at the white man's inroads into the traditional lands of his tribe. In this connection his writing has a content and flavour which still seem remarkably relevant. He died at Brantford, Upper Canada, on 29 June 1856. (see also p. 120).

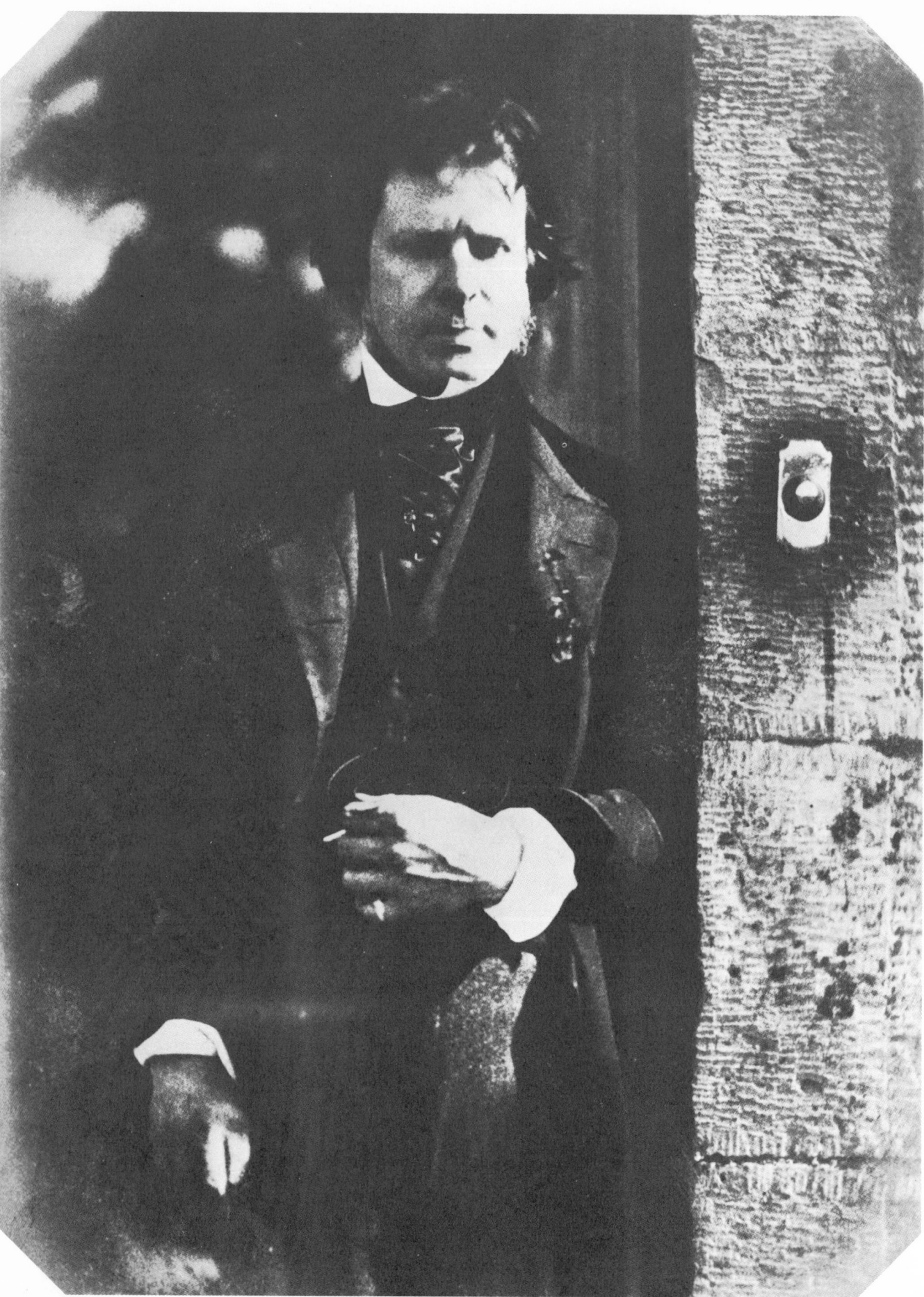

82

D. O. Hill at the Door of Rock House

188 × 138 mm. ($7\frac{13}{32}$ × $5\frac{7}{16}$ in.)
Scottish National Portrait Gallery

Rock House rarely appears in the calotypes, except as a familiar background to portrait and group shots but the house itself is worth more than a passing reference. It stands on the side of the Calton Hill near to the East End of Princes Street. It was built in the period 1770–80 and consists of two storeys and attics. Hill occupied it, at first in partnership with Adamson, from 1843–64, as his house and studio.

Its elevated position and central location in Edinburgh must have made it an ideal base for the calotypists both in terms of access for their visitors and by virtue of its setting. On the south-west side, where the 'daylight studio' was situated, it had potentially uninterrupted sunlight from early morning to late afternoon.

83

Patrick Byrne

205 × 156 mm. $(8\frac{1}{16} \times 6\frac{5}{32}$ in.)
Scottish National Portrait Gallery

Patrick Byrne (*c.* 1784–1863) was a well-known blind musician who visited
Edinburgh in 1843–4. He was the product of a strange musical academy founded
in Belfast in 1807 for the purpose of teaching the harp to blind youngsters. The
pupils were eventually each equipped with a new harp bearing the title of the
sponsoring organization, the Belfast Harp Society.

Byrne's prowess delighted Kohl, the German traveller, when he played for him
at a house in Drogheda in 1843. It must have been soon after that that Byrne
set out for Scotland.

The garb in which Byrne appears for this calotype was not a regular costume.
The probable explanation of the apparel is that Hill wished to photograph him
as an Ossianic bard. Certainly Hill had already painted such characters and there
are particular instances in *The Land of Burns*.

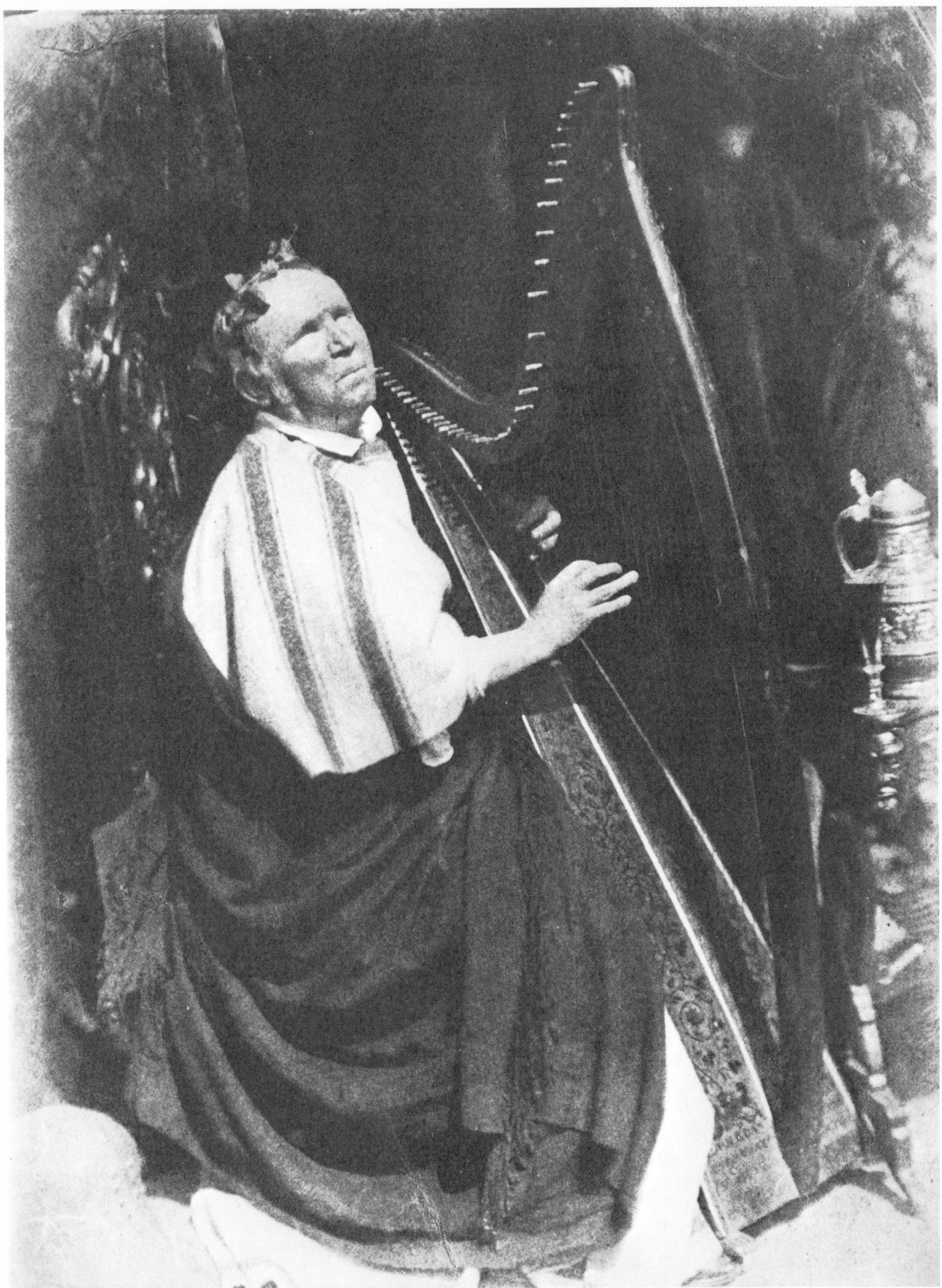

Mrs Jameson

207×156 mm. ($8\frac{5}{32} \times 6\frac{5}{32}$ in.)
Scottish National Portrait Gallery

Anna Brownell Jameson was an art critic and a formidable character. She was born in Dublin in 1794. In 1825 she married a barrister but the marriage was not a success and a separation took place almost at once. He subsequently became Speaker of the House of Assembly in Upper Canada, where she visited him. *Winter Strides and Summer Rambles in Canada* was the literary outcome of the expedition.

She was a regular visitor to Edinburgh and was a friend of Miss Rigby (Lady Eastlake), Hill's and Adamson's most frequent sitter. Her most admired writings were *Sacred and Legendary Art* (1848) and *Legends of the Madonna* (1852).

Appropriately enough, when the sitter is an art historian, the calotype has given rise to comment on its painterly allusions, particularly with reference to Rembrandt. Whatever influences governed the pose and lighting, the picture gives a powerful expression of personality.

86

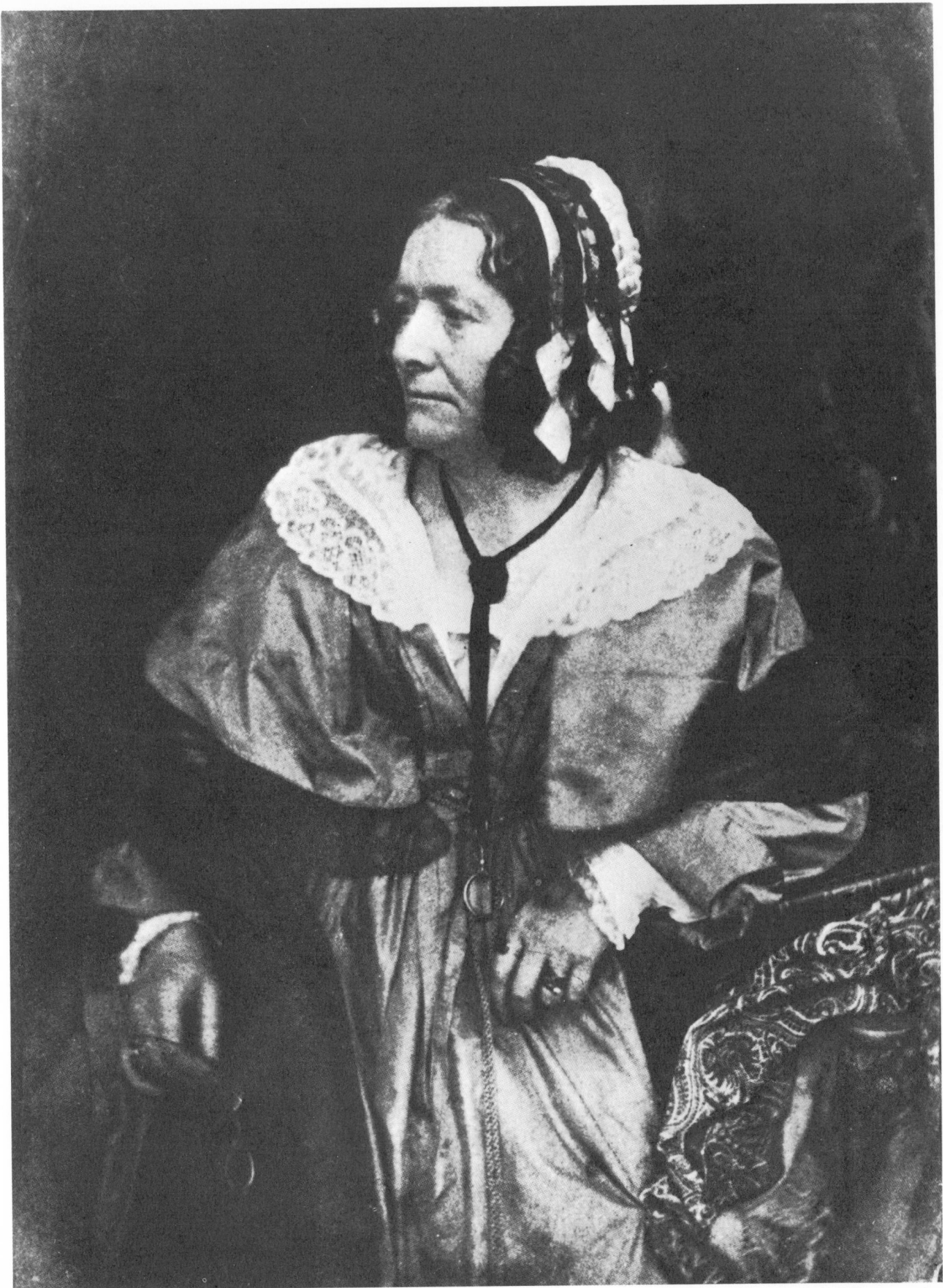

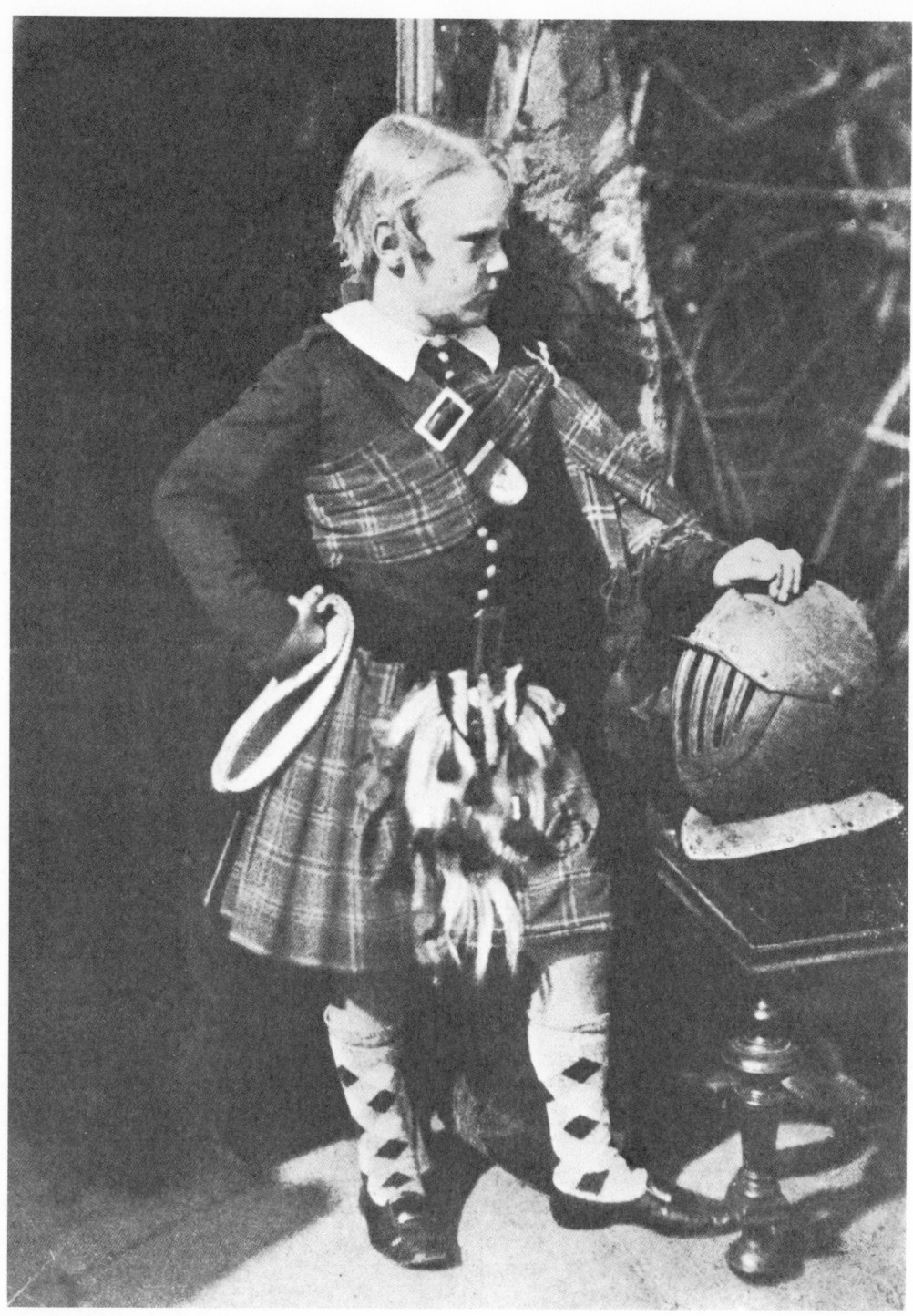

Master Miller

196 × 142 mm. (7$\frac{23}{32}$ × 5$\frac{19}{32}$ in.)
Scottish National Portrait Gallery

James Miller was the son of a professor at Edinburgh University. He is noteworthy as being one of the children to appear in the Disruption Painting. This calotype is one of four, showing the boy in various poses. Hill entitled one of them 'A Young Savage'.

The picture owes a great deal to Scott's romantic influence, *vide* the presence of the mediaeval helm. It bears little relation to our view of childhood today.

'His Faither's Breeks'

199 × 148 mm. (7 $\frac{27}{32}$ × 5 $\frac{13}{16}$ in.)
Scottish National Portrait Gallery

In at least one album Hill juxtaposed this calotype with the picture of Master James Miller in full Highland regalia. Whether this was meant as some sort of social comment is not known but the two pictures serve to illustrate the wide social spectrum which the calotypists covered in their search for subjects.

The 'props' in this particular shot are familiar; the boat and the basket containing the fishing line appear in many of the Newhaven pictures. The chair, however, appears to serve a purpose which is less artistic than practical; that is to say, it looks very much as if it is being used for the boy to lean on, to keep him still.

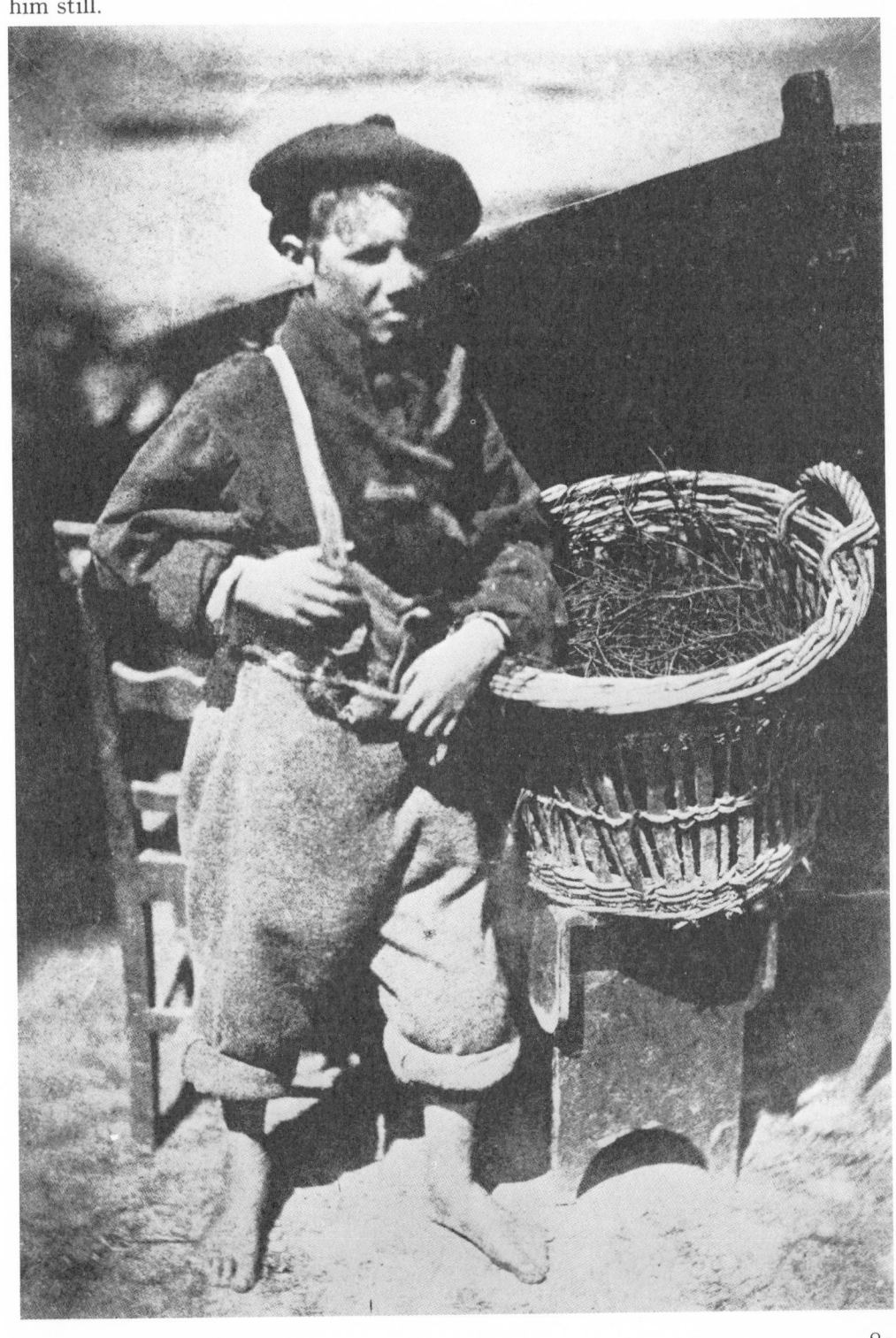

Colinton Woods

213×153 mm. $(8\frac{3}{8} \times 6\frac{1}{32}$ in.)
Scottish National Portrait Gallery

Whether described as 'landscape' or 'study' this calotype is surprising for two reasons. First, it bears little relation to any of Hill's landscape painting before the calotypes (a reasonable expectation) and second, it is 'modern' in the sense that its play of light and shade in the trees and use of soft focus presents us with an effect of the sort that today's photographers attempt but seldom capture as effectively.

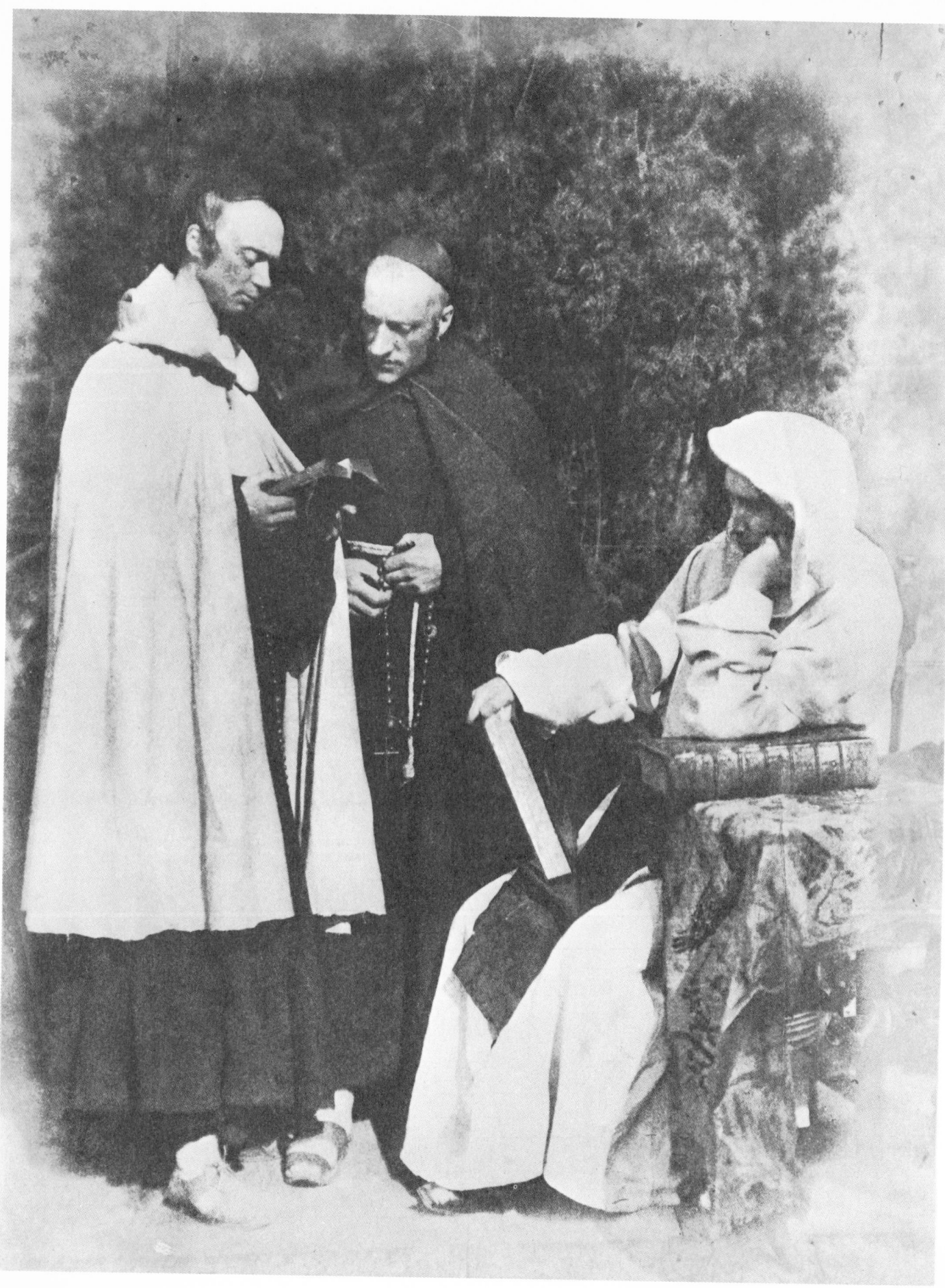

92

'Three Monks'

Borthwick Johnstone, Leighton Leitch and David Scott

293 × 223 mm. ($11\frac{17}{32} \times 8\frac{25}{32}$ in.)
Scottish National Portrait Gallery

These three 'monks' were, in fact, three of Hill's brother artists. William Borthwick Johnstone (1804–68) who appears with Hill himself in at least one calotype, was Treasurer of the Royal Scottish Academy and from 1858 the first Director of the Scottish National Gallery. William Leighton Leitch (1804–83) was a Glasgow landscape painter whose main distinction is that he was employed by the Royal Family to teach drawing to Queen Victoria's children at Osborne.

David Scott, RSA (1806–49) was regarded by some of his contemporaries as Scotland's finest painter. He had a predilection for biblical and historical painting usually on a grand scale, including subjects such as *The Kiss of Judas* and *Vasco da Gama Encountering the Spirit of the Storm*.

Elizabeth Johnstone, of Newhaven

198 × 145 mm. $(7\frac{25}{32} \times 5\frac{23}{32}$ in.)
Scottish National Portrait Gallery

Elizabeth Johnstone was known as a Newhaven beauty, which self-evidently she was. Her beauty, however, cannot disguise the hard nature of her work, which, as her hands testify, was concerned with the business of gutting fish and portering them, in a heavy creel on her back, up the hill from the shores of the Firth of Forth to sell in the streets of Edinburgh.

One of the most famous of the calotypes, it illustrates well the reasons for which Hill's and Adamson's work was readily accepted as comparable to the best painting of the day. One critic declared that given the choice of a Rembrandt or a calotype he would choose the latter.

94

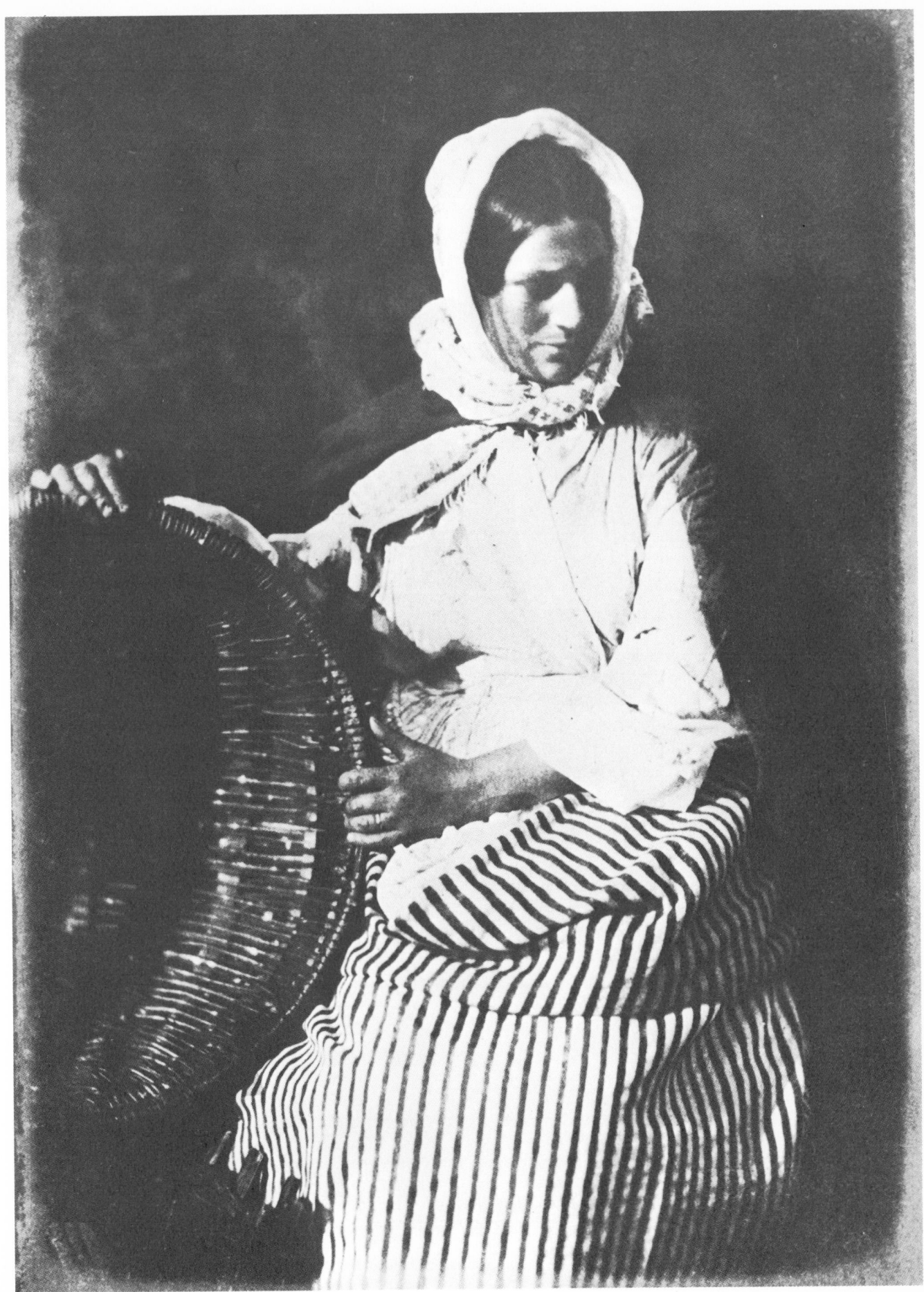

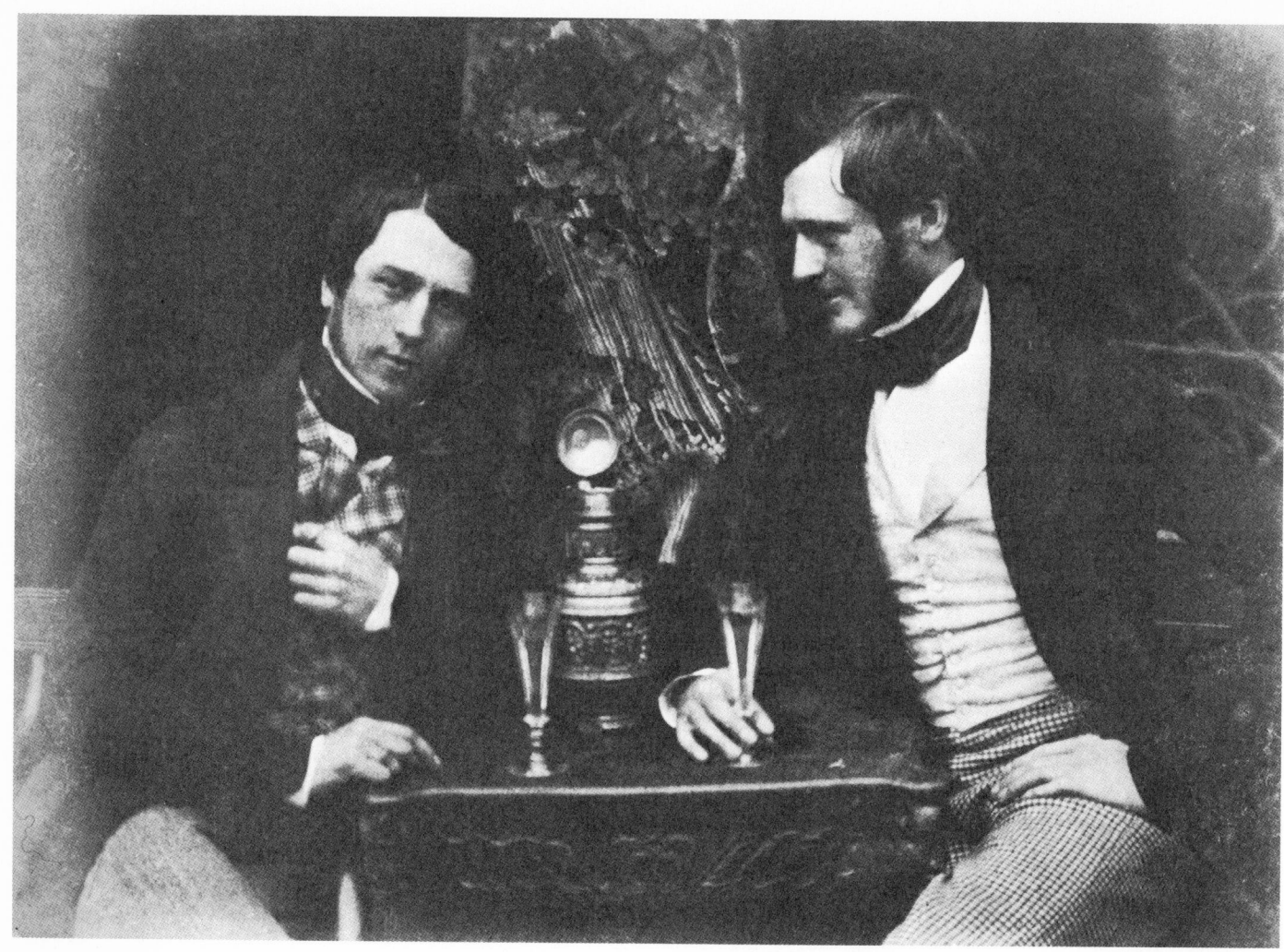

Two Gentlemen

141 × 200 mm. (5 $\frac{9}{16}$ × 7 $\frac{7}{8}$ in.)
Scottish National Portrait Gallery

This is an admirable calotype of two gentlemen in conversation over wine. The one on the right is thought to be a Mr Wainwright; the one on the left was reputedly Sir James Young Simpson but according to evidence from his family this now seems unlikely to be the case.

'The Morning After' (*opposite*)

198 × 146 mm. (7 $\frac{25}{32}$ × 5 $\frac{3}{4}$ in.)
Scottish National Portrait Gallery

Sometimes known as 'He greatly daring dined', this calotype was probably made for amusement's sake. The participants are Hill and Professor Miller, observed by the monumental bust, *The Last Roman*. The placing of Hill's left hand is particularly nicely done to cast its shadow on the large plain area of the plinth to the sculpture.

There is a certain irony that Hill should be photographed feigning illness, when in truth his health was not good.

96

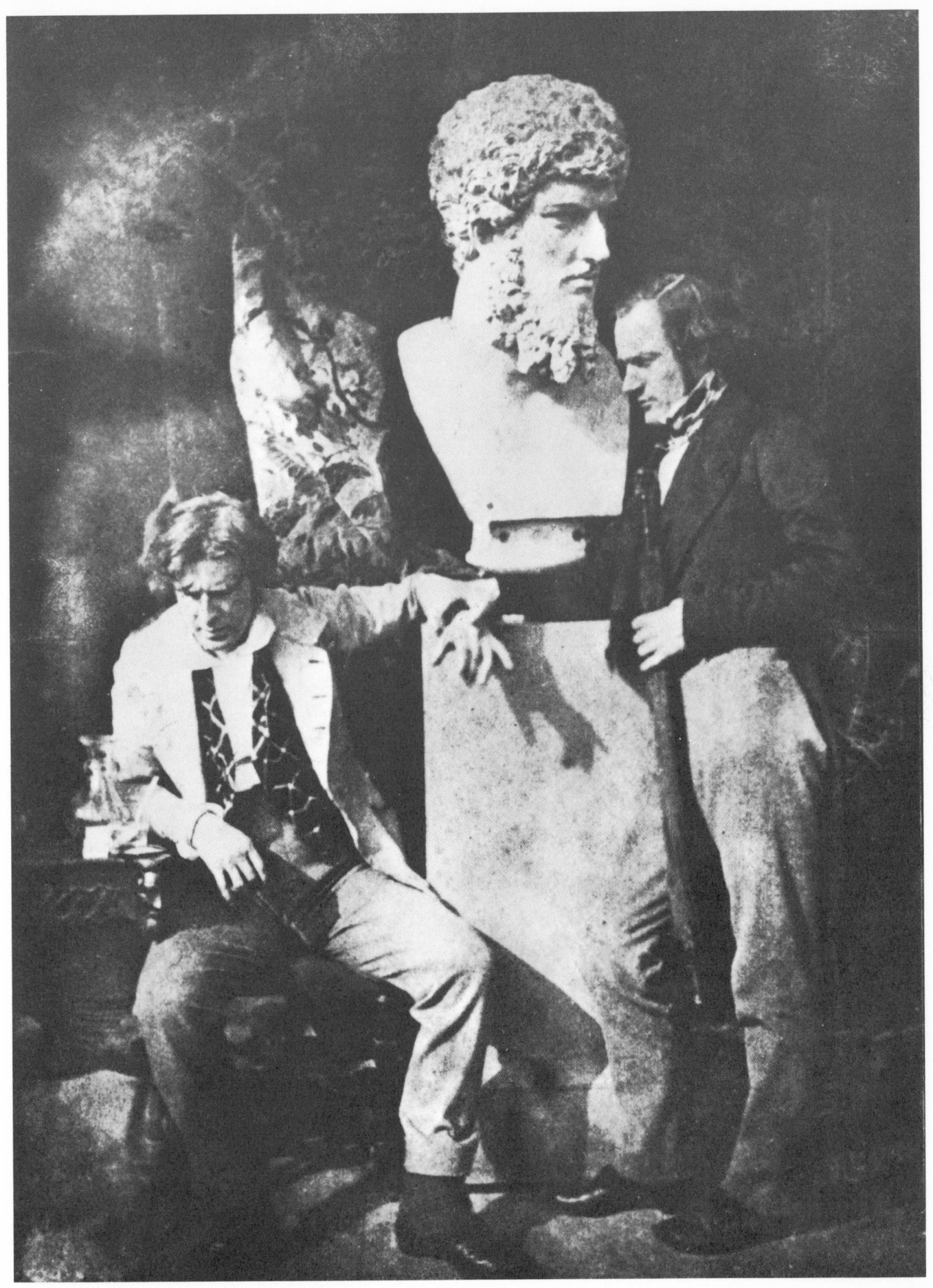

G

The Misses Grierson

198 × 144 mm. ($7\frac{25}{32} \times 5\frac{21}{32}$ in.)
Scottish National Portrait Gallery

The children are probably daughters of the Rev. Mr Grierson of Errol in Angus.
The calotype is one of the most delightful of the Hill/Adamson studies of
childhood.

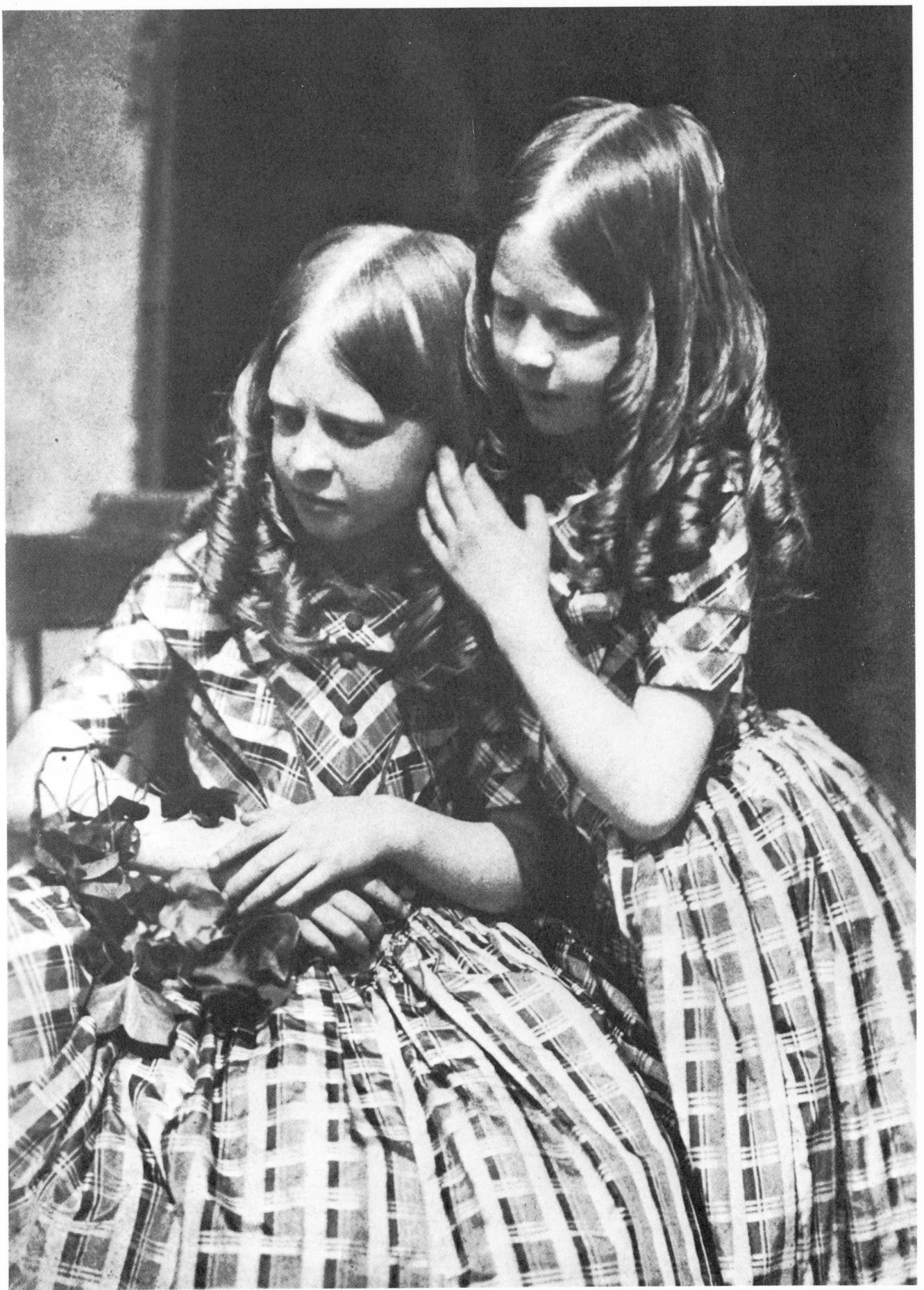

Edinburgh Castle

150 × 199 mm. ($5\frac{29}{32} \times 7\frac{27}{32}$ in.)
Scottish National Portrait Gallery

The 92nd (Gordon Highlanders) arrived in Edinburgh in July 1845 and were stationed at the Castle for about a year. They moved to Ireland in August 1846.

It is in the 'sequence' of pictures of the Gordons at Edinburgh Castle that we become most aware of Hill's skill as a director in dealing with large numbers of people. His role may have been something like that of a film director and the cinematic analogy may also hold good in terms of his relationship with his cameraman, Adamson. Adamson's role is thereby allowed to be creative and lifts him from the position of being simply a mechanic.

The disposition of forces in this picture makes it one of the most skilfully executed of all the calotypes. The spatial relationship of the foreground figures, both among themselves, and in relation to the group on the rampart, is such that the eye is drawn in and swung right to the cannon in a single movement. More important is the sensation, which recurs many times in the Hill/Adamson calotypes, that there is another scene, another actuality, *outside* the frame and our field of vision. In this case the soldiers are merely play-acting but the world beyond the wall is real.

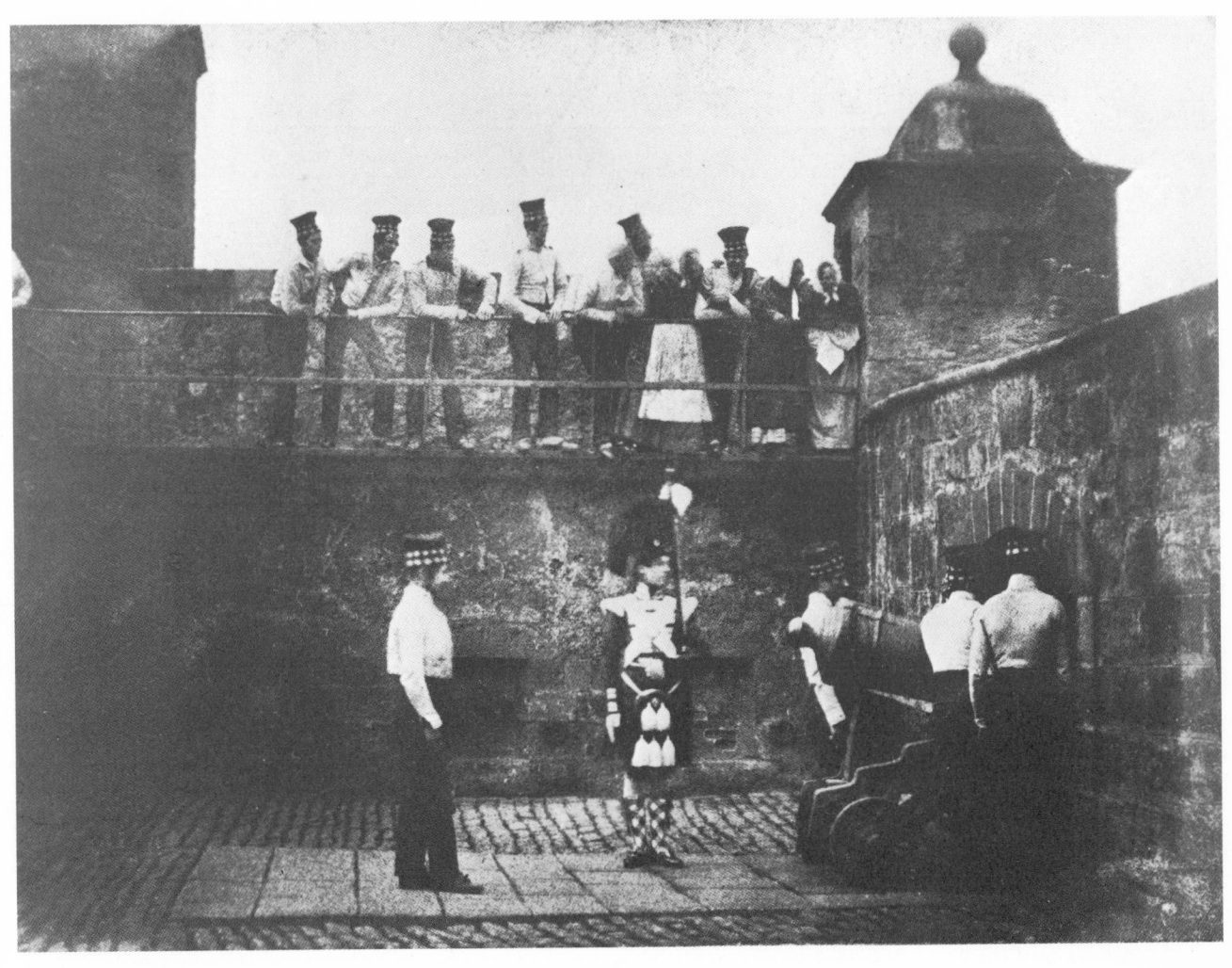

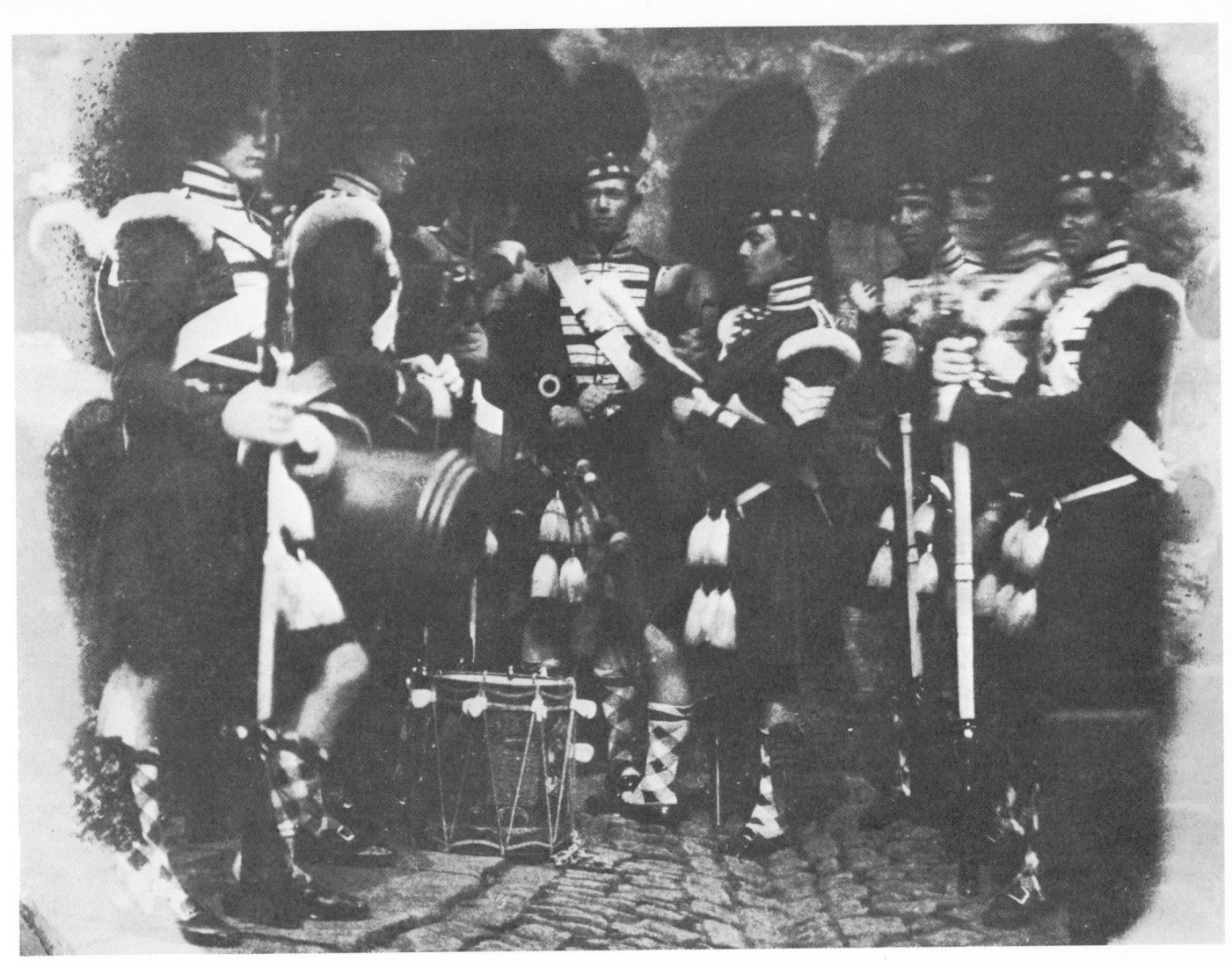

'Orders of the Day'

146 × 199 mm. (5¾ × 7 27⁄32 in.)
Scottish National Portrait Gallery

The 92nd Gordon Highlanders were stationed at Edinburgh Castle in 1845–6. As romantic subject-matter in the post-Scott period they were ideal but the reality was rather stark for it was soldiers like these who were to die in the Crimea ten years later.

John Henning at the Cottage, Bonaly (*opposite*)

207 × 153 mm. (8 5⁄32 × 6 1⁄32 in.)
Scottish National Portrait Gallery

John Henning here again personifies Edie Ochiltree, the character from Scott's *The Antiquary* but in this context his presence may be more to do with providing 'human interest' than making an illustrative point (see also pp. 78 and 109).

Dr Wilson as an Arab

286 × 207 mm. ($11\frac{1}{4}$ × $8\frac{5}{32}$ in.)
Scottish National Portrait Gallery

The Rev. Dr Wilson, FRS (1804–75) was stationed at Bombay where he had gone as a missionary in 1828. He is described, in an early edition of *Chambers's Biographical Dictionary*, as 'An active promoter of education, legal reform, toleration, and philanthropic movements of every kind'. In 1843 he joined the Free Church and continued his ministry under its auspices until his death.

 As vice chancellor of Bombay University it is strange to find him garbed as an Arab.

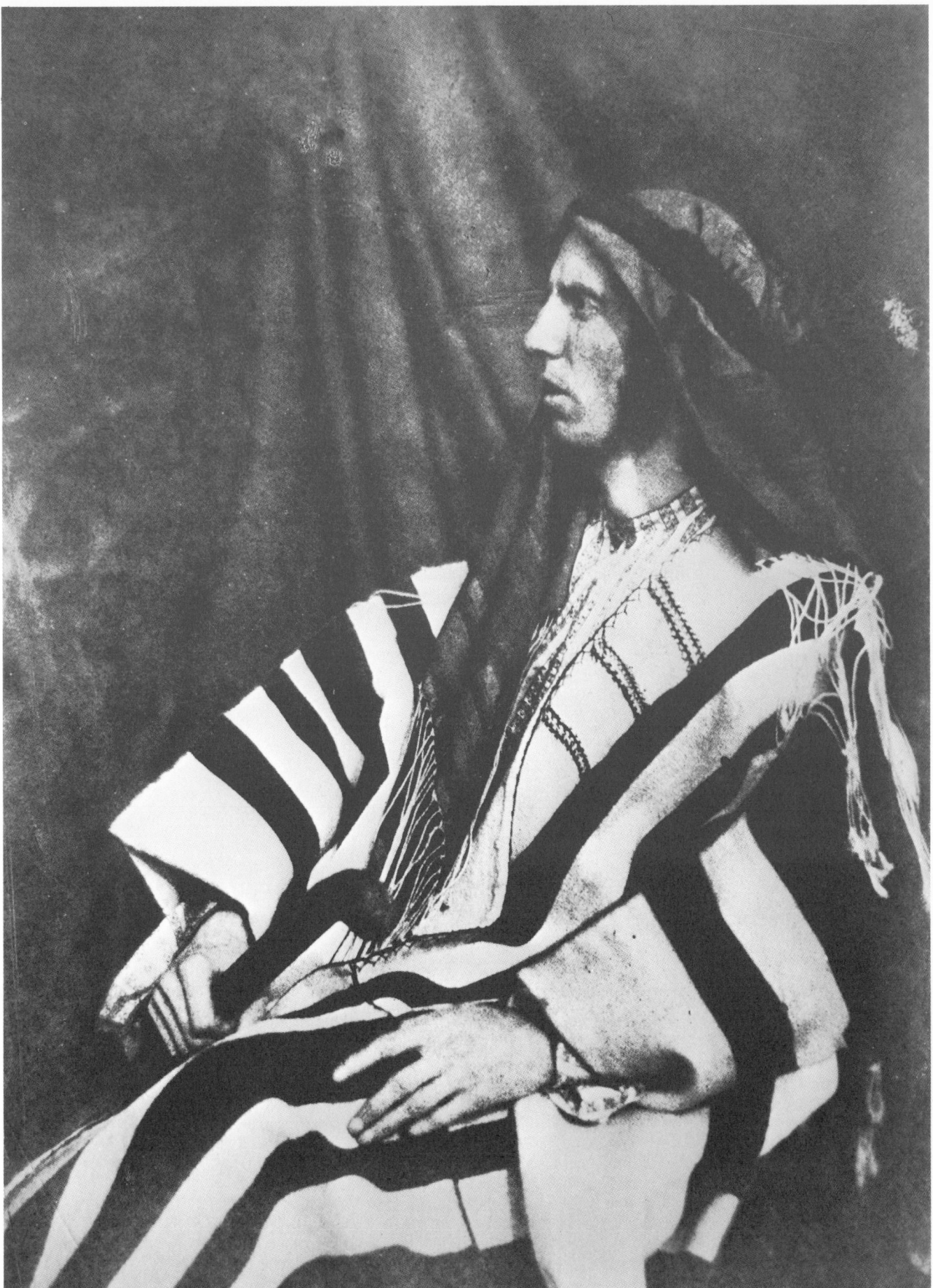

John Steell

188 × 139 mm. ($7\frac{13}{32}$ × $5\frac{15}{32}$ in.)
Scottish National Portrait Gallery

John Steell, sculptor, was born in Aberdeen in 1804. His education and training
were received in Edinburgh and Rome. Thereafter most of his work was
completed in Edinburgh. His most celebrated pieces are an equestrian statue of
the Duke of Wellington (at the East End of Princes Street) and a statue of Prince
Albert for which he was knighted in 1876.

His connection with the calotypists was through his work on the statue of
Sir Walter Scott, which now sits at the base of the monument. Hill and
Adamson photographed it while it was still in Steell's studio. The statue is in
Carrara marble, double life-size, and was widely acclaimed for its excellence and
its fidelity to Scott's appearance. Steell was subsequently commissioned to
produce a replica for exhibition in New York.

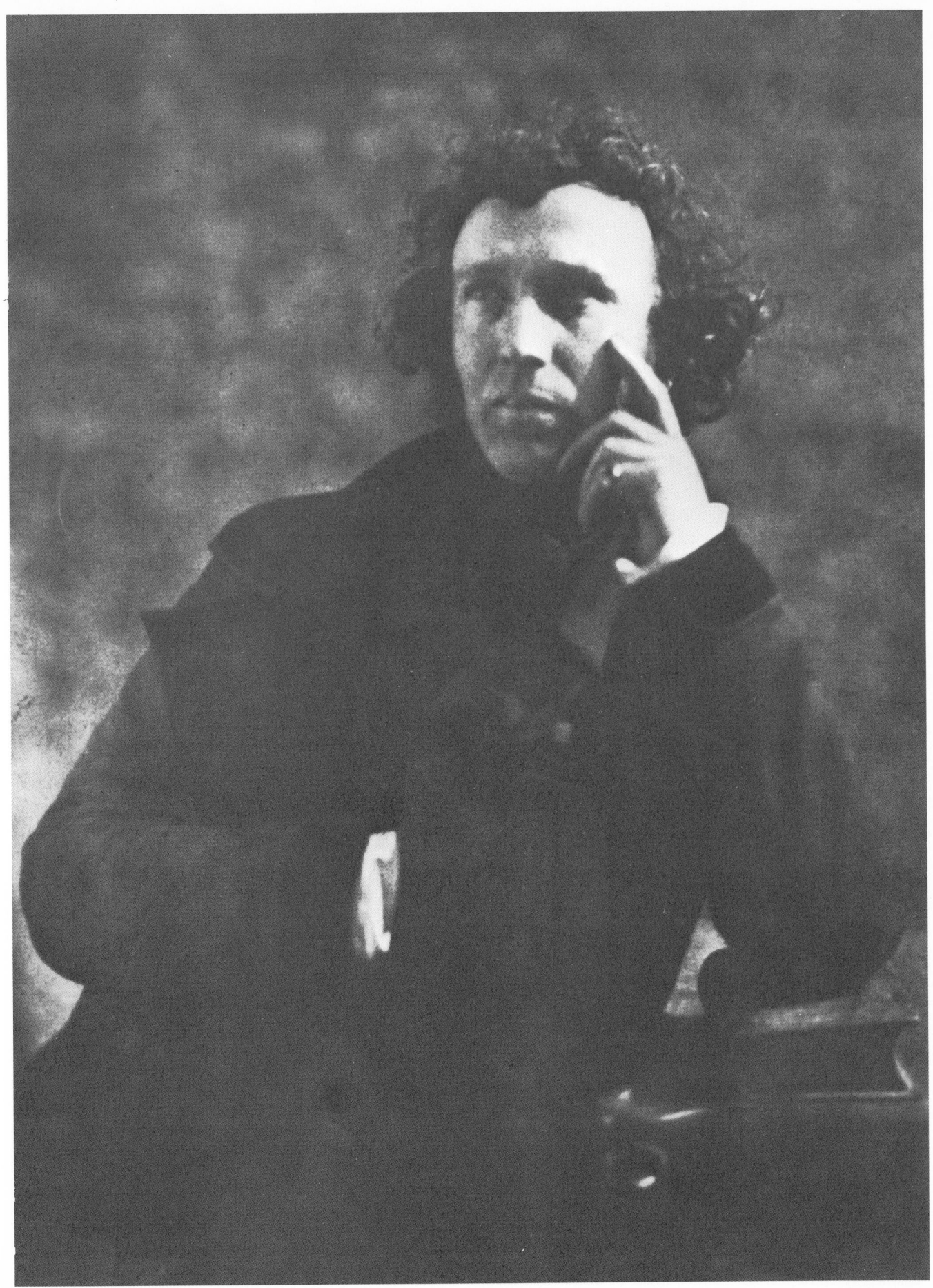

Masons at the Scott Monument

145 × 199 mm. (5 23/32 × 7 27/32 in.)
Scottish National Portrait Gallery

The Scott Monument, 200 feet high, is an elaborate edifice. It is encrusted with a
variety of decoration including sixty-four statuettes of characters from Scott's
novels and the sort of gothic ornamentation that is in keeping with the style of
the author to whom it is dedicated. Its construction took many years and
continued long after the official opening in 1846. The statuettes were not all in
place until 1882.

The group of masons above has been skilfully arranged by Hill to convey a
sense of business that brings the picture as near to reportage as the long exposure
would allow.

John Henning and Mrs Cleghorn (*opposite*)

212 × 159 mm. (8 11/32 × 6 1/4 in.)
Scottish National Portrait Gallery

This calotype is another instance of Hill's illustrative interests. The novel is
Scott's *The Antiquary*. The allusion is to a particular point in the story (Chapter
Twelve) where the 'Blue-Gown' converses at length through the pantry window.
He will not enter the house as his feet were 'never yet' on a carpet.

The young lady playing 'Miss Wardour' in the *tableau vivant*, is one of Lord
Cockburn's daughters Mrs Cleghorn, who, by all accounts, led a happy but rather
uneventful life.

108

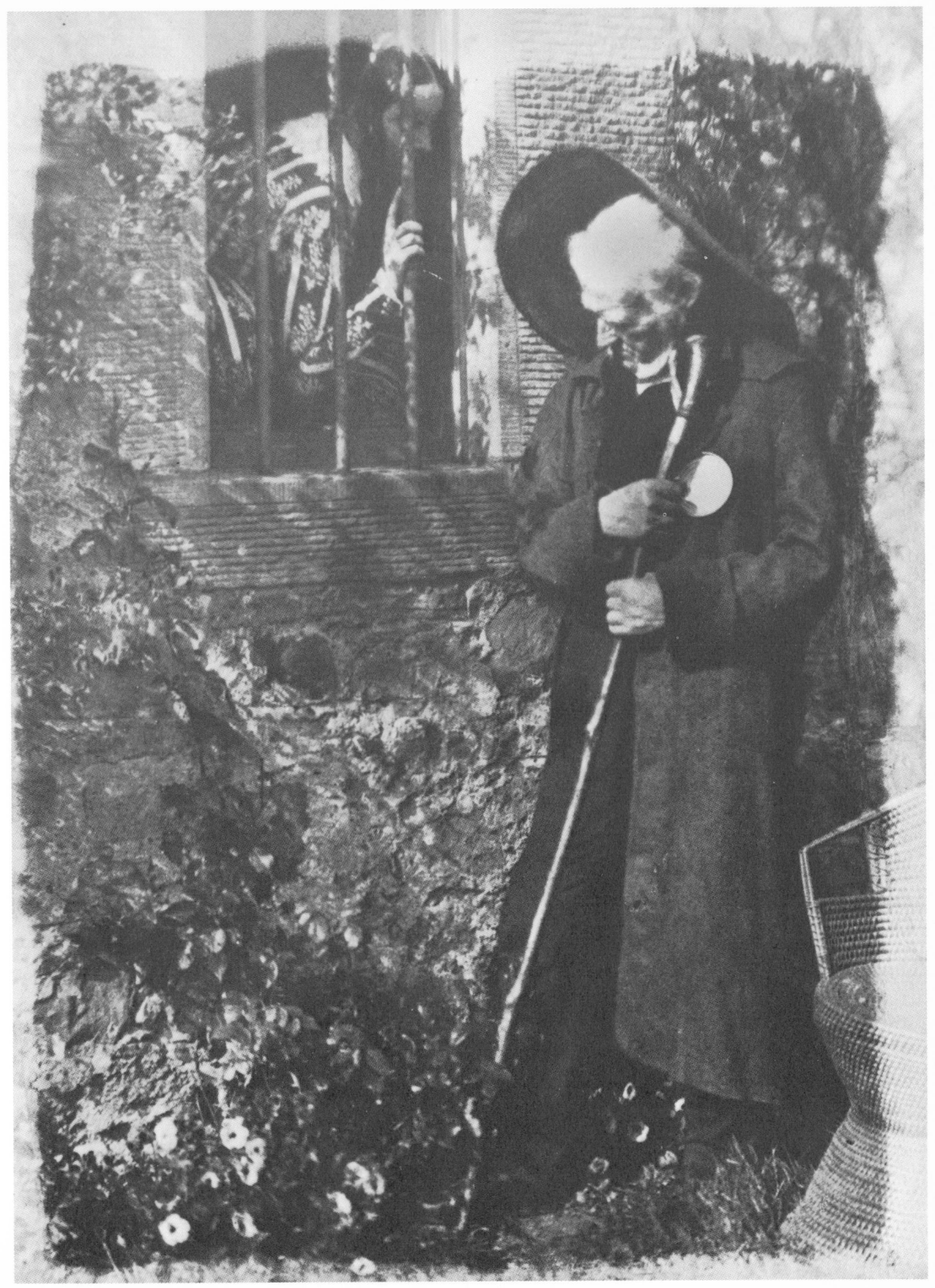

McCulloch's Tomb, Greyfriars

209 × 161 mm. ($8\frac{7}{32}$ × $6\frac{3}{8}$ in.)
Scottish National Portrait Gallery

Greyfriars Churchyard had a particular fascination for the calotypists. It has
even been suggested, a little unkindly, that the attraction of the subject was due
to a streak of morbidity, not just in them but in Edinburgh Society as a whole,
for there were numerous pictures made in this and similar locations. In the
calotypists' defence, however, it should be pointed out that such subject matter
was common in painting of the time and that the preoccupation with death was
to become even more marked in later Victorian photography (*cf. Fading Away*
by Henry Peach Robinson).

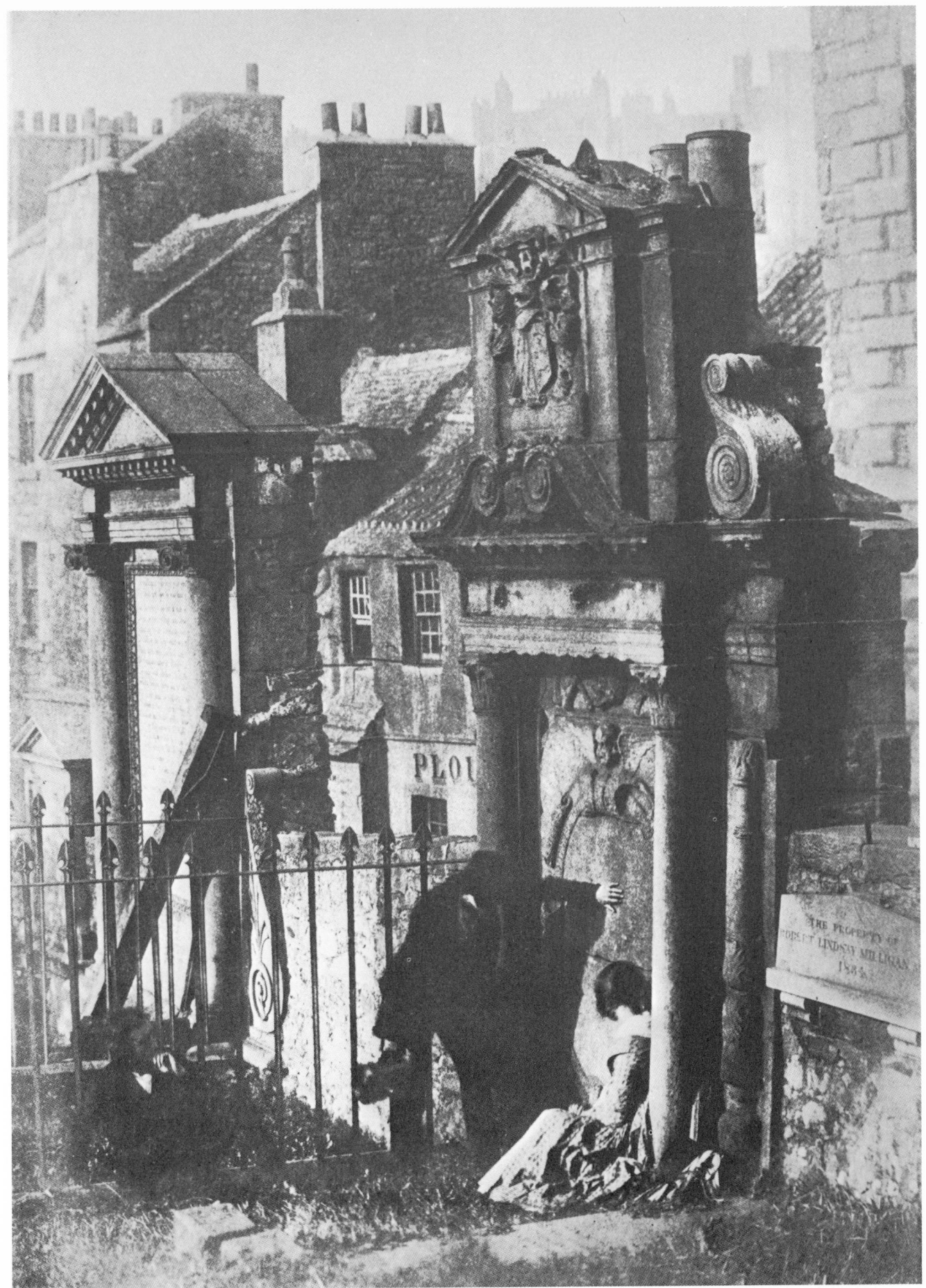

III

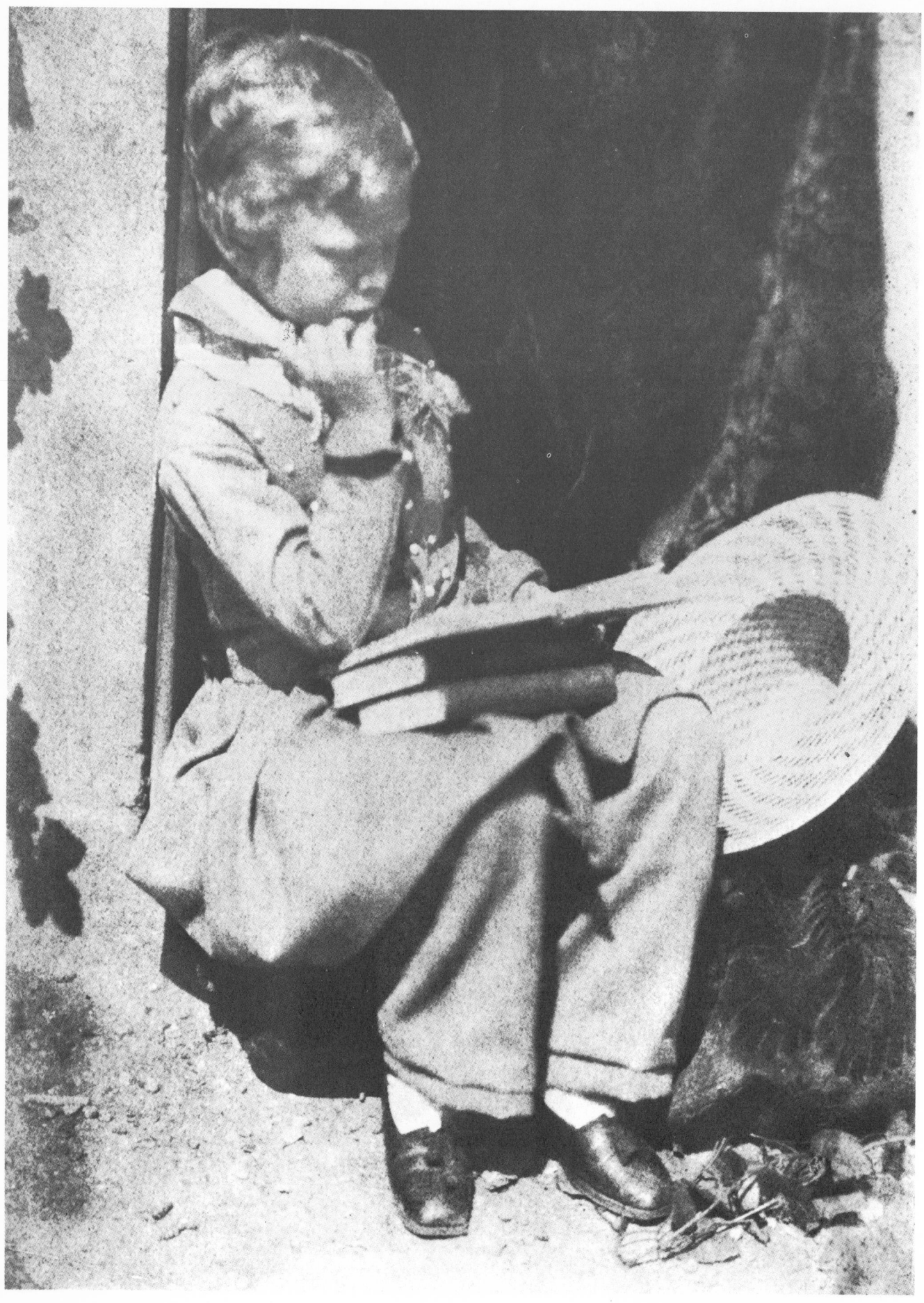

'Burnside'

139 × 199 mm. (5$\frac{15}{32}$ × 7$\frac{27}{32}$ in.)
Scottish National Portrait Gallery

The name 'Burnside' has probably a double meaning, in this context. Not only does it convey the content of the picture, i.e. beside the stream, but also, in all likelihood, the location of the shot. 'Burnside' was the home in Fife of Robert Adamson's family.

Bearing in mind the limitation of the calotype system in terms of accurate representation of detail, in which the daguerreotype was superior, there is some surprisingly good detail in the picture. The day must have been especially still, or the spot remarkably sheltered, as any discernible movement of foliage or water would have spoiled the shot.

This is one of the pictures which disprove the widely held idea that there were no Hill/Adamson calotypes dealing purely with landscape.

Master Grierson (?) (*opposite*)

192 × 139 mm. (7$\frac{9}{16}$ × 5$\frac{15}{32}$ in.)
Scottish National Portrait Gallery

The identity of the boy on the doorstep is not certain but he is probably the son of the Rev. Dr James Grierson (1791–1875) of Errol in Angus.

Hill and Adamson were not always successful in their attempts at portraiture with children, though there are some charming exceptions. The main problem must have been in trying to persuade a child to stay motionless for the required minute or more, which may explain the slight element of compromise which occasionally is evident in the pictures.

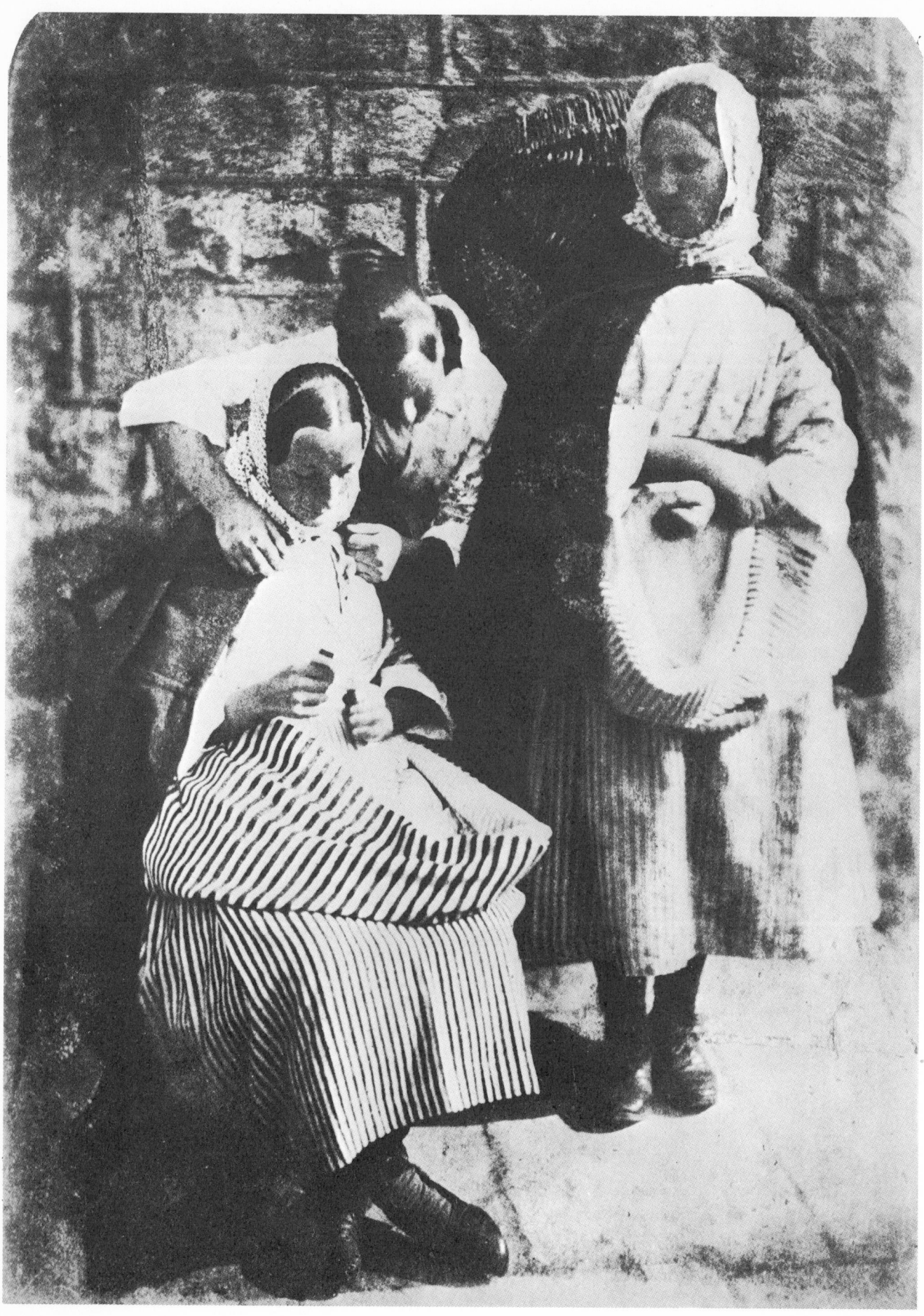

'The Letter'

Newhaven Fisherlassies

191 × 138 mm. $(7\frac{17}{32} \times 5\frac{7}{16}$ in.)
Scottish National Portrait Gallery

One of the best-known of the Hill/Adamson calotypes, it provides evidence of the usual compositional care which owes more to Hill's training as an artist, and his familiarity with contemporary painting, than to any discovery of the potential of a new medium. The effect is certainly very pleasing but it contrives to romanticize the fisherlassies and their extremely hard life in a way which a modern photographer might not dare to do.

The picture, though with a Newhaven subject, was shot at Rock House.

Mrs Isabella Burns Begg

215 × 163 mm. (8$\frac{15}{32}$ × 6$\frac{13}{32}$ in.)
Scottish National Portrait Gallery

Isabella Burns (1771–1856) was the youngest sister of Robert Burns. She married John Begg of Mossgiel who died in 1813 when he was thrown from his horse. Thereafter she moved to East Lothian and only returned to her native Ayrshire late in life.

According to *The Burns Encyclopaedia* she 'supplied various Burns enthusiasts with recollection of her life with her famous brother'. She had six sons and three daughters.

Mrs Begg was well into her seventies when the calotype was made. The strength of her features and her fixed gaze tell us more about Burns and his family than all the conscious artistry with which the portrait of her nephew (p. 118) is imbued.

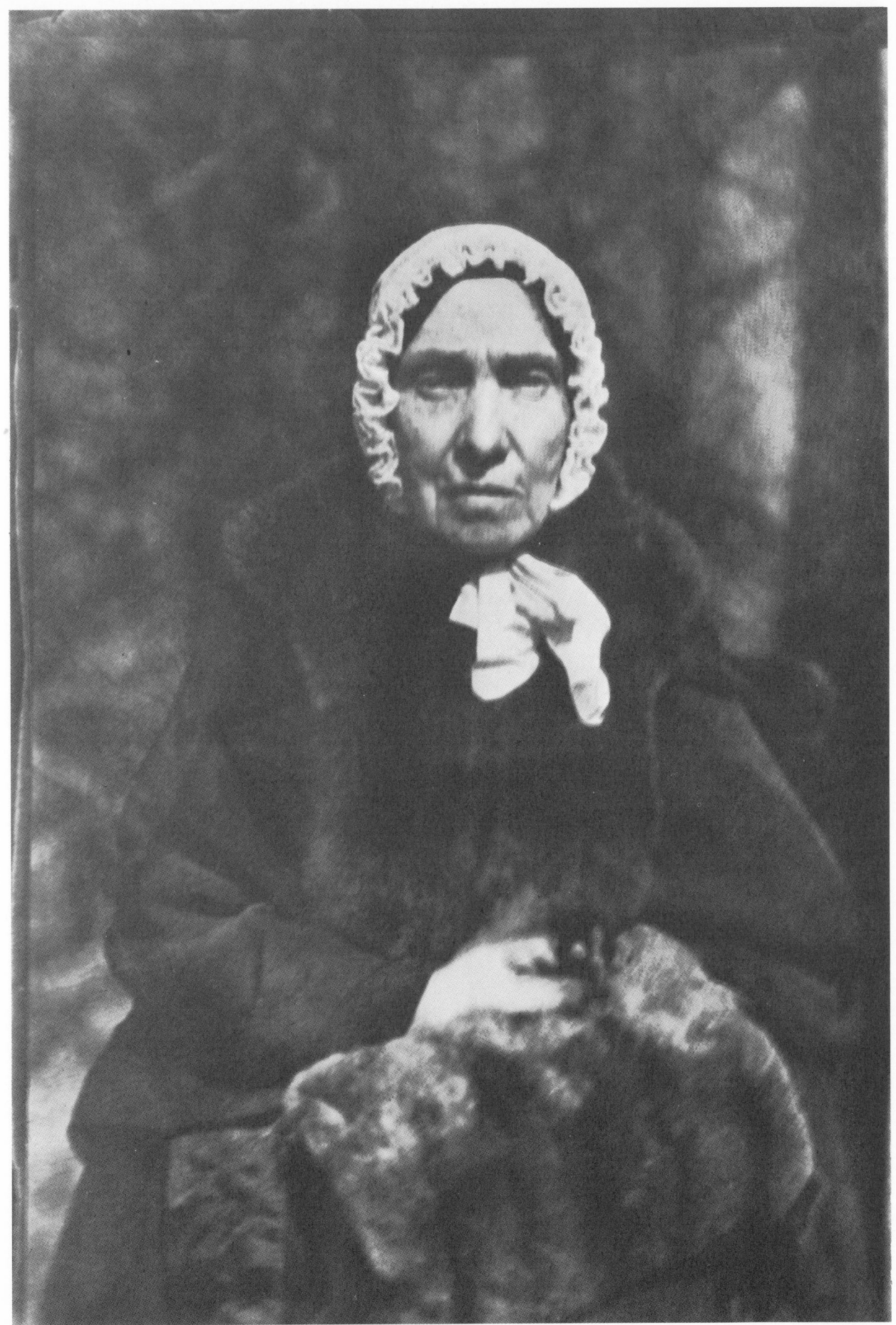

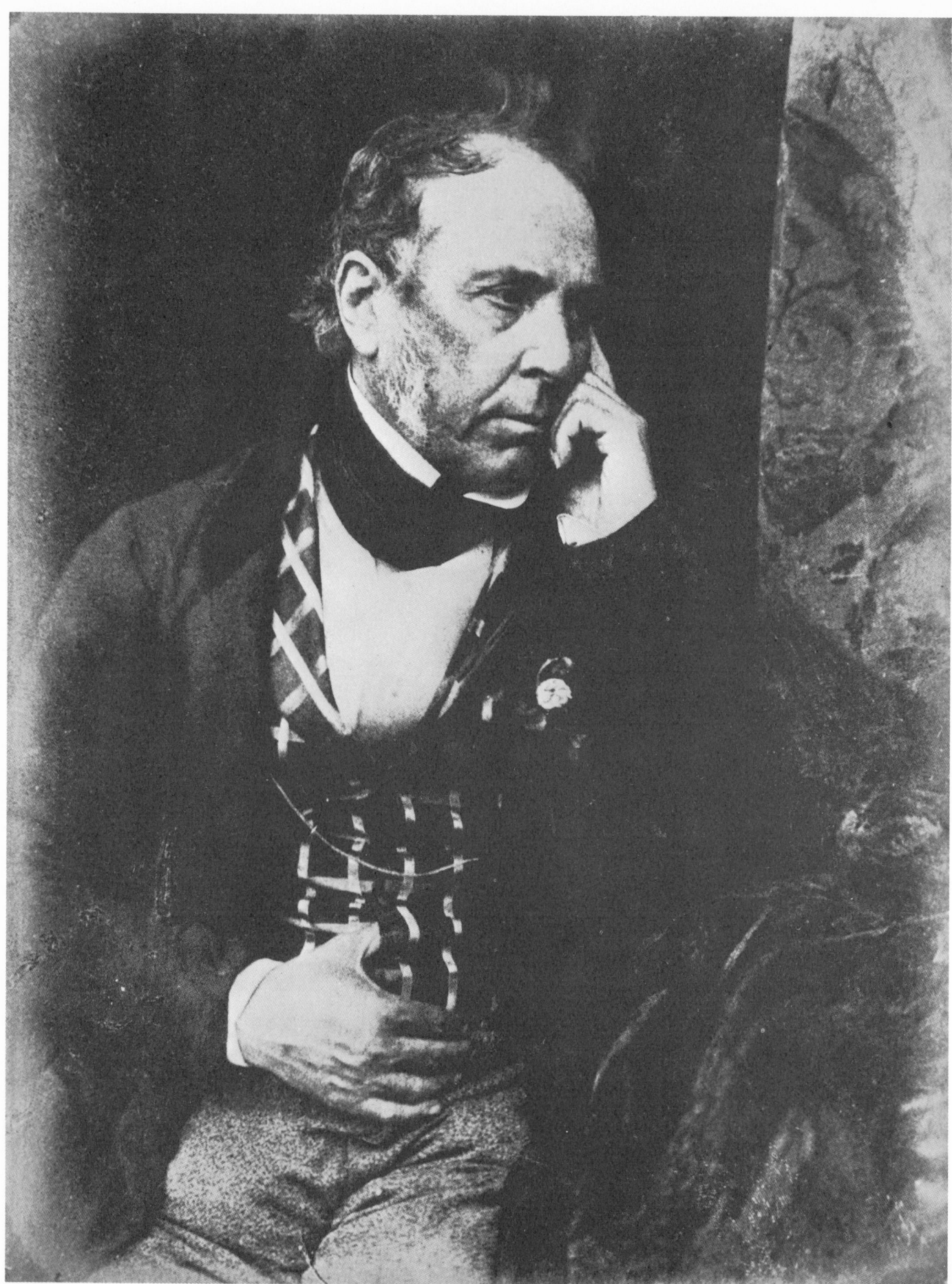

118

Major James Glencairn Burns

198 × 153 mm. ($7\frac{25}{32}$ × $6\frac{1}{32}$ in.)
Scottish National Portrait Gallery

James Glencairn Burns (1794–1865) was the youngest son of the poet Robert Burns (1759–1796). His middle name derives from that of Burns' patron James Cunningham, fourteenth Earl of Glencairn (1749–91) whom Burns described as 'the man to whom I owe all that I am and have'.

Major Burns (he was later promoted Lieutenant-Colonel) had probably just returned from India in August 1844, when Hill met him. The calotype presumably dates from this period. It may be a deliberate attempt to make the soldier look as much like his father as possible. In this it is in striking contrast to that of the subject's aunt (preceding photograph).

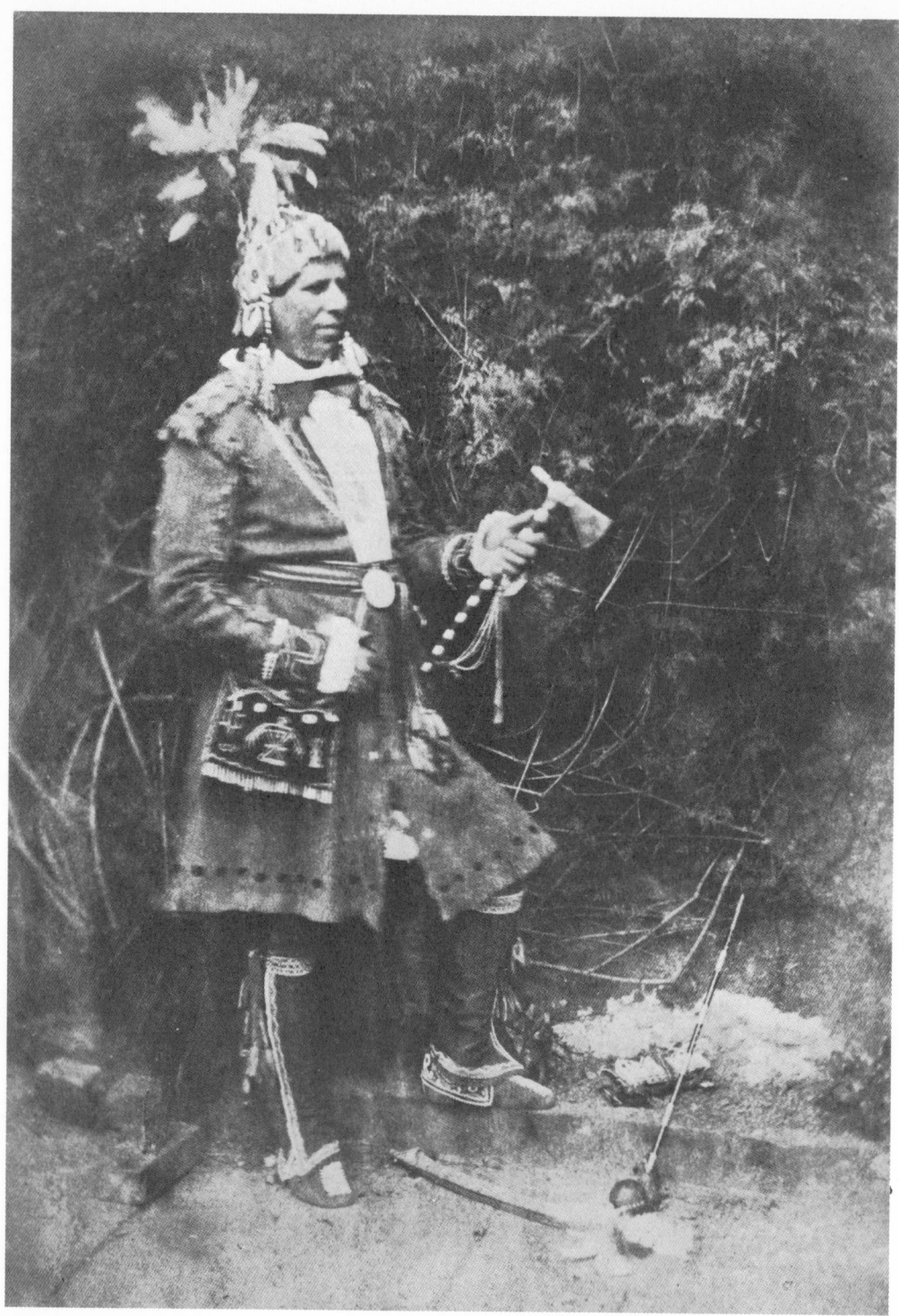

Rev. Mr Peter Jones (Kahkewaquonaby)

196 × 144 mm. (7$\frac{23}{32}$ × 5$\frac{21}{32}$ in.)
Scottish National Portrait Gallery

Given the information (see p. 81) that 'Kahkewaquonaby' was genuinely born in the woods and brought up with his mother's tribe, the Ojibway Indians, it seems odd that he should pose so uncomfortably. It was this shot in particular that gave rise to the mistaken idea that Mr Jones was a British missionary in fancy dress.

According to the Smithsonian Institute, Washington, this calotype, the one on page 80, and another of Jones in clerical dress, are the oldest surviving photographs of a North American Indian.

Mary Watson

208 × 155 mm. ($8\frac{3}{16} \times 6\frac{3}{32}$ in.)
Scottish National Portrait Gallery

Mary Watson (if it is indeed she and not, as is just possible, one of her sisters)
is seen here with two of Hill's and Adamson's favourite 'props'. The birdcage and
the pair of cherubs are to be found in several of the calotypes.
 The Watson girls were Hill's nieces.

Leith Docks

198 × 145 mm. $(7\frac{25}{32} \times 5\frac{23}{32}$ in.)
Edinburgh Public Libraries

In contrast to the nearby fishing village of Newhaven, the port of Leith was Edinburgh's commercial outlet to the sea and it was here that merchantmen and men-of-war would be found.

Hill and Adamson seem to have preferred the smaller port, and Leith has little of their attention despite its importance. Nevertheless this calotype must be regarded as one of their best.

Dr George Bell, Miss Bell and Rev. Thomas Bell

200 × 142 mm. (7⅞ × 5¹⁹/₃₂ in.)
Scottish National Portrait Gallery

Dr George Bell, a commissioner in Lunacy, was highly concerned with matters of social welfare. He drew attention to the disgraceful condition of the old dwellings on the Royal Mile. In his writings (*Day and Night in the Wynds of Edinburgh* and *Blackfriars Wynd Analyzed* – recently republished) he compared the 'closes' off the High Street to Hell.

Miss Alexandrina Mary Bell maried a minister who inherited the title Lord Moncrieff. He was thus the first man to be a noble lord *and* a Free Church minister.

The Rev. Thomas Blizzard Bell of Leswalt (1815–86) was an early subscriber to the Disruption Painting.

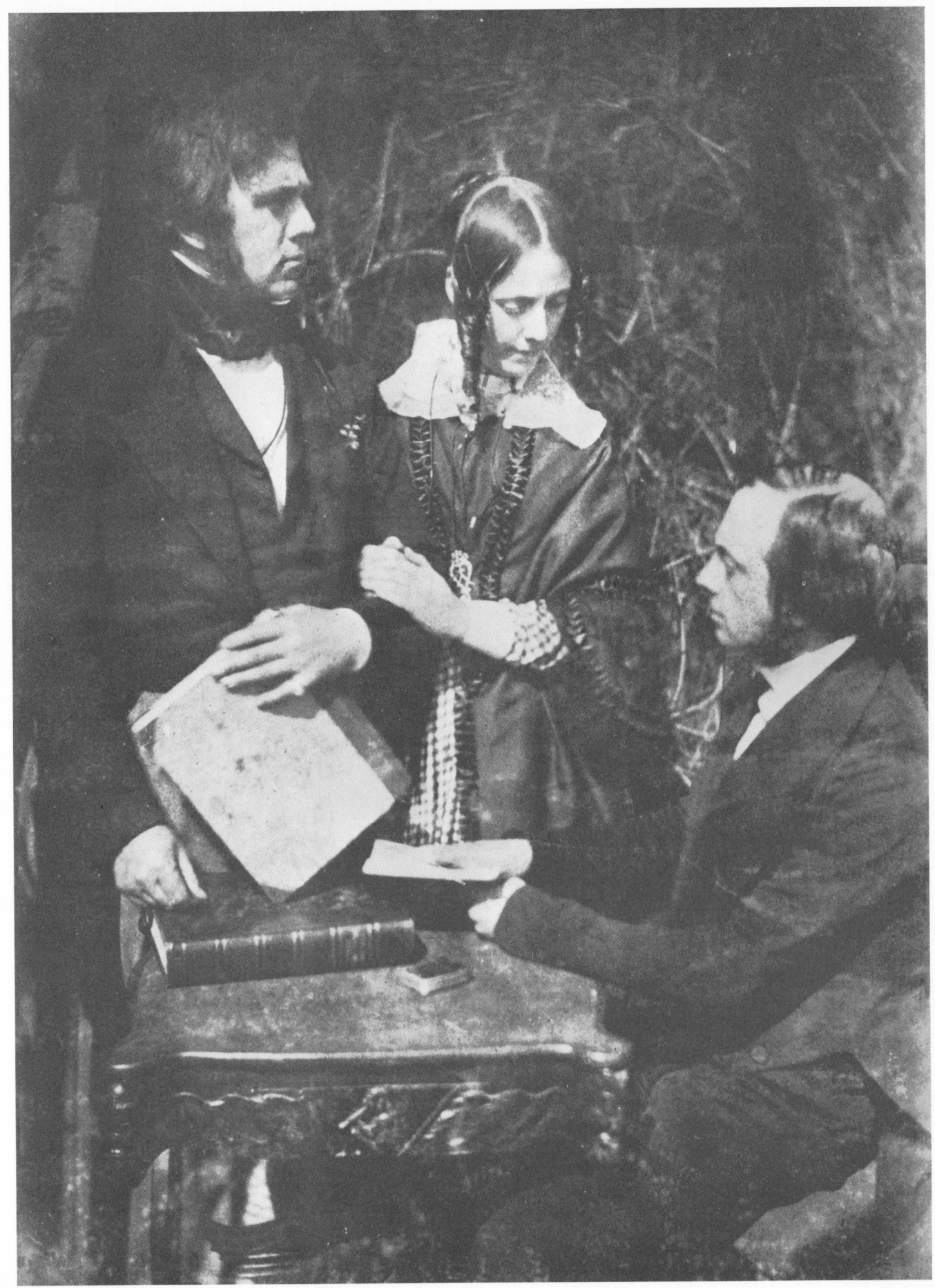

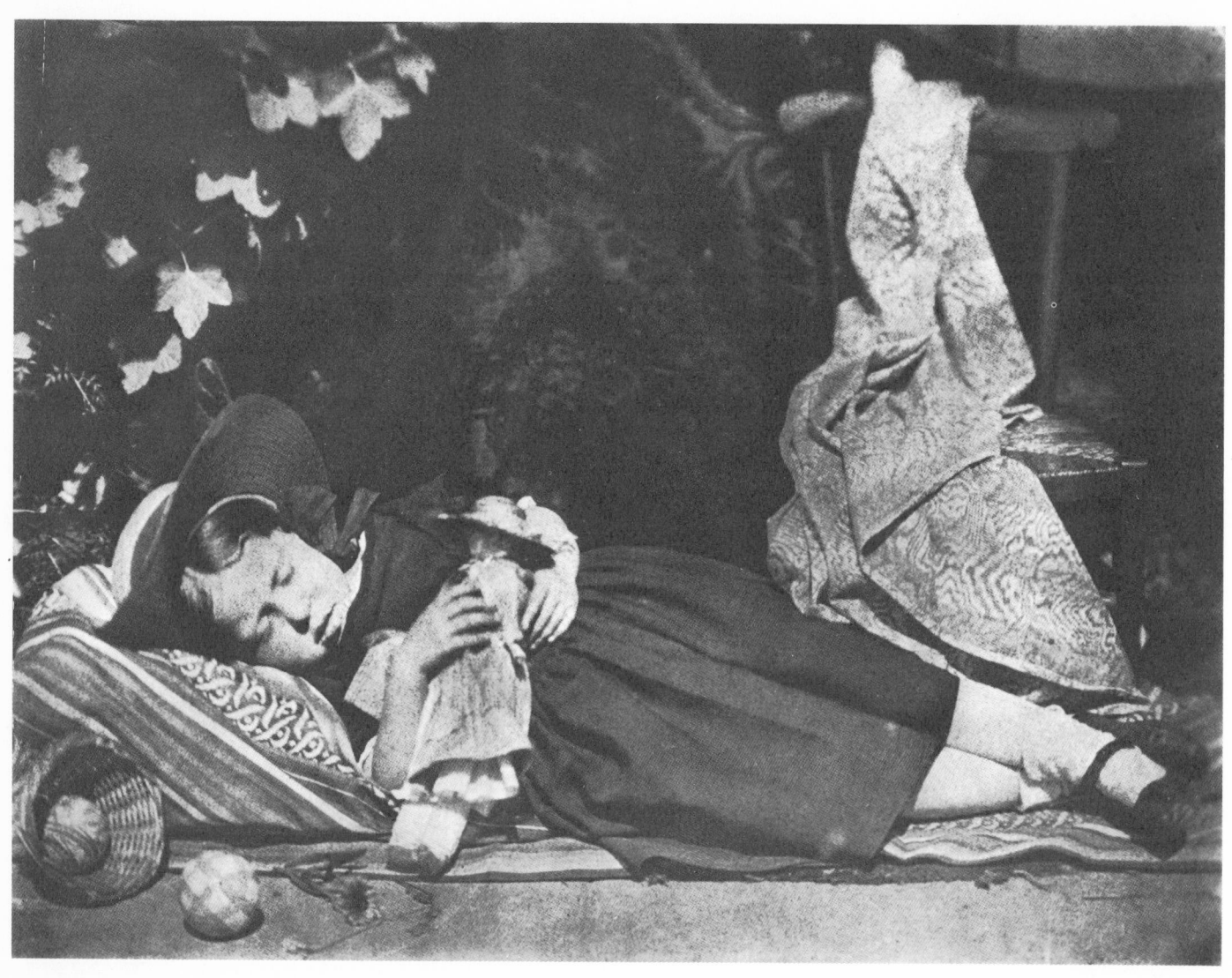

Miss Logan

160 × 200 mm. (6 5/16 × 7 7/8 in.)
Scottish National Portrait Gallery

Miss Logan was the child of Sheriff Logan of Forfar. She appears 'asleep' in more
than one calotype. The device of having her feign sleep was no doubt a useful
subterfuge in that it determined a pose which she could hold for an adequate
time for the exposure.

Photographs of the same girl, by now more grown up, appear in Hill's later
work with McGlashan (1860–62).

126

Tombs in Greyfriars

157 × 210 mm. (6 3/16 × 8 1/4 in.)
Scottish National Portrait Gallery

Greyfriars provided the calotypists with a romantic setting for numerous portraits and studies. They may also have felt attracted to the location because of its association with the signing of the National Covenant in 1638.
Reference to the Covenant was frequently made by the leaders of the 1843 Disruption since the events had in common the declaration of democratic church independence.

The Covenanters resistance to episcopacy put them in jeopardy of not only disestablishment but of losing their lives.

Nowadays the Churchyard is more commonly associated with the story of a dog, 'Greyfriar's Bobby', who for fourteen years remained faithful to the grave of his master John Grey, a shepherd, who was buried in 1858.

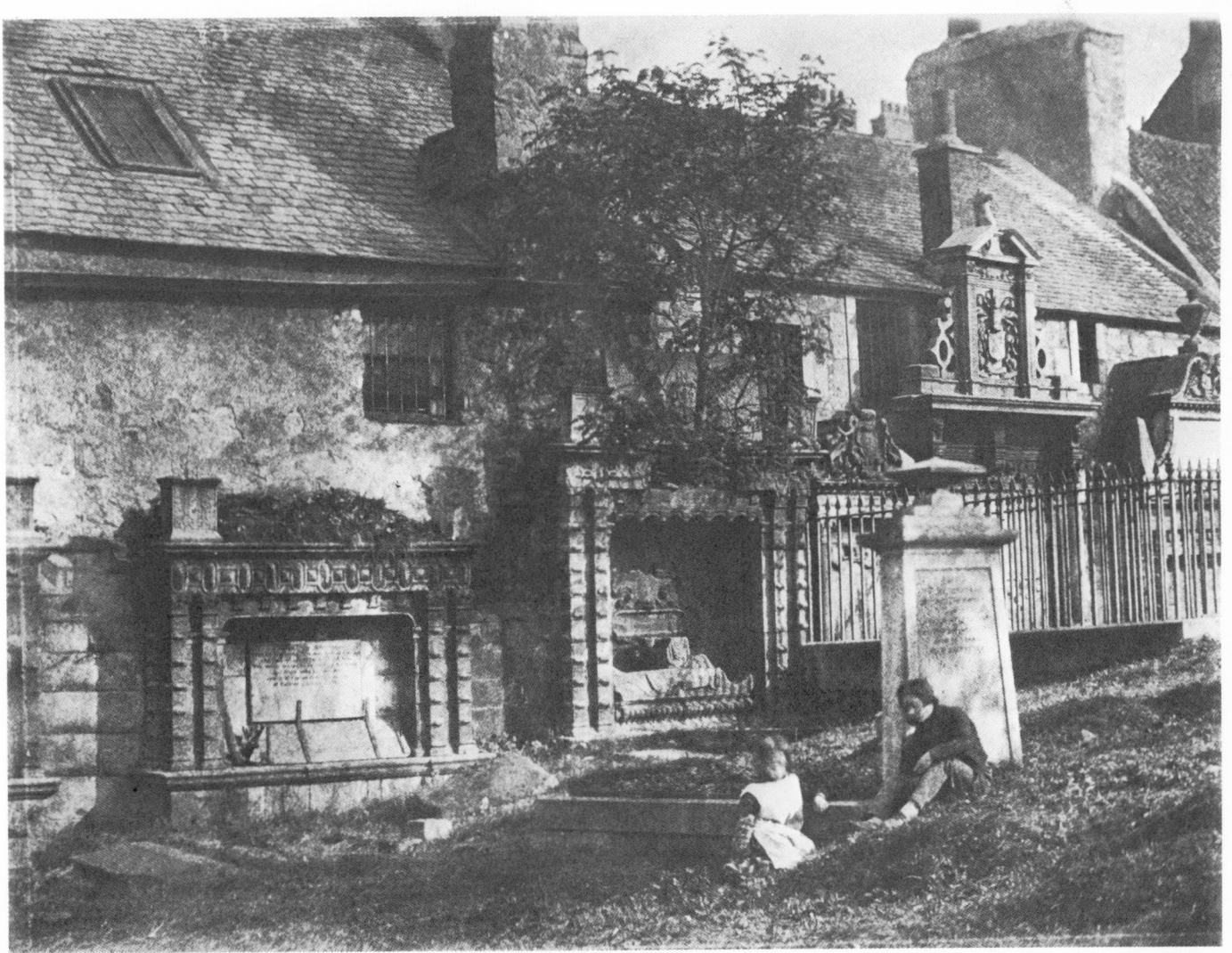

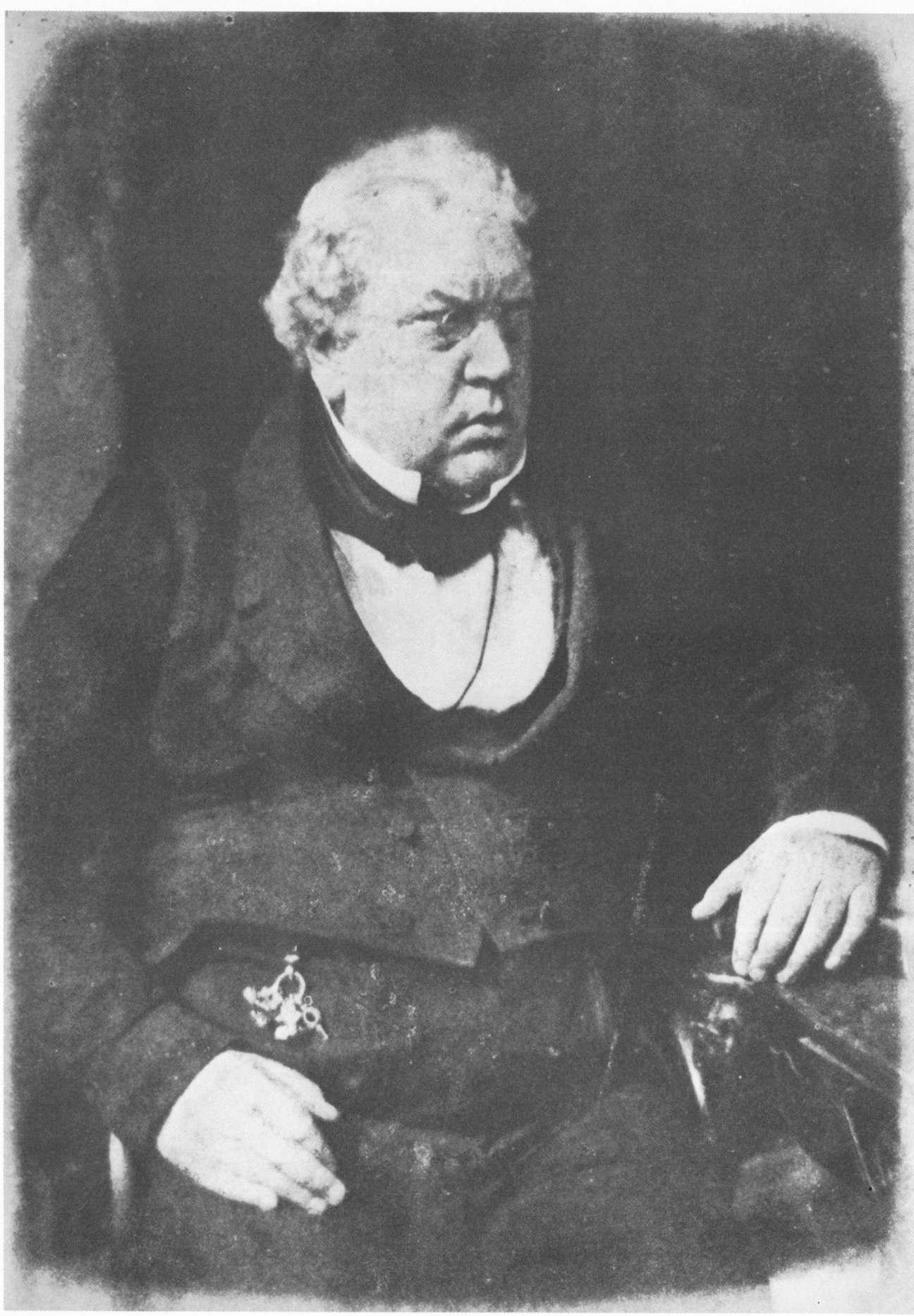

128

Lord Patrick Robertson

198 × 145 mm. (7$\frac{13}{16}$ × 5$\frac{23}{32}$ in.)
Edinburgh Public Libraries

Patrick Robertson (1794–1855) was a brilliant lawyer, a dreadful poet and a man of tremendous good humour. According to his contemporaries (who were not given to reserve in describing physical attributes) his figure, viewed from the side, 'presented the shape of a "P"!'

He was present at the dinner in 1827 when Scott confessed to being the author of the hitherto anonymous Waverley Novels. Robertson thereupon 'confessed' to an unexplained Edinburgh murder. His wit was such that it is surprising that he seemed unaware of his own failings as a poet.

As Peter R. Landreth in *Calotypes of D. O. Hill and R. Adamson* by A. Elliott observed, Lockhart's epigram on Robertson's death is a little hard. Nevertheless he quotes it:

> 'Here lies a paper Lord, the great, fat Peter,
> Who broke the laws of God and man, and metre.'

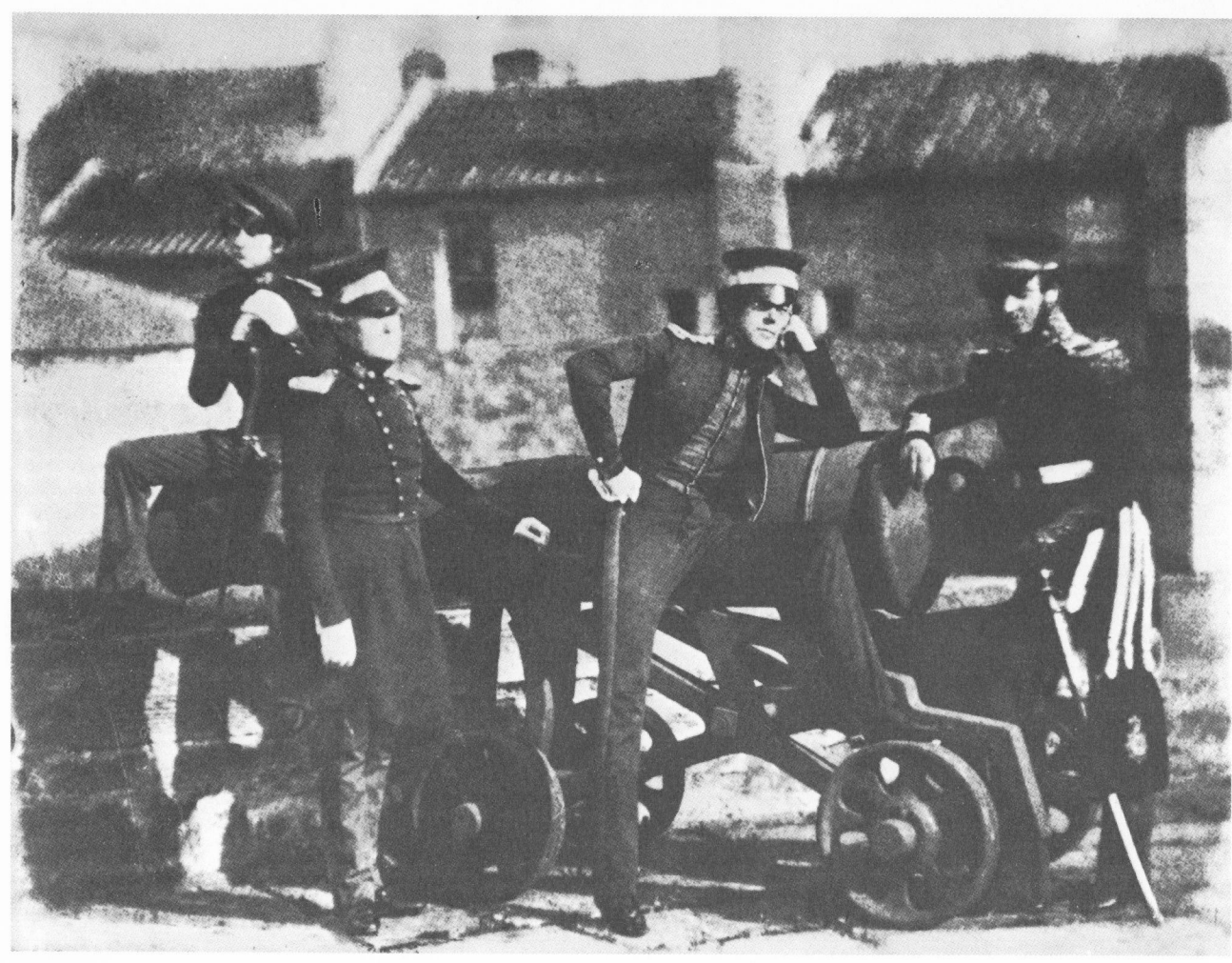

Leith Fort

143 × 195 mm. (5⅝ × 7 11/16 in.)
Royal Scottish Academy

The 'sequence' of pictures made at Leith Fort is splendid, but puzzling. Until evidence to the contrary is forthcoming, we must assume that Hill and Adamson imported the military gentlemen from a nearby barracks for it seems that by the 1840s the fort had ceased to house a garrison.

In previous centuries the site had indeed seen action. General Monk built a citadel in 1656 but its subsequent history seems more to do with quelling troop revolts than protecting the citizenry of Leith. Towards the end of the eighteenth century a new battery was built after Leith had been attacked by John Paul Jones.

The four artillery-men are Major Wright, Major Crawford, Captain St George and Captain Bortingham.

Newhaven Fishermen (*opposite*)

190 × 142 mm. (7 15/32 × 5 19/32 in.)
Scottish National Portrait Gallery

The fisherman on the left is Linton, the most frequent sitter of Hill's and Adamson's Newhaven subjects.

130

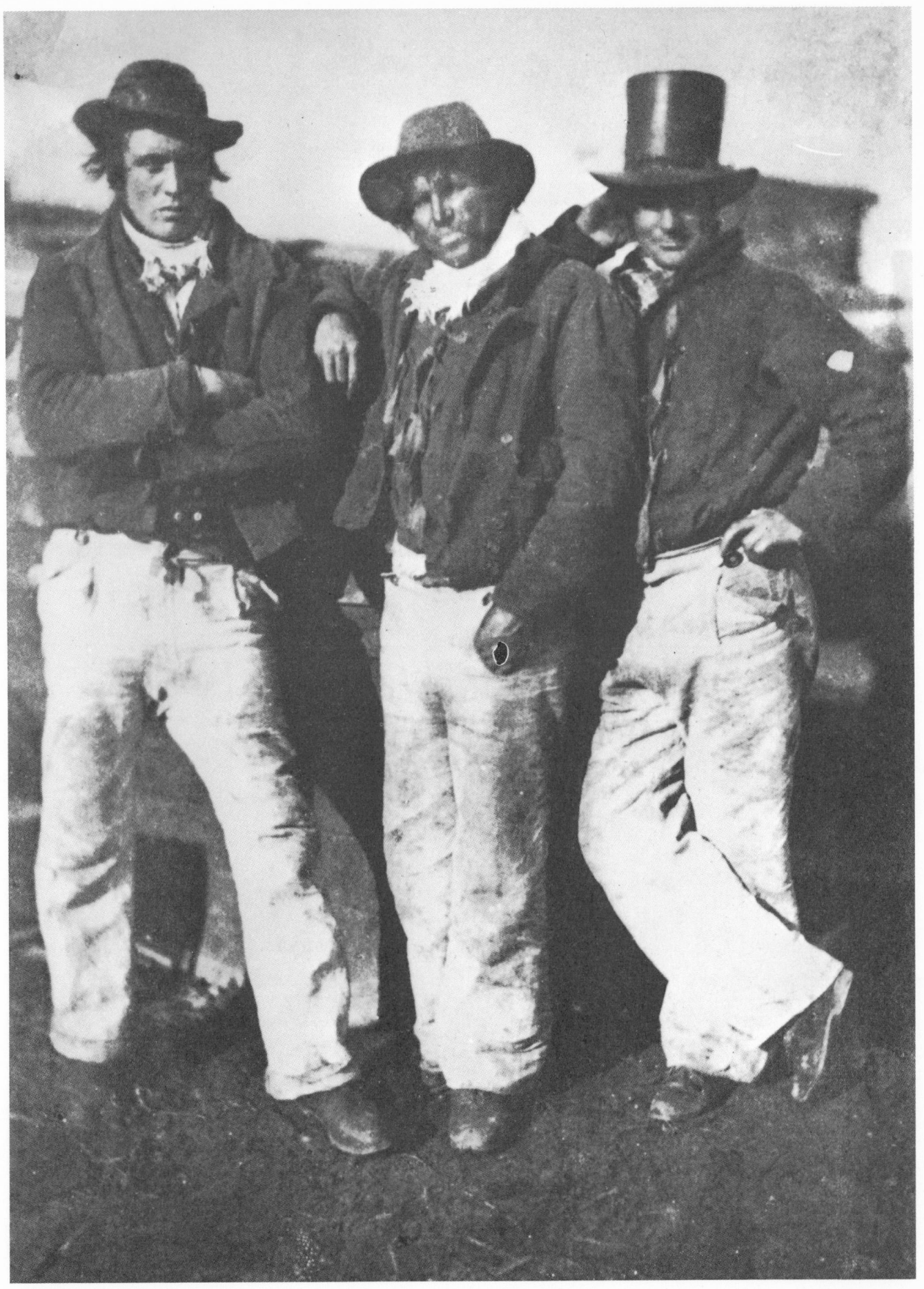

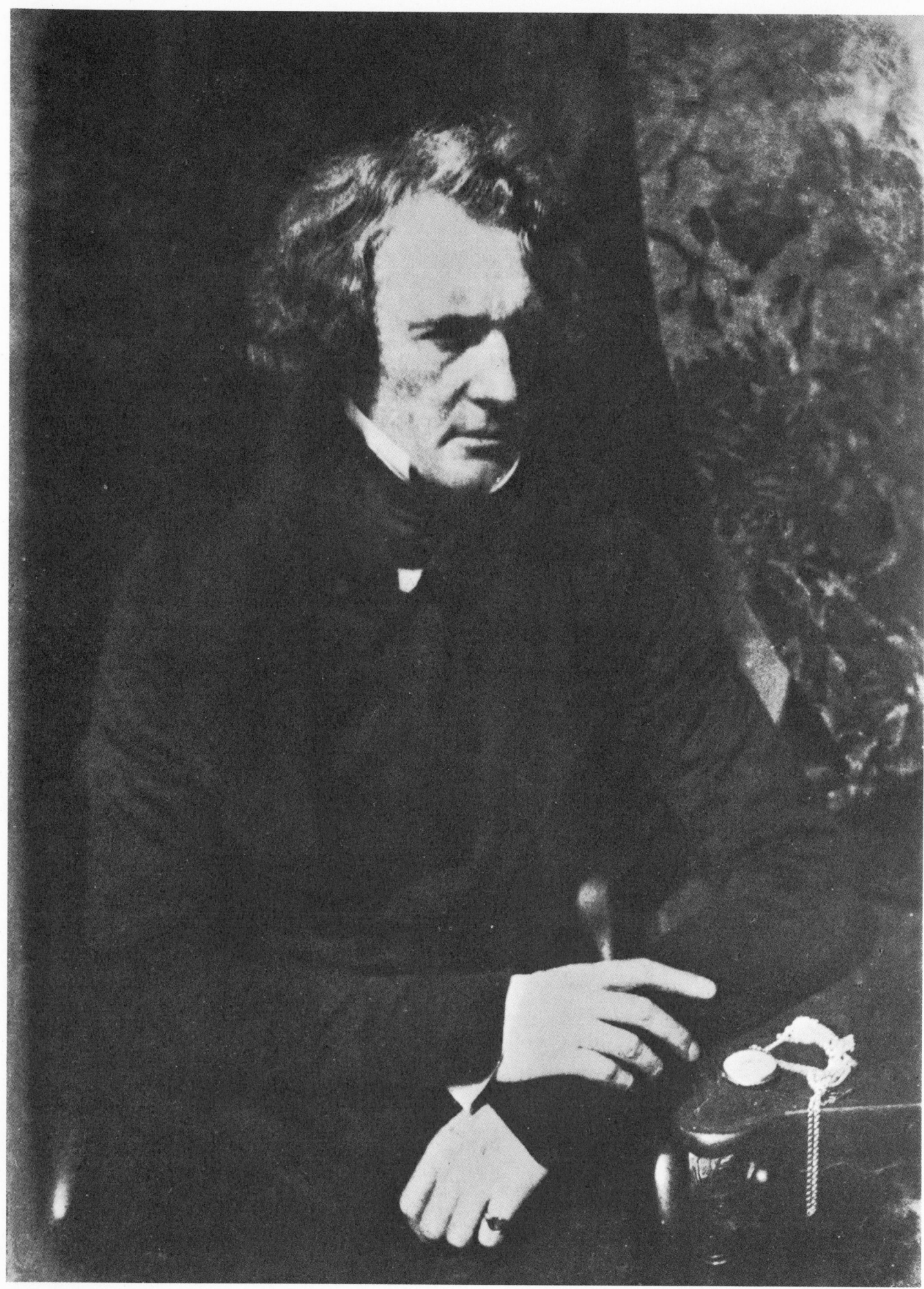

132

Sir John McNeill

192 × 142 mm. (7$\frac{9}{16}$ × 5$\frac{19}{32}$ in.)
National Library of Scotland

Sir John McNeill was born on the island of Colonsay in 1795. He studied medicine at Edinburgh University and in 1816 went to Bombay as a surgeon for the East India Company. Thereafter, his career moved in diplomatic rather than medical circles.

Until 1835 he was attached to the East India Company Legation in Persia and he was made Ambassador in 1836. He concluded a treaty of commerce between Britain and Persia in 1862.

He was in Scotland in 1845 where he was in charge of wording the new Scottish Poor Law Act; he subsequently led an inquiry on the potato famine in the Highlands. Ten years later he was involved in another kind of investigation, into the supply and accounts department of the army in the Crimea.

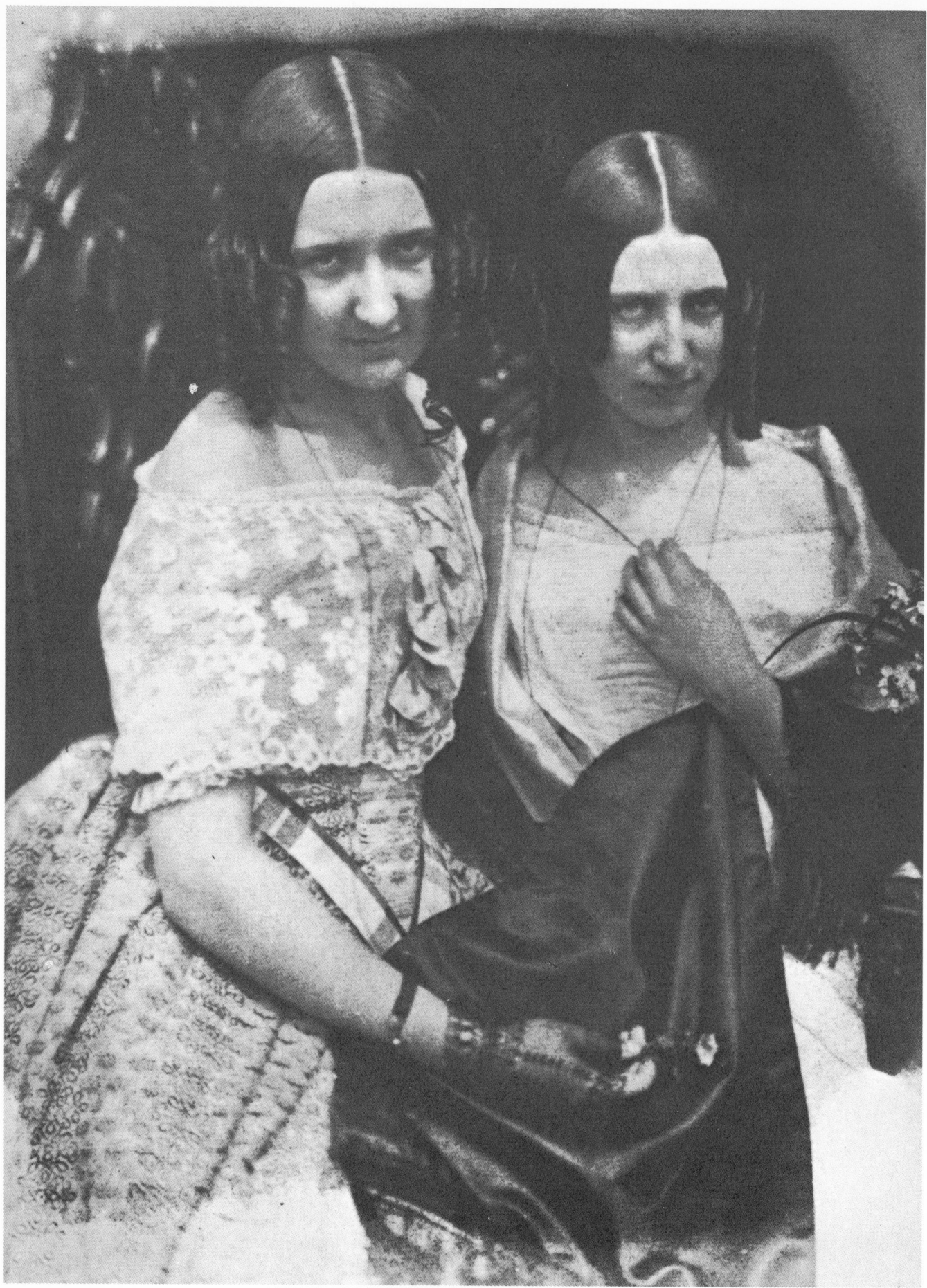

The Misses Binnie

207 × 158 mm. ($8\frac{5}{32}$ × $6\frac{7}{32}$ in.)
Scottish National Portrait Gallery

The two Misses Binnie, became respectively Mrs Webster and Mrs Marrable.
There is a minor mystery about this calotype. On a modern print there is some
suggestion that the calotype was made in 1848 *after* the death of Adamson.
Though the likelihood is that this is simply an error on someone's part it raises
the doubt that perhaps, after all, the studio did not stop production as abruptly
as had been supposed. Further evidence in the matter is clearly required.

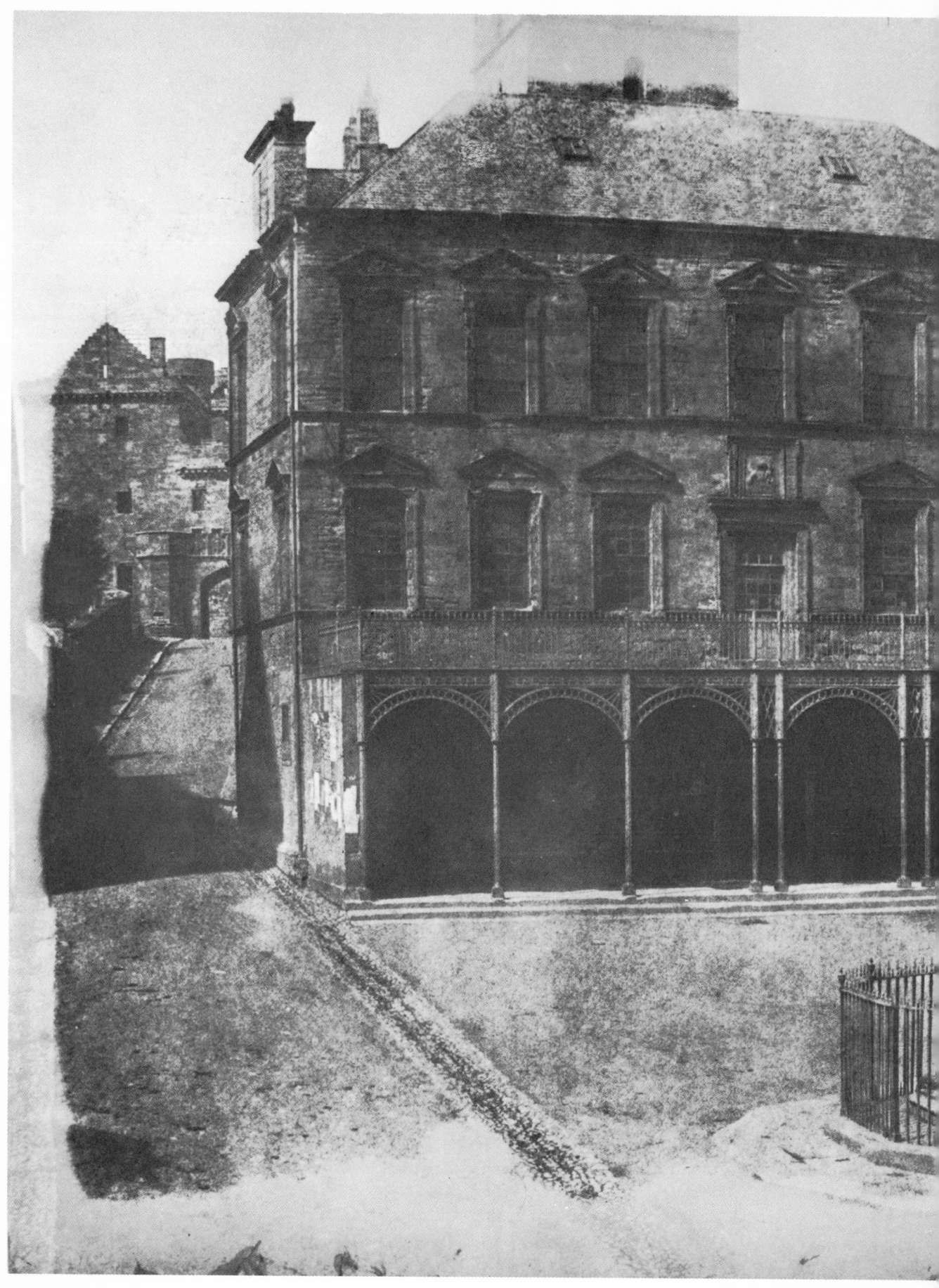

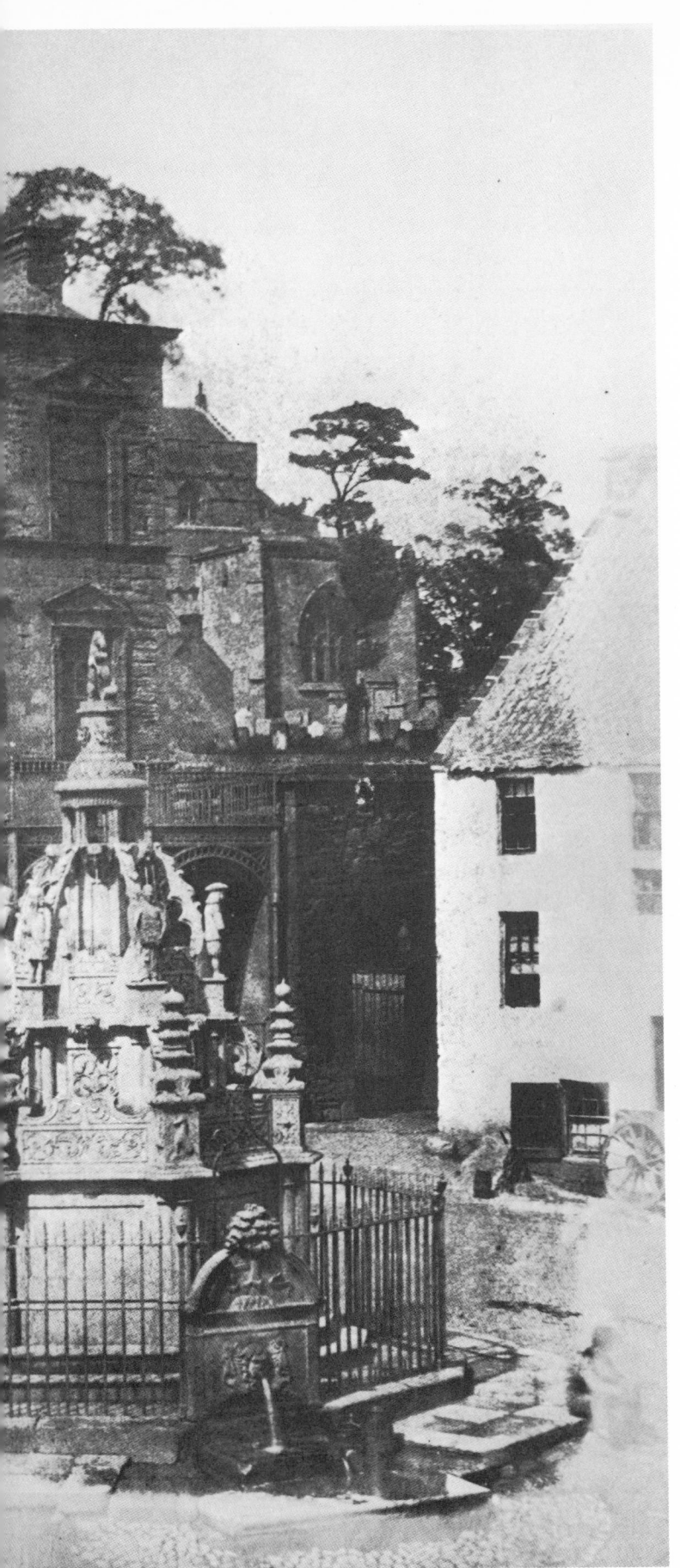

Linlithgow

310 × 379 mm. $(12\frac{7}{32} \times 14\frac{29}{32}$ in.)
Royal Scottish Academy

The calotype shows the centre of Linlithgow
(see p. 231). The roadway on the left leads
to the ruined palace. The Town House
frontage has been substantially remodelled
since the photograph was taken, probably
in 1845.

Lane and Peddie as Afghans

198 × 143 mm. ($7\frac{25}{32}$ × $5\frac{5}{8}$ in.)
Scottish National Portrait Gallery

As is observed elsewhere in this book, Edward W. Lane was an eminent Arabic scholar. He possessed a considerable collection of exotic costumes of which these spectacular specimens are presumably part.

Peddie is identified on one of the positive copies only, but Peddie is a comparatively common Edinburgh name. A Mrs Peddie, presumably his wife, is also among the calotypists' sitters.

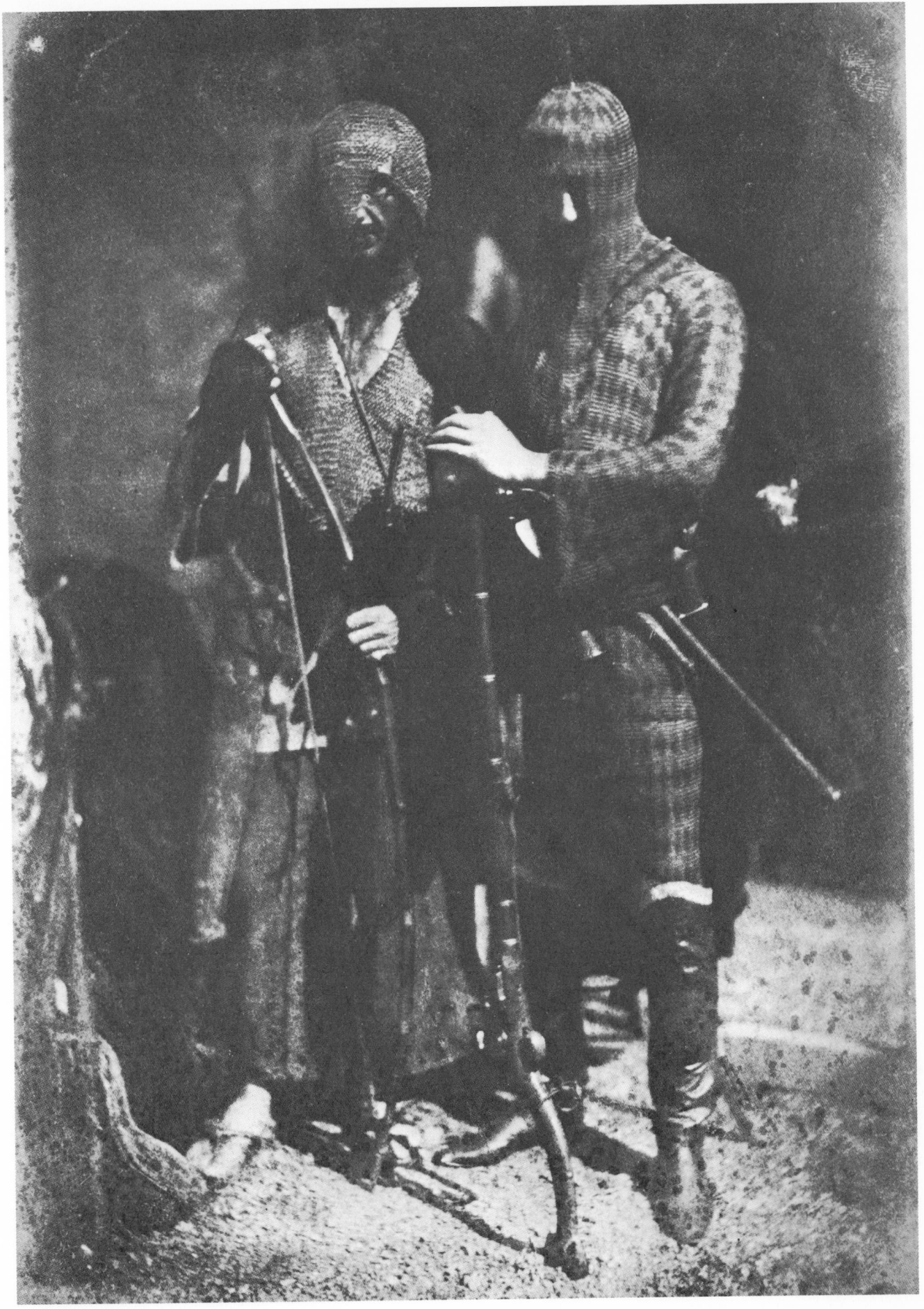

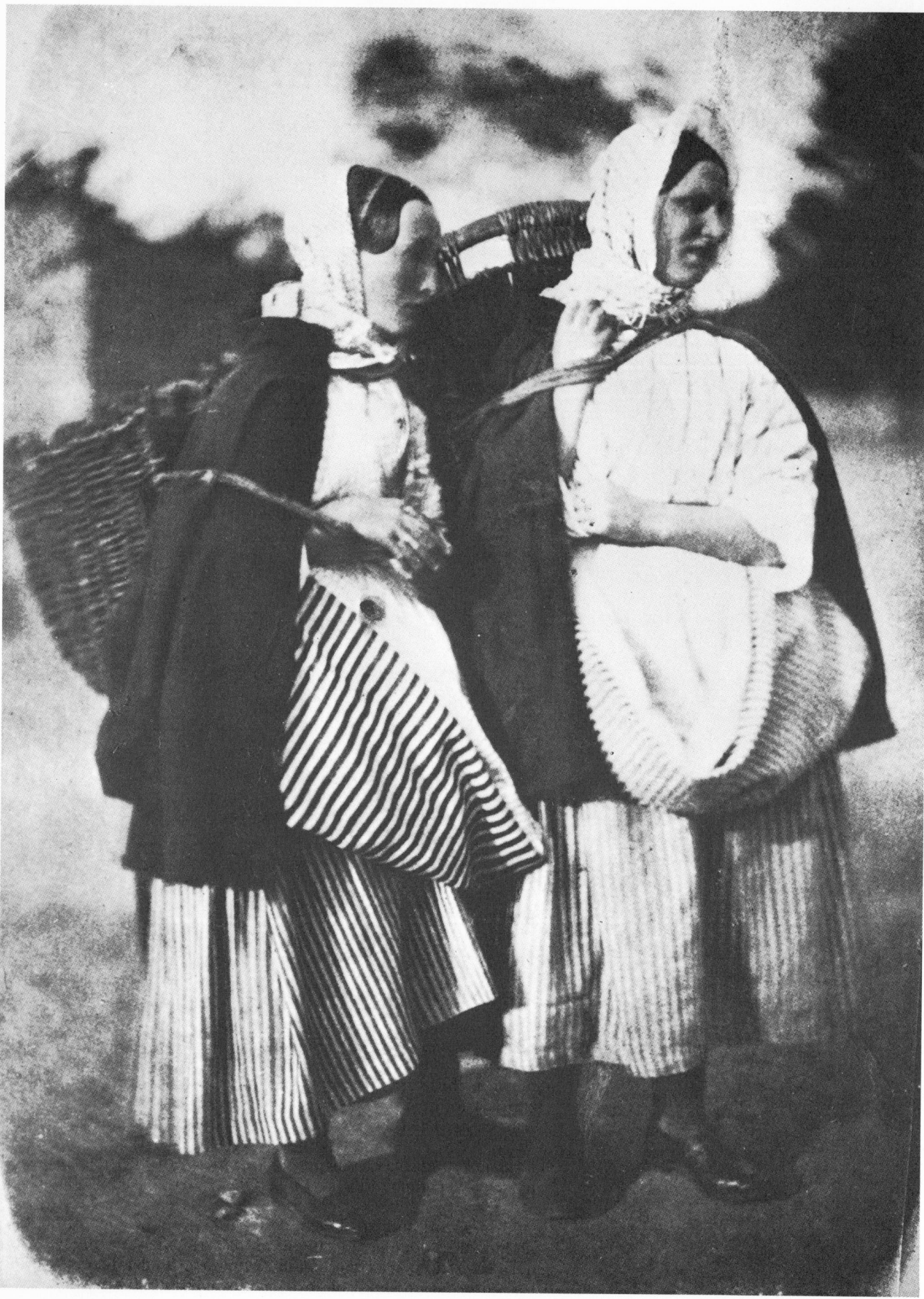

Two Newhaven Fisherwomen

199×144 mm. $(7\frac{2\cdot}{32} \times 5\frac{21}{32}$ in.)
Scottish National Portrait Gallery

What at first appears to be a comparatively casual shot of two fisherlassies
standing in the street takes on entirely different connotations when one consults
the caption to it in an album in the British Museum. From this it transpires the
girls are (supposedly) looking out to sea longing for the return of their menfolk.

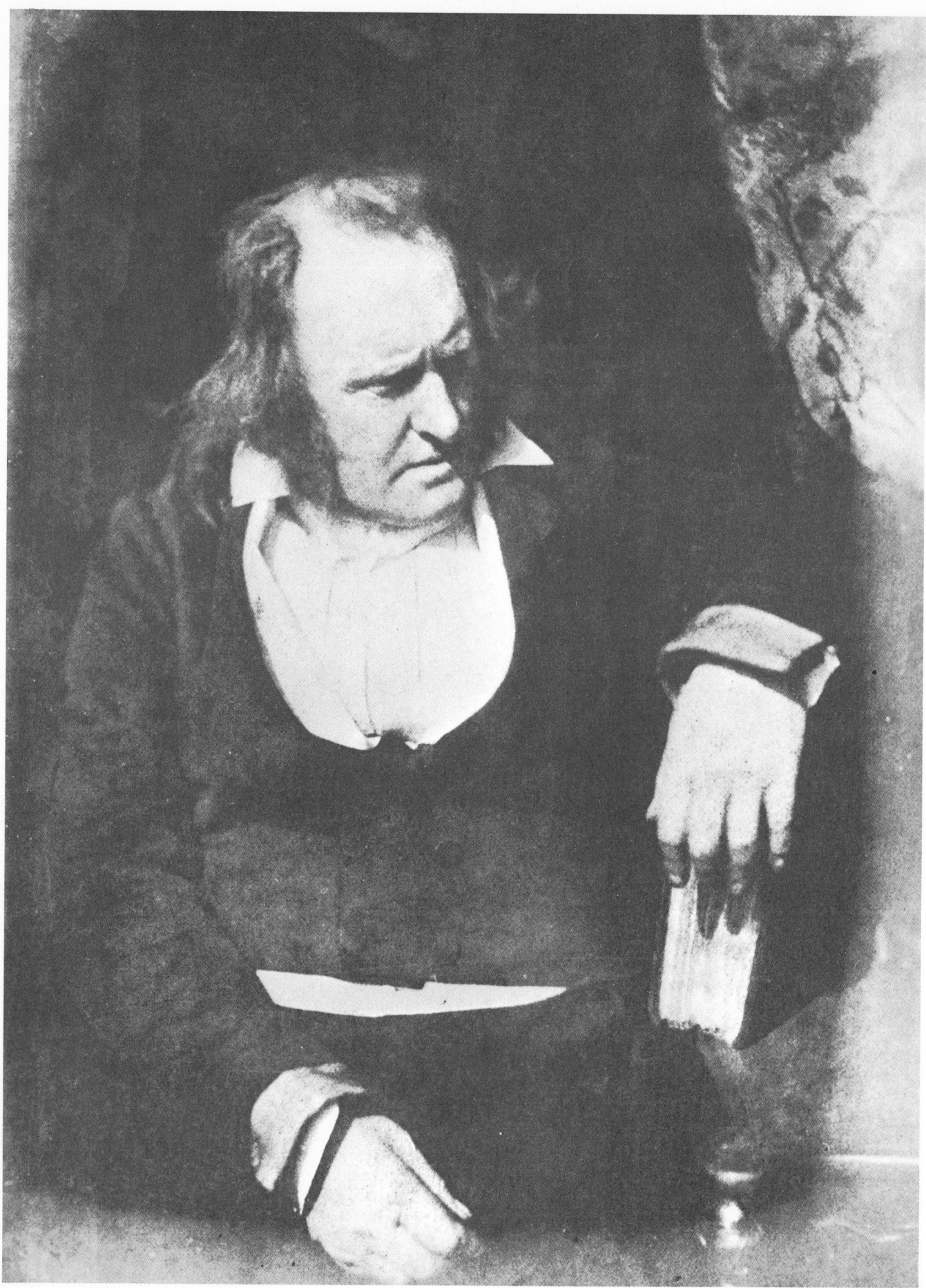

142

John Wilson ('Christopher North')

198×146 mm. (7$\frac{25}{32}$×5$\frac{3}{4}$ in.)
Edinburgh Public Libraries

Professor John Wilson (1785–1854) was born in Paisley and was educated at
Glasgow and Oxford. He seemed well set for a life of leisure and settled in the
Lake District where he became part of Wordsworth's circle. Unfortunately, his
financial affairs took a bad turn and he moved to Edinburgh where he studied
law. However, his literary interests were such that he was soon a regular
contributor to *Blackwood's Magazine*. In 1820 he succeeded, a little unexpectedly,
in gaining the Chair of Moral Philosophy at Edinburgh University. He continued
to write for *Blackwood's*, attacking Knox (see p. 77) in the Burke and Hare
episode. In 1834 he collaborated with Hill in producing *The Land of Burns*.

The calotype opposite is the outcome of interesting circumstances. On 28 March
1844, when Rock House had been in operation for only about nine months,
Gibson Lockhart, Sir Walter Scott's biographer, wrote to John Wilson in ecstatic
terms about the quality of the calotypes being produced by Hill and Adamson.
Lockhart, who was probably familiar with the daguerreotype system, was certainly
seeing calotypes for the first time and his response is therefore very interesting.
He called them, confusingly, 'the Edinburgh daguerreotypes' and said that that
of Dr Brewster was 'by far the best specimen of the art I have ever seen. It is
so good I should take it very kind if you would sit to the man whom Brewster
patronises for me . . . This art is about to revolutionise book illustration
entirely.'

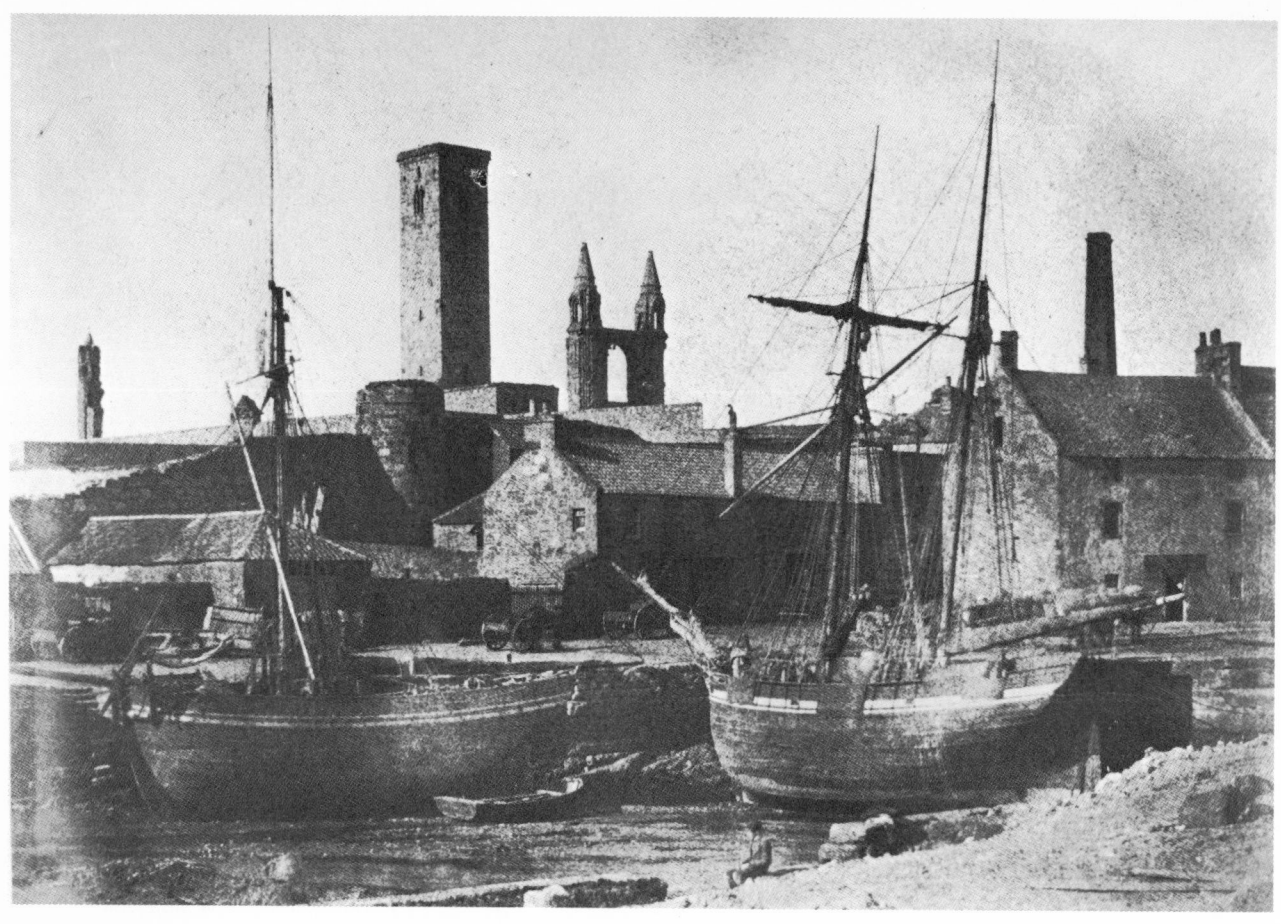

St Andrews

138 × 193 mm. ($5\frac{7}{16} \times 7\frac{19}{32}$ in.)
Edinburgh Public Libraries

St Andrews in Fife is an ancient university town whose fortunes have fluctuated a great deal over the centuries. For a long time it flourished as the ecclesiastical capital of Scotland. The square tower of St Rule (or St Regulus) probably dates from 1127; the cathedral was begun in 1161 and, when complete, was the largest church building in Scotland.

During the Reformation the town suffered a particularly violent period and the cathedral was destroyed in 1559. From then on, St Andrews declined and it was only in the nineteenth century that it began once more to regain its lost prestige. As late as 1825, *Brooke's Gazeteer* found the harbour 'in bad condition', but by the end of the 1830s it was, as we have seen, the home of the distinguished and the enquiring. It was here that Sir David Brewster and the Adamsons lived and worked.

The calotypes of St Andrews have a special sense of peace about them: none more so than this one.

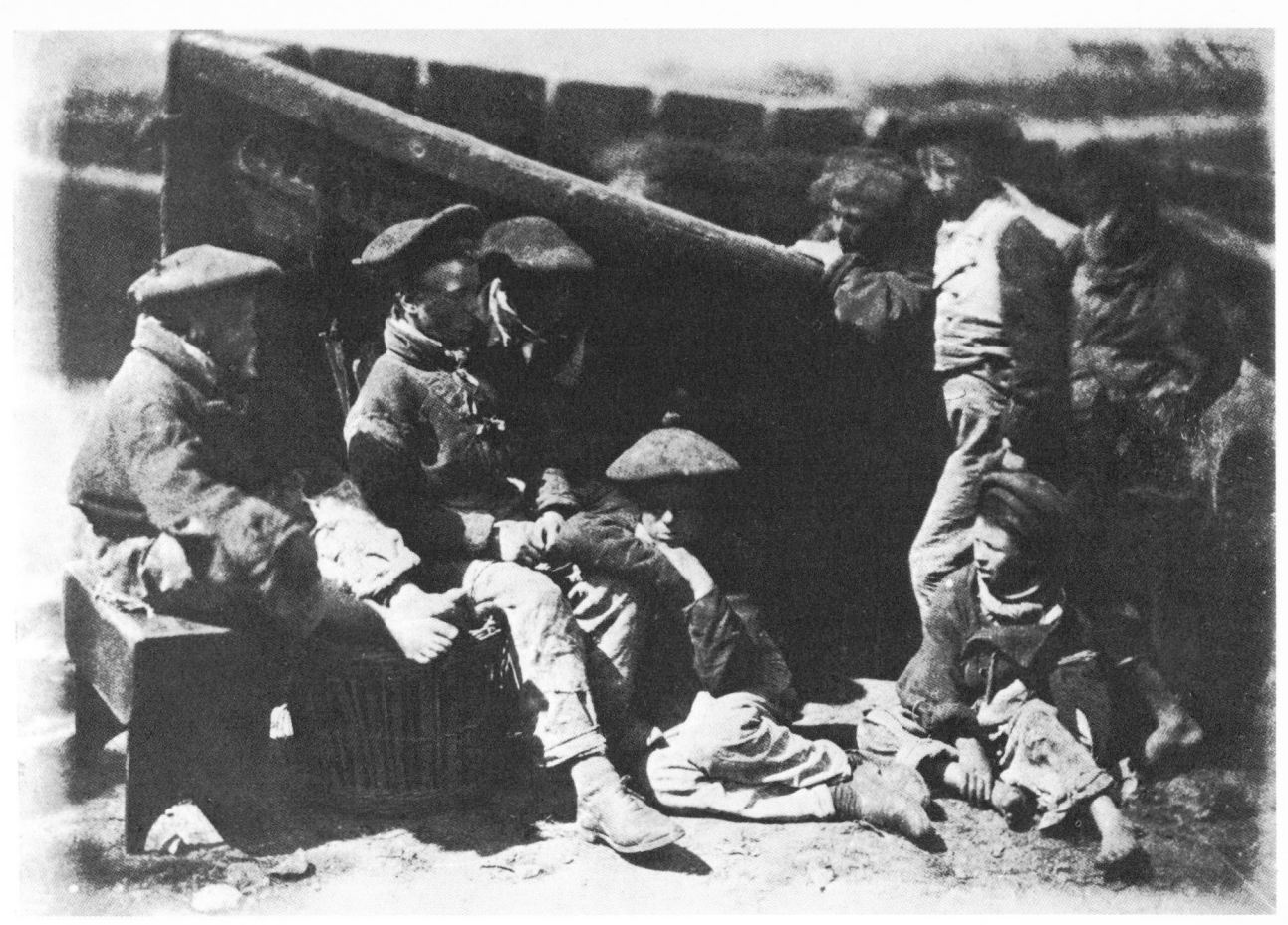

Fisherladdies, Newhaven

139 × 196 mm. $(5\frac{15}{32} \times 7\frac{23}{32}$ in.)
National Library of Scotland

Of the pictures containing a number of children this is undoubtedly the most
successful though even in this calotype the usual difficulty of handling a long
exposure is apparent. Two or three of the figures have not been held perfectly
still but this fault is not evident in the key individuals in the centre of the frame.

K

Miss Elizabeth Rigby

147×113 mm. $(5\frac{25}{32} \times 4\frac{7}{16}$ in.)
National Library of Scotland

Elizabeth Rigby was the most frequent of Hill's and Adamson's female sitters. She appears in no fewer than sixteen portraits and in at least three groups. In 1849 she married Charles Eastlake who was knighted the following year and became director of the National Gallery in 1855. He died ten years later but she survived until 1893 by which time she was well into her eighties.

She wrote a considerable amount of literature including two volumes of journal and correspondence.

This calotype shows signs of more than usually conscious elaboration. The black drape over the white dress, the elegantly arched right hand and the placing of the familiar Rock House cherubs create an effect far removed from the more naturalistic portraits – some of them of this same sitter.

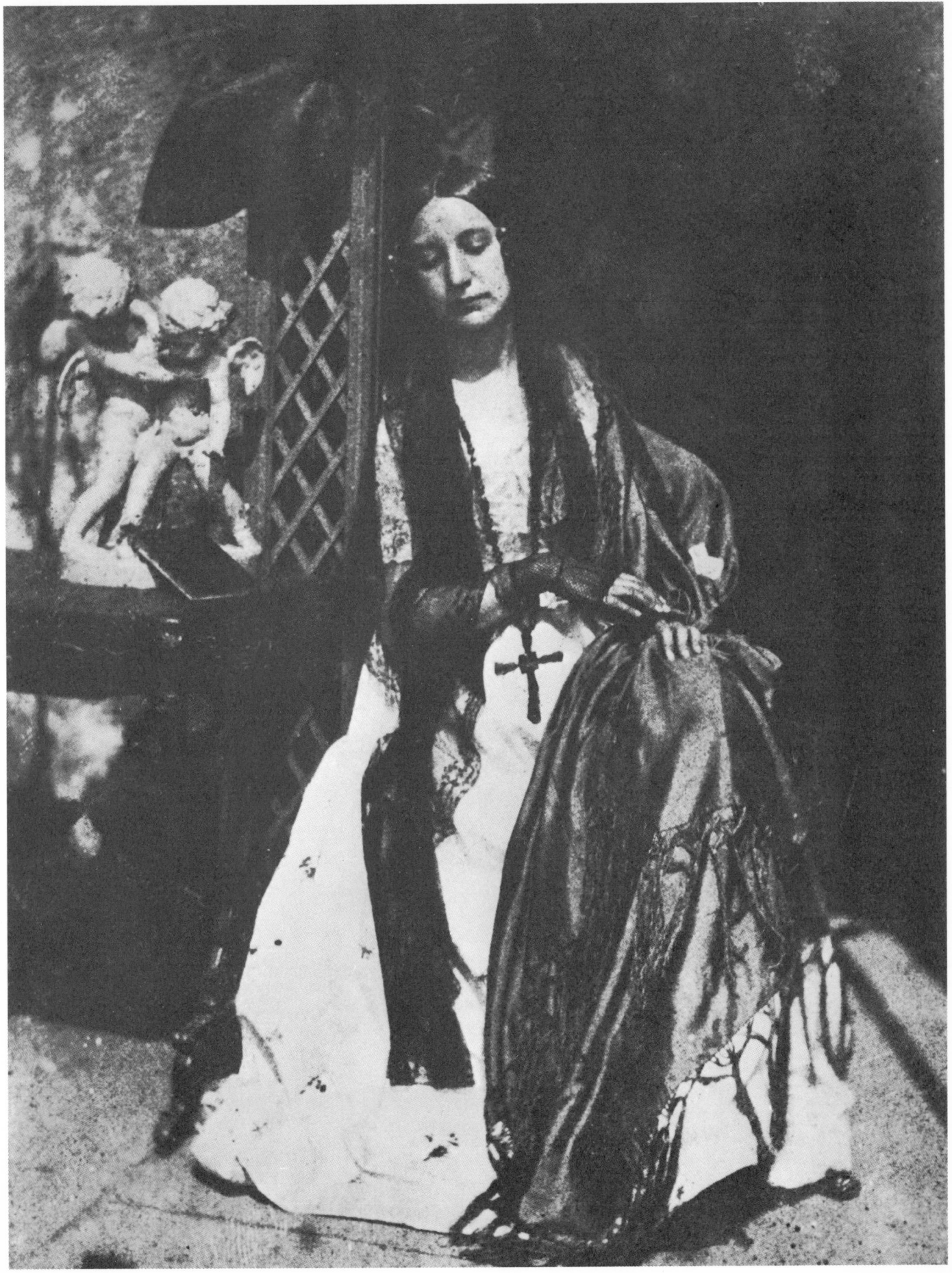

Captain Sinclair (?) at Dennystoun's Tomb, Greyfriars

203 × 148 mm. (8 × 5 13/16 in.)
Scottish National Portrait Gallery

The quality of this calotype, of a gentleman seated at a tombstone in Greyfriars Churchyard, justifies its inclusion on its own account. At one time it was thought that the sitter was John Ruskin (in *David Octavius Hill*, Schwarz 1932).

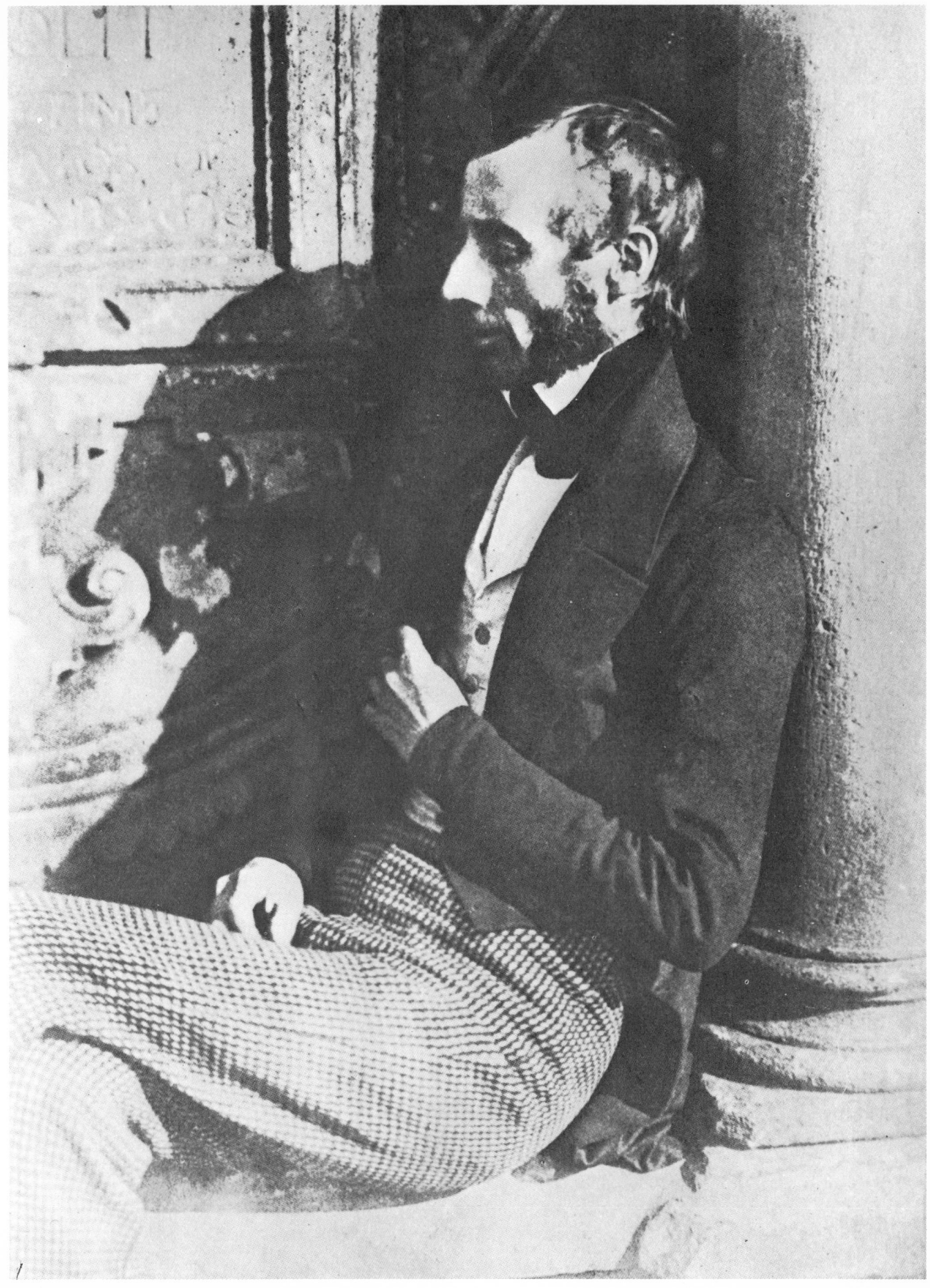

149

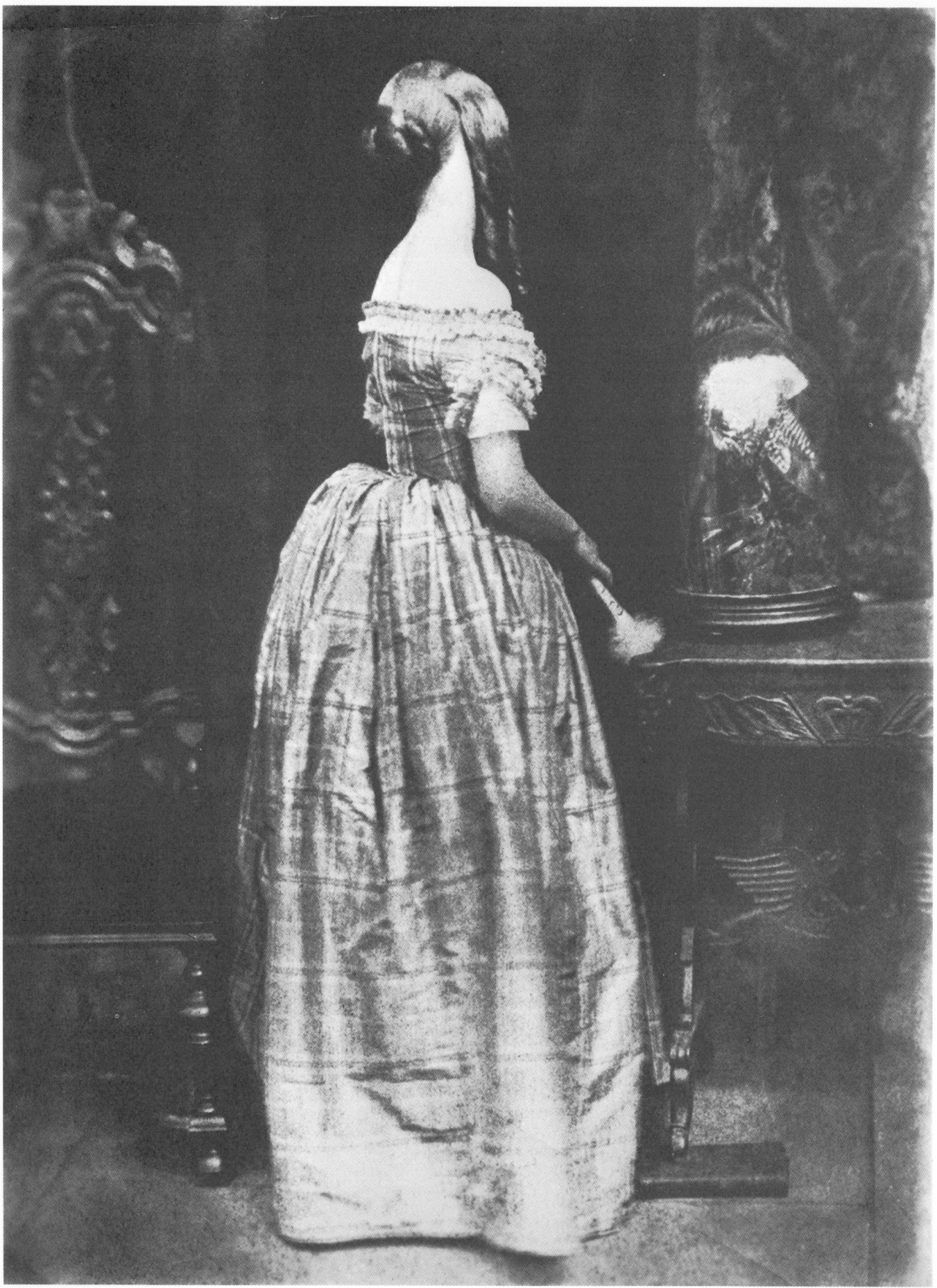

Miss Justine Munro

199 × 154 mm. $(7\frac{27}{32} \times 6\frac{1}{16}$ in.)
Scottish National Portrait Gallery

Miss Justine Munro was probably the daughter of Sheriff Munro. She married a
Mr Gallie, with whom she appears in another calotype and indeed she appears in
several portraits and groups.

Deliberately to devise a portrait composition without showing the face creates
special problems. It concentrates the interest on formal aspects of the pictures,
particularly the juxtaposing of areas of light and dark and the division of the
frame into three vertical panels. This draws attention to the elegance and the
height of figure.

Gordon Highlanders at Edinburgh Castle (*overleaf*)

137 × 186 mm. $(5\frac{13}{32} \times 7\frac{5}{16}$ in.)
Edinburgh Public Libraries

Of the 'action' pictures by Hill and Adamson this is one of the most famous; it
is also one of the most successful. We associate movement in photography with a
blurring of outline. Here, a combination of the fibrous texture of the paper
negative, soft focus and slight movement create a dramatic sense of action. This
is one of the most impressionistic photographs in the Hill/Adamson collection and
arguably one of the finest from a twentieth-century viewpoint.

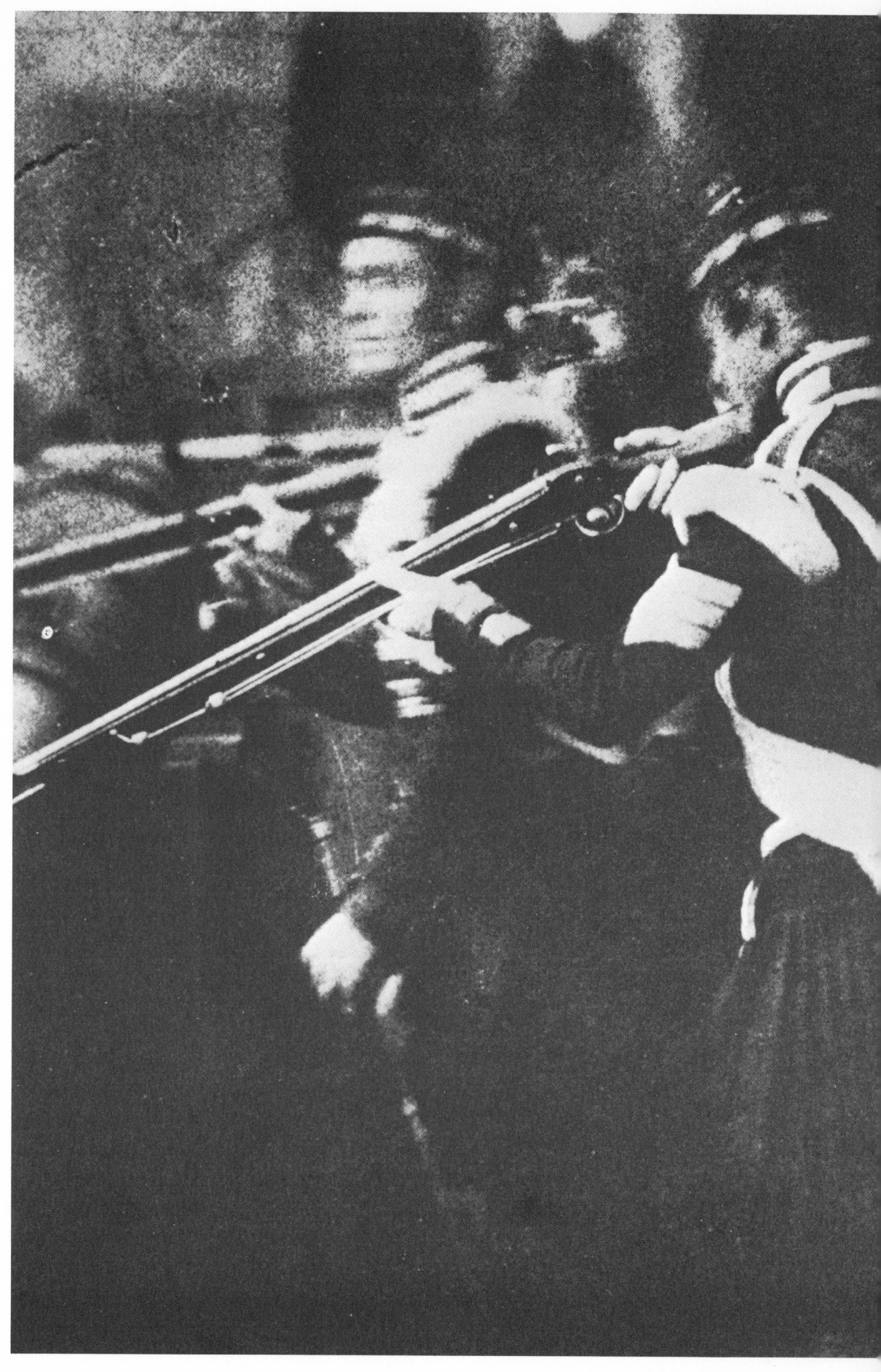

George Combe

202 × 156 mm. (7$\frac{15}{16}$ × 6$\frac{5}{32}$ in.)
National Library of Scotland

George Combe (1788–1858) was one of the seventeen children of an Edinburgh brewer. He became interested in (one might almost say obsessed with) phrenology and was an ardent disciple of Gall, and Spurzheim whom he visited in Paris in 1817.

Combe published *Elements of Phrenology* in 1824 and *Essays on the Constitution of Man* in 1828. The latter work caused some upset as it was thought to be supporting materialistic atheism.

In 1833 he married Cecilia (daughter of Sarah Siddons) of whose head he said her anterior lobe was large: 'her Benevolence, Conscientiousness, Firmness, Self-Esteem and Love of Approbation amply developed', whilst her veneration and wonder was equally moderate with his own.

He visited America in 1838 and Germany in 1842. He bought a house in Melville Street, Edinburgh where the novelist George Eliot visited him.

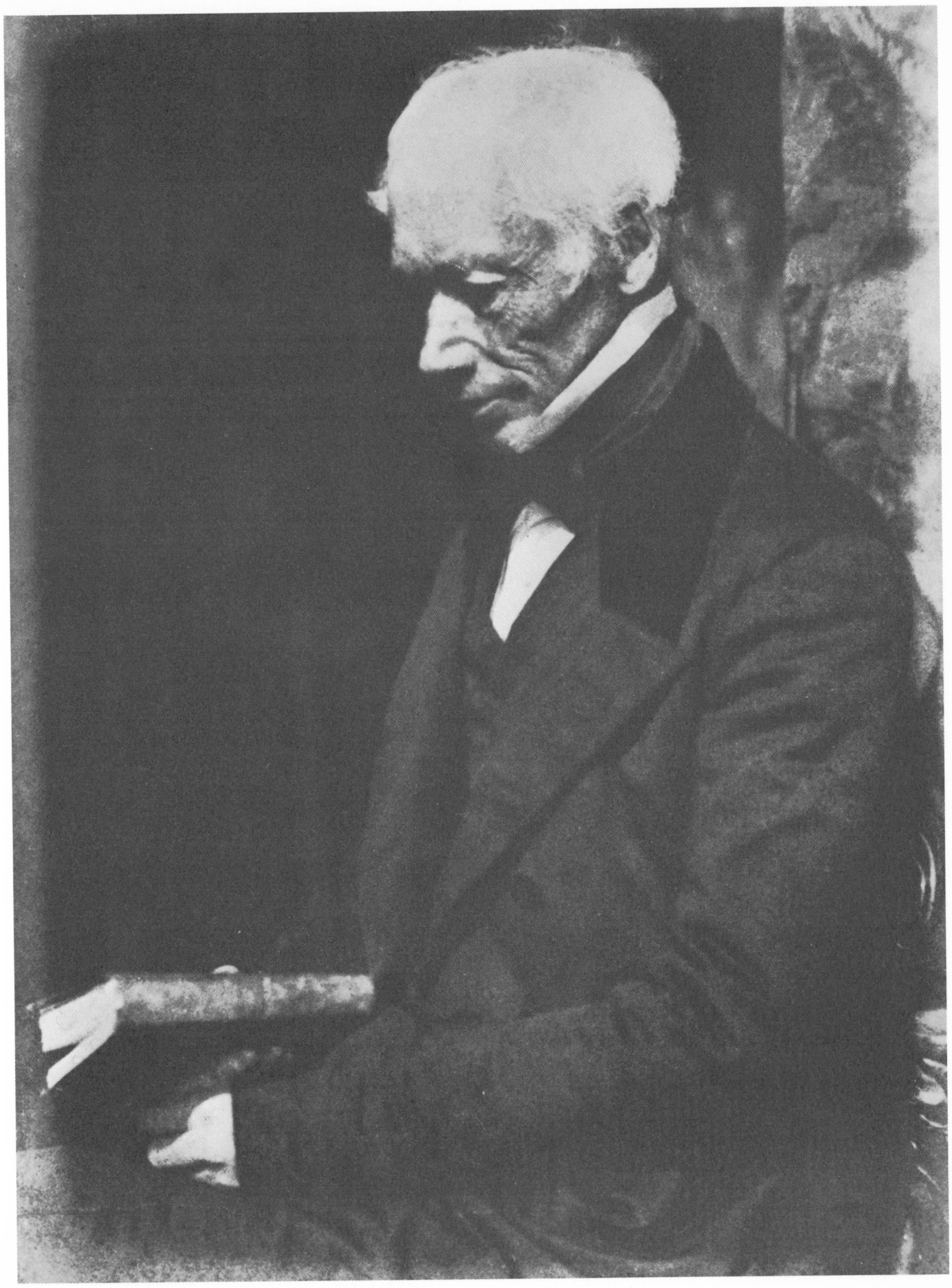

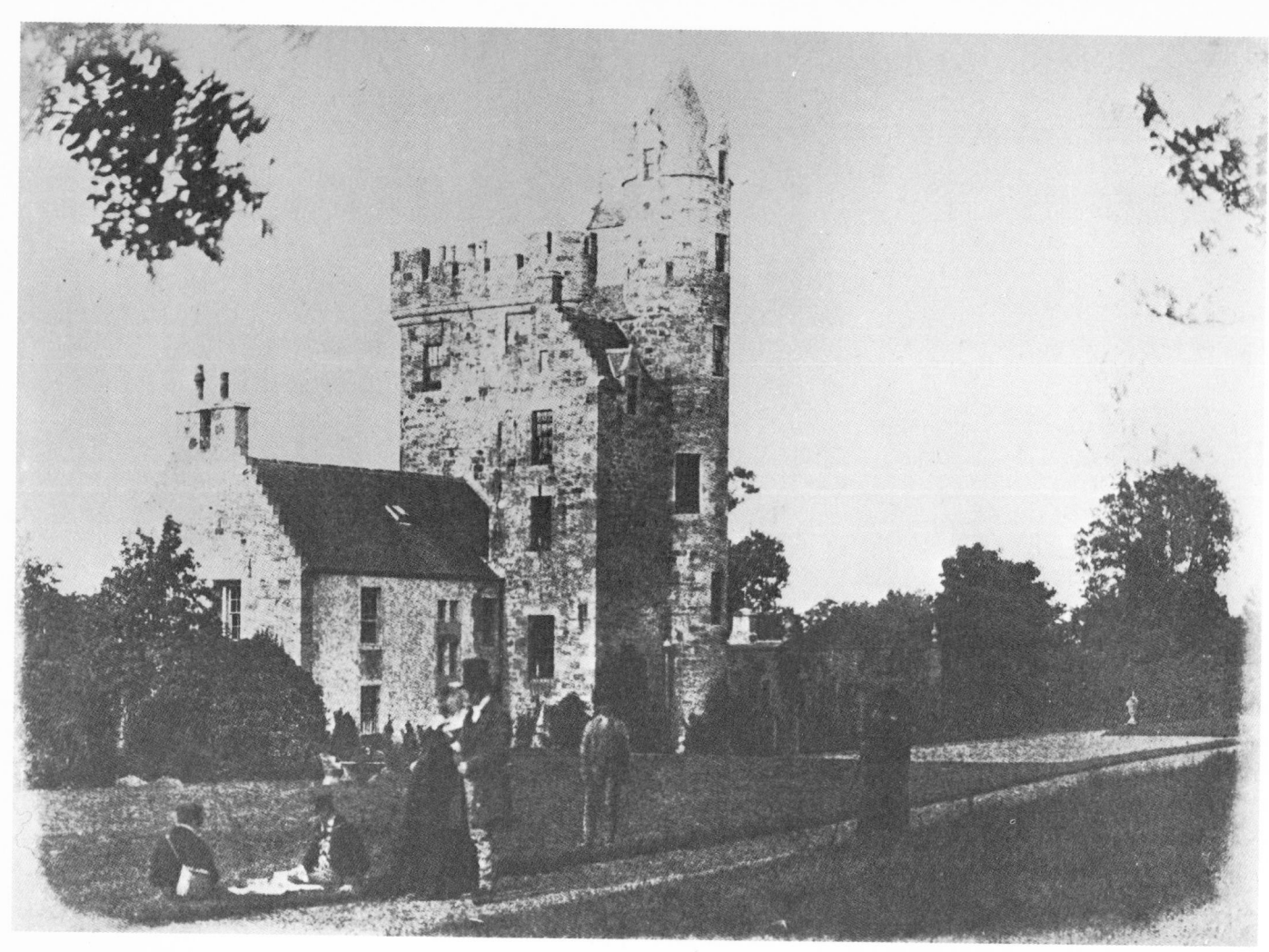

Bonaly Tower

153×210 mm. $(6\frac{1}{32} \times 8\frac{9}{32}$ in.)
Royal Scottish Academy

The figures in the foreground are Lord and Lady Cockburn. Henning, as Edie
Ochiltree, is to the right (see pp. 78 and 108).

'The Pastor's Visit'

141 × 195 mm. (5 9/16 × 7 11/16 in.)
National Library of Scotland

The Pastor of the picture's title was Dr James Fairbairn (1804–79) whose parish was the fishing village of Newhaven, the scene of many of Hill's and Adamson's calotypes. Dr Fairbairn took up his charge in 1838 and was so quickly established in the affections of his congregation that when he joined the Free Church at the Disruption his flock followed without exception.

According to Elliott's *Calotypes*, Dr Fairbairn knew every one of his parishioners by name. He took a particular interest in the welfare of the fishermen and was instrumental in organizing a scheme to raise money to buy boats which gave greater comfort and protection to the fishers.

This calotype was not made in Newhaven. Behind the group is what is quite evidently the door of Rock House but it is not at all surprising to find the fisherlassies in the setting. It was their daily work to bring fish in their creels from Newhaven to the streets of Edinburgh for sale. The other participant in the picture is identified in Elliott as Mr Gall.

The Misses McCandlish

205 × 160 mm. $(8\frac{1}{16} \times 6\frac{5}{16}$ in.)
Royal Scottish Academy

Charming as this calotype is, there is a feeling that it demonstrates the weakness
of the calotype system. The fibrous texture does not always lend itself to the
exploitation of essentially sentimental subject matter. It is possible to speculate
whether the daguerreotype might not have been the more appropriate medium.

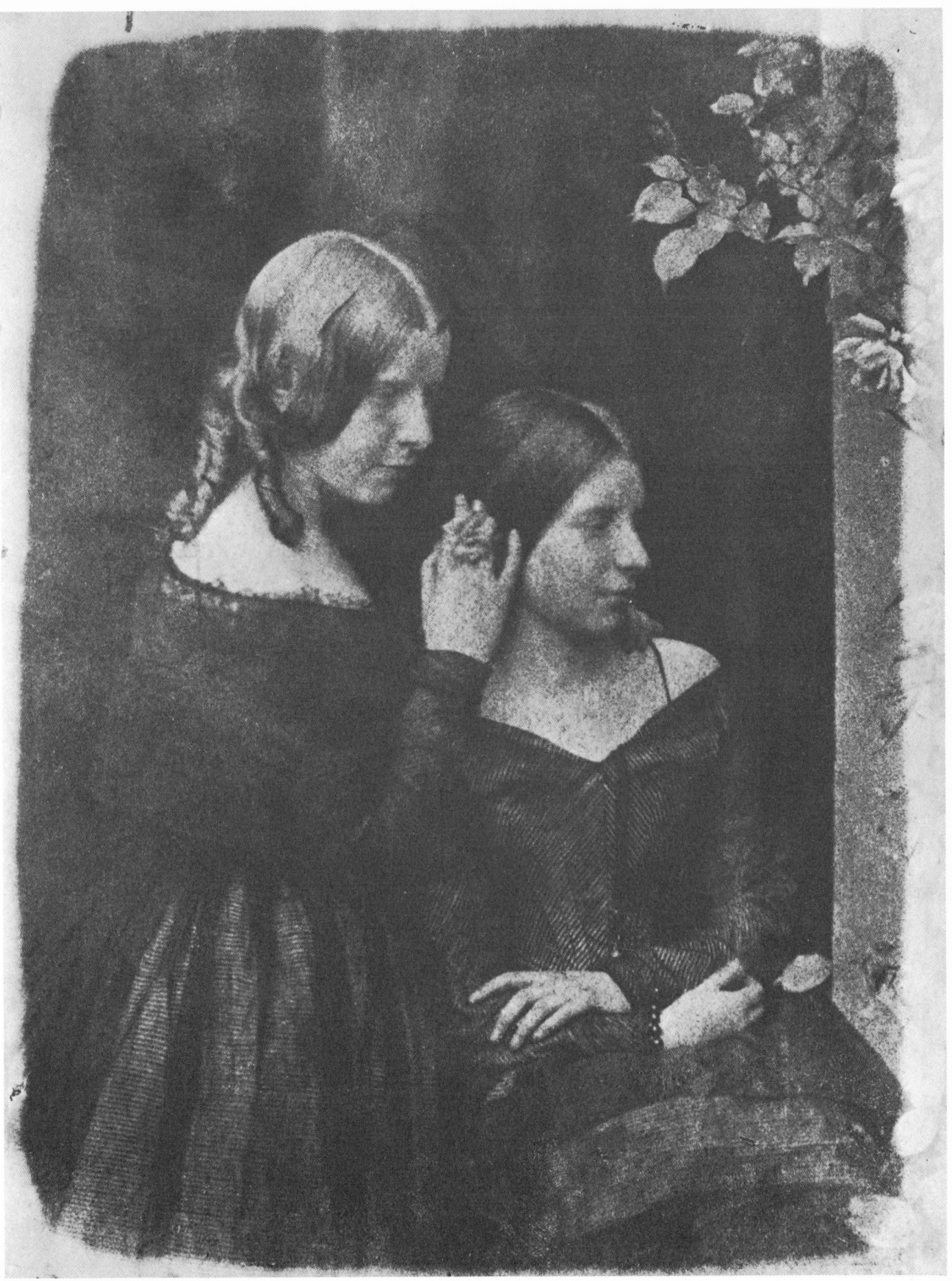

159

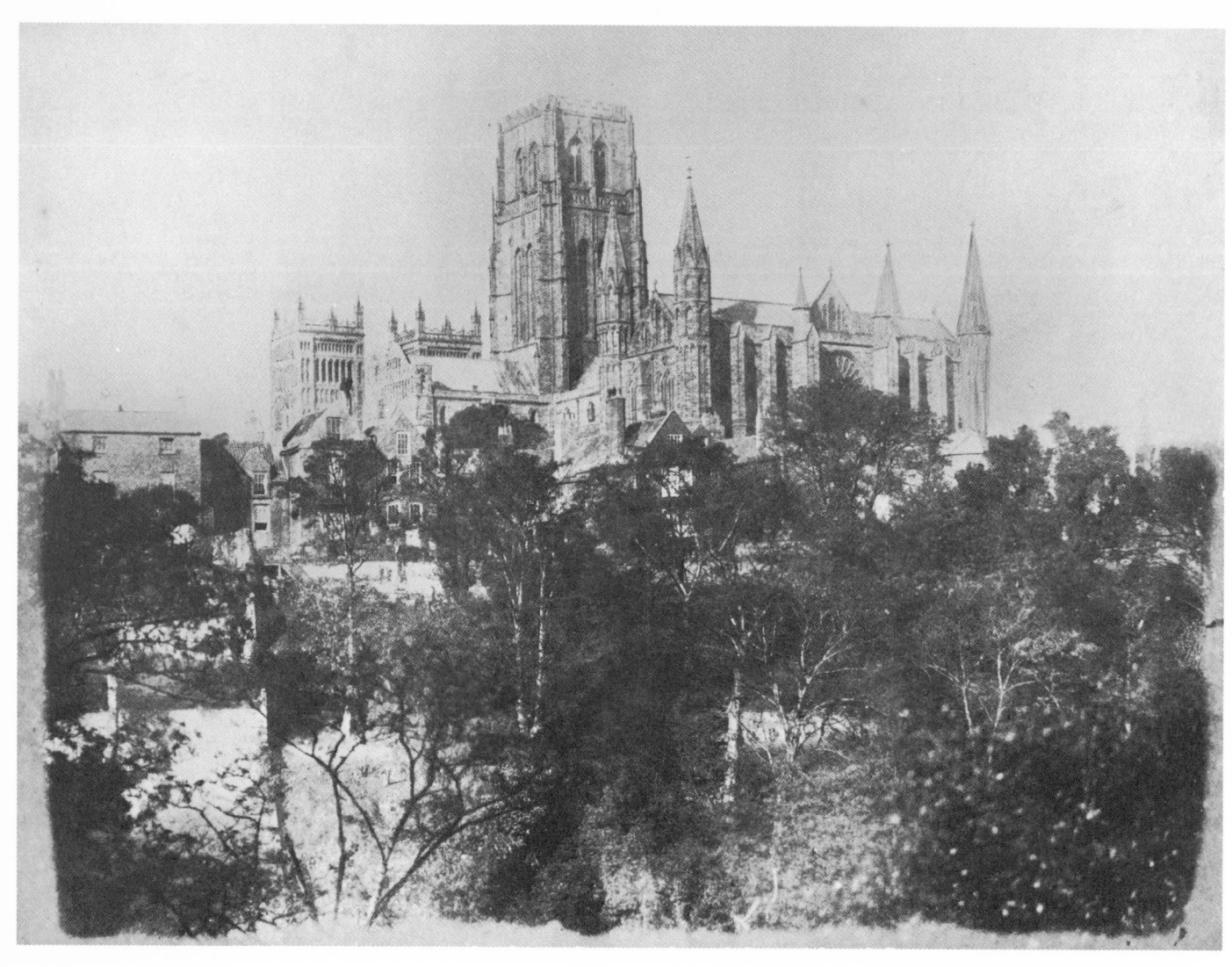

Durham Cathedral

303×382 mm. ($11\frac{15}{16} \times 15\frac{1}{32}$ in.)
Royal Scottish Academy

Unfortunately for posterity, Hill and Adamson travelled only short distances together from Edinburgh. In contrast to many of their sitters, of whom a remarkable number had been to far-off countries in the service of their Queen or their Church, the calotypists seem never to have taken their equipment farther than Glasgow, St Andrews and York. (Hill made frequent visits to London on behalf of the RSA but never on photographic occasions.)

The Durham calotypes were made within about a year of the opening of the Rock House Studio. In her journal for 19 December 1844 Miss Rigby wrote 'To Mr Hill's to see his wonderful calotypes – one of Durham most exquisite.'

Mrs Rigby and Miss Elizabeth Rigby

208 × 156 mm. (8 $\frac{3}{16}$ × 6 $\frac{5}{32}$ in.)
Royal Scottish Academy

The Rigbys, mother and daughter, were surprisingly frequent sitters for the
calotypists in view of the fact that they were only visitors to Edinburgh. Mrs
Rigby was the wife of a doctor in Norfolk. Miss Elizabeth Rigby, later Lady
Eastlake, perpetrated a famous attack on Charlotte Bronte's *Jane Eyre* in
The Quarterly.

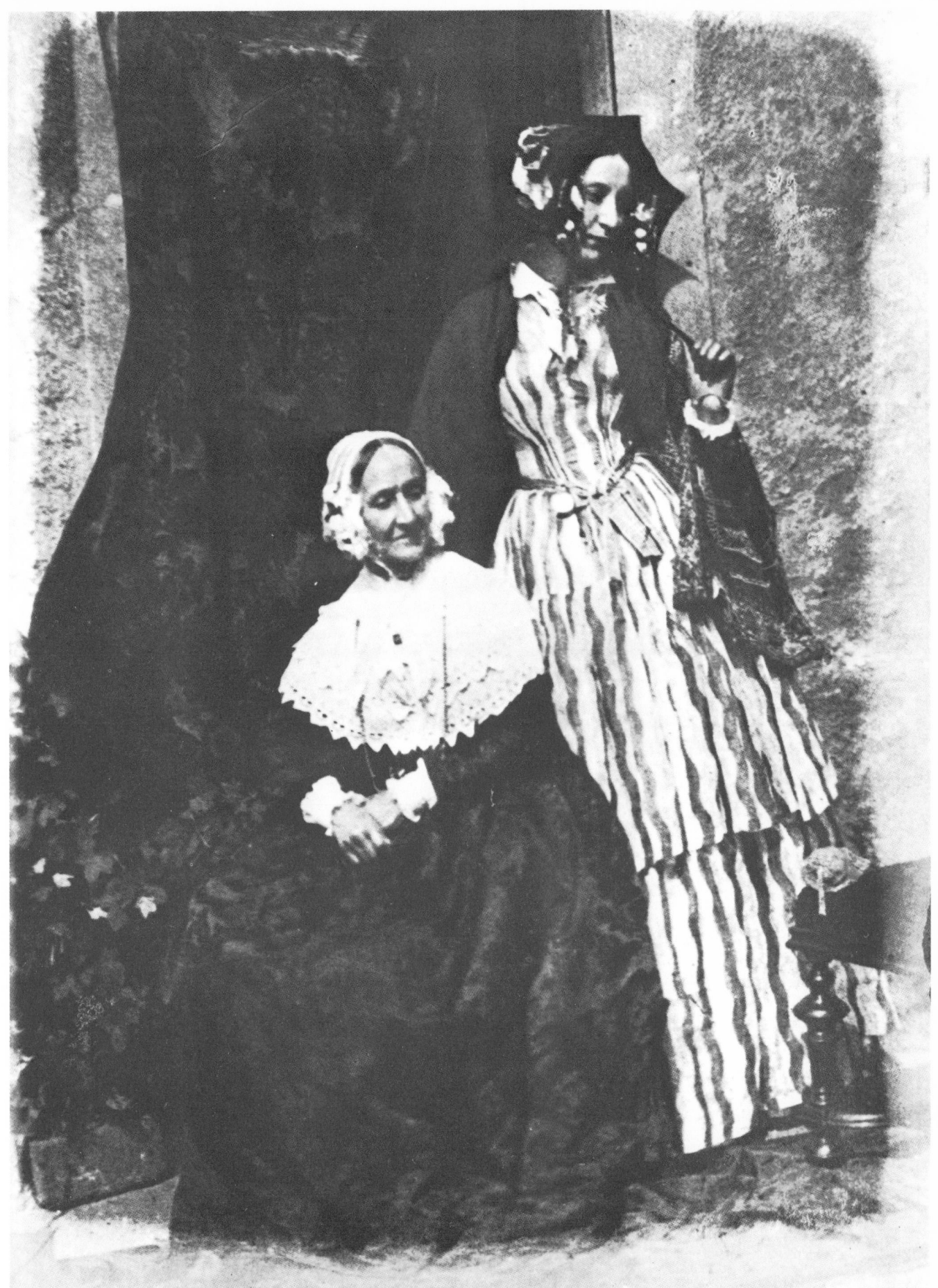

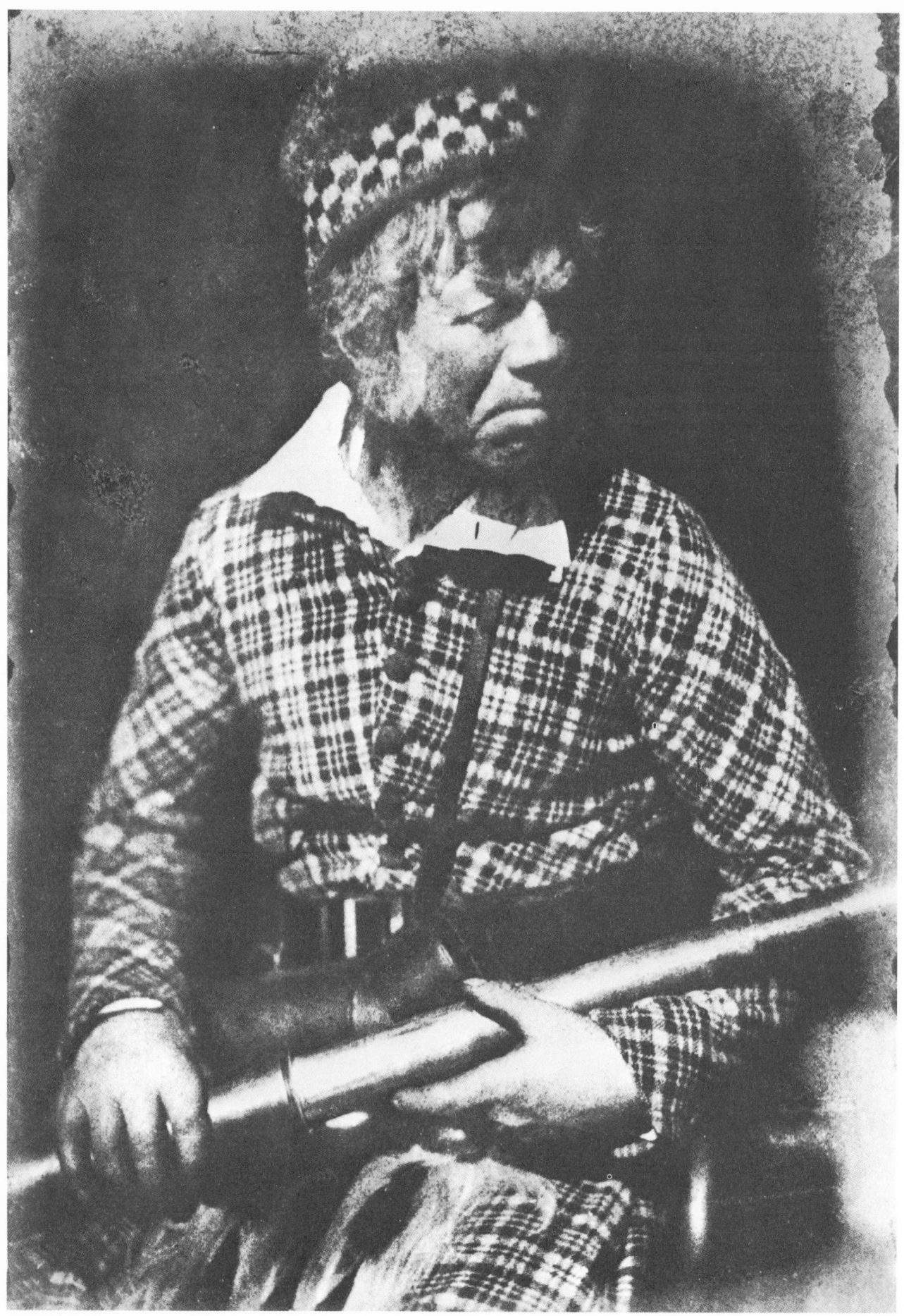

Finlay of Colonsay

204 × 145 mm. ($8\frac{1}{32}$ × $5\frac{23}{32}$ in.)
Royal Scottish Academy

Finlay of Colonsay was a deerstalker. The large telescope which he holds is evidence of his trade.

In Hill's and Adamson's coverage (presumably unplanned) of every walk of contemporary Scottish life there are comparatively few highlanders.

Hill possibly met Finlay on a visit to the island of Colonsay in 1830 or 1831. The calotype was made in August 1845.

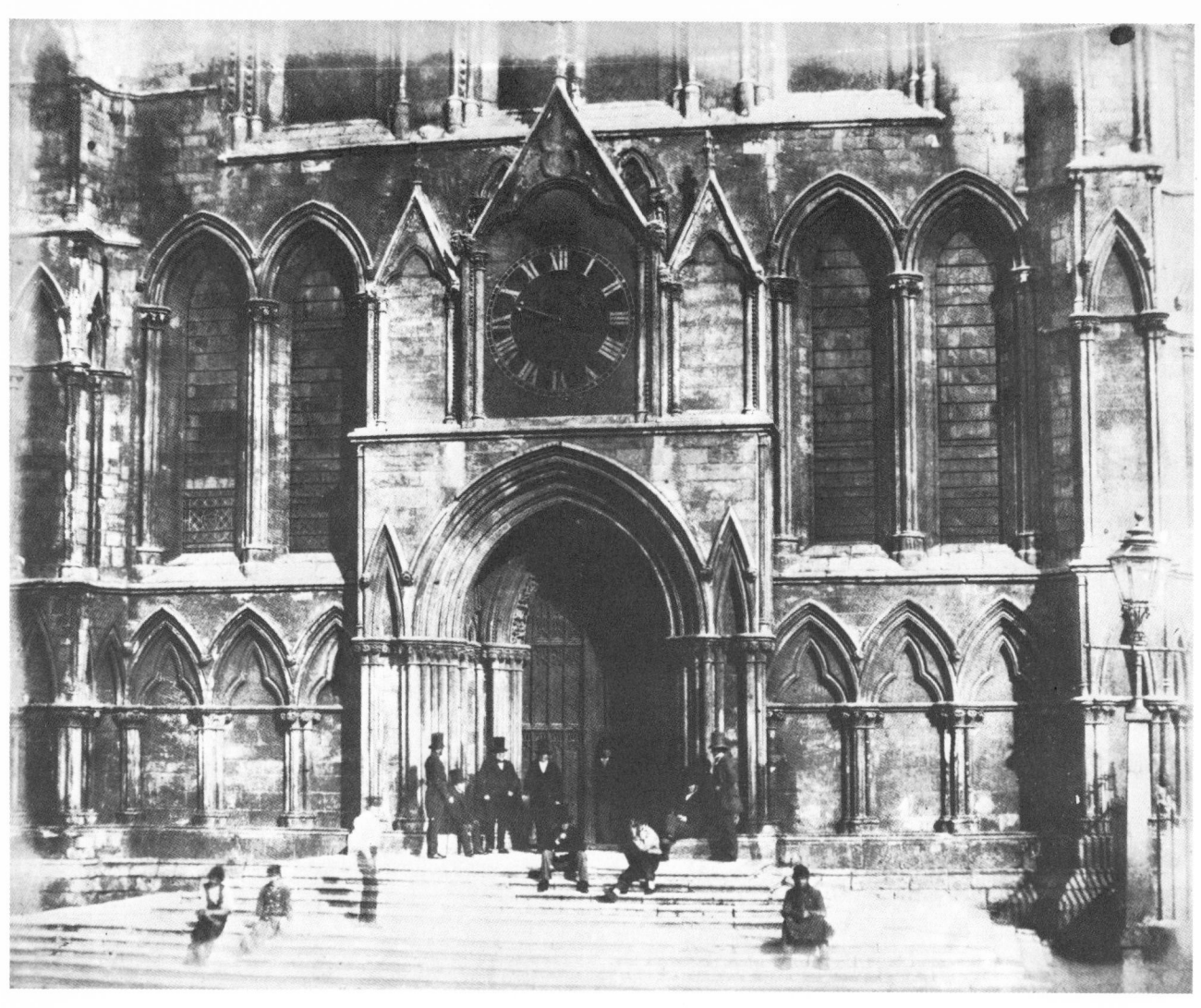

York Minster

299×375 mm. ($11\frac{25}{32} \times 14\frac{3}{4}$ in.)
Royal Scottish Academy

In October 1844 Hill and Adamson travelled to York to attend the meeting of the British Association. The occasion was potentially one of great significance to photography since not only were Hill and Adamson there, the men who had proved the artistic potential of the new medium, but so was the calotype's inventor, William Henry Fox Talbot.

Unfortunately very little remains to us as evidence of their encounter, only three letters and the picture above which is of the South Door of the Minster. It is tantalizing that though we can say that the picture represents one of the first photographs taken at a scientific conference we can go no further. We cannot say which of the top-hatted gentlemen is Fox Talbot or, indeed, if he is there at all, even though the chances must be quite strong that the gentleman scientist from Wiltshire is one of the group.

Two Fishermen

157 × 113 mm. (6 $\frac{3}{16}$ × 4 $\frac{7}{16}$ in.)
Scottish National Portrait Gallery

It is comparatively unusual to find a Hill/Adamson portrait calotype, of this format at least, which is shot against an apparently white background. The background was, of course, not empty but any distant detail was simply 'washed out'. The calotype dates from June 1845.

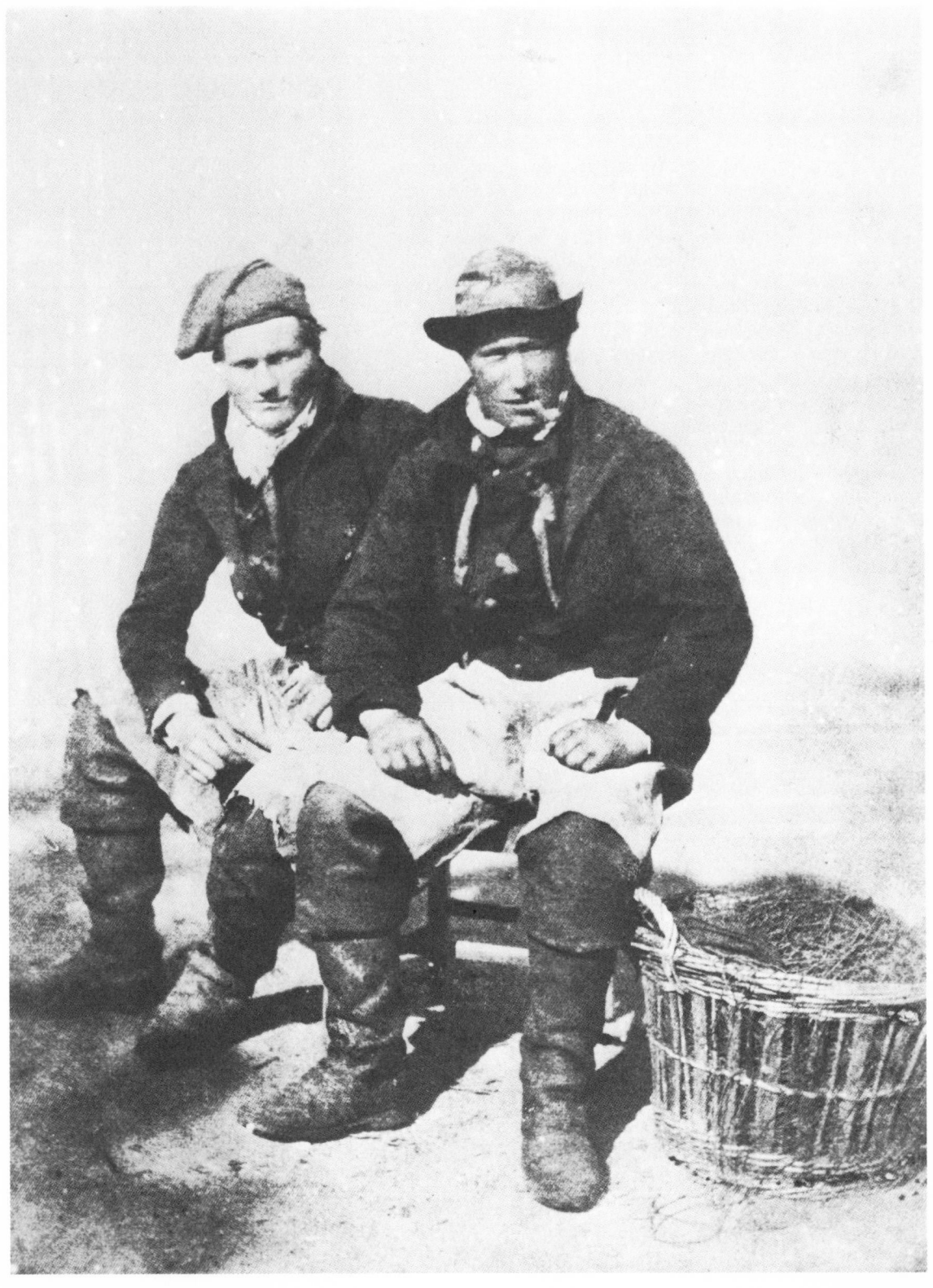

Market Place, St Andrews

143 × 193 mm. (5⅝ × 7¹⁹⁄₃₂ in.)
Scottish National Portrait Gallery

This fascinating photograph is one of a pair, almost
identical, but whose discrepancies tell us something.
Apart from some slight positional changes (the child in
the light clothing, second from the right, is at the edge
of the pavement in the other version) the shadow cast
by the central figure has moved appreciably, suggesting
half an hour or more between the taking of the shots.
From this we may deduce that much effort was needed
to set the shot up artistically and technically.

It must have required some skill on Hill's part to
organize his forces. The choice of a high angle is
appropriate but unusual in the calotypes. Several
commentators have remarked particularly on the vigour
with which the central figure is striding across the
scene. Most certainly she was not; she was completely
still but a convincing semblance of movement is
achieved even though the picture must have required
at least a minute's exposure.

This calotype marks one of the pinnacles of Hill's
and Adamson's achievement.

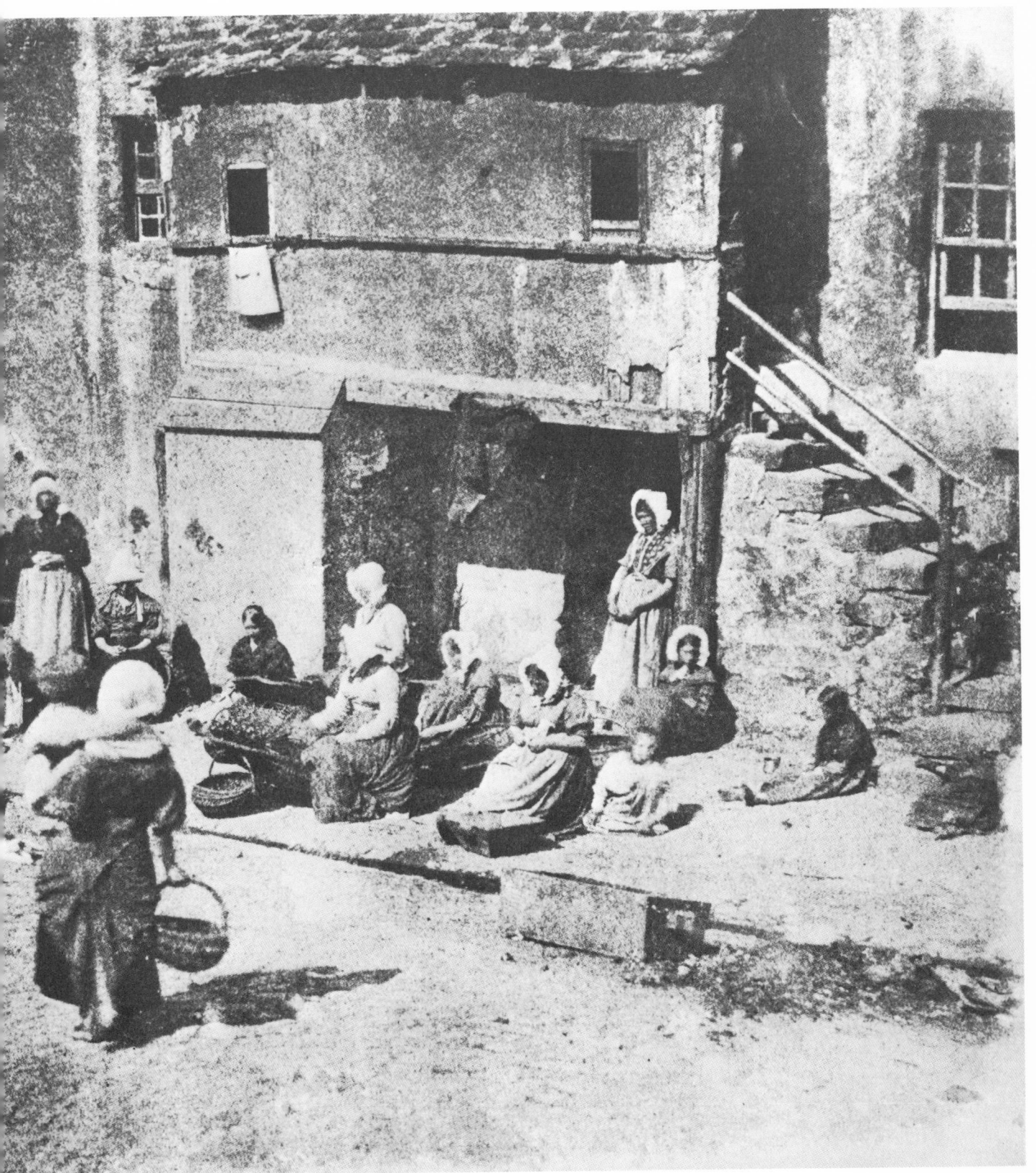

James Ballantine

180 × 154 mm. ($7\frac{3}{32}$ × $6\frac{1}{16}$ in.)
Scottish National Portrait Gallery

'This genial and gifted Scotsman' as Elliott's *Calotypes* describes him, 'whose songs will plead against oblivion for his name', lived from 1808 to 1877. He was an exceedingly versatile man whose achievements included writing biography and verse and the production of stained glass. He began his career as a house painter but in 1845 he published a treatise on stained glass that so impressed the authorities that he was given the job of designing windows in the House of Lords.

170

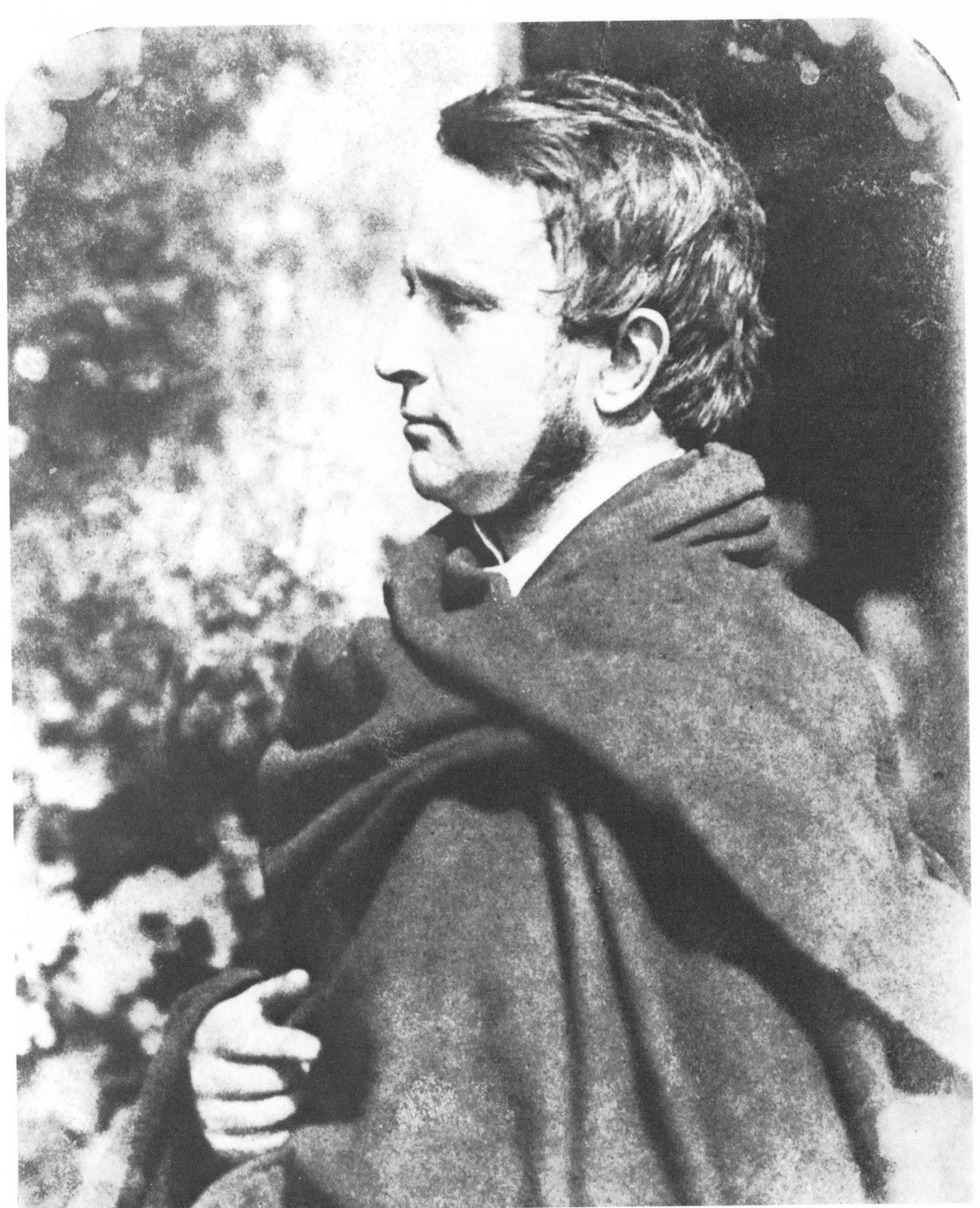

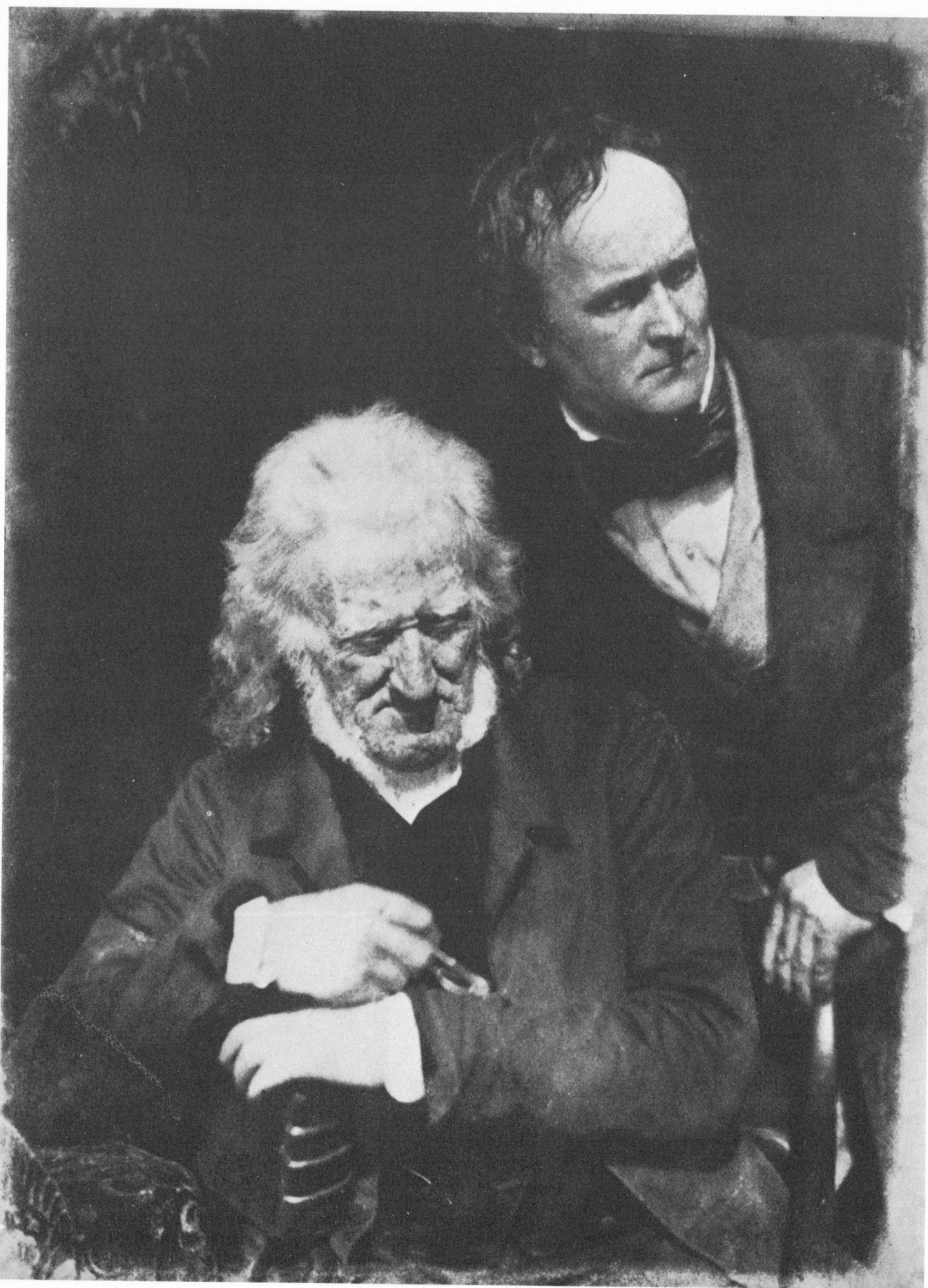

172

John Henning and Alexander Handiside Ritchie

209 × 157 mm. ($8\frac{7}{32}$ × $6\frac{3}{16}$ in.)
Scottish National Portrait Gallery

John Henning, whose features are so familiar to admirers of Hill's and Adamson's work, appears elsewhere in this volume. Alexander Handiside Ritchie (1804–70) was one of Hill's many sculptor friends and his work is still to be found in parts of Edinburgh today.

He was trained in Edinburgh and Rome and his main output was of decorative figures for monuments and other public buildings. It is his portrait bust of George Meikle Kemp, the architect of the Scott Monument, which is in the monument today. His work also features on the Wallace Monument near Stirling, and at the Hamilton Mausoleum. A large scale example is to be found at the Commercial Bank in George Street, Edinburgh. The period of the calotypes coincides with that of Ritchie's greatest activity.

Apart from this calotype, and others in which he appears with John Henning, Ritchie was also photographed several times on his own.

Sandy (?) Linton, Newhaven Fisherman

204 × 151 mm. ($8\frac{1}{32} \times 5\frac{15}{16}$ in.)
Scottish National Portrait Gallery

This is one of the group of calotypes thought to have been made in June 1845.
There are several similar pictures using the same subject and, indeed, the same
boat. Copies of these shots are to be found in virtually all of Hill's albums but
the quantity in which they are available in no way detracts from the importance
of the shots which together make up one of the best units within the work of
Hill and Adamson.

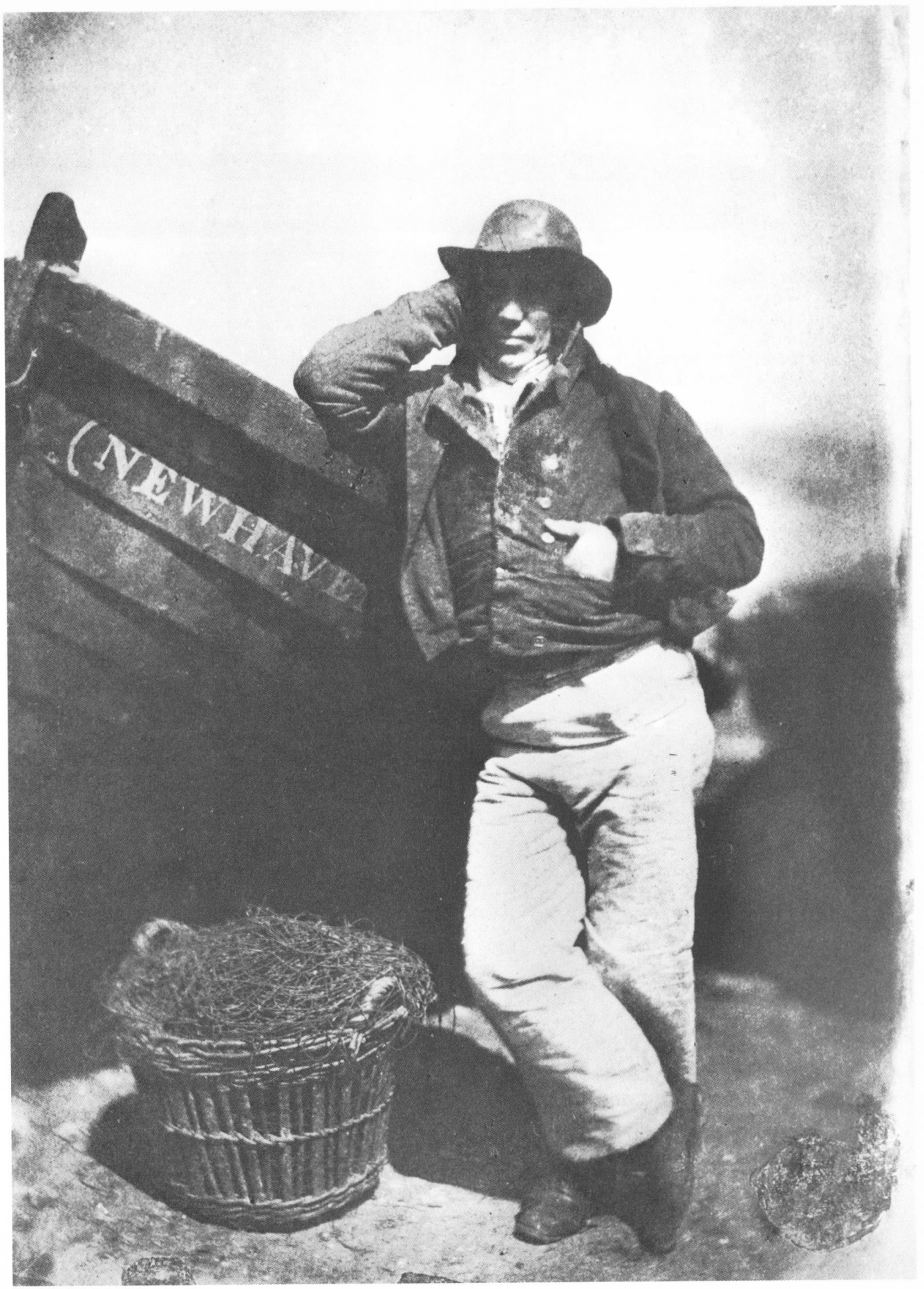

Linton, His Boat, and His Bairns

201 × 146 mm. (7$\frac{29}{32}$ × 5$\frac{3}{4}$ in.)
Scottish National Portrait Gallery

This is one of the most immediately recognizable of the Hill/Adamson calotypes. It undoubtedly has a sense of style about it which lifts it out of the ordinary. It is a picture about which much has been written in terms of painterly influences but to justify it entirely in these terms may be a disservice to Hill and Adamson and to the practice of photography.

It is simply superb and one of the great examples of early photography. The picture is one of those taken at Newhaven in June 1845.

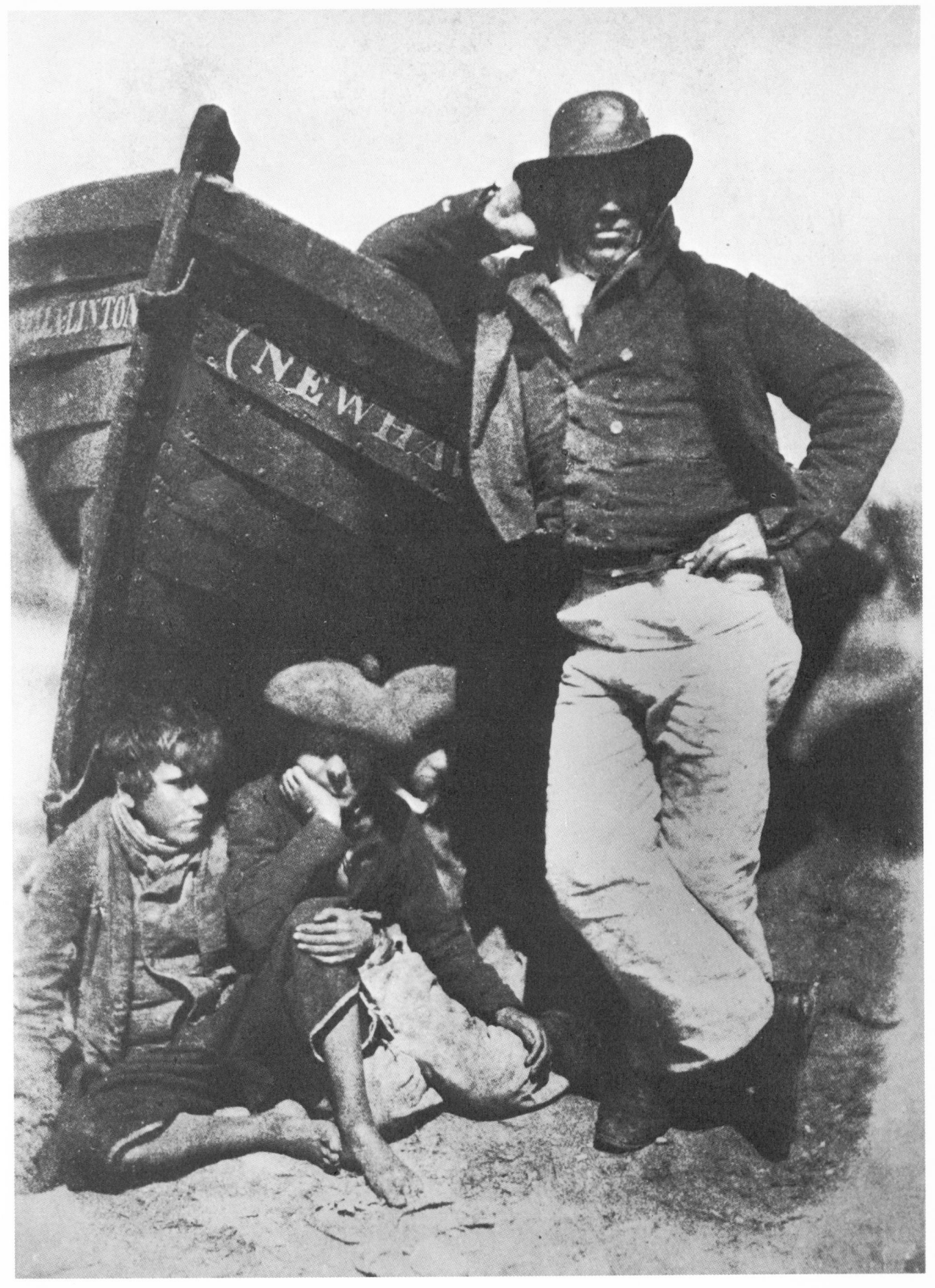

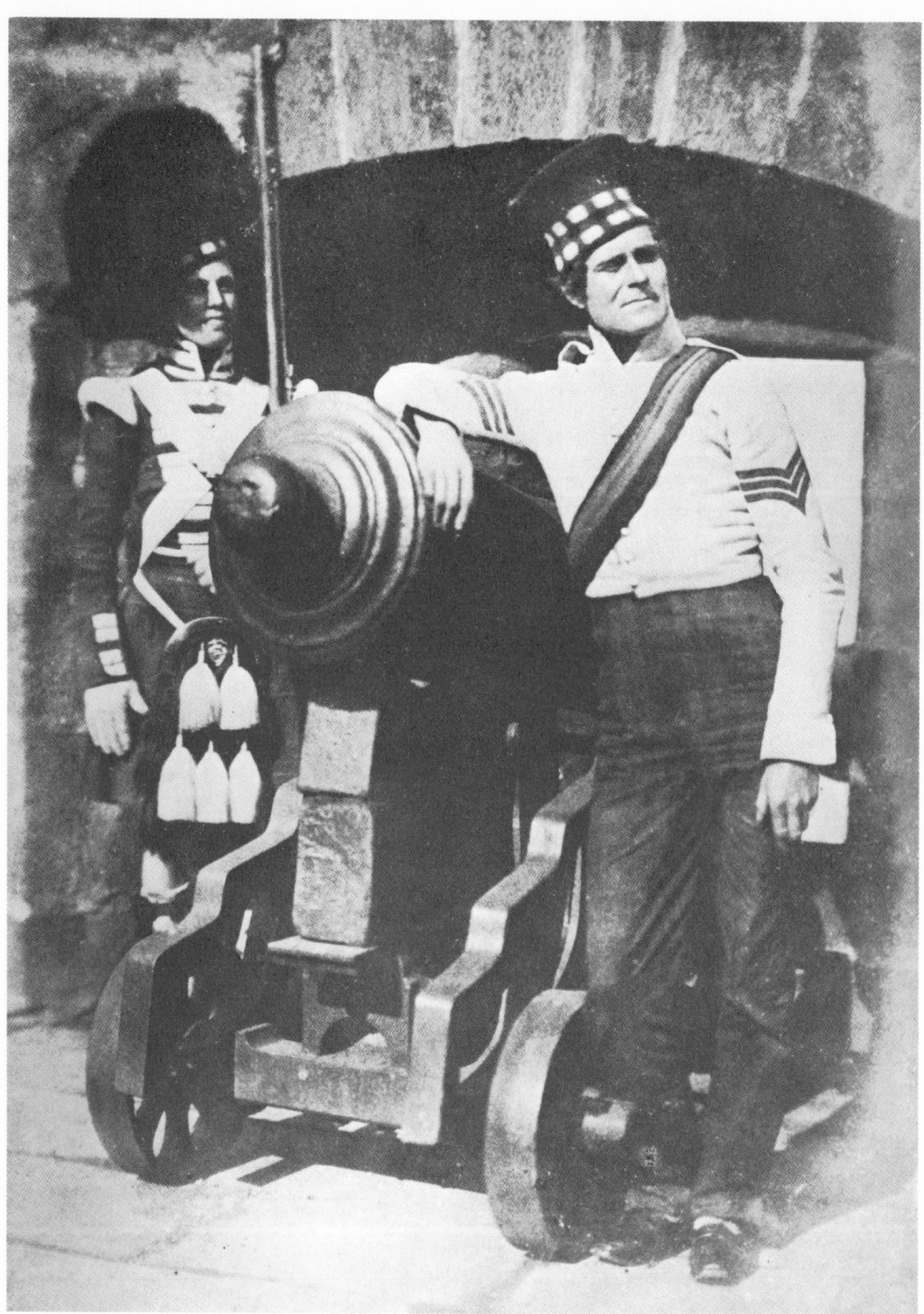

A Port Hole, Edinburgh Castle

196 × 146 mm. (7$\frac{23}{32}$ × 5$\frac{3}{4}$ in.)
Scottish National Portrait Gallery

Some concern was expressed to Katherine Michaelson when she showed this calotype to military historians. It transpired that the sergeant is wearing his sash across the wrong shoulder but there seems to be no evidence of the print being reversed.

There the matter must rest, a minor mystery, which in no way detracts from the splendidness of the picture.

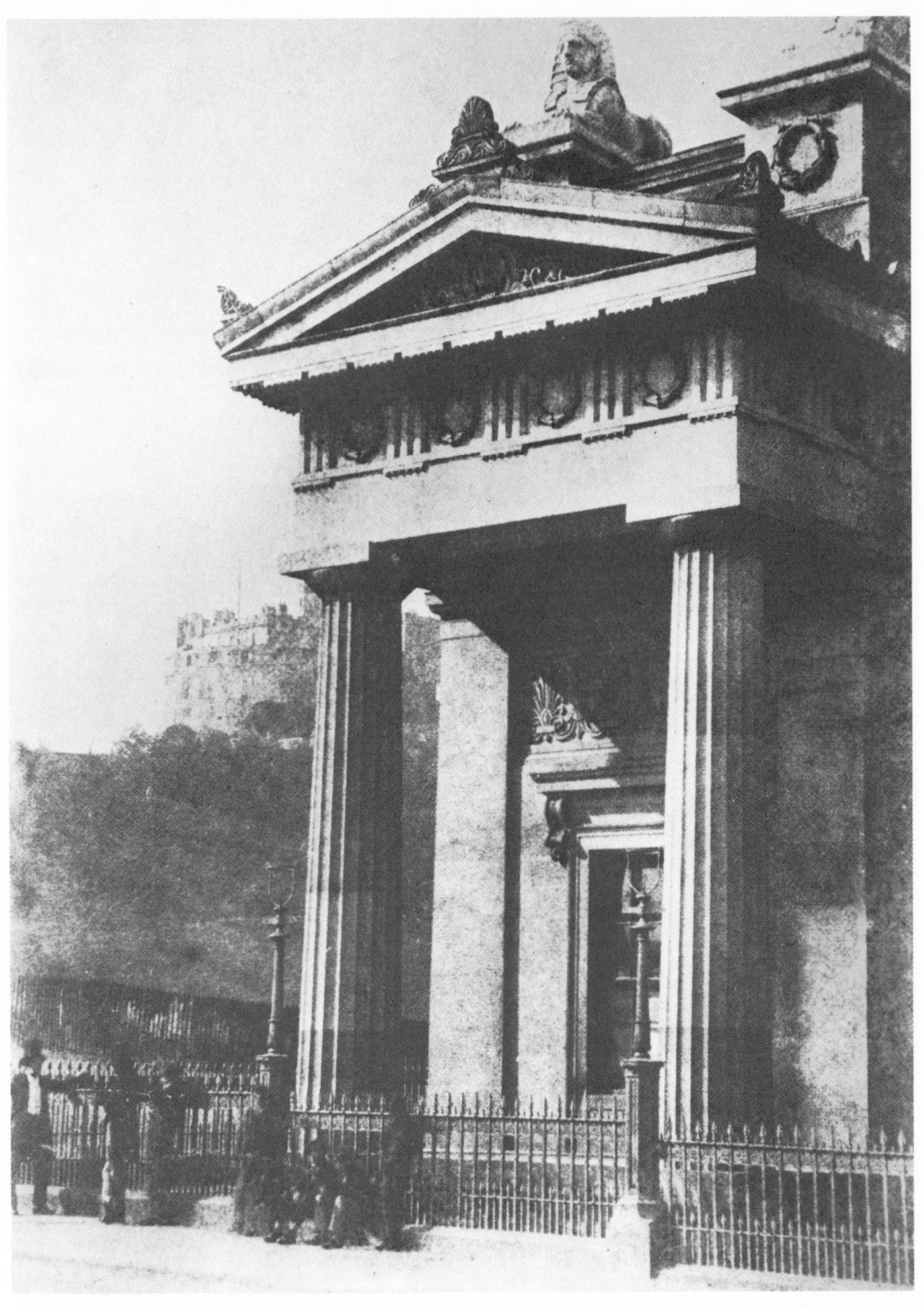

The Royal Institution, Edinburgh

195 × 145 mm. (7 $\frac{11}{16}$ × 5 $\frac{23}{32}$ in.)
Scottish National Portrait Gallery

The Royal Institution, now known as the Royal Scottish Academy, is at the
foot of The Mound, the artificial earthwork thrown up to join the older portion
of Edinburgh with the New Town. This particular view may have had sentimental
associations for Hill who, as Secretary of the RSA, would turn this corner every
working day.

Mr Robert Bryson, Horologer

212 × 156 mm. (8$\frac{11}{32}$ × 6$\frac{5}{32}$ in.)
Scottish National Portrait Gallery

Robert Bryson was a 'horologer' or watchmaker and optician whose shop at
66 Princes Street was, incidentally, practically next door to that of Hill's brother,
Alexander. He appears in the Disruption Painting.

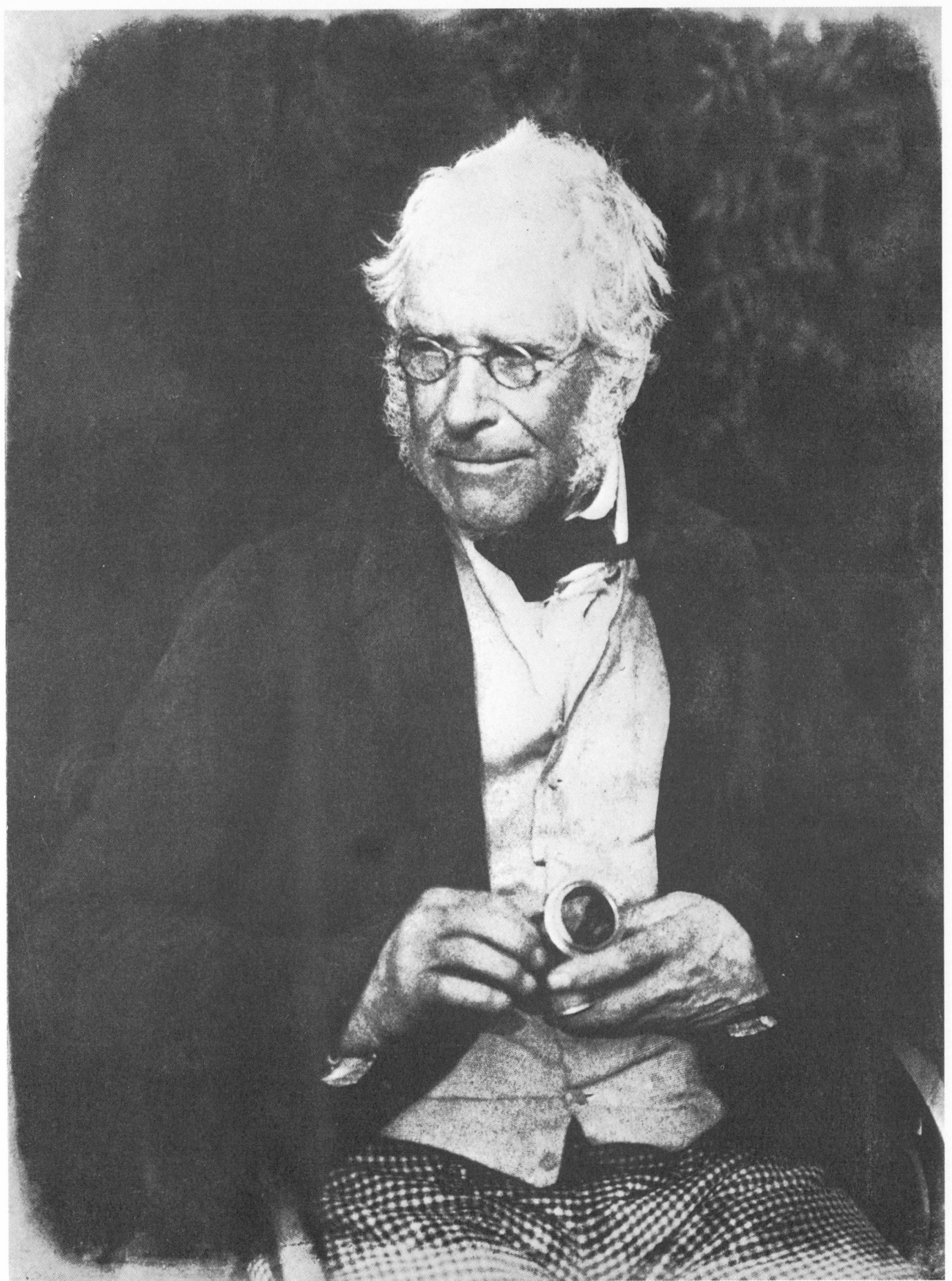

Bonaly Tower

199×155 mm. ($7\frac{27}{32}×6\frac{3}{32}$ in.)
Scottish National Portrait Gallery

In the summer of 1846 and 1847 the weather was unusually sunny and warm, a state of affairs welcome to photographers and those who had large country estates to enjoy. This calotype shows a considerable number of Lord Cockburn's family but it is worth noting also the presence of the family servants in the background. Indeed, Lord Cockburn's staff appear in most of the group shots (see also p. 55).

182

The Picnic at Bonaly

147 × 195 mm. (5$\frac{25}{32}$ × 7$\frac{11}{16}$ in.)
Scottish National Portrait Gallery

Lord Cockburn's picnics were greatly celebrated and at this particular one in August 1846 on the edge of the Pentland Hills overlooking Bonaly Tower there was a distinguished guest. In the foreground (right) is Sir Charles Lyell (1797–1875) the author of *Principles of Geology* (1830–33), one of the most influential scientific books of the nineteenth century. During the 1840s he made two visits to America and Lord Cockburn is quoted as saying that when Lyell visited him at Bonaly he was 'still clotted with the mud of the Mississippi'. Lyell was created a baronet in 1864 and was buried in Westminster Abbey.

On the left of the calotype either something has gone uncharacteristically awry for Hill and Adamson or there is an attempt to be humorous. For whatever reason, there is a lady in the picture who has a head but no body.

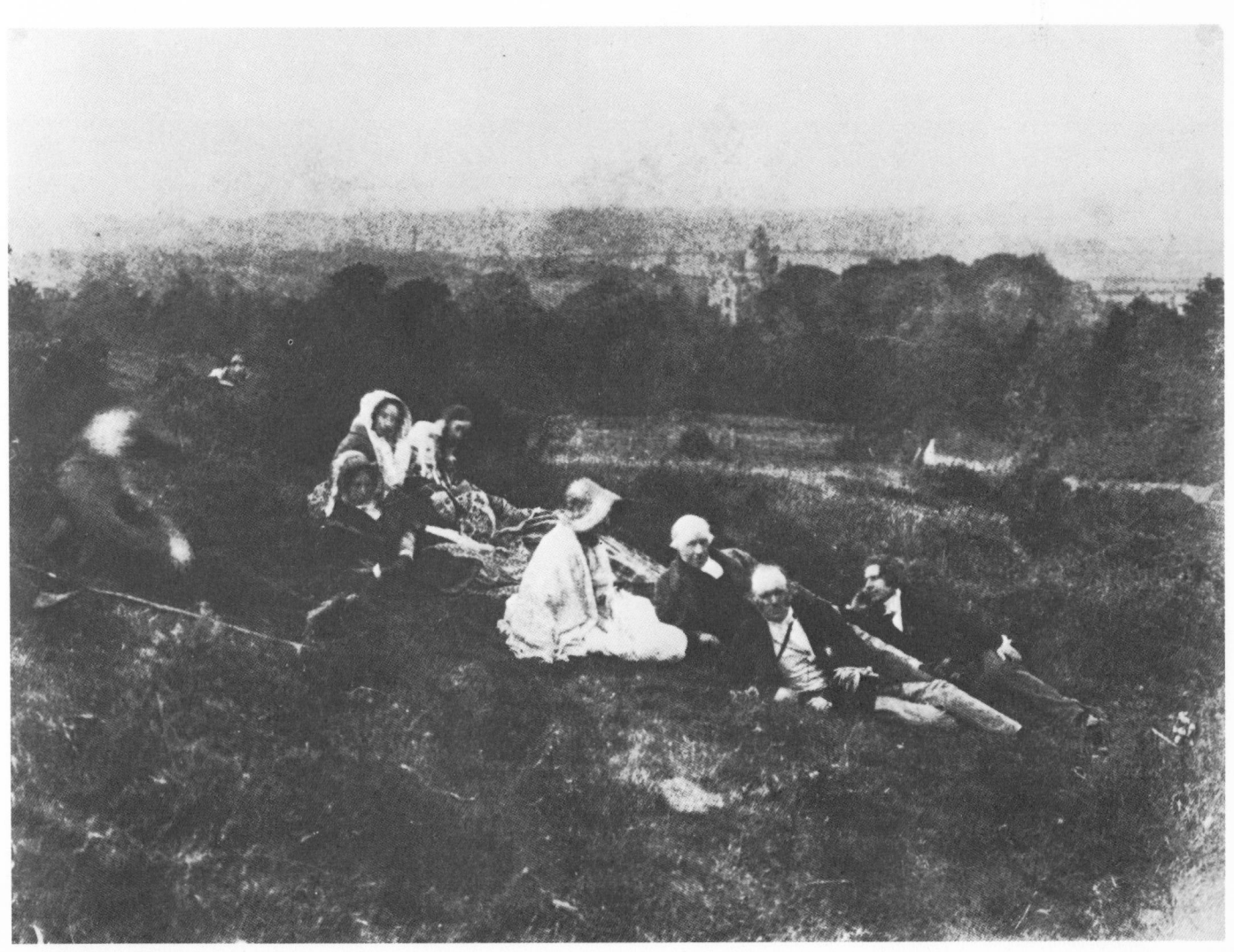

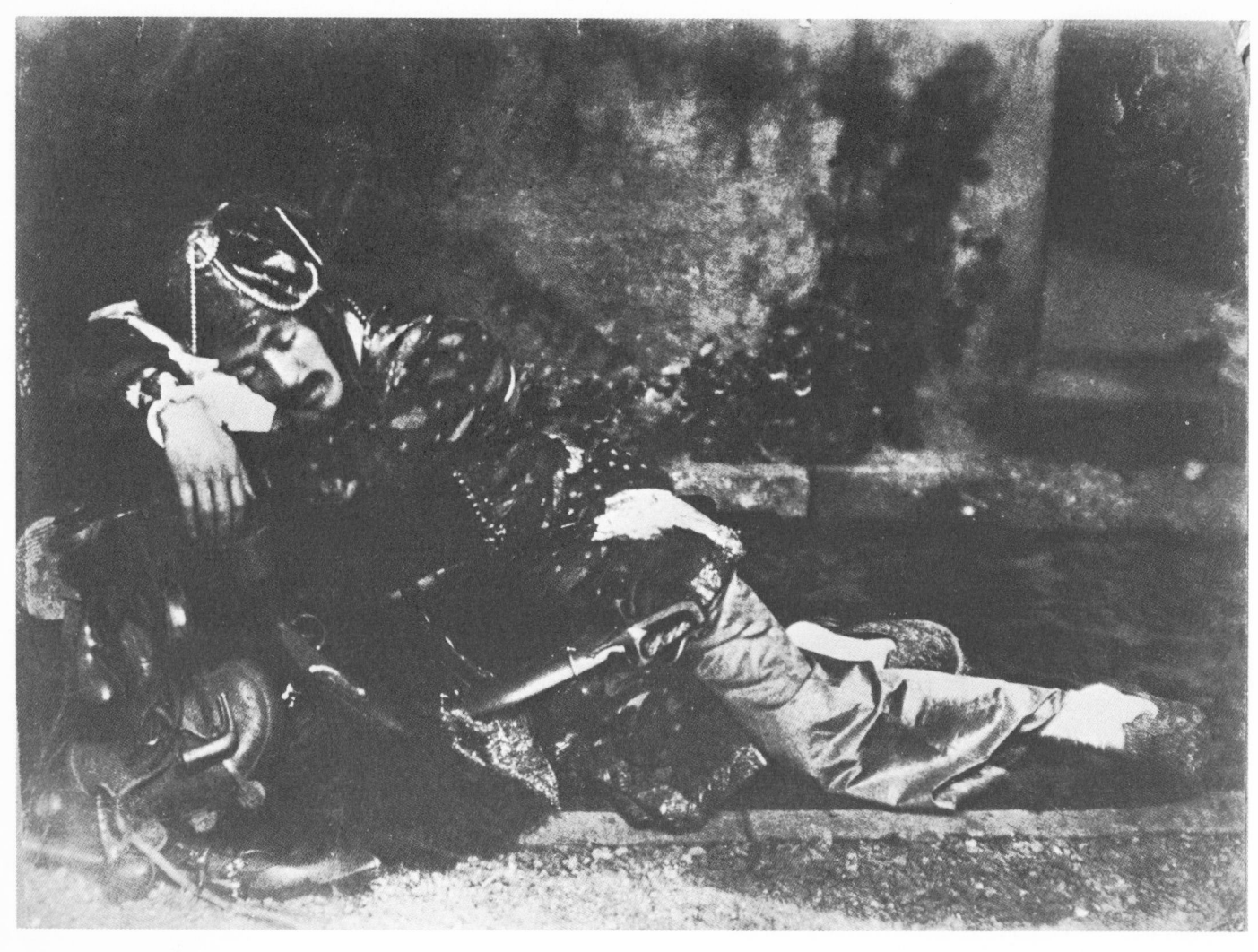

Edward W. Lane, As a Persian

147 × 202 mm. (5 25/32 × 7 15/16 in.)
Scottish National Portrait Gallery

Edward W. Lane (1801–76) was one of the most colourful characters encountered by Hill and Adamson. He posed for them at least eight times in various costumes. He was one of the outstanding Arabic scholars of his day and he translated into English *Tales of a Thousand and One Nights, with Notes Illustrative of the Egyptian Arabs* (1838–40). It is an accurate if slightly watered-down translation. Notable among his many other works are *Selections from the Koran* (1843) and the five-volume *Arabic Lexicon*. On a more domestic note, he is credited with a recipe for curry in Elizabeth Acton's *Modern Domestic Cookery*.

Newhaven Children

133 × 192 mm. (5¼ × 7 9/16 in.)
Scottish National Portrait Gallery

The problems associated with the making of this calotype are only too evident.
It was perhaps a little rash of Hill and Adamson to attempt to keep eight
children still long enough to take the photograph. Nevertheless, for all the
blurred edges, there is a genuine sense of informal charm about the finished
result.

The picture probably dates from June 1845.

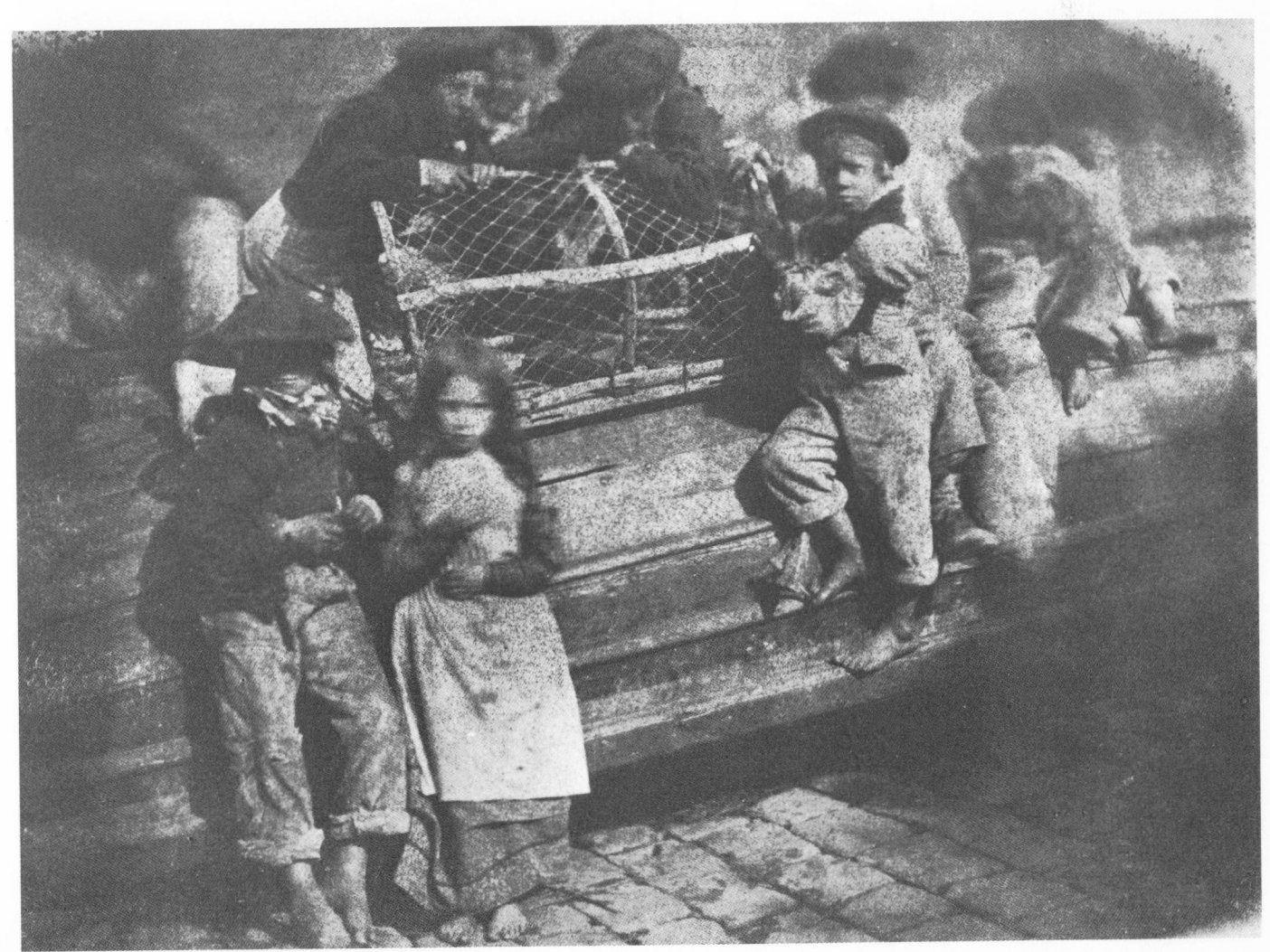

Trees at Bonaly

207 × 153 mm. $(8\frac{5}{32} \times 6\frac{1}{32}$ in.)
Scottish National Portrait Gallery

One of the calotypes made in and around Bonaly, this picture shows John
Henning in the familiar persona of Edie Ochiltree in a setting of which Scott
would certainly have approved. The screen of trees performs the function of
providing a backdrop but it might be argued that the figures (the second one is
probably D. O. Hill) are placed too far from the camera to be of significance in
the composition.

David Roberts

192×152 mm. $(7\frac{9}{16} \times 5\frac{31}{32}$ in.)
National Library of Scotland

David Roberts (1796–1866) was one of the most popular painters of his day; he was also one of the most far-travelled. His journeys took him to Egypt, Syria and the Holy Land. He began as a housepainter and decorator and graduated to scene painting, first, in his native Edinburgh, and then at Drury Lane in London.

His choice of subject matter was typical of the day and works such as *Destruction of Jerusalem* and *Departure of the Israelites from Egypt* figure prominently in his output.

The calotype was made at Dennystoun's Tomb, Greyfriar's churchyard. It contains a detail which recurs quite frequently in Hill's and Adamson's work – a top hat on its side.

188

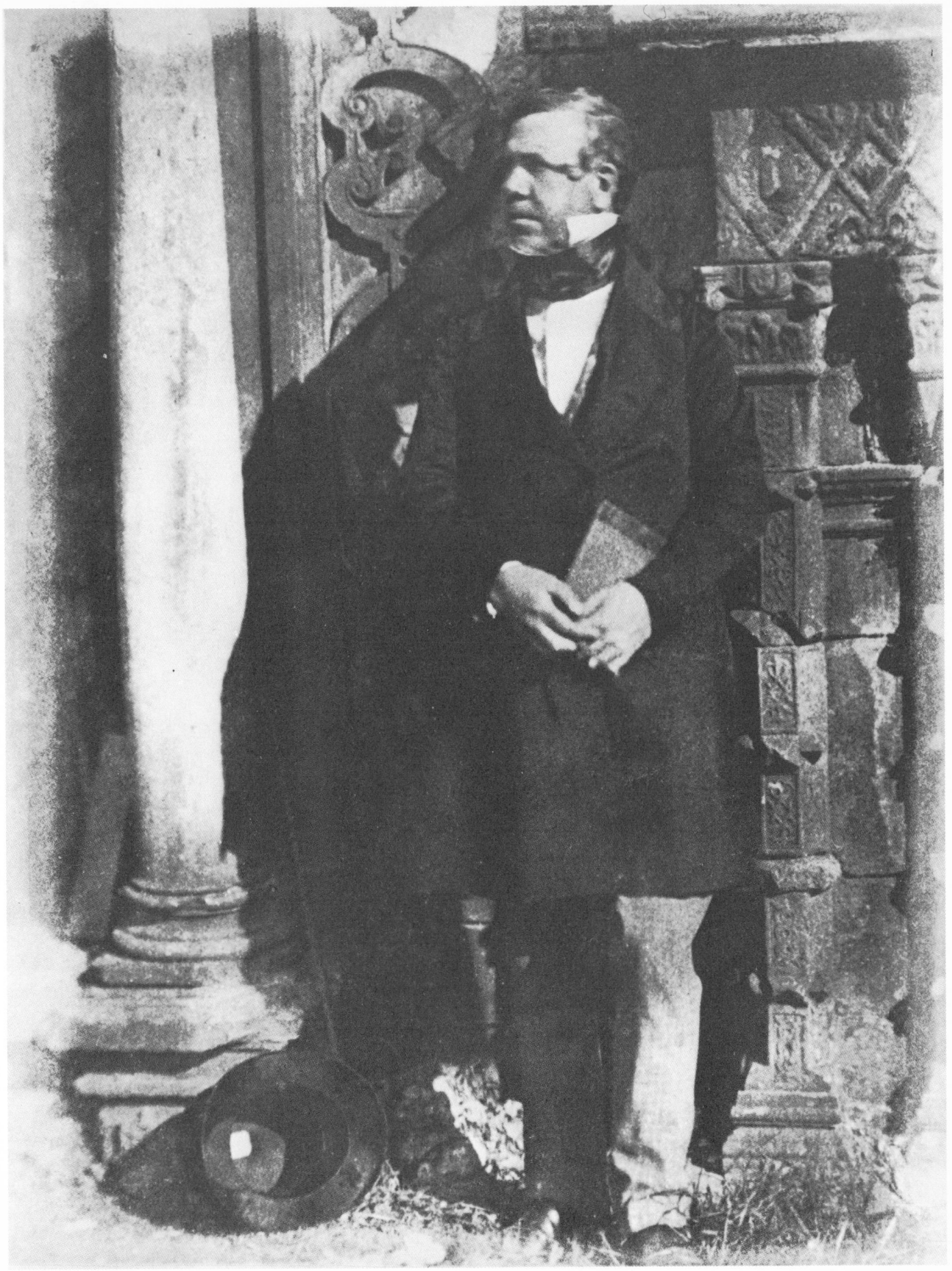

189

The Pends, St Andrews

195 × 142 mm. (7$\frac{11}{16}$ × 5$\frac{19}{32}$ in.)
Royal Scottish Academy

St Andrews was the home of Sir David Brewster at the time of his correspondence on photography with Fox Talbot. It was also the home of the Adamson family of whom first John and then Robert mastered the art of the calotype.

This ancient university town was a most suitable setting for photographic experiment with its harbour, castle, ruined cathedral and seascapes. The Adamsons were meticulous in their work and took great pains on such matters as the best time of day to shoot in particular locations. A note, extant, by one of them lists precise locations and times for the best results; e.g. the Castle, 11 a.m., Blackfriars, 1 p.m., etc.

Evidence of such detailed reconnaissance gives an insight into the work of Hill and Adamson. It increases our awareness both of the problems they had to overcome and of the measure of their achievement.

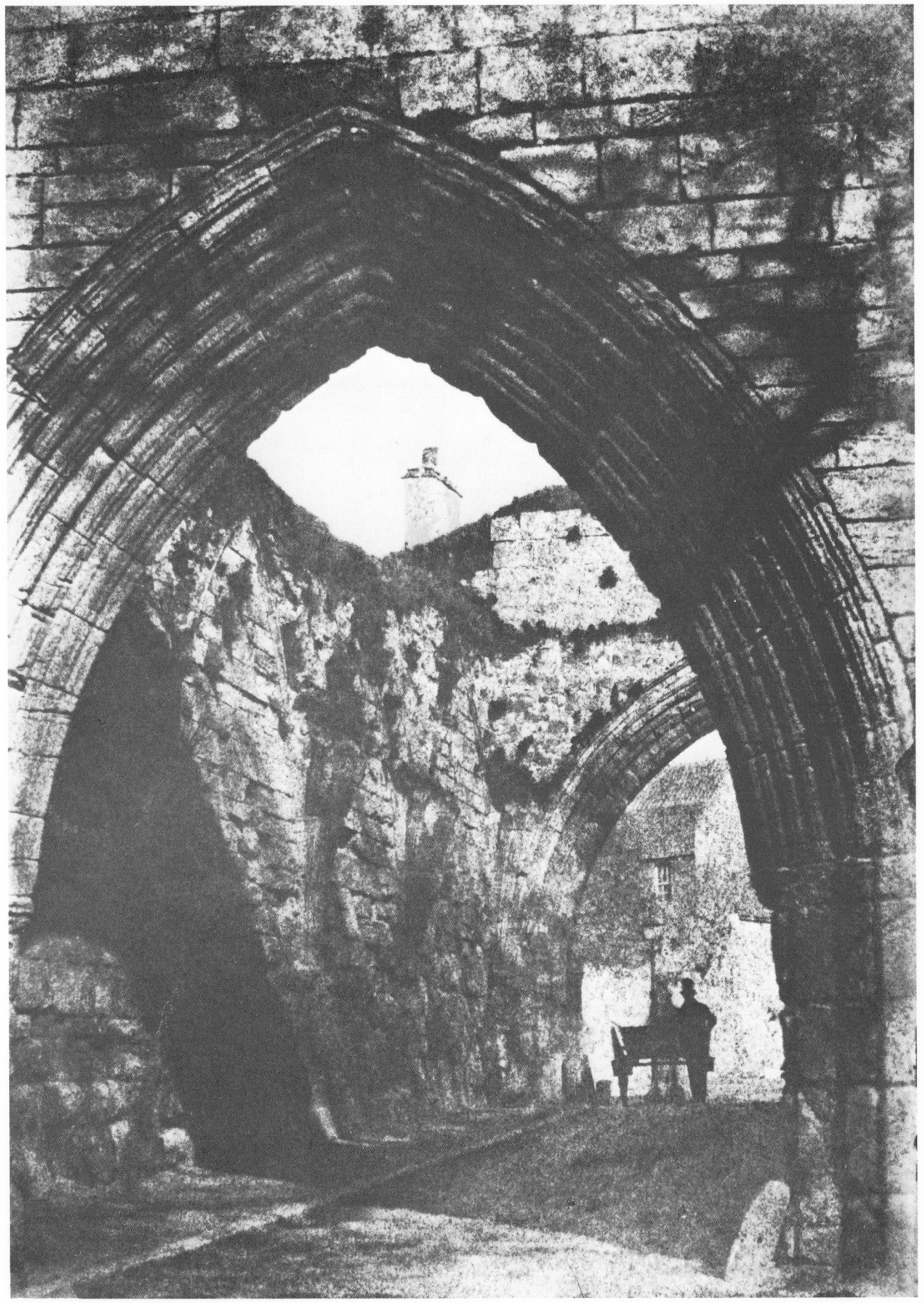

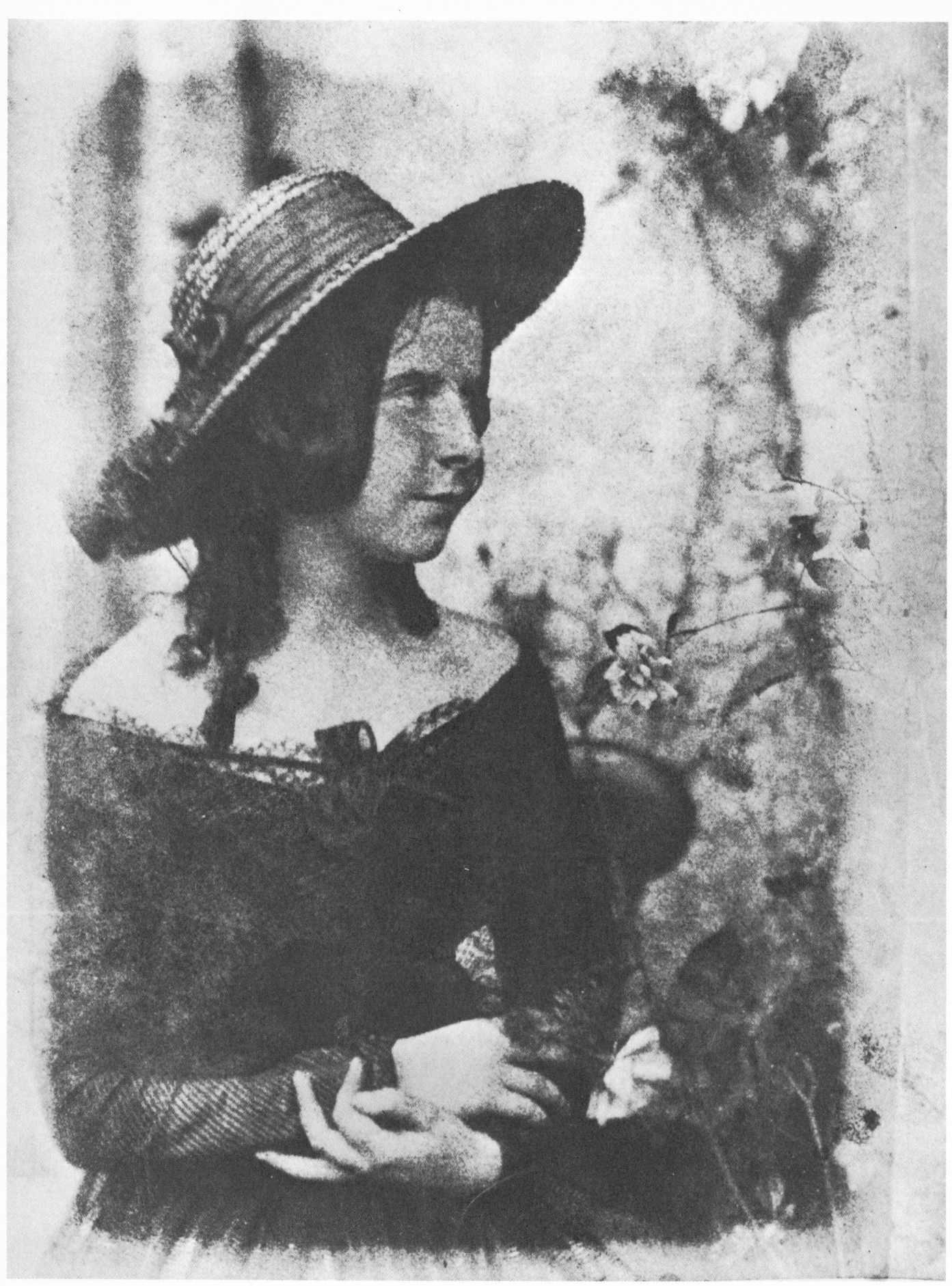

Miss McCandlish

200×160 mm. $(7\frac{7}{8} \times 6\frac{5}{16}$ in.)
Royal Scottish Academy

This calotype shows Miss McCandlish, later Mrs Arkley, against a white background which gives a greater sense of informality than in other shots of the same girl. Nevertheless, great care has been taken with detail, particularly in the arrangement of her hands.

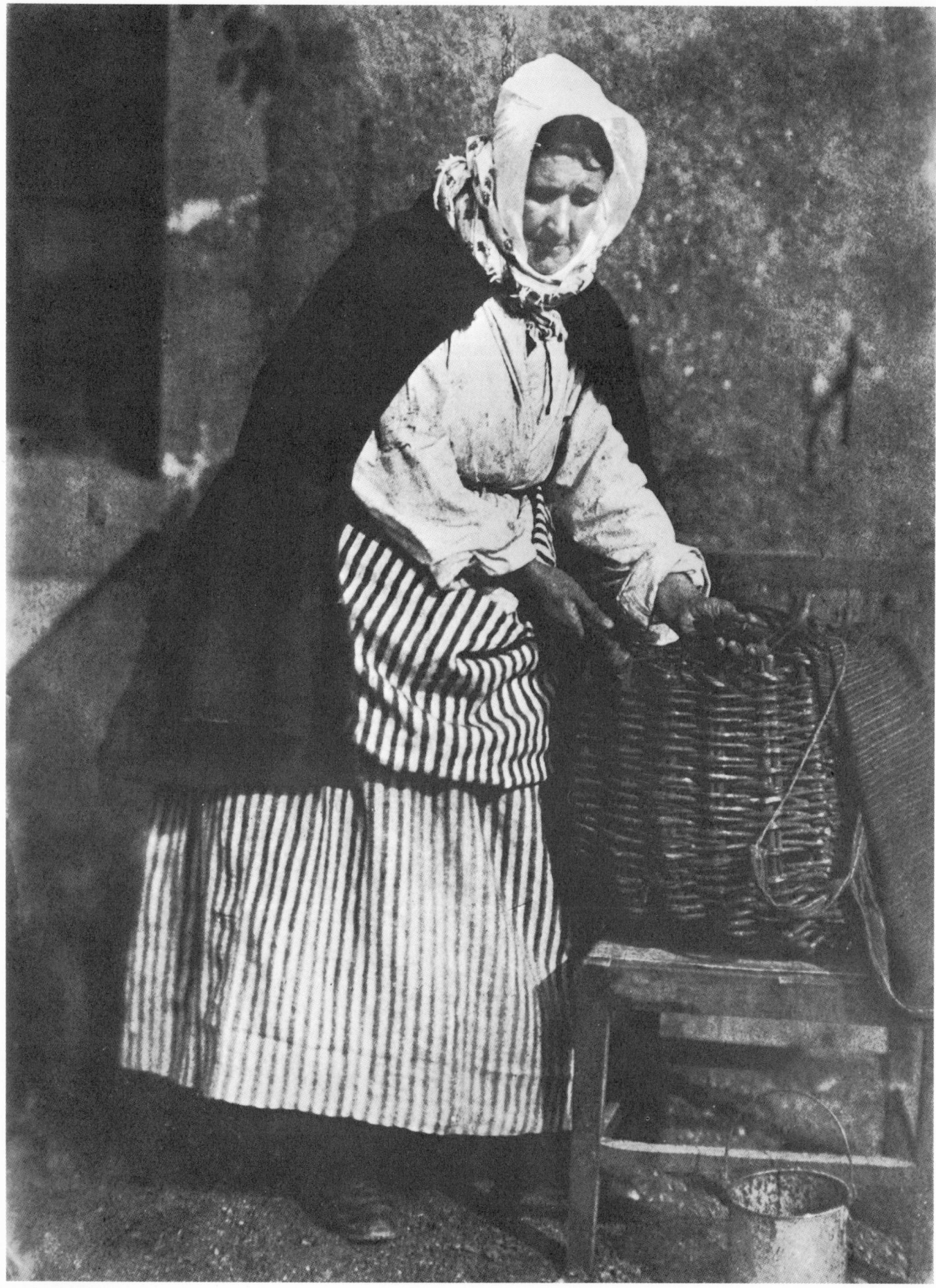

194

Mrs Flucker of Newhaven (*opposite*)

218 × 161 mm. (8$\frac{19}{32}$ × 6$\frac{11}{32}$ in.)
Scottish National Portrait Gallery

Mrs Flucker was an oyster-woman. She was a well-known character in Edinburgh, where she sold her wares. The can at the bottom right hand corner of the picture was the receptacle for shells.

Leith Fort

149 × 198 mm. (5$\frac{7}{8}$ × 7$\frac{25}{32}$ in.)
Royal Scottish Academy

There is a stylishness about the calotypes made at Leith Fort which must owe something to the military swagger of the participants. It is a measure of the calotypists' flexibility that they seem to have matched their photographic style to the subject matter and have introduced an element of boldness into the camera-work.

This shot is unusual in being slightly backlit to make the most of the shine on the gunbarrel and the rim of the wheel. The effect is well handled so that the picture has robustness and depth.

George Meikle Kemp

219×146 mm. ($8\frac{5}{8} \times 5\frac{3}{4}$ in.)
Scottish National Portrait Gallery

George Meikle Kemp (born in 1795) was the self-taught designer of the
Scott Monument in Princes Street, Edinburgh. In 1836 he answered an adver-
tisement for a design for a monument to commemorate Sir Walter Scott
and he won the ensuing competition under the assumed name of 'John Morvo'.
His first design won only third prize, but in 1838 his second design was
accepted.
 This calotype, which shows him surrounded by decoration for the monument,
was taken within a few months of the setting up of the Rock House Studio.
Kemp did not live to see the completion of his one finished work. On the night
of 5 March 1844, he fell into the Union Canal and drowned.

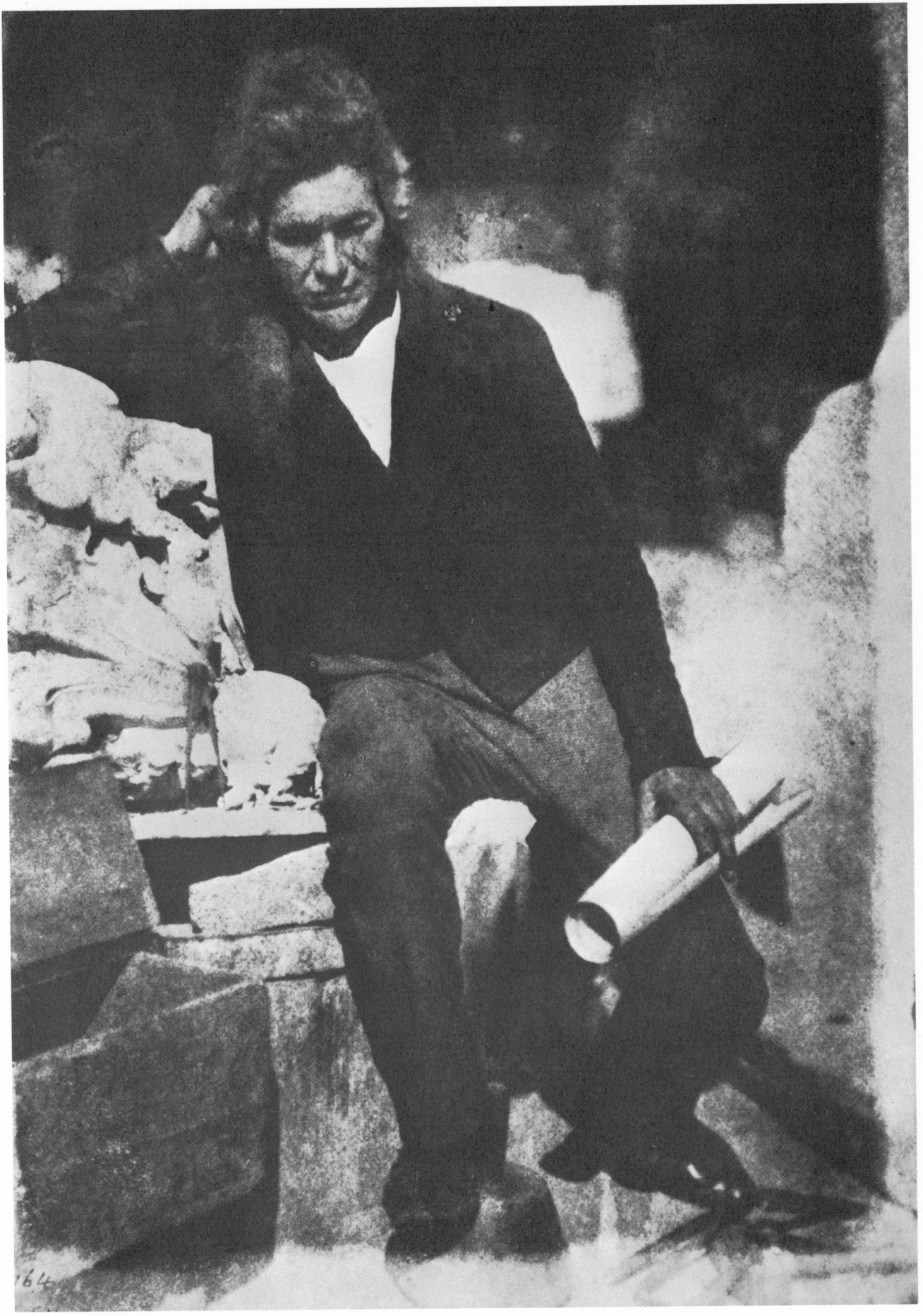

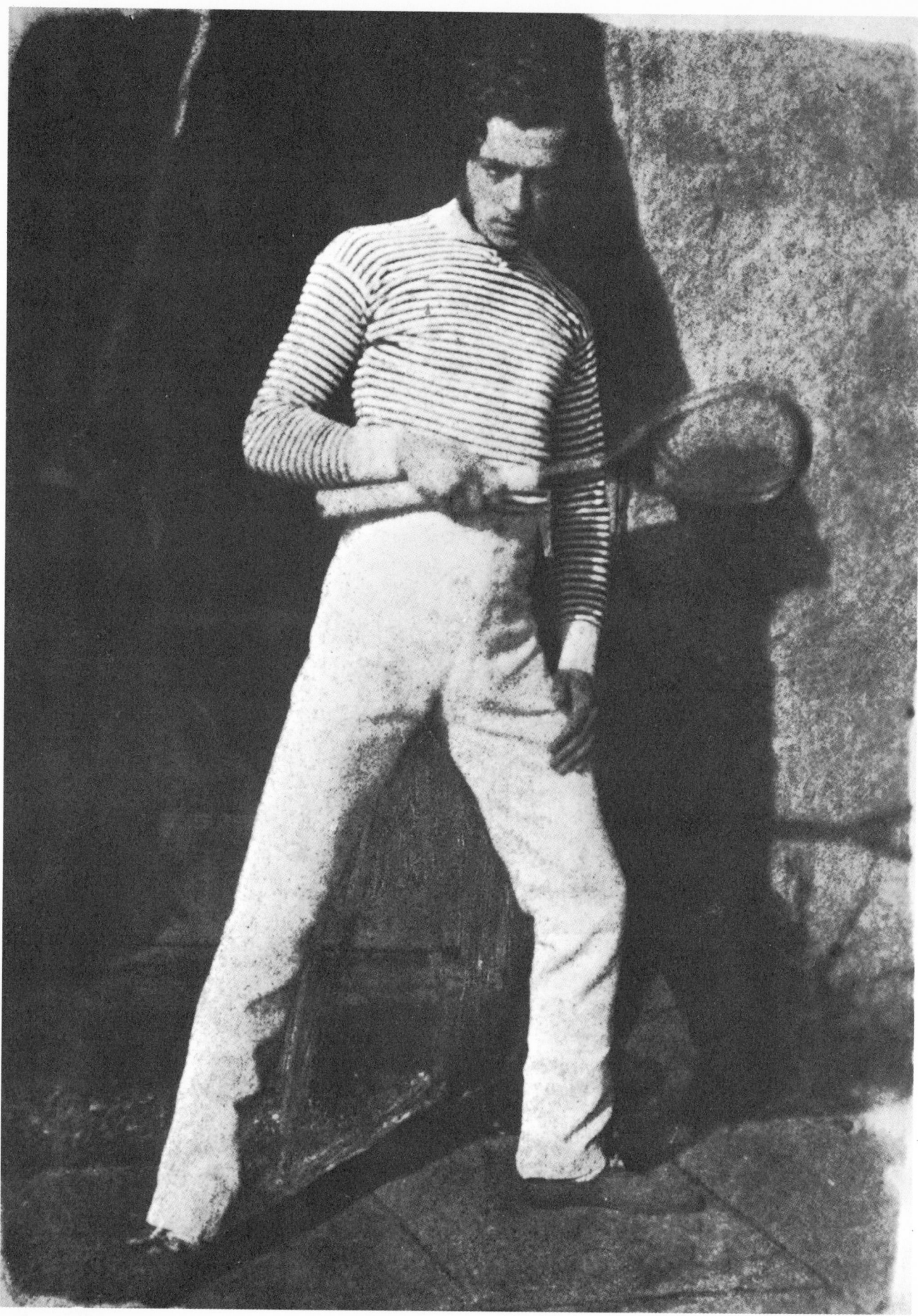

Lane with a Tennis Racket

196 × 143 mm. $(7\frac{23}{32} \times 5\frac{5}{8}$ in.)
Scottish National Portrait Gallery

In the calotypes of Hill and Adamson, Edward W. Lane, Arabic scholar, is to be seen in a variety of costumes and poses; some are to be found elsewhere in this book.

It is difficult to be sure what effect was intended in this unusual picture. It is certainly a clever attempt to convey a sense of action. (It has been suggested that the racket in the sportsman's hand was supported by a piece of string.) If it is not simply for amusement's sake, the likely explanation is that this calotype is one of a small group including, reputedly, three long-vanished nudes, which were intended as action studies for students of drawing.

Sleeping Flower Gatherers (*overleaf*)

151 × 205 mm. $(5\frac{15}{16} \times 8\frac{1}{16}$ in.)
National Portrait Gallery

The picture is notable for its striking content and composition. The shape of the print reproduced here is also rather unusual.

Because any number of prints could be made from a calotype negative several copies of the same picture may survive. However, that is not to say that all the copies are identical even apart from discrepancies caused by different rates of deterioration. Printing was done by contact with the negative so the image is always the same size but it was, of course, at the calotypist's discretion to crop each print to a different size or shape. Indeed the dimensions of any two prints from the same negative are rarely identical.

The shape of the print can be important and alter its effect quite substantially. Other, rectangular, copies of the picture overleaf show irrelevant detail in the top left corner and a little more foreground. By rounding off the corners and trimming the bottom edge this rather strange picture is considerably enhanced.

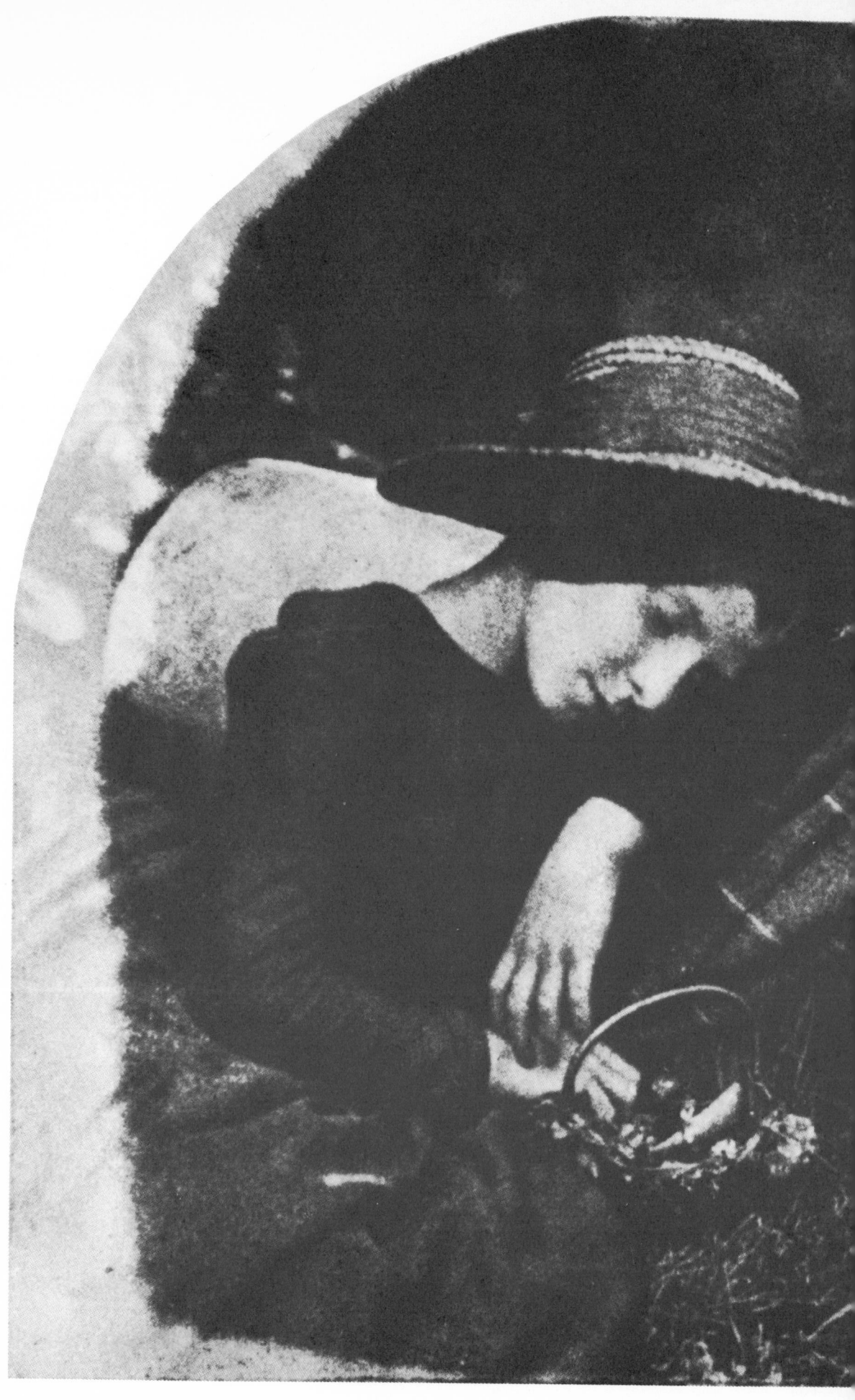

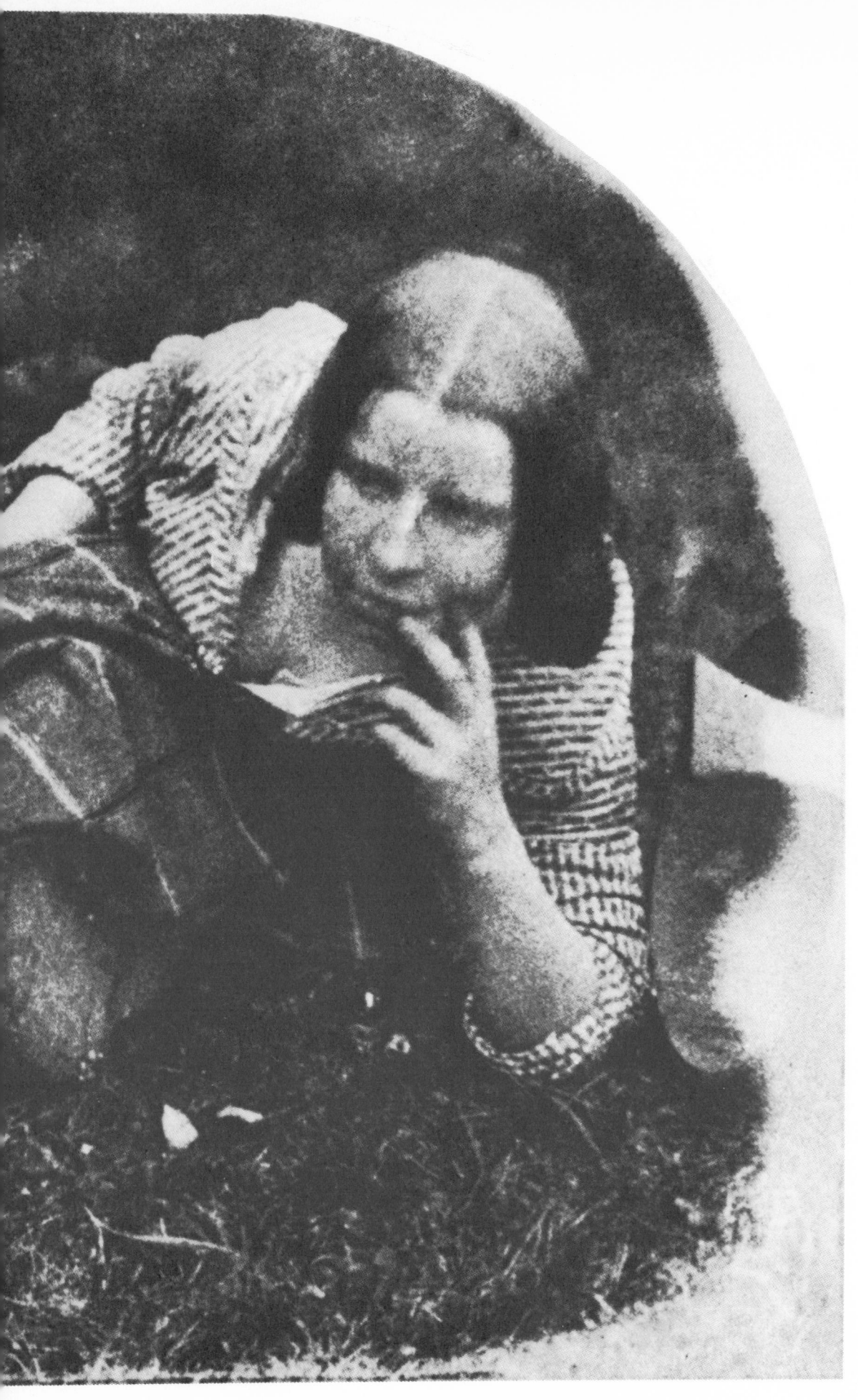

Three Fisherladdies

198 × 144 mm. (7$\frac{25}{32}$ × 5$\frac{21}{32}$ in.)
Scottish National Portrait Gallery

The 'props' in the Newhaven scenes soon become familiar to anyone who studies the calotypes. The chair on the left hand side of the frame, the basket containing the fishing line and the boat itself are familiar objects.

There is an interesting element in this calotype which has given rise to speculation on the question of the use of rests by Hill and Adamson. It has been suggested that the boy on the right has been kept still by means of a tripod support, one leg of which has been more or less erased (picture right), and another left undisguised, showing below the boy's right knee. Further possible evidence is to be found in the boy's shadow which seems to show something above the level of his head.

The matter is not certain, by any means, and the absence of evidence of the use of tripods in other Newhaven pictures must increase the suspicion that what we see by the boy's right foot is something other than a tripod.

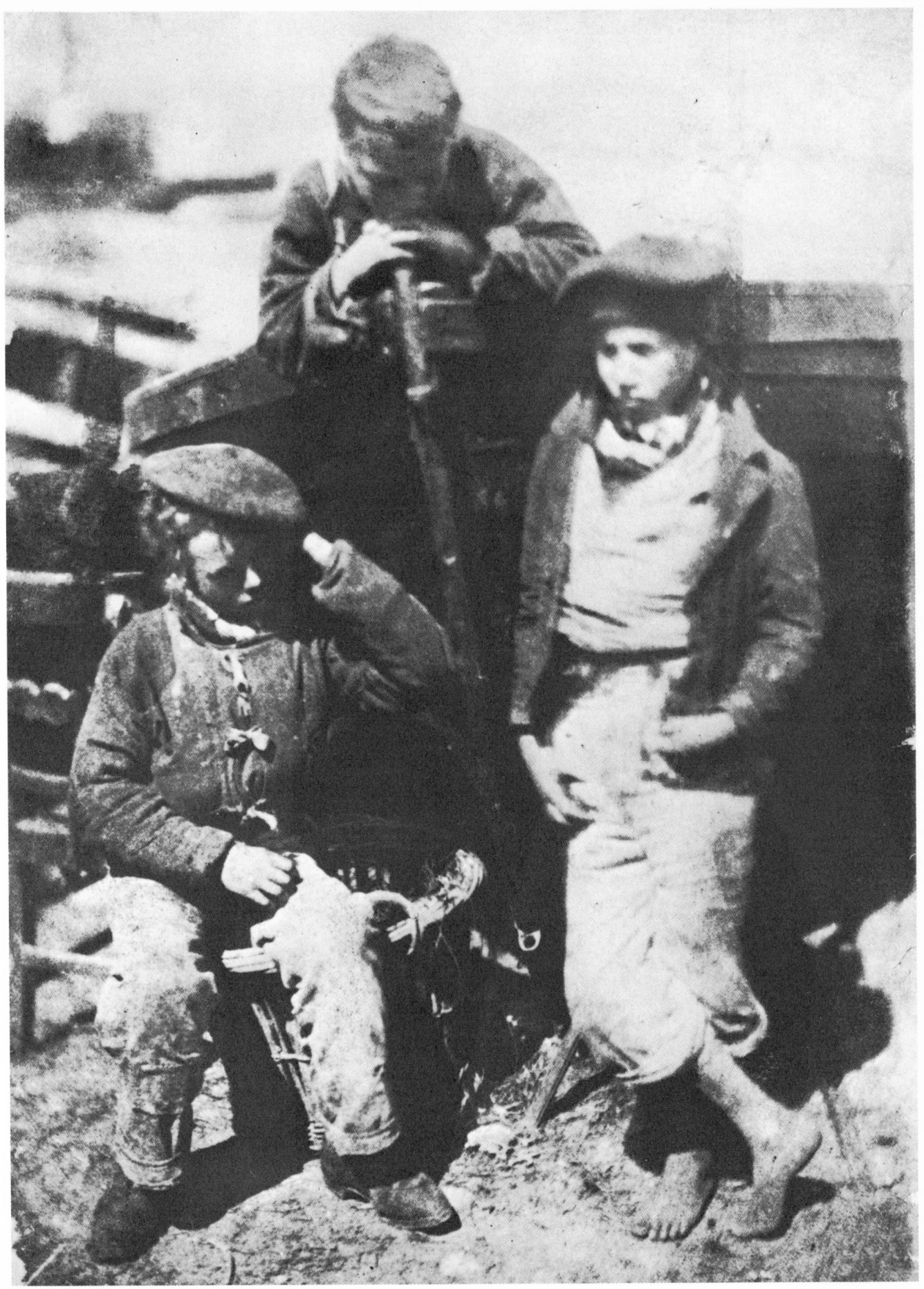

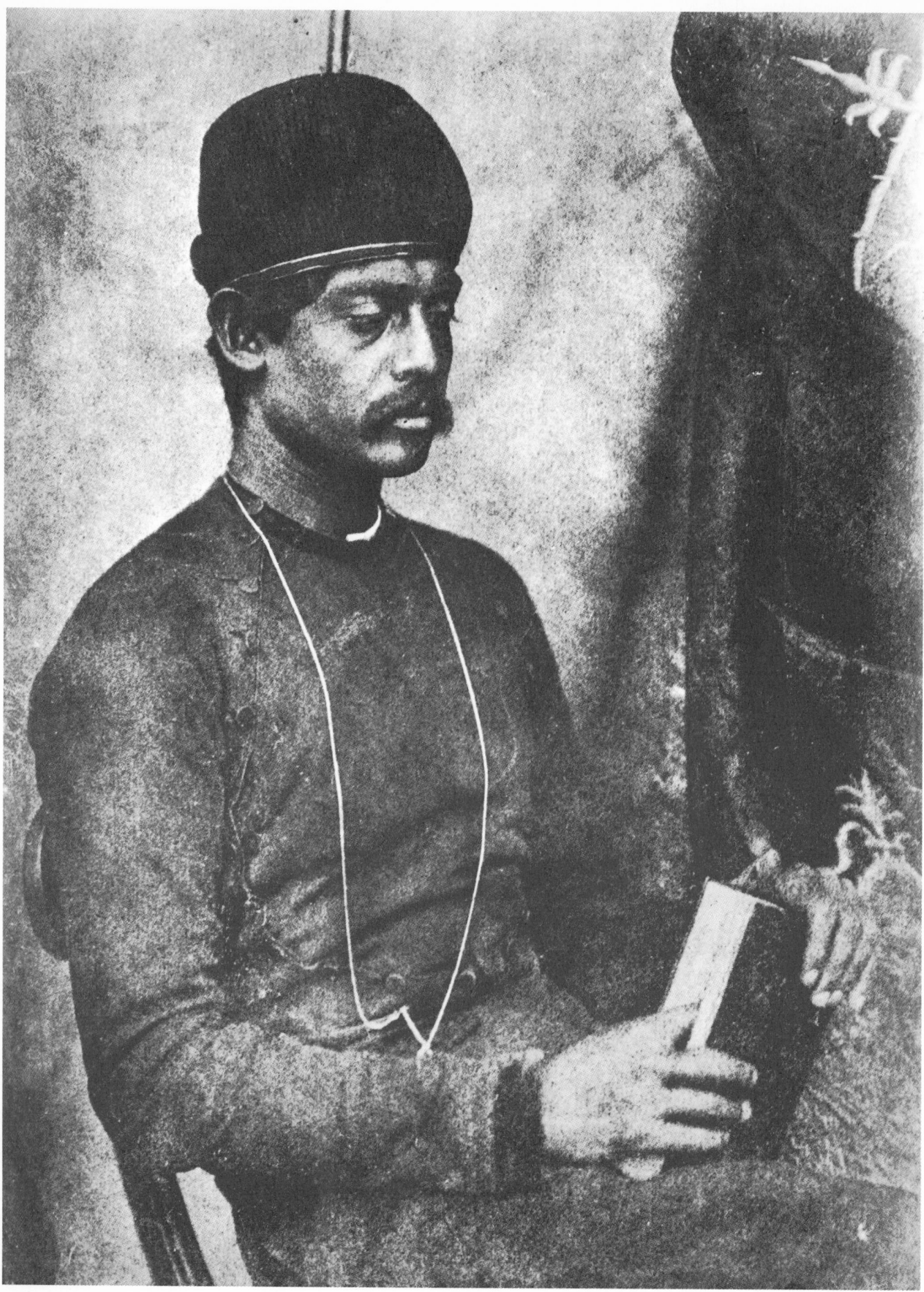

Mohul Lal

212 × 163 mm. $(8\frac{11}{32} \times 6\frac{13}{32}$ in.)
Scottish National Portrait Gallery

Mirza Mohul Lal was Persian Secretary to the British Mission at Kabul. When he
visited Scotland he sat not only for Hill and Adamson but also for the painter
Sir William Allan, President of the Royal Scottish Academy (and a close friend
of Hill). The resulting portrait was exhibited at the nineteenth RSA Exhibition
in 1845.

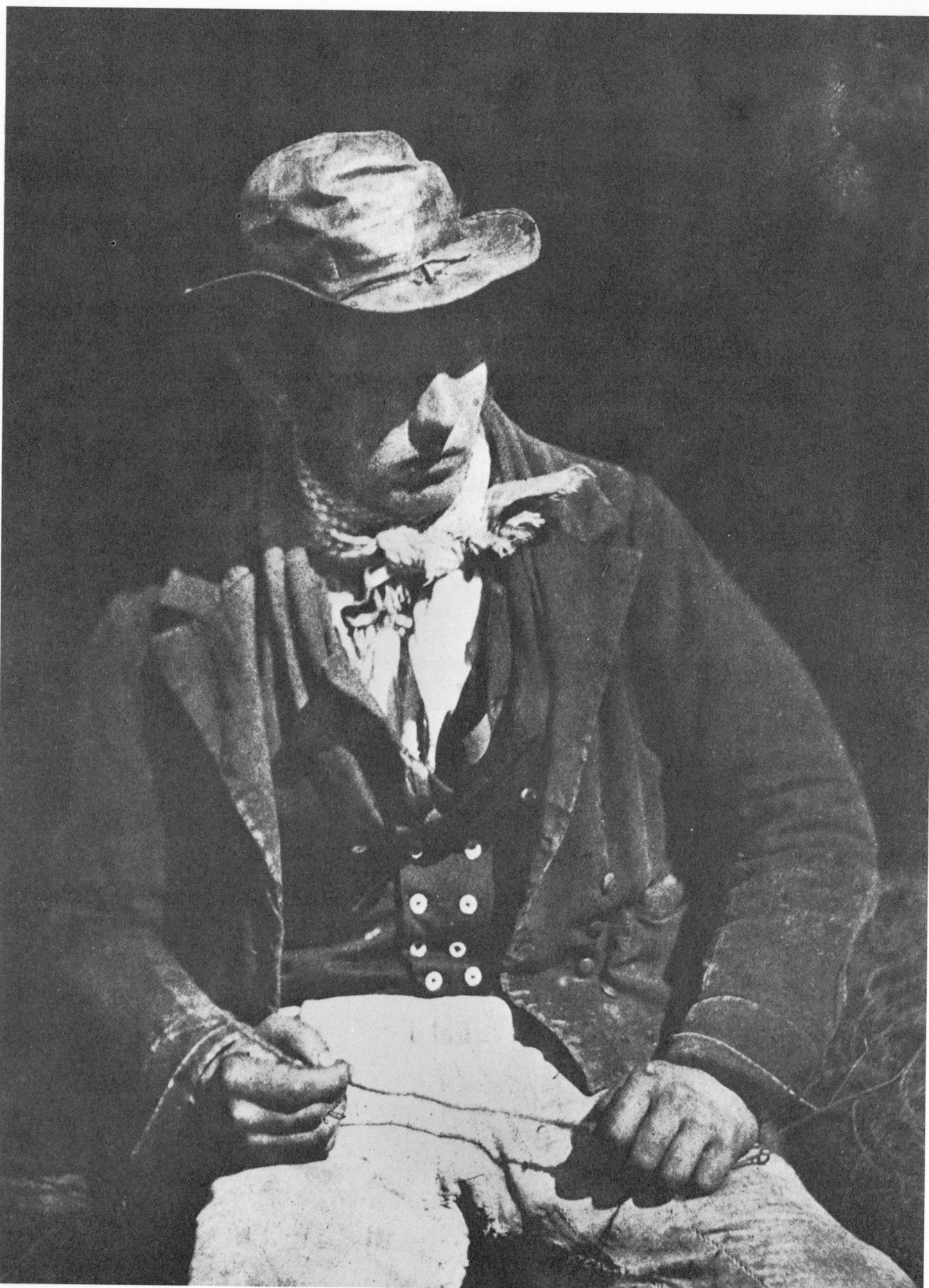

'Redding the Line'

195 × 145 mm. (7$\frac{11}{16}$ × 5$\frac{11}{16}$ in.)
Scottish National Portrait Gallery

This must surely be one of the best of all the calotypes, a picture which
measures up well to any photographic achievement.

The fisherman is thought to be Linton; the operation he is purporting to carry
out is of 'redding the line', i.e. preparing the fishing line for use by removing
any kinks or knots. The main feature of the picture, however, is its quite
extraordinary lighting effect, so controlled that it is hard to believe that it is not
artificial.

The calotype was probably made in June 1845.

Lady Ruthven

201 × 154 mm. ($7\frac{29}{32}$ × $6\frac{1}{16}$ in.)
Scottish National Portrait Gallery

Lady Ruthven, born in 1789, was the wife of an army officer who, rather unexpectedly, inherited a very large estate in West Lothian. Once established there she became deeply involved in literary and artistic circles. She was a close friend of Sir Walter Scott, of whom she commissioned a portrait, painted by Francis Grant in 1831. She was reputed to be something of an artist herself and an accomplished linguist and musician.

When she died in 1885 it was said of her (quoted in Elliott's *Calotypes*) 'She lived to a great age, dispensing kindness and benevolence to the last, and cheered in the sore infirmities of her later years by the love of friends of all ranks, and all parties of all ages. The "Living Lamp of Lothian", which from Winton has so long shed its beneficient lustre has been extinguished.'

There are a few instances, among the Hill/Adamson calotypes, of back views of a subject and, inevitably, when such pictures occur speculation arises as to why such a pose should be adopted for that particular person. Miss Munro (pp. 150 and 215) appears in both back and front views. This would tend to dispel suspicions that the subject had suffered the effects of, for instance, smallpox. Whatever the reason, the effect is very engaging.

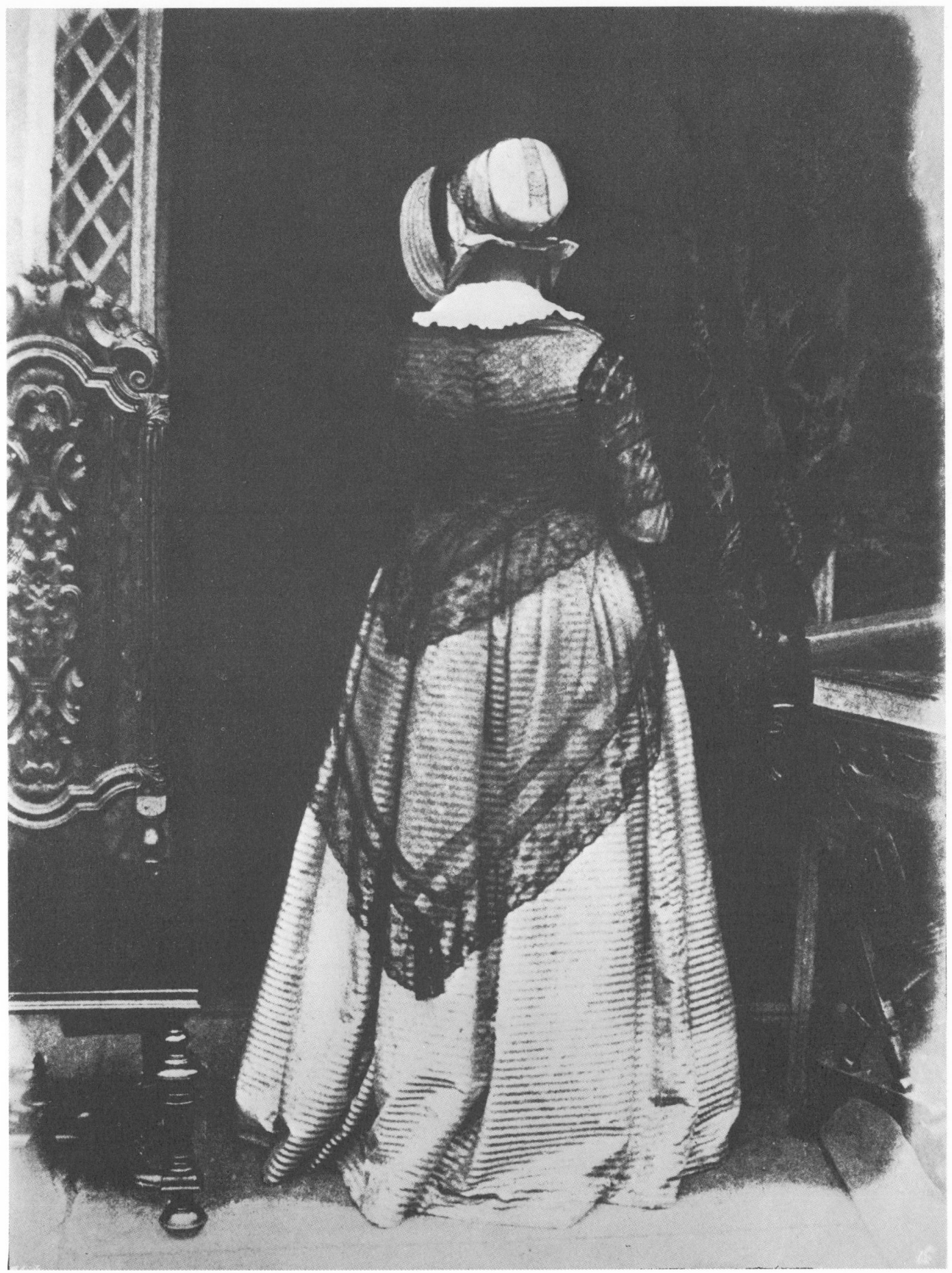

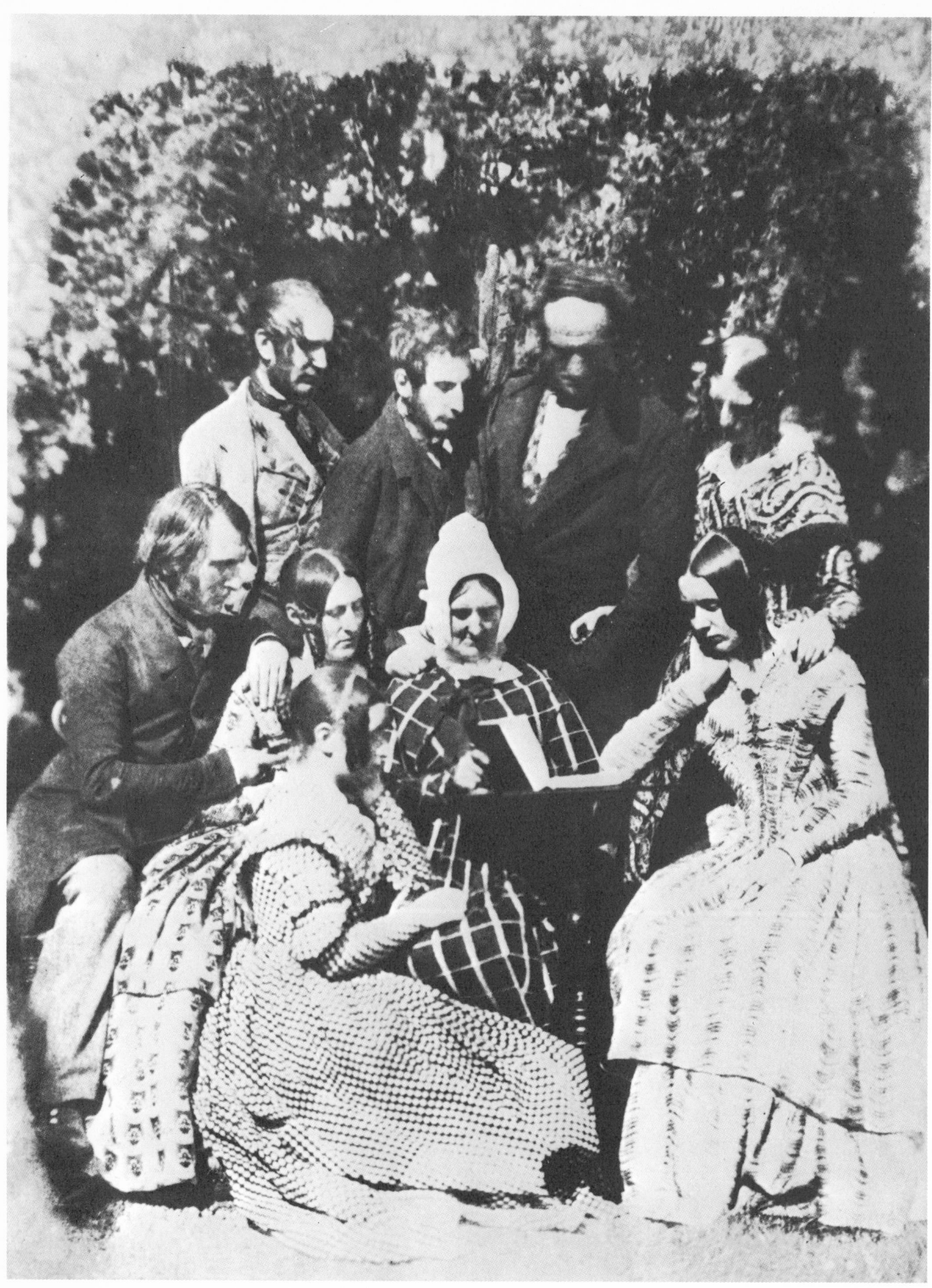

210

The Adamson Family at Burnside

205×155 mm. ($8\frac{1}{16} \times 6\frac{3}{32}$ in.)
Scottish National Portrait Gallery

Included in the group is Dr John Adamson, the first successful calotypist in
Scotland, the man who instructed Robert in the art. Robert himself is second
from the left at the back, and looks rather frail in comparison to his robust
brother-in-law Colonel Bell, on his left. Robert's wife is seated right, and his
mother in the centre.

 The date and the photographer are matters of speculation. The date is
probably 1847; Bell married Robert's sister in April of that year, and it would
therefore be taken within a year of Robert's death.

 It is likely that the photographer was Hill himself, by which we mean that not
only did he arrange the group, as usual, but would expose the picture as well.
Robert would presumably undertake the preparation and subsequent chemical
processes.

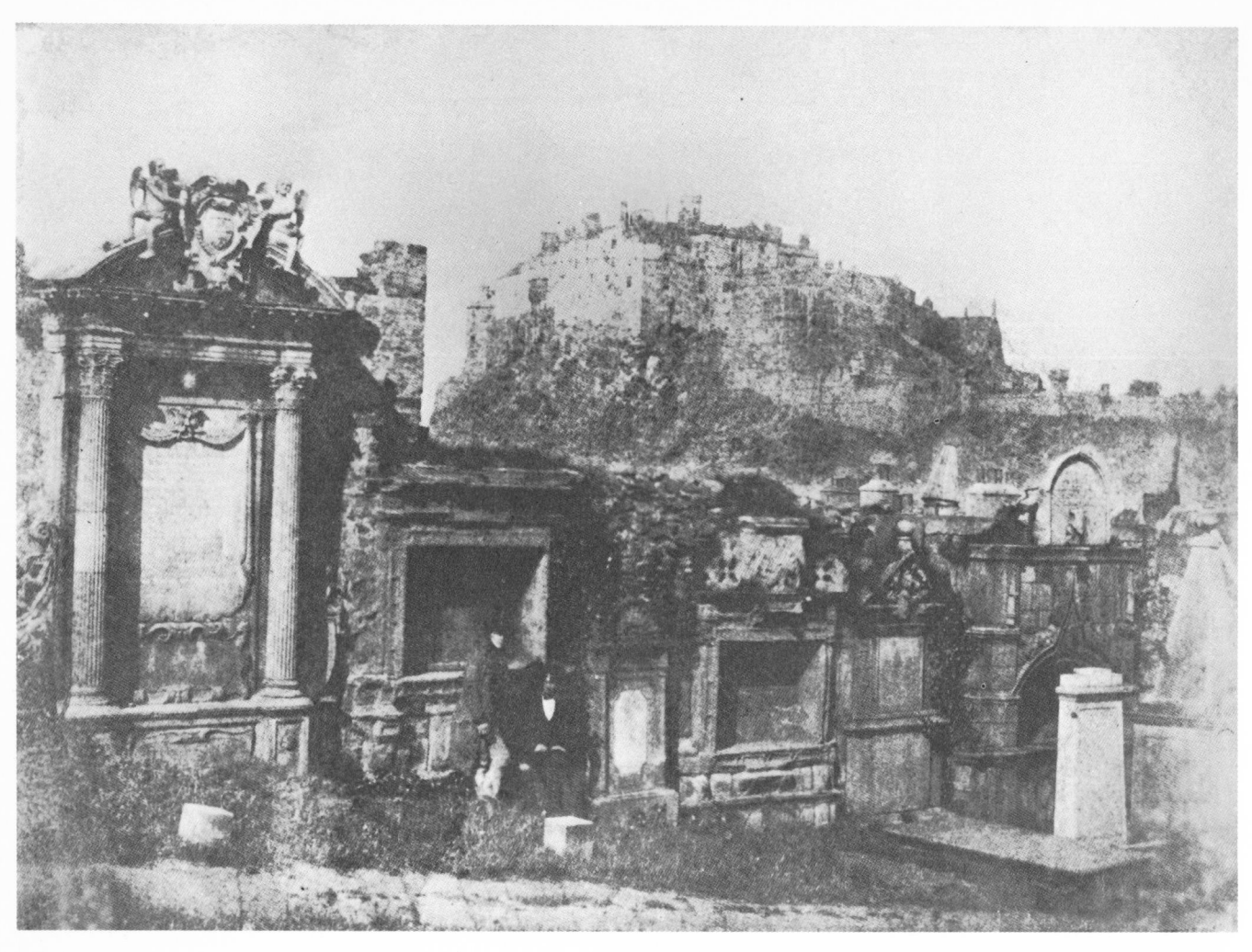

Greyfriars Churchyard and Edinburgh Castle

116 × 158 mm. (4 9/16 × 6 7/32 in.)
Scottish National Portrait Gallery

There is a minor puzzle about this calotype. It has been suggested that the picture is made from two separate negatives, that of the castle being shot at a different time in different light. Certainly, there is an apparent discrepancy, though it is possible that the explanation for the faintness of the Castle has to do with distance or, more likely, the atmosphere of Edinburgh, the city known as 'Auld Reekie'. The considerable number of dwellings between the camera and the Castle are probably putting up quite sufficient smoke to cause Edinburgh's familiar haze.

The Foreshore, Leith

139 × 198 mm. (5$\frac{15}{32}$ × 7$\frac{25}{32}$ in.)
Scottish National Portrait Gallery

As in many of the landscape calotypes there is, for us viewing the scene from a long distance in time, a strange blend of interest. Certainly the picture is very carefully composed, the figures occupying very much the sort of position that Hill would have given them in one of his lithographs, but there is more to it than that.

As one looks at it there is fascination in being provided with a window into a world of actuality, and one wishes to know more about the lives and circumstances of the people, of what happens further round the bay and on beyond the point.

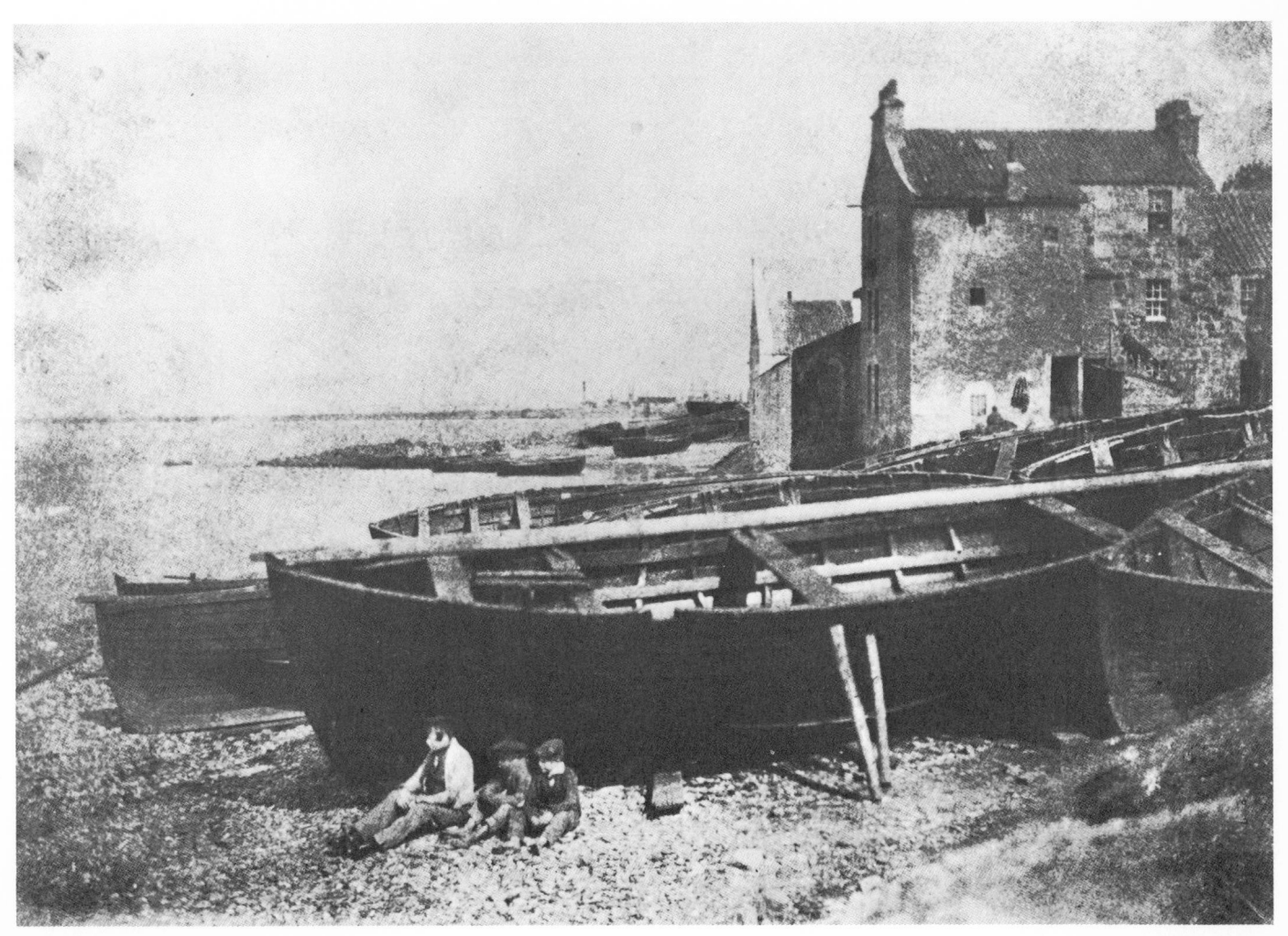

Miss Justine Munro

199 × 154 mm. (7$\frac{27}{32}$ × 6$\frac{1}{16}$ in.)
Scottish National Portrait Gallery

Justine Munro appears in at least three calotypes, including one back view and one with her husband, Mr Gallie. In many contexts, the 'camera eye' of Hill and Adamson is often surprisingly like that of modern photographers. Their attitudes strike a chord in us whereas the majority of their contemporaries and successors in the field seem, to our present taste, to belong to a separate culture.

We tend to see women in Hill/Adamson calotypes presented either for their place in society (Lady Ruthven or Mrs Jameson) or for their beauty, in which latter category Miss Munro must fall. Many people (including the author) find Miss Munro very agreeable to look at, but if frequency of appearance is any guide, Hill and Adamson found her much inferior to Miss Elizabeth Rigby who appears in some sixteen pictures. There is, it would seem, no accounting for changing taste.

There is one unusual compositional aspect of this calotype. Hill frequently divides the shot vertically in thirds, but here the right hand third of the shot is almost completely detached from the rest of the picture by a line through the edge of the drape, the girl's arm, and the edge of the table. Whether the device succeeds or not the reader must decide, but we may be sure that the effect is deliberate.

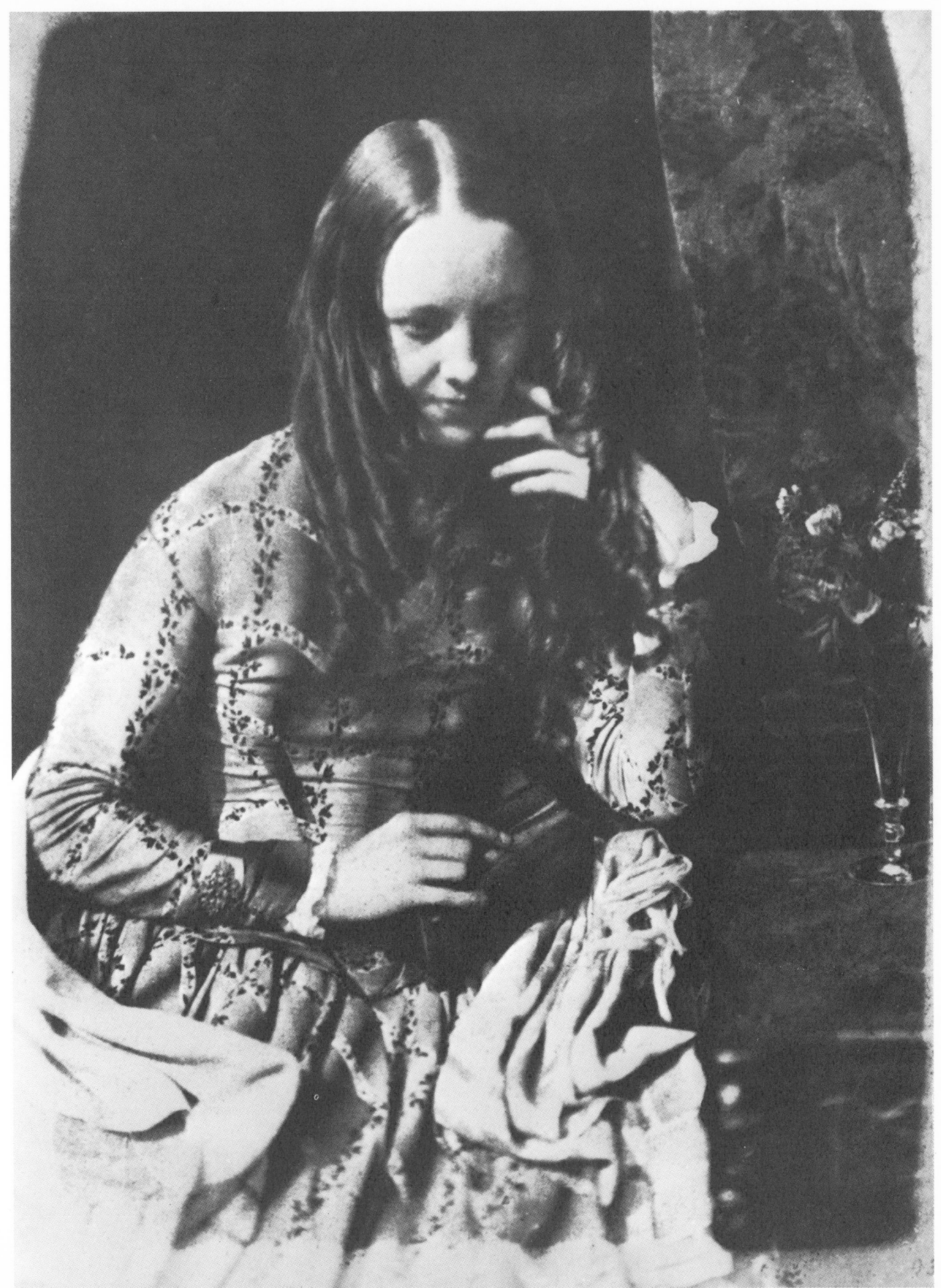

215

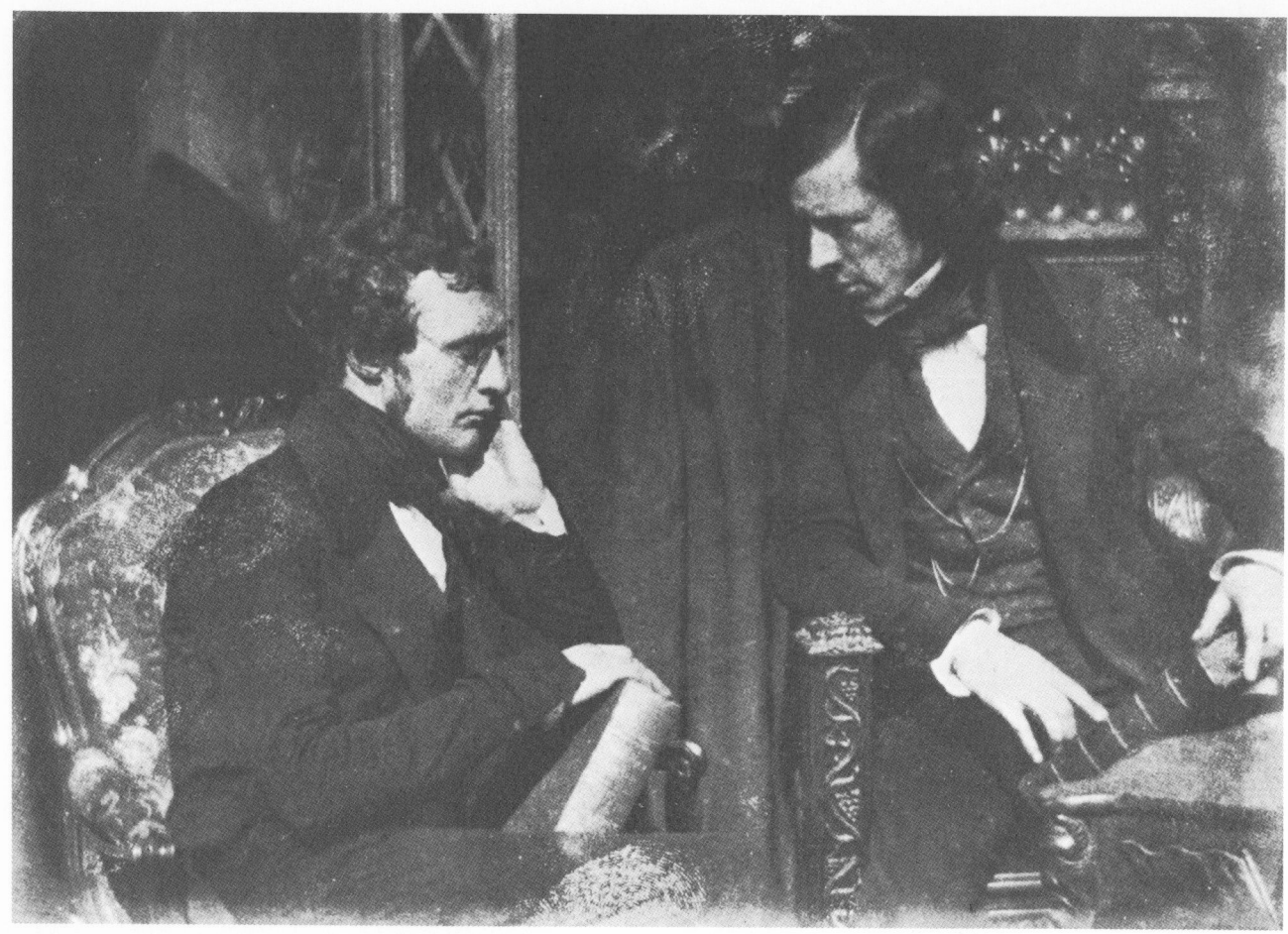

Dr Samuel Brown and Rev. George Gilfillan

140 × 199 mm. (5½ × 7 27/32 in.)
National Library of Scotland

Dr Brown was a chemist from Portobello, near Edinburgh. His interests seem to have been wide-ranging and he is recorded as having lectured in Dundee on the Atomic Theory of Mesmerism, Magnetism and the History of Chemistry. He stayed in Gilfillan's manse in Paradise Road, Dundee. The calotype is genuinely of two close friends in conversation.

The Rev. George Gilfillan was born in Comrie, in Perthshire, in January 1813. He was the eleventh of twelve children. According to Elliott's *Calotypes*, he was 'warmhearted, enthusiastic, with strong literary leanings'. He encouraged many young writers and edited a series of books of poems. His own prolific output includes lives of Scott and Burns. Ironically, he may well be remembered as the subject of some of the worst poetry in English or any other language. One of his closest friends was the poet and tragedian William McGonagall.

'The House of Death' (*opposite*)

194 × 138 mm. (7⅝ × 5 7/16 in.)
Scottish National Portrait Gallery

The 'monk' in this famous calotype is Leighton Leitch, the landscape painter who lived from 1804–83. He was drawing-master to Queen Victoria's family during the 1840s and 1850s.

216

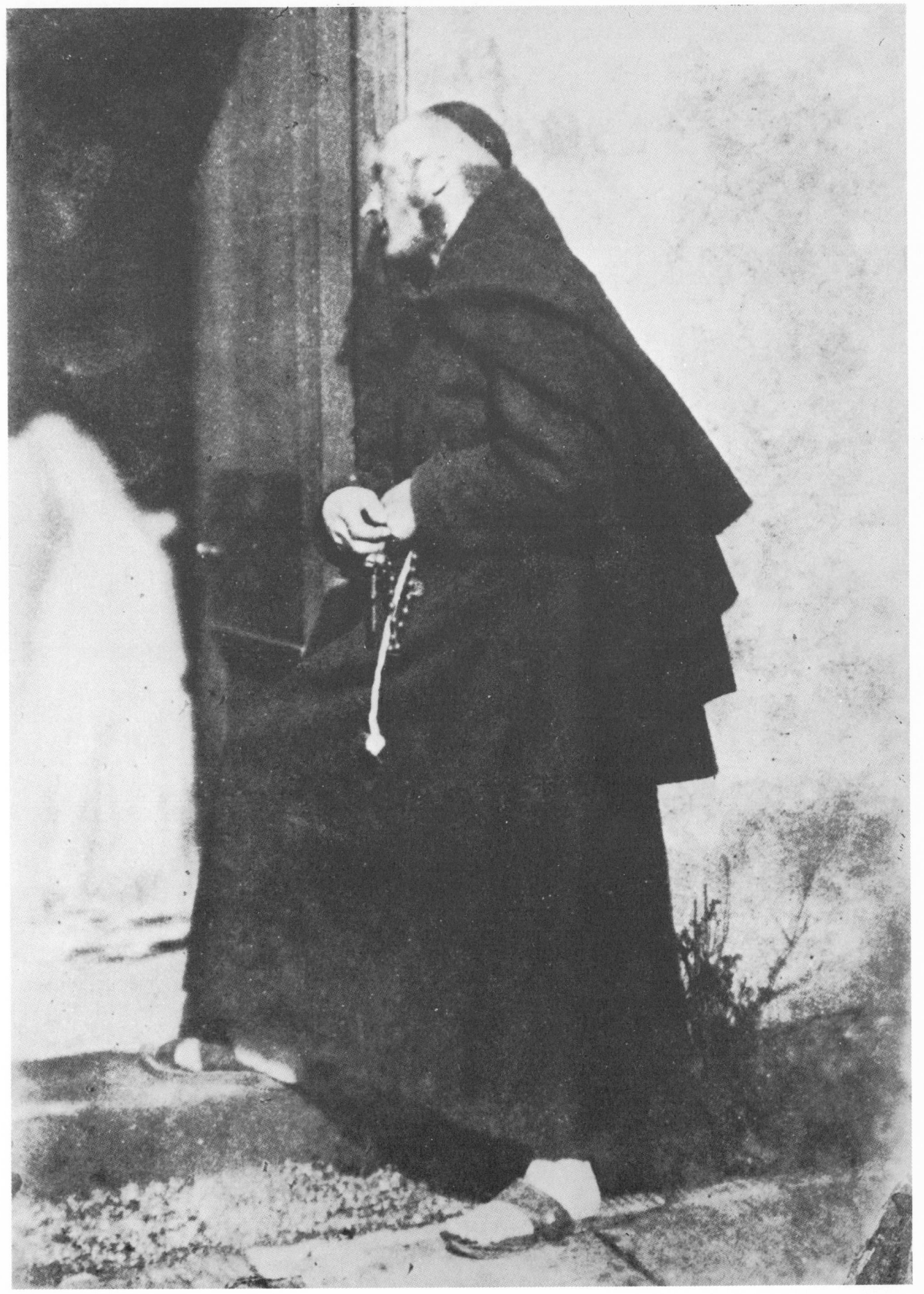

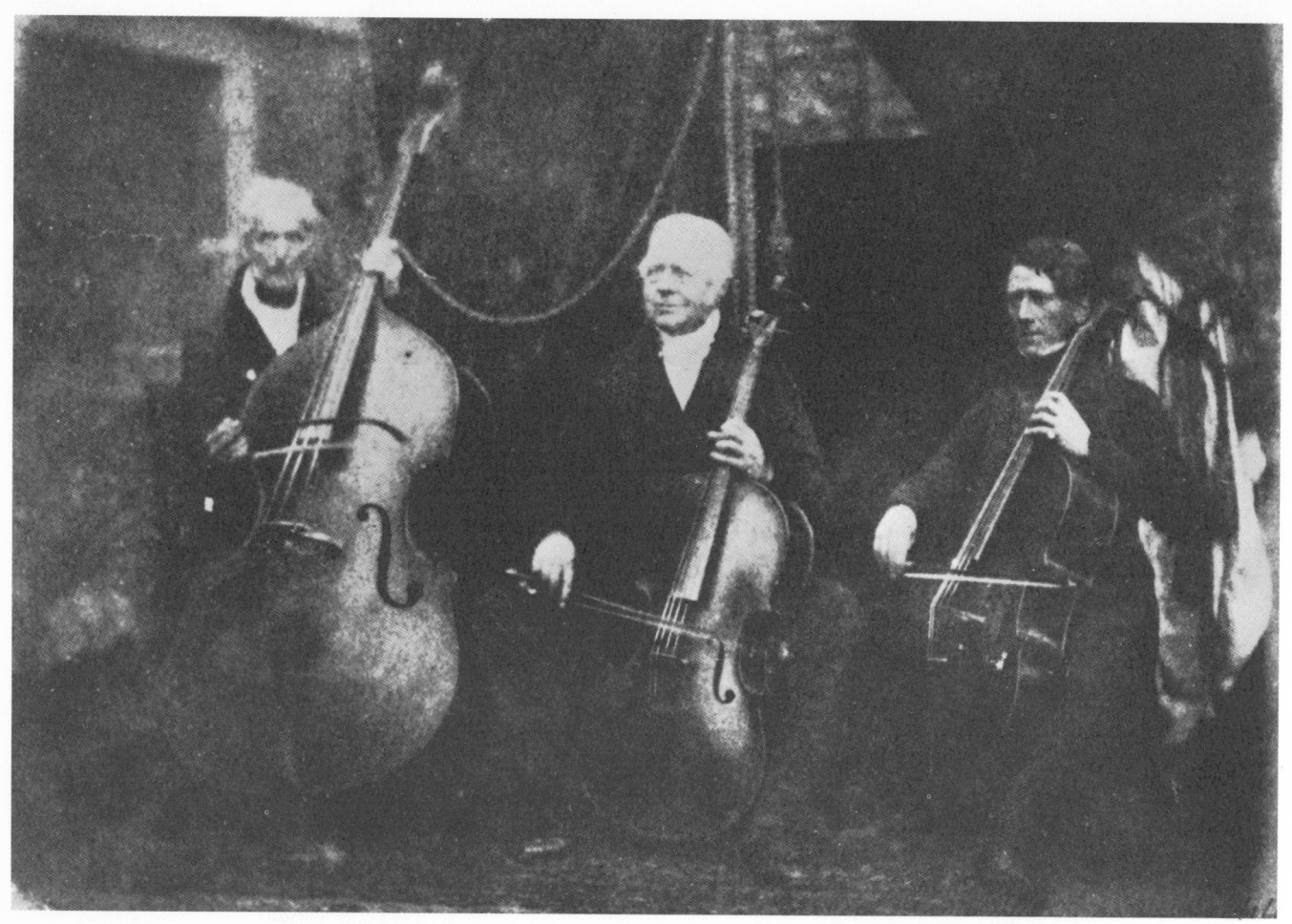

Dragonetti, Linley and Loder

109 × 159 mm. (4$\frac{9}{32}$ × 6$\frac{1}{4}$ in.)
Scottish National Portrait Gallery

Domenico Dragonetti, a double-bass player and composer, was born in Venice in 1763 and died in 1846. He had a collection of snuff boxes, and dolls. His dog, Carlo, came to every performance. Robert Linley was a Yorkshire cellist and a close friend of Dragonetti with whom he played for fifty-two years 'in all the chief London and provincial concerts'. Of Loder little is known. He may be John Fawcett Loder (1812–53). All three were brought to Edinburgh to play at a Royal Scottish Academy Promenade Concert.

The calotype dates from very early in the operation of the Rock House Studio.

'The Minnow Pool' (*opposite*)

200 × 152 mm. (8$\frac{1}{16}$ × 5$\frac{31}{32}$ in.)
Royal Scottish Academy

Otherwise known as 'The Finlay Family' the calotype shows Arthur, John Hope and Sophia Finlay in a rather consciously picturesque setting. John Hope Finlay followed his father's footsteps in a successful career at law. Sophia Finlay was to play an important part in identifying the calotypes very many years later at the beginning of the present century.

The negative of this picture is one of a limited number which could be printed straight or reversed at will and consequently this shot sometimes appears the other way round. Despite the title, the picture may well have been made in the garden of Rock House.

218

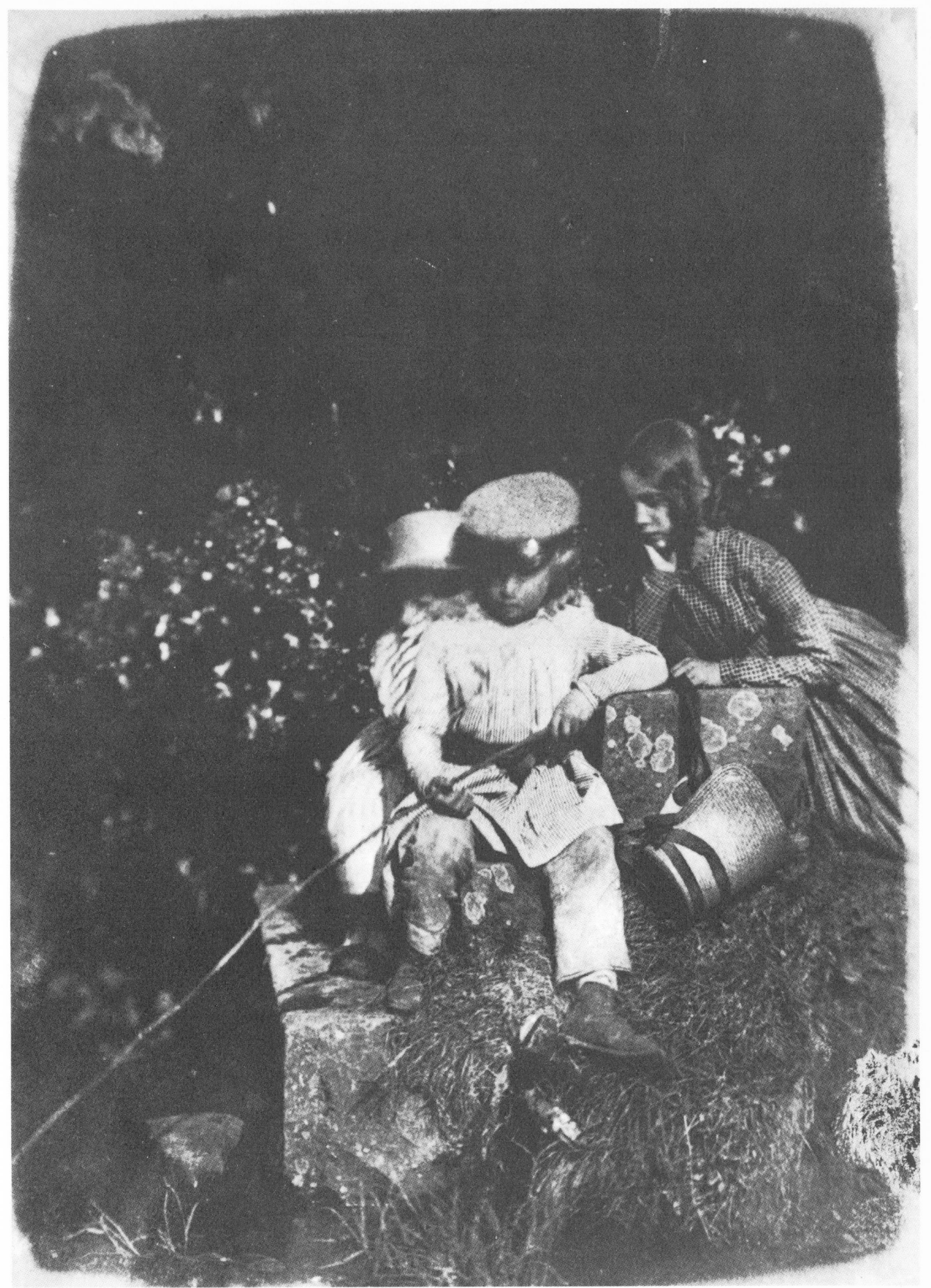

Elizabeth Johnstone

198 × 142 mm. ($7\frac{25}{32}$ × $5\frac{19}{32}$ in.)
Scottish National Portrait Gallery

The traditional dress (or at this time the ordinary working wear) of the Newhaven fisherwomen lends itself peculiarly well to the calotype medium. The stripes contrast with dark areas of cloak or with light skin tones. They find their echoes in the wickerwork of the creels.

 But the calotype is sufficiently imprecise to prevent such detail overwhelming the rest of the picture, as would almost certainly be the case with the daguerreotype. The overall effect is achieved without being fussy. The skilful deployment of areas of light and shade, the ever-important positioning of hands, stops just short of self-consciousness – a superb example of early photography.

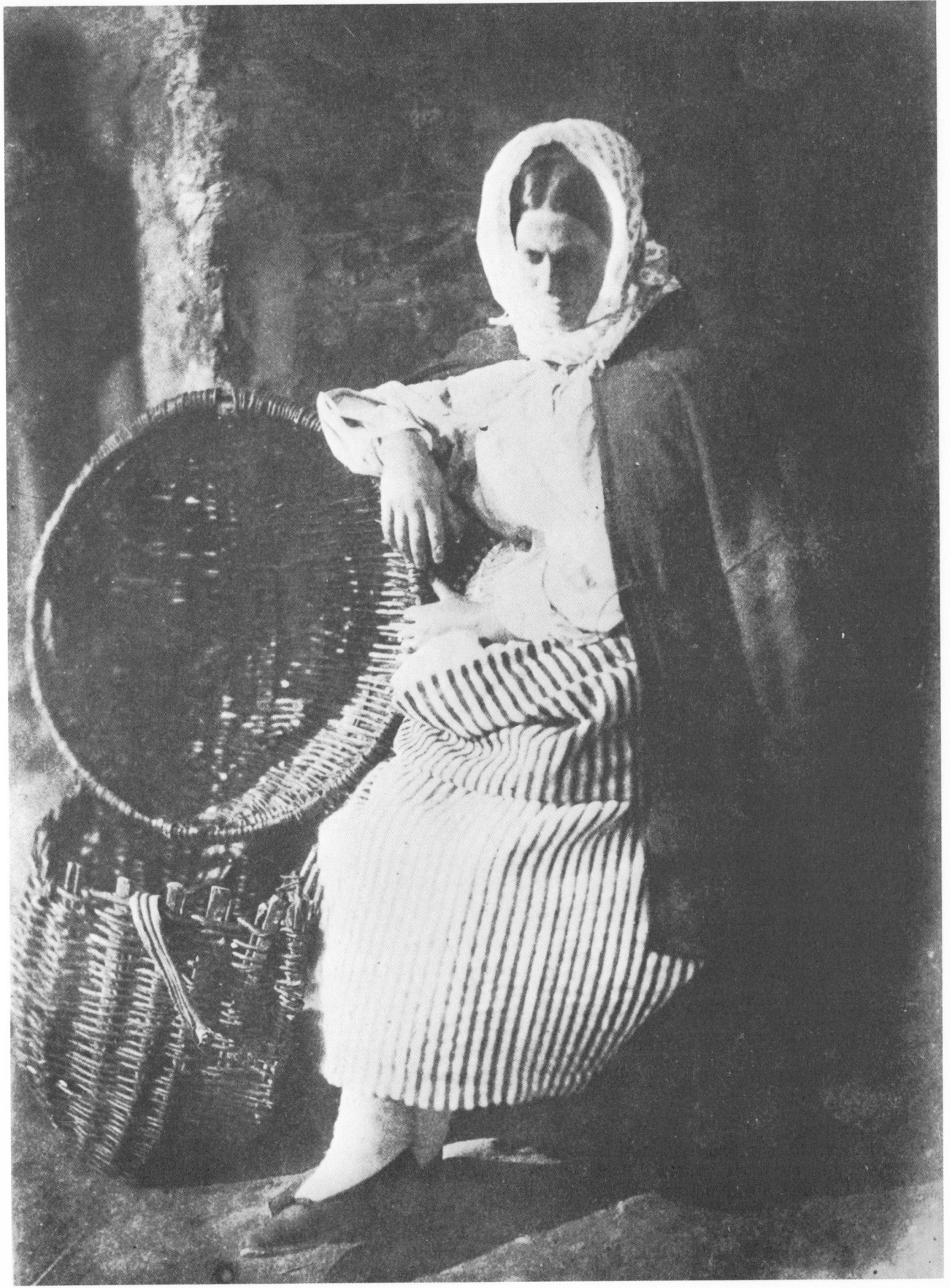

Edinburgh Castle

144 × 198 mm. (5$\frac{11}{16}$ × 7$\frac{25}{32}$ in.)
Edinburgh Public Libraries

In the foreground are masons at work on the site of the Scott Monument. In the middle distance The Mound runs between the Royal Scottish Academy on the right and some houses on the left which have since been removed.

Dominating the scene is Edinburgh Castle which has presided over the city for more than a thousand years. On the calotype it is possible that the outline of the Castle has been judiciously strengthened by Hill's pencil.

Professor Campbell Fraser's Class

224 × 299 mm. (8$\frac{13}{16}$ × 11$\frac{25}{32}$ in.)
Scottish National Portrait Gallery

It is often the case in times of political and social unrest that the part played by students in bringing about a new order of things is crucial. This was so at the time of the Disruption when the students sided strongly with the 'liberal element' and joined the Seceders.

The sacrifice made by them was considerable as they were, in effect, walking out on their university degrees, thereby denying themselves the right to be ordained for the ministry – the entire reason for their studies. However, the Disruption was supported so overwhelmingly that the Free Church was able, at once, to arrange courses for those students who wished to be ordained as ministers in the new Church.

Campbell Fraser (seated left) was a Professor of Logic and Metaphysics at Edinburgh. At one stage in his career he was so much under the influence of Hume that he nearly became an agnostic. According to a testimonial by Brewster he had 'a high reputation as an original and profound thinker'.

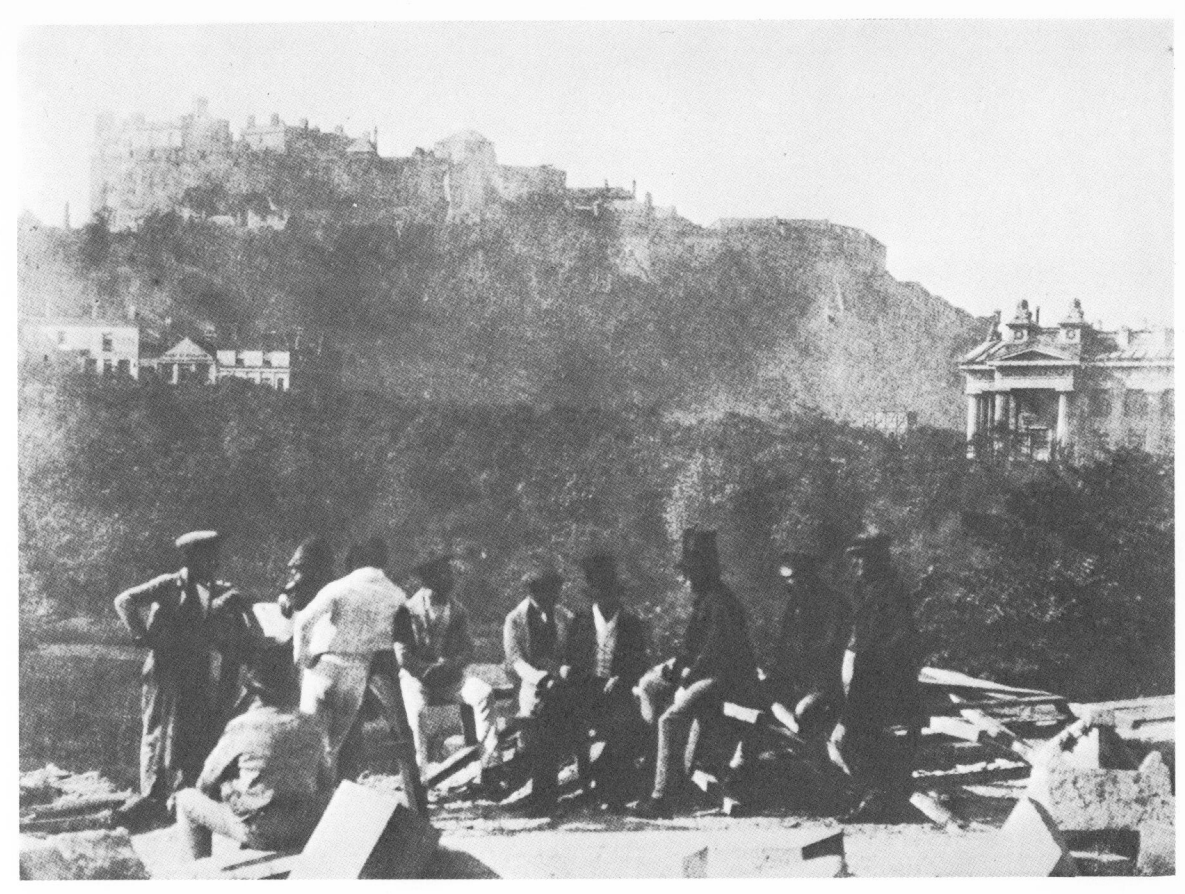

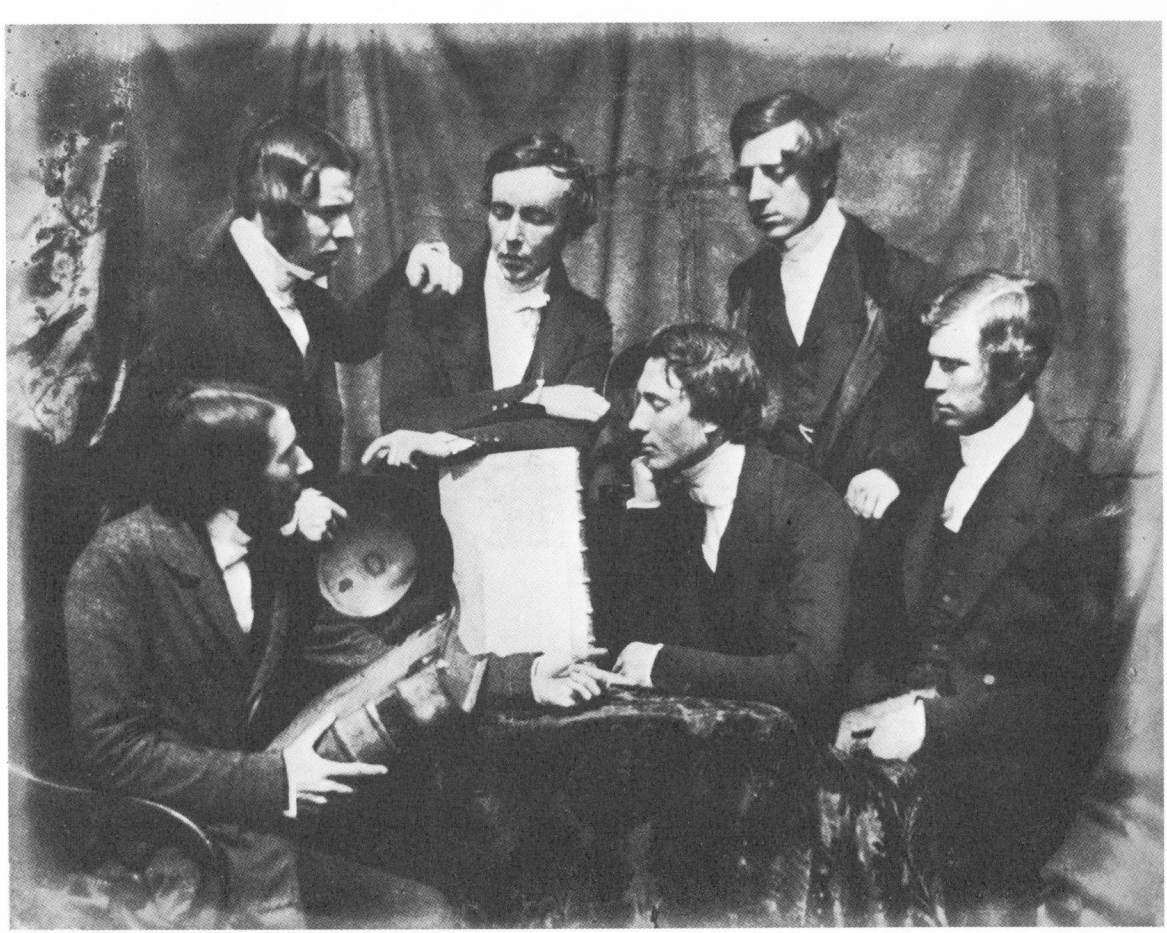

Colinton Manse

206 × 153 mm. (8⅛ × 6 1/32 in.)
Scottish National Portrait Gallery

For all its appearance of stillness and tranquillity, one of the main interests of this picture is movement – the movement of water. As any amateur knows, the problems associated with photographing water are considerable; too short an exposure may freeze the image and deprive it of any sensation of movement at all, but too long an exposure results only in an unsatisfactory blur. The ideal compromise is to find a shutter speed somewhere short of that required to 'stop' the water.

The calotypists' problems were of a different order. Their solution is to shoot from a distance and incorporate a passage of water which, because of the regular conformation of the weir, still allows a sensation of movement even after an exposure not of a fraction of a second, but of minutes.

225

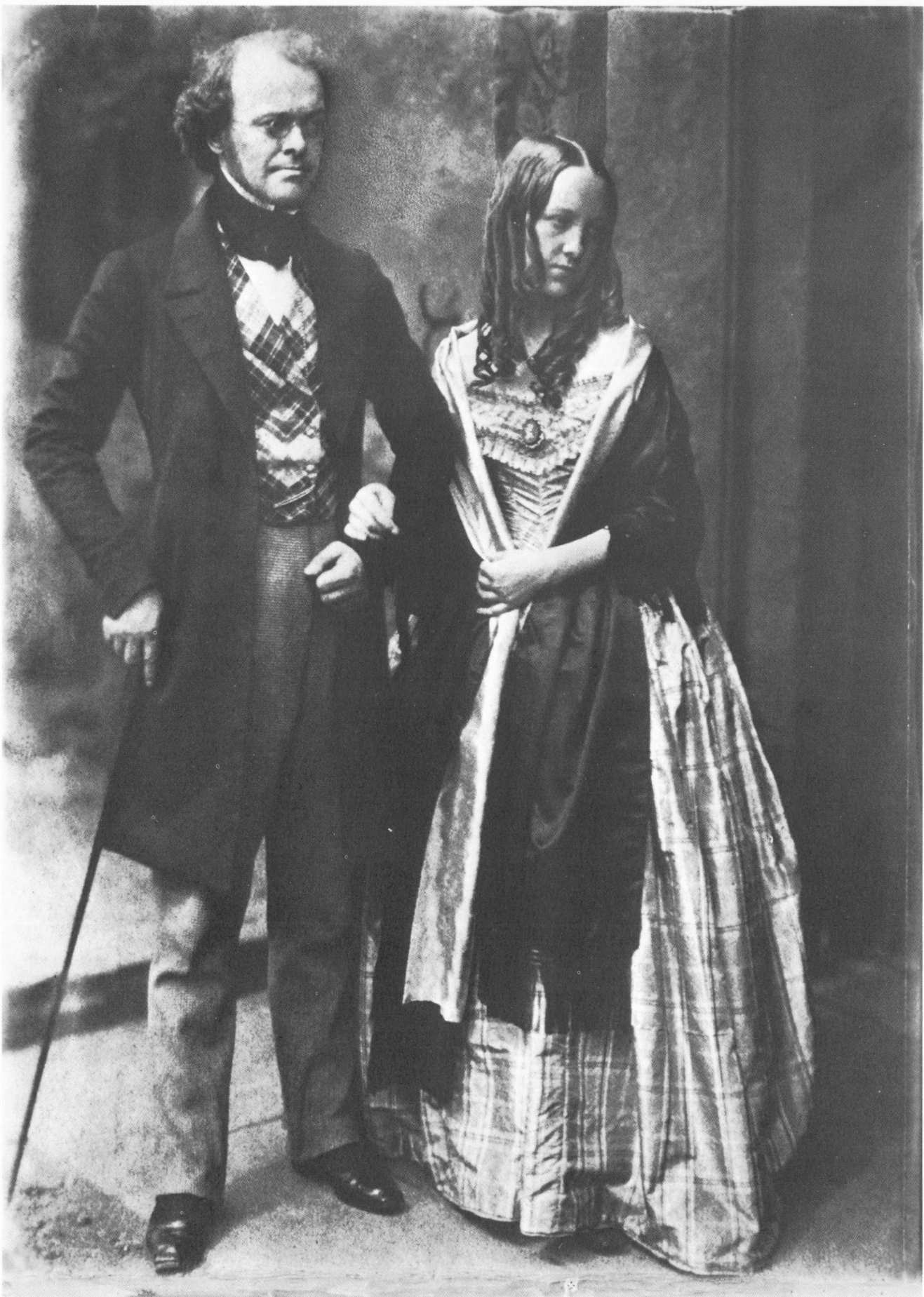

Mr Gallie and Miss Munro

219 × 162 mm. (8⅝ × 6⅜ in.)
Scottish National Portrait Gallery

There are not very many calotypes of couples. Such pictures as there are tend to be more conventional than the individual portraits. In this instance the fact that both figures are standing contributes to the stiffness.

Of Mr Gallie we know very little and of Miss Munro not much more except that she appears in a number of portrait and group calotypes. We know that they married.

Miss Matilda Rigby

202 × 149 mm. (7$\frac{15}{16}$ × 5$\frac{7}{8}$ in.)
Scottish National Portrait Gallery

Miss Matilda Rigby, whose sister Elizabeth and mother are also well represented
in the calotypes, married a Mr Smith, a publisher. Smith's firm, Smith and Elder,
published the works of John Ruskin, Charlotte Bronte and Mrs Gaskell.

228

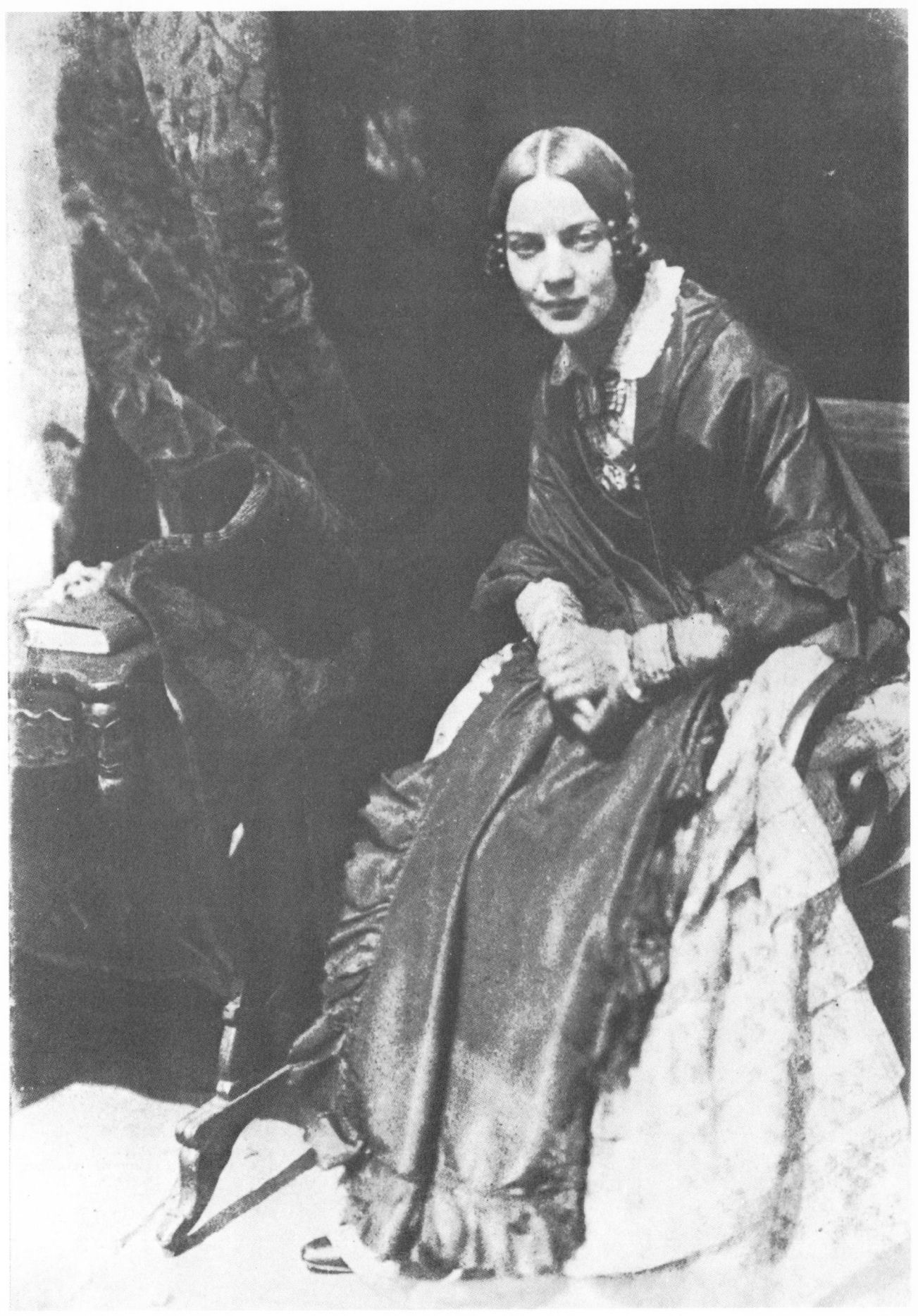

The Scotch Draper

117 × 166 mm. (4$\frac{19}{32}$ × 6$\frac{17}{32}$ in.)
Scottish National Portrait Gallery

The thinking behind this calotype is strongly influenced by Scott in its romantic view of the function of a travelling cloth merchant. Of the picture showing working-class life this is one in which the attempt to be informal is not entirely successful. It compares unfavourably with those in a similar genre taken amongst the fisherfolk of Newhaven.

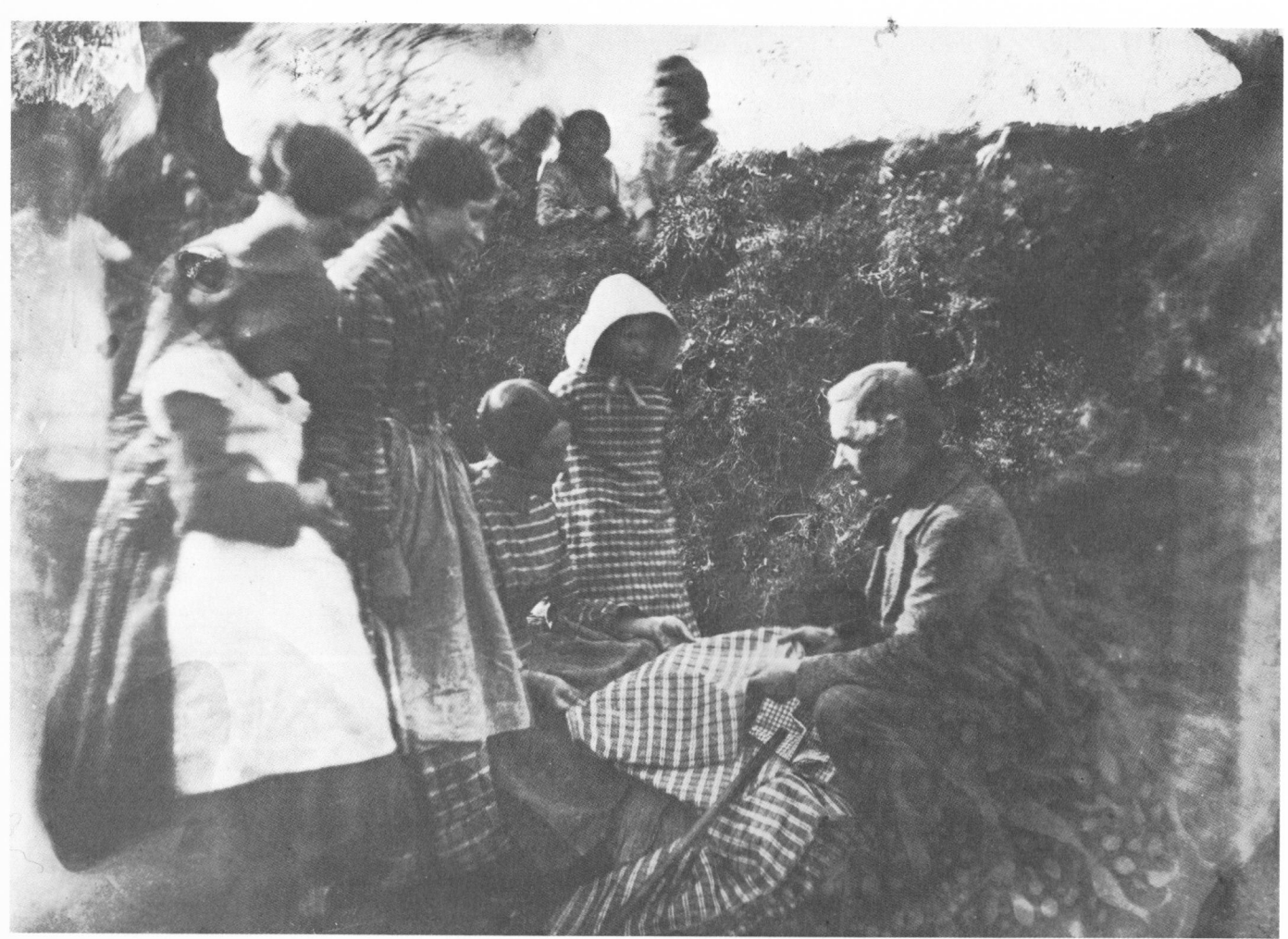

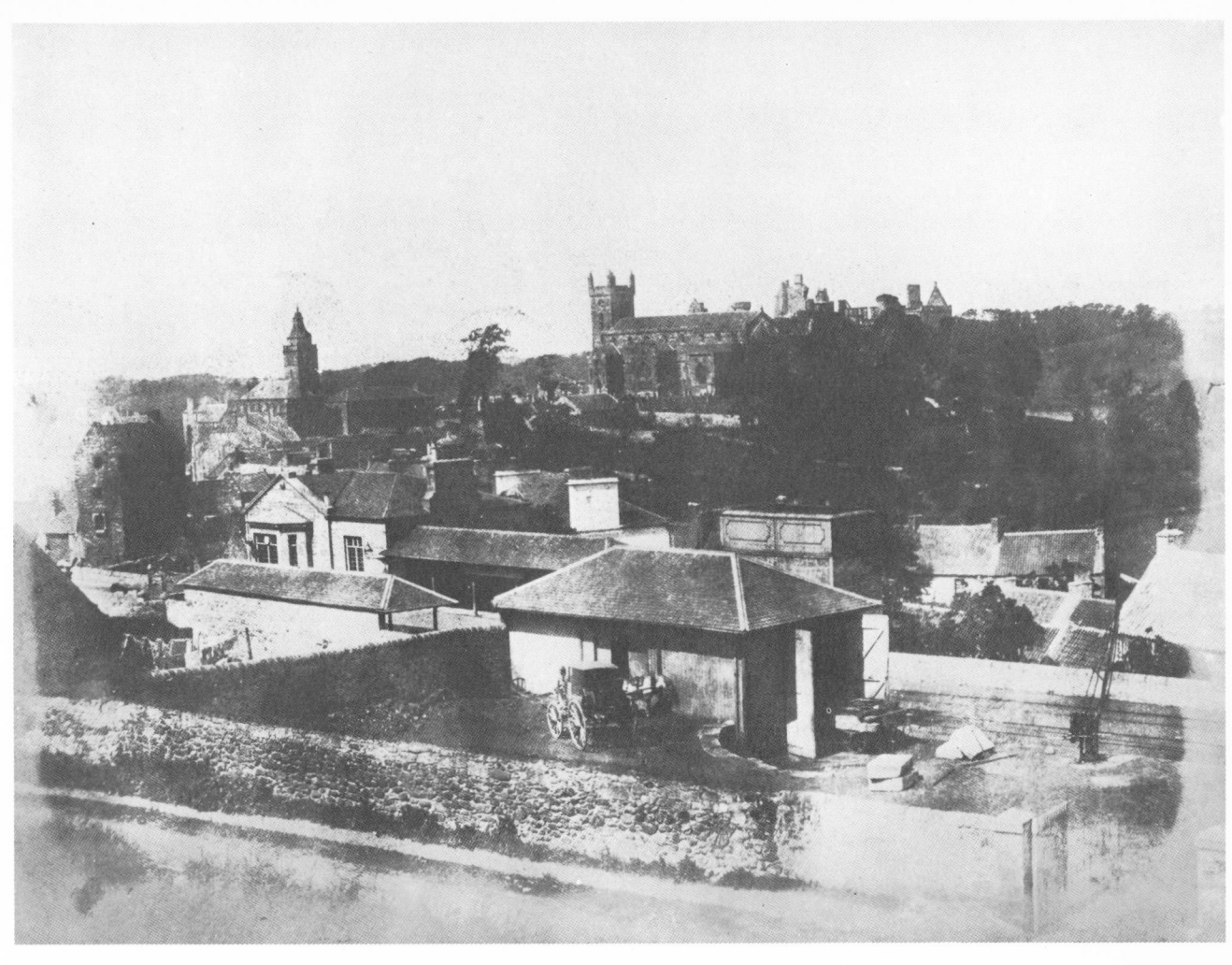

Linlithgow

305 × 390 mm. (12 × 15$\frac{11}{32}$ in.)
Royal Scottish Academy

Linlithgow is a small town eighteen miles west of Edinburgh on the road to Stirling. For many centuries it was a royal residence. It was in the palace, whose ruins show above the trees beside St Michael's Church, that Mary Queen of Scots was born. Her father, James V, was also born there.

St Michael's Church dates from the fifteenth century. Beyond the palace is Linlithgow Loch of which a small part shows towards the right of the picture.

The calotype, which dates from 1845, shows both the railway and a more traditional method of transport – a stage coach. It may have been made as a study for a painting, now lost.

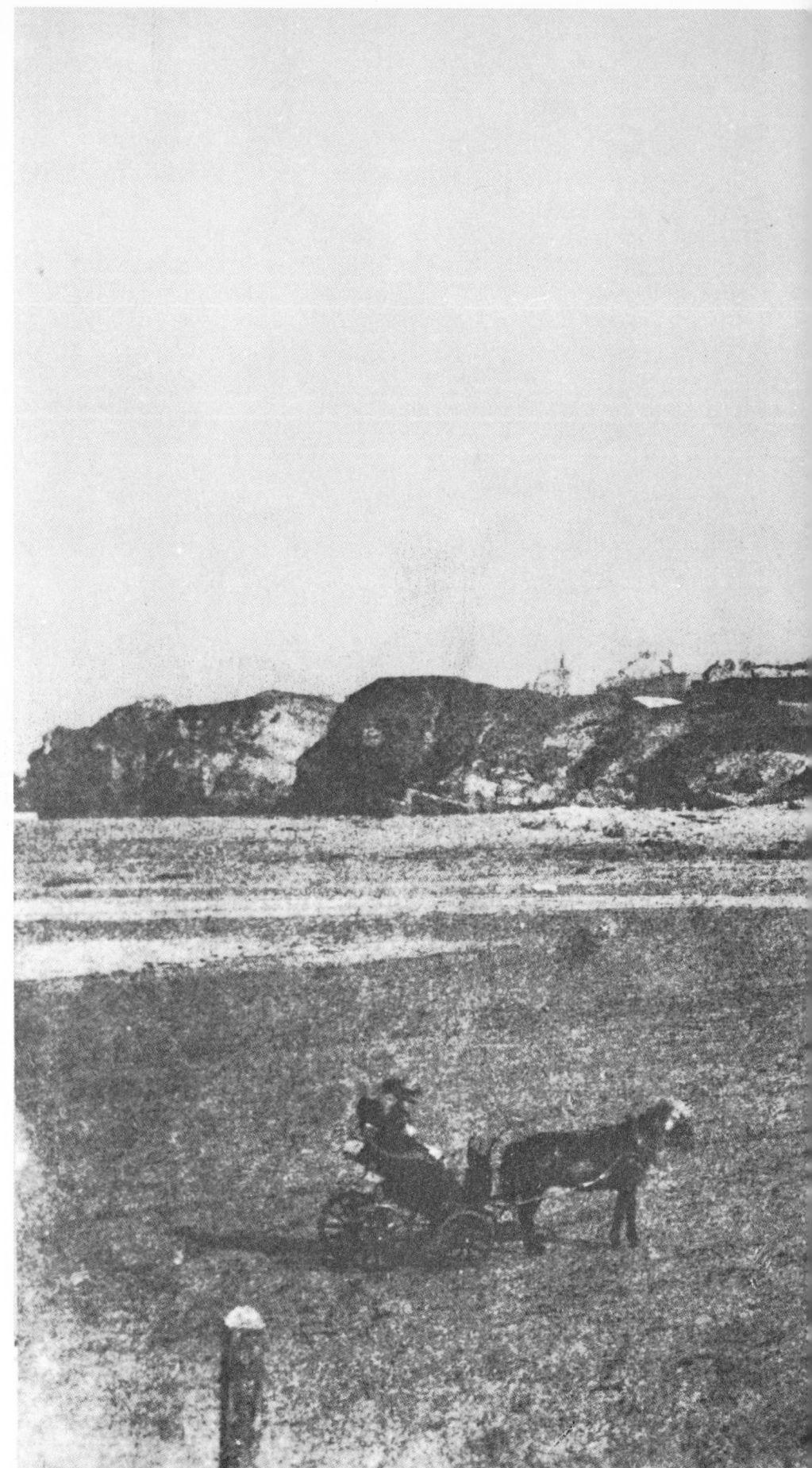

St Andrews from the West Sands

141 × 196 mm. ($5\frac{9}{16} \times 7\frac{23}{32}$ in.)
Scottish National Portrait Gallery

Of all the landscape calotypes this is one of the most fascinating. It has a slightly disturbing effect.

The panorama of the West Sands of St Andrews today is as then. But the presence of the figures in the foreground brings home dramatically the remoteness in time of the calotypes. It records a moment of actuality as truthfully as would any photograph taken today.

232

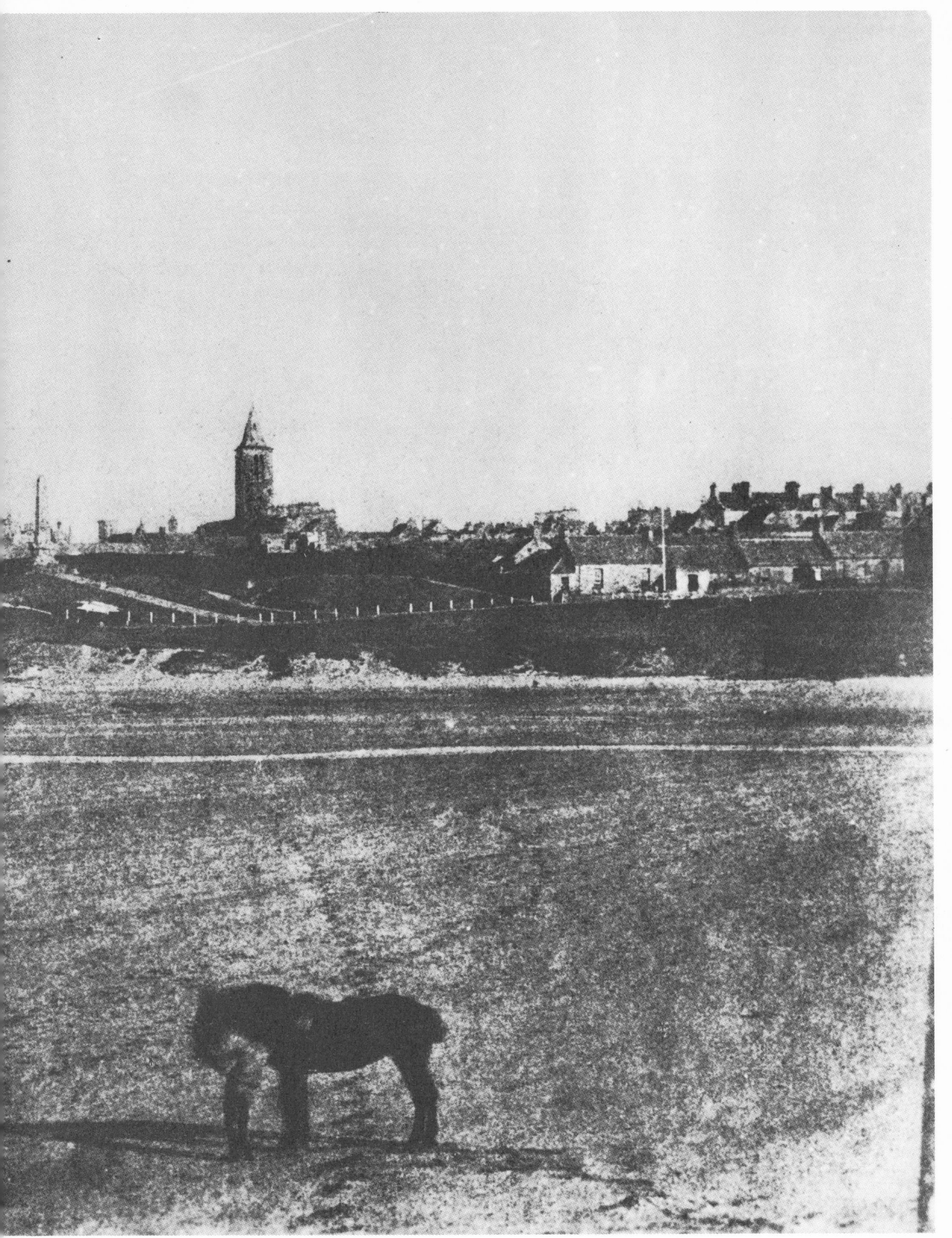

233

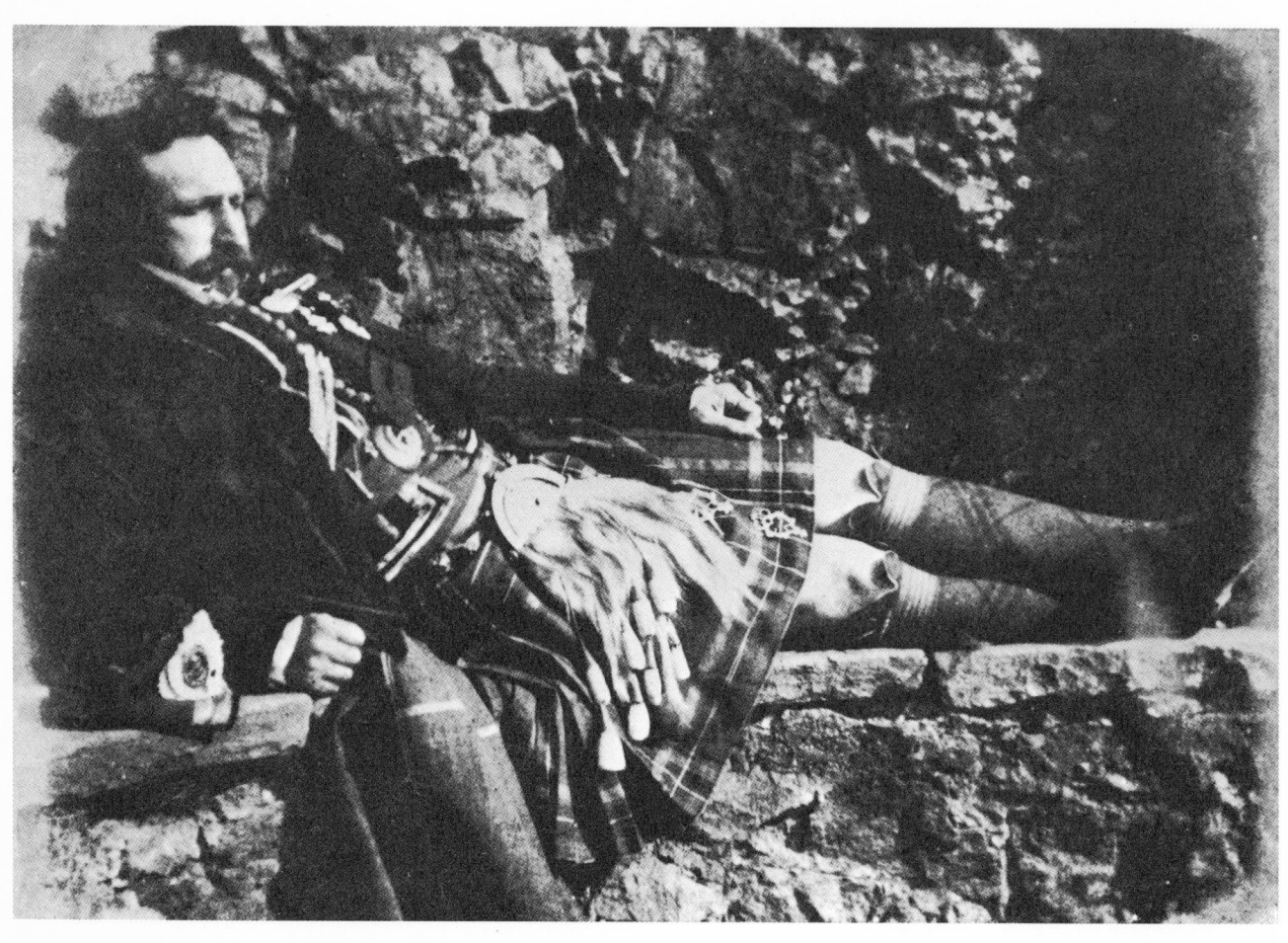

234

Charles Sobieski Stuart

145 × 201 mm. ($5\frac{23}{32}$ × $7\frac{29}{32}$ in.)
Scottish National Portrait Gallery

Charles Sobieski Stuart (1799(?)–1880) and his brother John Sobieski Stolberg Stuart (1795(?)–1872) claimed to be descendants of Bonnie Prince Charlie, and therefore heirs to the crown of Great Britain and Ireland. They may perhaps have been born at Versailles but their identities were only revealed to them, dramatically, in 1811. They went to fight for Napoleon and were with him at Dresden, Leipzig and Waterloo.

In London they learnt Gaelic from a Mr McPherson. They arrived in Edinburgh about 1818. They lived for a time in Argyllshire where they were accepted by the highland landowners. Though previously they had been Protestants they were definitely Catholics by 1838 when they were living on an island in the River Beauly from which they rowed to Mass each Friday, with a banner flying. In 1845 they removed to Prague, where they were treated as royalty. By 1868 they were to be found at work in the Reading Room of the British Museum, with coronets on their writing cases. They are buried, beneath a large Celtic Cross, at Eskdale.

The Hill/Adamson calotype, like the entry in the *Dictionary of National Biography*, is ambiguous. The Sobieski Stuarts' story is so full of romance – Napoleonic medals, pipers, lost scions of royal households – that it seems a little unlikely. Many prominent people supported their claim, and there are Jacobites alive today who believe that what they told was the unvarnished truth, but the most recent verdict, in *Charles Edward Stuart* by David Daiches, is that the brothers were 'romantic and self-deluding' and their story 'wholly imaginary'.

Mrs Rigby

211 × 154 mm. (8$\frac{5}{16}$ × 6$\frac{1}{16}$ in.)
Scottish National Portrait Gallery

Mrs Rigby was one of the many formidable and long-lived ladies who sat for Hill and Adamson. She was born in 1777 in Yarmouth, married a doctor (whom she outlived by half a century), had twelve children and died at the age of ninety-five in 1872. Among her children were Elizabeth and Matilda, also well-represented in the calotypes (see pp. 147, 163 and 229).

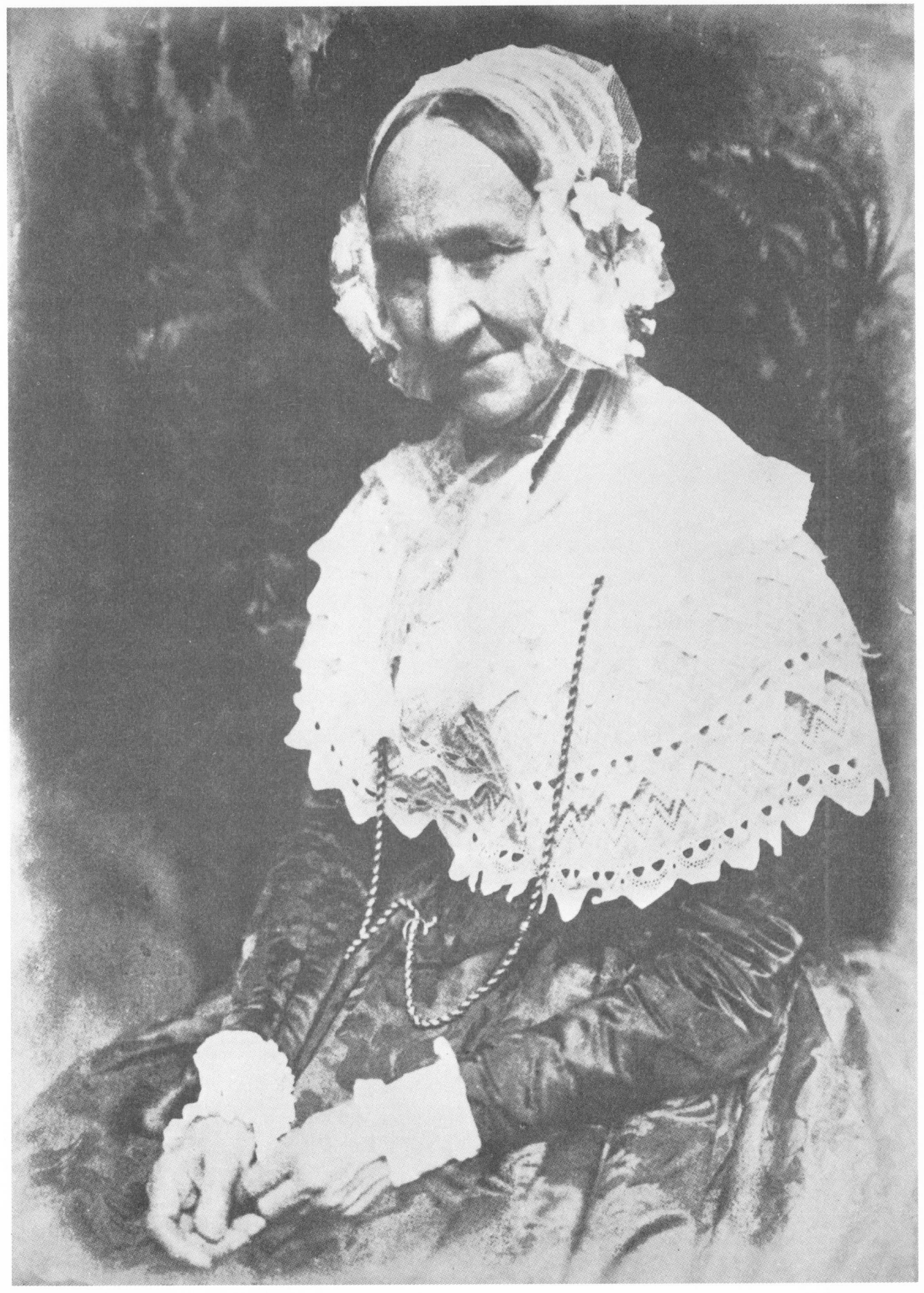

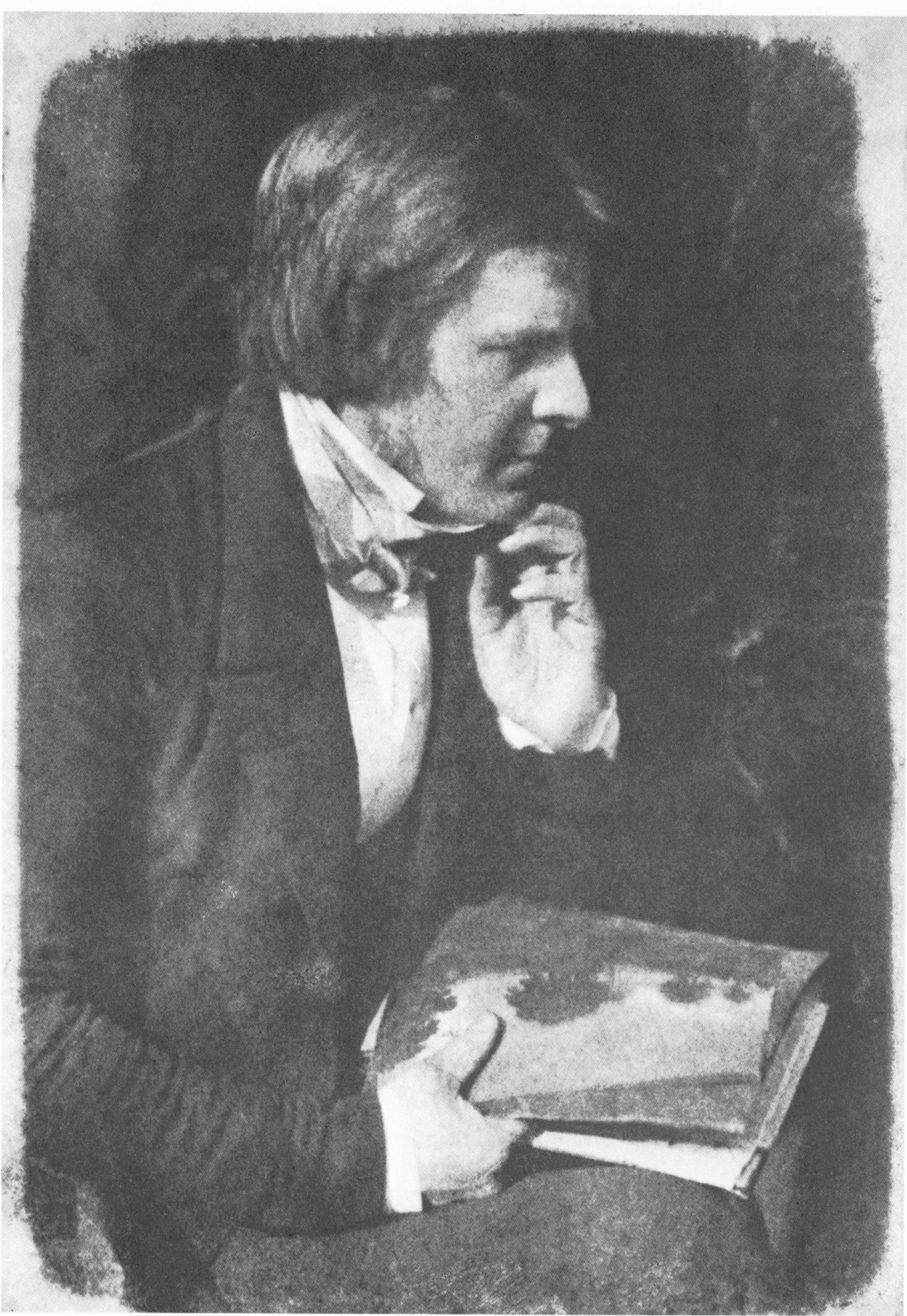

238

D. O. Hill

202 × 146 mm. (7$\frac{15}{16}$ × 5$\frac{3}{4}$ in.)
Royal Scottish Academy

The main interest in this calotype is the book which Hill is holding. It is not at all clear whether this is an instance of retouching or whether the painting has genuinely shown up in the photograph.

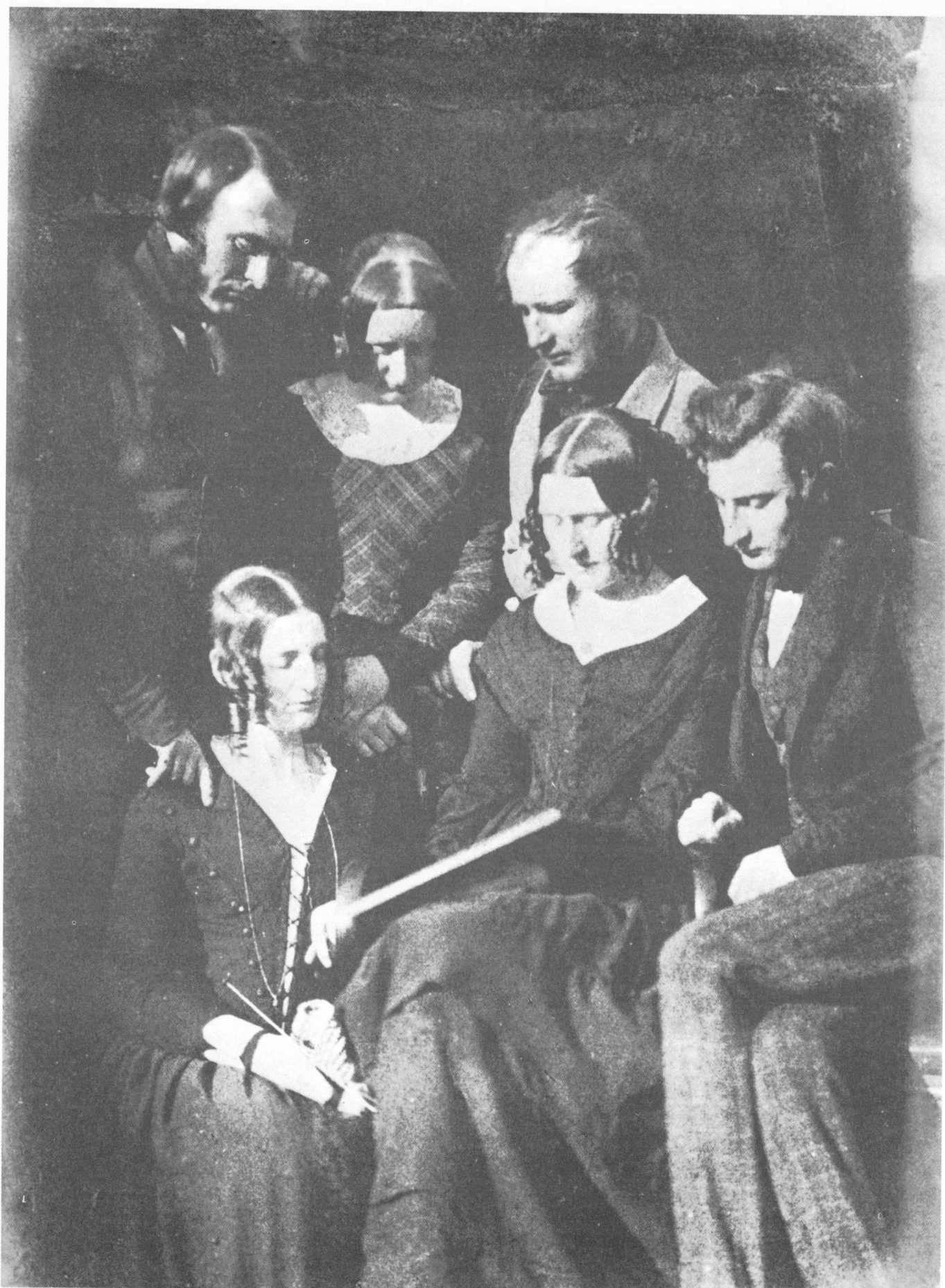

240

The Adamson Family

190 × 144 mm. (7$\frac{15}{32}$ × 5$\frac{21}{32}$ in.)
Edinburgh Public Libraries

Of the group photographs by Hill and Adamson this is arguably one of the finest. It is probably entirely Hill's handiwork since Robert Adamson is himself shown on the right of the picture.

Adamson's pose is to be found carefully transferred into the Disruption Painting which suggests that Hill thought it the most satisfactory likeness.

Selected Bibliography

Booth, Arthur H. *William Henry Fox Talbot* Arthur Barker, London 1965

Daguerre, L. J. M. 'History and Principles of Photogenic Drawing, or the true Principles of the Daguerreotype', trs. J. S. Memes *Edinburgh Review* 154, January 1843

Dunbar, A. 'The Work of David Octavius Hill R.S.A.' *Photographic Journal* 104, 1964.

Elliott, A. *Calotypes by D. O. Hill and R. Adamson* Edinburgh 1928

Ewing, William *Annals of the Free Church of Scotland (1843-1900)*, T. & T. Clark, Edinburgh 1914

Gernsheim, Helmut *Creative Photography: Aesthetic Trends 1839-1960*, Faber, London 1962

Gernsheim, Helmut *The History of Photography* Oxford University Press, London 1969

Grant, James *Old and New Edinburgh* Cassell, London 1880-83

Gunnis, Rupert *Dictionary of British Sculptors* Odhams Press, London 1953

Laver, James *Victoriana* (chapter on photographs) Ward Lock, London 1966

Mackinnon, Donald *Disruption Picture* Free Church of Scotland, Edinburgh 1943

Newton *London Journal & Repertory of Patent Inventions* Nos. 8842, 8 February 1841 and 9753, 1 June 1843

Nickel, H. *David Octavius Hill* Halle, Germany 1960

Schwarz, Heinrich *David Octavius Hill, Master Photographer* Harrup, Germany 1932

Scottish Arts Council *Centenary Exhibition* catalogue 1970

Stephen and Lee (ed.) *Dictionary of National Biography* Oxford University Press, London 1952

Talbot, H. Fox 'Some Account of the Art of Photogenic Drawing, or the Process by which Natural Objects may be made to Delineate themselves without the aid of the Artist's Pencil' *Edinburgh Review* 154, January 1843

Thomas, D. B. *The First Negatives* HMSO, London 1964

Turner, A. L. *Story of a Great Hospital: The Royal Infirmary of Edinburgh 1779-1929* Oliver and Boyd, Edinburgh 1937

and the following reports from the *Scotsman*:
'The Disruption' 17 and 20 May 1843
'Obituary of D. O. Hill' 18 May 1870

Index